Wisdom With Understanding is Better Than Rubies

Lurine Karon Greenberg
Fine Arts Collection

ILLUSTRATED BIOGRAPHY BY BEN MADDOW

AFTERWORD BY JOHN G. MORRIS

AN APERTURE BOOK

LET TRUTH BE THE PREJUDICE

W. EUGENE SMITH

HIS LIFE

AND PHOTOGRAPHS

THIS PUBLICATION AND EXHIBITION ARE MADE POSSIBLE
BY ATLANTIC RICHFIELD FOUNDATION.

*The exhibition was supported by grants from The Pew
Memorial Trust and the National Endowment for the Arts, a
Federal Agency.*

*The research, planning, and editorial development of this
project were supported by a generous contribution from
Mr. and Mrs. Robert A. Hauslohner.*

THIS VOLUME ACCOMPANIED THE MAJOR
RETROSPECTIVE EXHIBITION, W. EUGENE SMITH:
LET TRUTH BE THE PREJUDICE. ORGANIZED BY
THE ALFRED STIEGLITZ CENTER OF THE
PHILADELPHIA MUSEUM OF ART, THE EXHIBI-
TION TRAVELED TO THE FOLLOWING VENUES:

PHILADELPHIA MUSEUM OF ART

Philadelphia, Pennsylvania
October 19, 1985–January 5, 1986

INTERNATIONAL CENTER OF PHOTOGRAPHY
New York, New York
March 21–April 27, 1986

MUSEUM OF CONTEMPORARY ART
Los Angeles, California
June 8–August 10, 1986

AMON CARTER MUSEUM
Fort Worth, Texas
January 10–March 1, 1987

HIGH MUSEUM OF ART
Atlanta, Georgia
June 2–August 23, 1987

MINNEAPOLIS INSTITUTE OF ARTS
Minneapolis, Minnesota
September 12–November 8, 1987

THE CLEVELAND MUSEUM OF ART
Cleveland, Ohio
December 2, 1987–January 24, 1988

GLENBOW MUSEUM
Calgary, Alberta, Canada
August 27–October 23, 1988

INDIANAPOLIS MUSEUM OF ART
Indianapolis, Indiana
December 3, 1988–January 29, 1989

CENTER FOR CREATIVE PHOTOGRAPHY
Tucson, Arizona
February 25–April 23, 1989

*Aperture Foundation publishes a periodical, books,
and portfolios of fine photography to communicate with
serious photographers and creative people everywhere.
A complete catalog is available upon request. Address:
20 East 23rd Street, New York, New York 10010.
Phone: (212)598-4205. Fax: (212) 598-4015.
Toll-free: (800)929-2323. Visit Aperture's website:
http://www.aperture.org*

ACKNOWLEDGEMENTS:
Ben Maddow and the staff at Aperture are indebted to
many people for their insights, advice, background mate-
rial, and patience. The warm generosity of W. Eugene
Smith's friends, lovers, and collaborators was overwhelm-
ing. For the record, more than mere thanks are owed to
the following people, listed alphabetically: Cornell Capa,
Ted Castle, Martha Chahroudi, Anne d'Harnoncourt,
Maitland Edey, Helen Gee, Arthur Goldsmith, Robert S.
Harrah, Jim Hughes, James Karales, Aileen M. (Smith)
Katagari, Barbara Lobron, Wally Mac Gaillard, Marion
Osmun, John Poppy, Patrick and Phyllis Smith, Margery
Smith, Kevin Eugene Smith, Sherry Suris, Carole
Thomas, Edward Thompson, Leslie Teicholz, Evans G.
Valens, Lee Witkin, Carmen Smith Wood.

SPECIAL GRATITUDE goes to William Johnson, whose
publications on Smith are essential to a measured and
careful assessment of Smith's work; and to Smith's long-
time friend John G. Morris. Both these men examined the
original manuscript, layout, and picture selection, made
detailed criticism, and suggested changes. Their contri-
butions went far beyond the conventions of scholarly
assistance. Carole Kismaric deserves special credit for
her work on this project in its initial stages and her over-
all contribution to its completion.

ORIGINAL PRINTS were provided by the Center for
Creative Photography, University of Arizona, in Tucson.
We wish to thank James L. Enyeart, the director, and
staff members Sharon Denton, Lawrence Fong, Amy
Stark, and Terence Pitts for their generous time and
assistance in both the retrieval of prints and the study of
the voluminous Smith archive.

THE EXPOSITORY MATERIAL that accompanies W.
Eugene Smith's work throughout the photography sec-
tion of this book was assembled from many different
sources. The main introductions to the five chapters of
the photography section were graciously contributed by
Ben Maddow. The material featured throughout these
chapters was written by Lawrence Frascella or collected
from the writings of W. Eugene Smith, John Morris, and
William Johnson. The Bibliography was provided by
William Johnson.

Aperture Foundation books are distributed inter-
nationally through: CANADA: General Publishing, 30
Lesmill Road, Don Mills, Ontario, M3B 2T6. Fax: (416)
445-5991. UNITED KINGDOM, SCANDINAVIA, AND EUROPE:
Robert Hale, Ltd., Clerkenwell House,45-47 Clerkenwell
Green, London EC1R OHT. Fax: 44-171-490-4958.
NETHERLANDS: Nilsson & Lamm, BV, Pampuslaan 212-
214, P.O. Box 195, 1382 JS Weesp. Fax: 31-294-415054.

For international magazine subscription orders
for the periodical *Aperture*, contact Aperture Inter-
national Subscription Service, P.O. Box 14, Harold Hill,
Romford, RM3 8EQ, England. One year: $50.00. Price
subject to change.

To subscribe to the periodical *Aperture* in the U.S.A.
write Aperture, P.O. Box 3000, Denville, NJ 07834. Tel:
(800) 783-4903. One year: $40.00. Two years: $66.00.

Composition by David E. Seham Assoc., Inc., Metuchen,
New Jersey; Duotone negatives by Robert Hennessey;
Printed and bound by Seong Chong, Hong Kong. Library
of Congress Catalog Card Number: 85-70045
ISBN: 0-89381-179-3 (cloth)
ISBN: 0-89381-207-2 (paper)

Book design by Betty Binns Graphics/Betty Binns and
David Skolkin

The staff at Aperture for *W. Eugene Smith: Let Truth
Be the Prejudice* is Michael E. Hoffman, Executive Direc-
tor; Christopher Hudson, Publishing Director; Lawrence
Frascella, Managing Editor; Stevan Baron, Production
Director; Katherine Houck, Production Associate.

ALL QUOTED MATERIAL within the photography
section was written by W. Eugene Smith. It was selected
from war dispatches, personal letters, and undated man-
uscript notes with the following exceptions: p. 102 from
"He Photographed the Real War," by Selma Robinson,
P.M.'s Sunday Picture News magazine section, May 26,
1946; p. 143 from *W. Eugene Smith: A Portfolio of Ten
Photographs*, Witkin-Berley, 1977; p. 153 from "A
Spanish Village," by W. Eugene Smith, *U.S. Camera
Annual* 1952; p. 170 from *U.S. Camera*, April 20, 1955; p.
220 and 222 from *Japan: A Chapter of Image*, A
Photographic Essay by W. Eugene Smith, with Carole
Thomas, Hitachi Ltd., Tokyo, 1963; p. 233 from
Minamata, Words and Photographs by W. Eugene
Smith and Aileen Smith, Holt, Rinehart and Winston,
New York, 1976.

First edition
10 9 8 7 6 5 4 3 2

CONTENTS

THE WOUNDED ANGEL

By Ben Maddow

1. *"He rolled his life with a wide gesture."*

WILLIAM EUGENE SMITH was born in Wichita, Kansas, on December 30, 1918, and died in Tucson, Arizona, on October 15, 1978. Everyone's life is finally inexplicable; his was rather less so. His vocation, he once said, was to do nothing less than record, by word and photograph, the human condition. No one could really succeed at such a job; yet Smith almost did. During his relatively brief and often painful life, he created at least fifty images so powerful that they have altered the perception of our history.

Though he traveled, and never for pleasure, to Europe, Africa, and Japan—and to that even further and more dramatic country, the Deep South—he was, at his very center, a Midwestern boy. By nature and even more by expectation, he was clever, energetic, furiously competitive, shy, genteel, selfish, naive, boyishly humorous, mechanically apt, and intellectually amateur. For good or bad, he became famous early in life, and suffered no real eclipse, except in his own fierce mind. This mid-century Tom Sawyer, raised in the narrow optimism of the American small town, propelled himself into the wicked, tolerant, and cynical urban culture of post-World War II, enjoyed it tremendously, but could never make peace with his earlier self.

He was a dramatic and intense man with a thick chest and powerful arms; virility was very important to him. And many people loved him; too many, perhaps. There were at least ten women of some importance in his emotional life: two were his wives, four were not; three were his daughters; one, with him until he was 37, was his powerful mother. He used all these people with merciless affection; they were attached to him by need and admiration, and he rewarded them not with money, but with a flattering intensity. By the testimony of his friends and lovers, Smith had care, respect, and sympathy toward all sorts of people—but always at a certain distance. One of his assistants once said, "Gene had a way of burning his bridges behind him." In private, he would scoff sometimes at his closest friends and assistants, and forget them when they were not there. By the sixties, certainly, he had tainted his original verve and innocence, and replaced it with a fury that exhausted him; he expressed it in a rhetoric so extreme that it was often, except for its anger, almost, though not quite, incomprehensible:

And I photograph—my name is dumb. Anger and sorrow fire the universe of my being. And pain is the searing twister causing freeze. I have much to say, including apologies, philosophies, and complaints. I am late to the track of the dollar, traced somehow within the forest mechanical upon its floor of concrete. The spoor of my prey is repellant even as I eagerly race after it—who is whom, whom is who, who's who on the racetrack circle.

There was, hidden at first, but plain at last, a 19th-century darkness in the man, of the sort lit by flashes of that nameless guilt that has always clouded the American creative spirit; not so much among our graphic artists, relentlessly cheerful, with few exceptions, from Thomas Cole to Rockwell; but among our literary parents: Poe, Melville, Dickinson, and Faulkner, for a start. W. Eugene Smith belongs in that dark company; his work has the same zones of black morbidity and defiant heroism.

Study certain famous Smith images: the woman from Minamata and her maimed daughter; the mourners at the wake of the Spanish father; the three Welsh miners with their charcoal faces; the three Spanish Civil Guards in their black tricorns; the blinding stare of the black woman in the dark stockade for the insane in Haiti; and the black sweat of the Pittsburgh steelworkers. One notices that dark areas dominate the plane of the print. That's even true of the two luminous children in "The Walk to Paradise Garden." Smith's technique was keyed to this ratio. In his own words:

I *overexpose* flashes about three times. I know everybody says you will get flat prints and blocked highlights. It just doesn't work that way for me . . . Sure, I have to burn in the faces, but I have all the crisp detail in the shadow.

Indeed, as he grew older, his prints of the same negatives grew instinctively darker.

Darkness is where Smith felt at home; the cave of the world illuminated by dramatic postures of light. It was the brilliant, somber drama of his photographs that made him famous—shafts of formal light through a chaotic dark, like Rembrandt's drawings for the Bible. Smith knew these drawings, once suggesting a double show that would present his work and Rembrandt's together.

He insisted he was humble, but only in comparison with perfection. He had a passion not merely to be good but to be best; and not merely to be best but to be recognized as best; and not merely to be recognized but to be recognized over and over again. And this was the machine that drove him into bitter self-criticism,

rewarded him with mistrusted fame, and repeatedly—ironically—poisoned his victory with a feeling of defeat. His self-joy and self-hatred were inextricable.

From his mid-teens on, Smith's photographic labors were truly immense. He made at least 20,000 negatives between 1937 and 1939. By 1941, before the U.S. entered World War II, he had accumulated more than 40,000, even though he had destroyed thousands of his earlier negatives. In the Smith archive at the University of Arizona's Center for Creative Photography in Tucson, there are at least 100,000 negatives. Of course, any serious photographer must, by the very mechanics of the medium, outnumber in images the man who works with ink, acrylic, or oil. But one must remember that the contact sheets, the first proofs of all of these negatives, do not represent finished and permanent work. They are sketches, steps in the circling hunt for the perfect angle, the perfect light, the perfect climax of drama. And while the faulty images may be as detailed as the best, psychologically and aesthetically, they are the rude charcoal sketches of an artist looking for the final place to see.

Yet even if we discount these interim negatives, Smith's labors remain enormous. His well-known photo-essays—"Country Doctor," "Spanish Village," "Nurse Midwife," Doctor Schweitzer in Lambarene, the giant, lyric, megalomaniac Pittsburgh project—are only part of his rich material. His assignments for *Life* magazine alone number close to 150. An assignment might involve a week's work or several intensive months of labor; and it might be printed and published, or it might not. But the unpublished work costs, in psychic energy, as much or more than the published. More exhausting still, Smith was a perfectionist.

It was the 1946 exhibit of Smith's World War II photographs at the Camera Club of New York that lifted him from his reputation as an excellent, hard-working photo-reporter up into the mysterious realm of the genius. Most flattering were the unsolicited reviews. Bruce Downes, then editor of *Popular Photography* magazine, wrote to Smith: "Your pictures are true and horrible and agonizing, but they also have a moving beauty of their own . . . Having seen your pictures I will not forget them for the rest of my life."

Lincoln Kirstein, one of our most sensitive and articulate critics, also wrote to Smith: "You make photography what it best is: heroic actuality . . . You . . . have a real grandeur, a terrible humanity, and an absolutely achieved reality." And his idiosyncratic and often acrid epilogue to Smith's 1969 monograph (*W. Eugene Smith*, An Aperture Monograph) comes around to saying of Smith's photographs: "I admired [him] more than any American, save Brady, Walker Evans, and Alice Boughton."

Henri Cartier-Bresson, whom Smith met several times, dictated an emotional tribute over the phone: "I feel Gene's photographs reflect a great turmoil. They are captured between the shirt and the skin; this camera, anchored in the heart, moves me by its integrity." That dangerous word, integrity, was used by Smith himself throughout his chaotic life.

Smith loved to teach; one of his courses, characteristically, was called "Photography Made Difficult." His personal intensity, and curiously enough, the lisping impediment of his speech, consequent to a bad prosthesis over a war wound, made him an unforgettable teacher. His decrepit easy chair, pasted with tape and decorated with phone numbers, rests in his archives. Students come and sit in it to absorb Smith's ambience. They remember his lectures years later partly, maybe even mainly, because he preached a social use:

Because I would experience ever deeper, and endeavor to give this experience, I frequently have sought out those who were in the least position to speak for themselves. By accident of birth, by accident of place—whoever, whatever, wherever—I am of their family. I can comment for them, if I believe in their cause, with a voice they do not possess . . .

One can hear in these words the familiar and necessary arrogance of the artist. Smith's complex and often voracious personality grew to obsess everyone who ever knew him. He was, by the testimony of friends, assistants, wives, lovers, and employers, "a very, very, very egotistical man"; "a very soft, gentle guy"; "inconspicuous"; "quiet, and amiable and shy"; "a quiet, sweet little lamb, but emotionally demanding"; "like a quiet, intense child"; and "he got a lot of mileage out of being likable—and he was that, too." Yet he could rant and rage, particularly if anyone tried to discipline his habits; he would throw his cameras against the wall; yet "he always knew exactly what he was doing," even in his most violent letters and tantrums. His talented assistant, Robert Harrah, took a photo of him at dinner in Greenwich Village in 1948. The table is lit by a candle; Smith has an iced drink in front of him; he wears a small moustache and glasses, dark suspenders, but no tie or jacket, and he has a conspicuous Band-Aid on one finger. Harrah explained, "The bandage on the knuckle was required after a telephone conversation with *Life* that resulted in Gene slamming his fist into a door." That was neither the first nor the last of such self-punishment.

Another, and not unexpected facet of his character, familiar to all of us who've been victims or perpetrators ourselves, was his juvenile American humor, accurately called "kidding." For example, while on the road, Harrah and Smith stopped in a hotel for the night, and dinner for two was brought to Harrah's room. According to Harrah, Gene:

. . . followed the waiter in and hung the Do Not Disturb sign on the door, at the same time tipping the waiter and saying, "Isn't he the cutest, most handsome thing you ever saw?" The poor waiter backed out dumbfounded. "See Robert, you can't wreck my rape-utation any more than I can. Let's eat, you rat, you."

Smith loved puns, inventing them like an adolescent who has just learned the queer ambiguity of words. He wrote whole paragraphs stuffed with puns like raisins, which gave his prose a somewhat sinister flavor.

In his correspondence, Smith conjured up a whole world of rich culture: the Beethoven late quartets, Bach, Whitman, Hemingway, Faulkner, Kafka, jazz, especially Louis Armstrong, and the renaissance of American folk music. All these are the stars of a cultural constellation that glittered over New York intellectual life in the forties and early fifties.

How Smith established intimate contact with the intellectual taste of the time is hard to trace. One suspects that the most influential person in Smith's life was himself; he was a truly self-educated man, with all the leaps and insights and insufficiencies that go with that effort. He boasted that he had over 6,000 books; but there is general testimony from his intimates that they never saw him read, though this is not quite accurate: he greatly admired the Nietzschean superhero of Ayn Rand's novel *The Fountainhead*. And he did read and annotate the great number of magazines he bought, because he used them as references, as inspiration for possible picture essays. As William Johnson, the curator of his work, has remarked, "Smith wanted to eat the world."

He had in his library some 25,000 musical records; a large investment, incidentally; he would think nothing of spending $150 in a record store. During his boyhood, his family had the usual middle-class records: the comedian Harry Lauder, Enrico Caruso, John McCormack, and John Philip Sousa, of course. "I used to play some of these while helping with the housework on Saturdays," Smith wrote. His taste changed in New York City. He played music not merely in the long, dim lonely hours of the dark-

room—many photographers do just that—but he turned on music as soon as he woke up, and played it all day long and much of the night. This he did from his twenties to the very end of his life. He insisted that music was the strongest influence on his photography, too; but the forms are really very different; time in music is a moving dimension, which is frozen and dissected in still photography.

But music affected Eugene Smith deeply and personally in quite another way; it was, literally, the score of his life. The romanticists—Moussorgsky, Puccini, Mahler, Beethoven, Wagner—served to heighten his personal dramas. With music roaring in his head, every annoyance and opposition became high tragedy.

Everyone who knew him testified to the melodramatic quality of his daily life. He was always on a stage of his own construction: the clown, sometimes, but mostly the tragic hero. Smith loved the theater, and adored the people in it. He photographed at least twenty stage productions, and as many actors, singers, and musicians. But it wasn't an ordinary drama in which he cast himself; it was more like a lifelong opera. There were intensely loyal friends, bitter villains, passionate lovers, tender children, and of course, front and center, with extended arias, himself.

He threatened suicide, not once or twice, but scores, perhaps hundreds of times, especially in his last 25 years. But how, if you loved him, were you to know the real from the dramatic? One of *Popular Photography*'s editors, Arthur Goldsmith, who described him as a "charming and witty man, a good companion," advanced money so that Smith would not kill himself. "Why carry on?" Smith would say. Goldsmith saw him two days later at a function of the American Society of Magazine Photographers (ASMP). Smith was wearing a tuxedo and in splendid spirits. Gene's son Patrick Smith relates how his father would call him up at 3 a.m. and declare he was going to kill himself. Pat and his wife would wake their two young children and all four would drive downstate for two hours to Smith's New York loft, where he would be in bed, alive, of course, and weeping. Jim Karales, his assistant during one of his longest and most severe professional crises, heard Smith's threats many times and finally said, "Go ahead, Gene, you don't have the guts." He was right; there was never a time when Smith was rescued from suicide by medical means.

Smith's medical history is thick and lengthy and mostly still unavailable. He was hurt often, and at least four times severely though not gravely. The most dangerous threat to his body was his double addiction to stimulants, mostly the amphetamines including Benzedrine, and to alcohol, which he drank heavily and continuously for many years.

Addiction is not a one-sided affair; drugs and the drugged love each other. Smith's enormous output, his ferocious energy, his slow but certain grasp of the essential drama at the core of human events—maybe these qualities were fed and sustained by such potent drugs. Benzedrine keeps your mind spinning at an exciting rate; you can't sleep, you have no appetite, but you know you are brilliant. And alcohol commonly enhances one's personal drama; it narrows and brightens whatever happens. It is also a dangerous poison, and the amphetamines are even worse; prolonged use

over many years brought Smith to the very edge of that cliff that overhangs paranoia.

It's possible, though, that the use of drugs was a necessity of Smith's character—he may not have survived the stress of his own conflicts without them. Within him was the battlefield of a furious mind resisting the very mid-American, mid-century culture that had created him.

He wrote to Robert Harrah:

You see, photography takes something that is born within some people, then this natural talent must be pushed into use by study and by a really grim determination to master it. To make it kneel to you and give to you, and in the struggle it often appears that it has become the master over your tired, battered person.

Smith was hardly 30 when he wrote this operatic recitative; there's some truth to it, nevertheless, as there was to his most frantic rhetoric.

There are, in the tons of miscellanea in Smith's archives in Tucson, Arizona, certain illuminating documents that mark the curve of Smith's development. They begin with the boyish letters to his mother in 1936 and 1937—"Dear Mom, Hello my precious little crabapple, how art thou?"—and stretch to the bitter 1970 inscriptions on an old metal locker he had in his famous New York loft: "What greater love can man have than to fuck his enemies . . . However, in this place you may get fucked but never as revenge."

But one fragment, unaddressed and undated, may be the most revealing:

He rolled his life with a wide gesture, he had a big talent, a bull headed stubbornness, a shy sensitivity, and fatal weakness of the flesh, and so as he made his move into the early thirties it was with a handicap weight of one wife, four children, and their miscellaneous sea anchors. He could not buckle into a normal beaten routine as do the great majority of the world's inhabitants, yet he could not sustain an individuality that allowed him the flow of his honest need to do work that was good, for the good of others, and thus of himself, and the struggle as the handicap weight bore him panting and wild into the muck of mediocrity and worse, was a terrifying thing to witness, the violence of his bitterness, yet knowing it was of his own doing, the screaming of his desire to be true to the good side of his split being.

If one dares to write about a fellow human being, it is only right to let him speak for himself. And Smith spoke very loudly, if not always clearly. He wrote a thousand letters or more and kept small notebooks with handwriting in large capitals, which together form a journal of his wars, public and private. Nothing Smith meant to say is lost; he saw to that. Witnesses to his life may be partial, or they may not want to testify at all, at least not yet; or they may be dead. One is obliged to quote him directly; the man himself insists upon it. And if the result is like a novel, with lots of dialogue, at least it is intimate with the truth.

The truths of a whole lifetime, unfortunately, are sometimes splendid and admirable, and sometimes not. But thus we may comprehend, through Smith, and in spite of his particularities, our own marvelous, tragic, and ridiculous selves.

2. *"A good and obedient child."*

ONE SIMPLY cannot, within the confines of this profile, map out all the details of Smith's complicated life. Later historians must correct the circumstantial errors of gossip and memory. Some of the legends about Smith will turn out to be true, some invented,

possibly by himself. But the main geography will not change: not the brilliant mountain chain of his seven chief essays in photography; nor the enormous shadow of his personality. As his first wife said, "Gene is dead, but he won't lie down."

What could be more ordinary than his boyhood? Like other "ordinary" American lives, it was far from average. His parents married in the peaceful year of 1907. His father, S. J. Smith, became a good and popular businessman, operating out of Wichita, Kansas, as a grain dealer. He was much respected, sent to testify before official committees, and was elected president of the Wichita Board of Trade. Smith's mother, Nettie, was a talented and formidable woman of some physical and psychological weight—obese in her later years. She had a powerful, square face, heavy cheekbones, and relentless eyes. She had studied composition in an art school in Wichita and, after her marriage, had bought a 3¼ x 4¼ Brownie camera, turning to photography to express her talent. When Smith was a boy, his mother had an improvised darkroom, which was by no means unusual. At the turn of the century, a good percentage of the Photo-Secession (an organization of photographers founded by Alfred Stieglitz) were women, who sent their photographs, as she did, to the exhibition salons of the period.

The house where Eugene Smith spent his childhood was a big, white, middle-class home. His parents had servants—by no means a privilege of the rich—who were black domestics that, if tired, would not be allowed to rest inside the house; they would be obliged to sit outside on the verandah instead. The family pride in grace and heritage largely belonged to Nettie Lee Caplinger Smith. Her family, the Caplingers, were Germans who had come to Virginia two centuries earlier. German towns were established everywhere along the Atlantic Seaboard; many had shop and street signs only in German. Smith himself sometimes boasted of his "prairie stock." One thinks of sod houses or wrenching stumps and plowing the virgin back forty with mule and wife. But the fact is that on his mother's side, his ancestors were sturdy businessmen: slave-owners, storekeepers and distillers, wholesale and retail. Through this family, Nettie inherited a personal fortune, modestly substantial, in farm acreage in Arkansas and Texas.

Of Smith's ancestry on his father's side, little is known except that his paternal grandparents were Catholic. What is fascinating, given her unyielding personality, is that Nettie Smith, a Protestant, became a convert to her husband's family faith—and an ardent and zealous one. She kept the customary scrapbook of family events and pasted in, along with clippings on her husband's career, articles about the local celebrities of the Catholic Church. In fact, both her children—Gene and his older brother, Paul—went to parochial schools.

Smith's father was a pleasant, quiet, amiable man. But his mother, by virtue of her inheritance of both land and character, was a much tougher person. Smith's view of her, looking back at that period, was not a happy one:

After I . . . receive a letter from you, I almost dread to open it, for I surely know one thing, that somewhere in it will be one or more sentences or paragraphs aimed by you to hurt me and to give me a feeling of guilt—but then, ever since I was a small child, you have managed your disapproval of any action or lack of doing by me that did not adhere to your wish, commands, or your opinions, in such a way that it has always hurt and intimidated me—even in the things I felt I was absolutely right about. I think that is one of the reasons my life is such a hurting today.

Paul, Gene's older brother, was stricken by polio when he was six; and paralysis withered the muscles of his left arm. When he played basketball (there was a hoop on a pole in every American backyard in those days) he shot and dribbled with one arm; the other, in family pictures, kept resting in his pocket. Fear of and actual injury to the left arm would be the ironic destiny of his younger brother. There was a marked and fateful difference between the mother's treatment of these two boys; she expected little of Paul, and Gene Smith was patronizing if not wholly con-

temptuous of his brother; indeed, as a grown man, Paul had a shifting, uncertain life. He farmed; he ran a restaurant; he was mostly poor and often out of a job. A mother's pride was early invested in her quiet, shy, and energetic second son; she wrote: "From the time he was three weeks old, he was taught to hang on tight to anything he had to hang onto, and to grab quick for something when he didn't . . . he is still hard at it."

Yet illness obsessed Gene Smith, especially when he wrote to his mother, or to his wife, and later, to his enemies as well as his friends. He complained all his life of physical suffering; yet he was a vigorous boy, and in later life, as late as 50, he was described by his second wife as having a good body, a powerful chest and arms. His parents insisted that:

. . . he take special courses in effective speaking and elocution in order to overcome his shyness in doing anything before either a class or a crowd; it is impossible to picture him as doing things either theatrical or dramatic, just for the adventure.

The latter, as we shall see, is a fond and mostly false estimate.

There were in Smith, as one friend wrote, "raging internal fires." They were directed outward at any arbitrary discipline imposed on himself; and this meant he opposed most authority, which is by its very nature often obtuse and impersonal. At school, he got revenge on a hated teacher by presenting him with a booby trap in a neatly tied box. Smith said he warned him, but the teacher disregarded his threat; the trap blew up in the teacher's face. One assumes there was no explosive, just a spring device like a jack-in-box, something a handy boy could devise in the back shed. This restless impatience with tyranny, domestic or professional, was strained by the discipline of parochial school, by Midwestern small town society—and by his mother. When he was seven years old, he wrote from his little desk at the Cathedral School, on the day before Christmas, 1925:

Dear Parents,
I am too small to give you a Christmas gift, but I shall ask the Sweet Babe of Bethlehem to bless you and make you very happy. I love you and thank you for your kind and loving care of me. I shall ask the child Jesus to make me a good and obedient child.

Your dear child
Eugene Smith

That's the good boy; the tough, self-reliant kid came later. Of course, the boy is not the man; but one need only look frankly at oneself to realize that the child does not wither away as we mature, but is clothed and bound under the layers of our new and more temperate selves. The sensual child can break out of these bounds and shriek or laugh or howl when we least expect; each younger age is concealed inside the older. So there was not only the bad, selfish, lusting, egotistical lad, but also the good, ambitious, hardworking, pious Catholic boy. Both sides were already embraced in what would be a lifelong and unresolved struggle.

Early in his teens, Smith developed a boyish passion for airplanes. He wanted to become an airplane designer (though he also wanted to be "a famous surgeon"). It was not all that long after two other grown-up American boys, Orville and Wilbur Wright, had flown, for all of 59 seconds, a contraption they built in their bicycle shop. America was a nation of backyard inventors, and a lot of them made flying machines, though most of them could not fly. The triumph of Charles Lindbergh in 1927, when Smith was nine, inflamed the dreams of his generation. Smith himself tried to borrow money from his mother—a lifelong habit—to pay for a collection of airplane photos he had ordered by mail. Instead Nettie suggested that it would be a lot more thrifty if he borrowed her camera and went to the local airfield and took his own pictures;

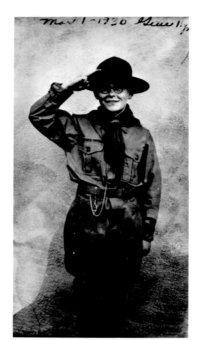

W. Eugene Smith as Boy Scout, c. 1930. Photographer unknown.

he did, and she developed his first negatives for him in her darkroom. Such was the beginning of a career that lasted almost five intense decades.

In 1932, when he was 14, he took photographs of the Cathedral High School basketball team and action photos of a high school wrestling match. Like any decent American boy or girl (the poetess Marianne Moore, for example), Smith was crazy about sports. But he was never good enough to be on a team—maybe because he wore glasses. There is an interesting letter of recommendation from Virgil Cay, sports editor of the *Wichita Eagle*. The newspaper had published nine Gene Smith photos in 1934, when he was only 15; and 42 more in 1935 and 1936; all but one, an auto accident, were sports photos. Cay wrote that Smith would follow every fire truck in town, and that he would hang by his heels out of the press box windows at the stadium to get unusual angles. Cay remembered a time when Smith had been photographing a flood from an airplane, and the machine ran out of gas. Smith ordered the pilot to coast in the air with a dead motor until he finished all the shots he wanted. Cay said that Smith, in the lingo of the time, had nerve, coolness, and guts—a news editor's ideal cameraman.

Floods and dust storms were, all across the Midwest, the natural consequence of the deforestation of middle America, the result of prosperous, greedy farm practices that plowed every inch of land and left no deep roots to conserve the winter rain. On Wednesday, July 25, 1934, *The New York Times* published a photograph of the Arkansas River dried up into a plate of mud; the photo was by Gene Smith, then 15. The top soil, all through the early thirties, blew away or flooded away. These unnatural disasters were joined by another catastrophe: the Great Depression.

There was a minor economic crisis in 1920 and 1921, particularly for the farmers, but nothing like the cataclysm of the thirties. Farm values in 1936 had dropped to half what they were in 1920. Gene's father, whose firm held grain in its elevators, faced immediate bankruptcy. Worst of all, he could not pay his employees, nor could he help what Smith described, much later, as his father's "sharecroppers"—possibly farmers who were dependent on him to market their grain.

He tried to borrow money on his wife's holdings, but she refused permission and would not allow him to draw on his sons' savings accounts. She wanted her inheritance, which included land in Texas that promised oil, to be kept for her two sons. One surmises that the marriage was not particularly happy, in spite of Gene Smith's much later admonition to his mother:

Listen you, get it out of your head that dad had any dislike for you. It was his worrying that made him act and us feel that he didn't care too much for us. He loved you very much; I know this for a fact and I insist that you believe it. It was his disappointment in not being able to make a go of it that made him seem always so surly and sad.

One tragic day, her husband wrote a note to his younger son, on the stationery of the Stevens Scott Grain Company:

Dear Gene:
 I love you and know you can make your own way. Now, Gene, try to go through college as I am leaving you $2,750 insurance. Be careful. Save some money each month.
 Remember your Dad.
 S.J.S.

He drove his car into a parking lot just outside the emergency ward of a Wichita hospital, and with Gene's shotgun, shot himself. The wound was at first not so damaging, nor medical help so distant, that he could not hope to be rescued from this despairing gesture. Gene's blood type must have been the same as his father's, because he gave a transfusion directly into his father's body, but his father died while they were still so connected.

Shortly afterward, young Gene went to his own car and drove to Wichita North High School, where, for lack of money to pay for parochial school, he had been transferred for his senior year. He stood on the hood of his car, and on assignment for the yearbook, took a picture of the high school. Only then did he keel over and faint. The photo was printed as the frontispiece of *Tower*, the yearbook in which a picture of Gene as a graduating senior appears.

It must be said that this account comes, in somewhat varying forms, from Smith himself. He told this tale many times to his friends and assistants. According to Jim Karales, the young man who worked as his darkroom assistant on the Pittsburgh project, Gene was "really pissed at my father for killing himself. If he'd only waited six more fucking months, he'd of been all right." But of course that was 20 years and many crises later. The most

curious version of this critical event was the one current in Japan when Smith was there in the seventies. The Japanese are as fond of melodrama as Smith was himself, and according to Smith's sec- ond wife, they believed that he had been assigned by an American magazine to cover an unknown suicide. When the sheet was drawn back from the bloody corpse . . . there was his father.

3.

"Boy oh boy have I been taking pictures today."

THROUGH Nettie Smith's church connections, plus her son's energetic talents as a photographer, Gene got a photography scholarship at Notre Dame University. Despite a lopsided scholastic record, he was given a stipend of $500 a year, instead of the customary $200, to serve as an official photographer. He was then three months short of 18, a slim, intense boy, with glasses and a high forehead.

His letters to his mother from Notre Dame are a strange amalgam of the good child and the fractious, moody rebel. They are a diary of a bright, and at first, non-literary young man. The tone of his written voice varies between the plain hunger for sweets that would be natural in a nine-year-old away from home for the first time, and the sensitivity and boastfulness of an emerging artist:

Boy oh boy have I been taking pictures today . . . We had a private '36 Studebaker President for the school photographers . . . We were hitting an even 60 for most of the way . . . It was more fun riding on the school sidewalks with the kids scattering off the walk in front of us. I stepped out and as luck would have it right into my hall mates. They all started booing but they were sure jealous of my luxury.

Using a borrowed camera, he was the only one who got photos of a visiting cardinal, which must have pleased his mother immensely. "All in all," he wrote, "I consider it to be a very lucky day for Mr. Smith."

He also complained a little bit:

If I have a heavy sweater I wish you would send it as I'm about to freeze. Also, do I have a heavy overcoat, the one of Dad's or will I have to buy a leather coat which I need? I am still limping around here on account of that heel. There is no blister but just a swelled place that feels like several needles playing mumble-peg. I don't know what the duce to do about it but I guess it will get well in time.

The letter ended with the refrain of a million middle-class letters from summer camp: "I can't think of anything more to say. It is along towards supper time so I shall stow another ten pounds."

His mother was no longer feeding him (except sometimes by mail), so food was very much on his mind:

These breakfasts keep me very muchly starved, as they don't give me anywhere near enough food. The other meals are okay . . . My stomach is hollering and food is calling so I think I'll go eat.

Later that year his mother wanted to take him to see his grandparents, but he refused. Greensburg, Kansas, where his grandparents lived, was "a dead jail," in his opinion. He was no longer "happy as I once was." The loss of his father had begun to affect him, an emptiness that began, he implied in a letter near the end of 1936, long before the suicide:

Mother I sometimes come close to tears after listening to some of the fellows tell about what they do at home, how their brothers and fathers are real pals to them. All I have or have ever had to match them is my dear mother, whom I will stack up against any of them. Every- time they talk about their dads and they have done this or that, it cuts deep inside of me, tearing me slowly apart. . . . Mother we have missed a lot and our home, although a fine house, has never been a true home, as God meant the home to be.

In the same letter, he set out a most remarkable program, considering that he was not quite 18:

My station in life is to capture the action of life, the life of the world, its humor, its tragedies, in other words life as it is. A true picture, unposed and real. There is enough sham and deceit in the world without faking life and the world about us. If I am shooting a beggar, I want the distress in his eyes, if a steel factory I want the symbol of strength and power that is there. If I want a picture of some joyous one I want a smile of pure joy, not a set smile for the camera. I can't seem to put it into words, the feeling, my outlook on photography. I no longer take pictures for the pure joy of taking them, but like many of the old masters of the paints, I want them to be symbolic of something.

These were thoughts prompted by the assignment of a college theme, but they were already showing a stubborn and ethical mind. He used an example that would touch his mother:

What do I want—a posed picture of Mons. Sheen or the picture of him when he is in his fight against Communism, when his eyes are flashing, his hand up as if in a command, quivering in every muscle, attempting to battle the loathsome communism by swaying people to do battle. That is the picture, that is when he is leading his life as he was meant to. He wasn't meant to sit gazing into a camera.

Msgr. Fulton J. Sheen was a strikingly handsome radio priest of the thirties, and the voice of the moderately right-wing Church. He attacked both Marx and Freud and was the personal advisor to Clare Booth Luce, whose husband owned the new magazine, *Life*. Smith heard him speak at Notre Dame, and as he wrote to his mother, "I really believe that he has done more to me than any speaker or person I have ever talked to in my life." Like any young man of that uneasy period, it was easy for Smith to attach himself to a figure, especially a masculine one, who had all the vague and thrilling answers. Smith would do it again and again in his life, perhaps because "I wish I had some real friends, some who I could trust."

A later letter to his mother was no less gloomy and no less determined:

I don't know what is wrong with me but changing. I feel like a wet blanket. I have to force myself to laugh and joke with the fellows and I don't seem to be able to smile the way I could. . . . I feel like I have a lead weight in my heart, I don't know why. I guess I just don't belong here. The fellows are all swell, or at least most of them.

And two days later he wrote, "Dear mom, I'm going to quit." The reason he gave was simply that he got a 60 in History. The grade was a mistake—there was another Smith in class. Gene should have gotten a 90, but he didn't know that for almost a year. In any case, it's doubtful that grades were the real reason:

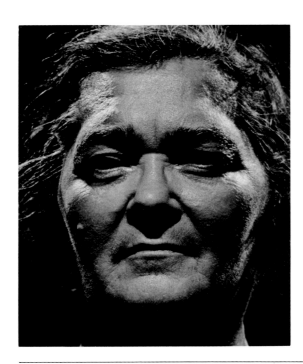

Nettie Smith,
date unknown.
By W. Eugene Smith.

I don't belong in college mother, please understand that. Some people aren't fitted for it and I'm one of them. Let me jump this place and head for the New York Institute of Photography. . . . Please mother, this is the best course. Let me get into something that I won't be such a horrible flop and a disgrace. Please answer immediately.

Love from your worthless son

Gene

These are the accents of a burning ambition; what else would a good American boy of 18 have on his mind? One notes that, dependent though he was on his mother's money, he didn't ask her advice; he told her:

Dear mom:

I've made up my mind, I'm going to New York as soon as I catch up on these pictures. Please give me permission. It is the only thing to do. I'm wasting my time and money at this place. That money will get much better returns at a photography school. . . .

He specified exactly what he would learn:

I won't be groping in the dark after I get through there, but will be able to stride straight to success and have the self-confidence I lack now . . . It is the knowledge that they can give me plus my own love of and originality for the work that will put me on top.

His mother didn't answer; maybe, like any parent, she thought the boy would get over it. He wrote her again on February 15, 1937, but, not waiting for a reply to his further plea, he sent her a telegram the following afternoon: "AM GOING MONDAY SEND MONEY AND SEPARATE WRITTEN PERMISSION." He sent a second telegram a week later from New York City, where he had taken a room at the YMCA on West 63rd Street: "AM HERE AM NEARLY BROKE AND IS IT SWELL THAT SCHOOL IS OKAY SEND ME $350 CARE OF SCHOOL ROOM COSTING $7 WEEK IS SMALL BUT NICE AND IS NEAR CENTRAL PARK RUSH MONEY."

This was one of the decisive moves in his life, one to which, obviously, his mother must have somehow, if reluctantly, agreed. From her fierce portrait and some contemporary accounts, one is led to think that Nettie Smith dominated the first half of Smith's career. The truth appears to be exactly the opposite; he was only 18, but already his mother was being drawn to become, like so many other people, the entranced servant to his genius; and she was bitter only when all his love and attention was not hers in return.

His next letter was all cheer: "Dear mom; Hello my precious little crabapple, how art thou? . . . I breezed through the first lessons today." He had made a friend and hoped he would be invited to dinner: "I miss the loads of food I ate at Notre Dame and have to lower my consumption gradually. I never eat as much as I want or I would be broke now." He tried to please her, though; he was still a good boy:

Went to my first and last burlesque show the other night. Paid out my good dough, stayed about five minutes and left with disgust, how people can go to such things I don't know. After I left I did something interesting, studied a book on composition.

In those poor, idyllic days of the late thirties, burlesque shows served to vent a young man's anxiety about sex by making lewd and clever fun of it; and, while it may sound ridiculous now, these shows taught the well-brought-up boy what a woman's body looked like, if in somewhat exaggerated form.

Smith was so enthusiastic about the New York School of Photography that, in another letter to his mother, he wrote:

I don't think I have ever been so happy in my life . . . I am learning right and left . . . this eating and sleeping on photography is making me perfectly contented and happy. It is also giving me a good appetite which is giving me the willies. My food bills are high and I haven't had a full meal since I've been here. I guess I'm like you are out there except that mine cost more.

Having won the first battle, by quitting college and coming to New York, he began an entirely new campaign: "I wish you were up here going to the school. I think you would enjoy it immensely. Anyway there should be one in the family who likes to retouch."

And he tried to placate her concerns: "Madam—Of course I'll watch my manners, my dress and anything else you want me to watch. What the deuce do you think I am."

Mrs. Smith worried that he would drink, and he assured her that he didn't. Meantime, Smith:

Took nice set of pictures Sunday:

1. Body floating in river
2. Pulling said body up
3. Bouncing the stiff body over edge of pier on way up
4. Starting to search him
5. Ripping open pockets in the search (Won't win any pictorial contest)

Also got some very nice pix of activities on fishing vessels.

He was flat broke again, of course, and owed money to the school for paper and film. He reported that the head of the school, Mrs. Helene Saunders, "says my sense of balance is wonderful (I owe that to my angel mother)." He encouraged Nettie to master photography, and fantasized an item in the newspapers about Mrs.

Smith and son Eugene taking off on an extended camera tour together: "Come on, throw your heart into the subject. I know down underneath you want to." He advised her to sell the furniture and "perhaps you might tell that dear father of yours that you are going to have to help me and that your part will be tinting pictures."

Smith's emotional attachment to his mother at the age of 18 was certainly unusual; his father's failure and suicide had made him the psychological head of the house—aged him in fact—and yet, paradoxically, made him sound younger than his age. At the same time, the flood of letters to his mother constitute a kind of journal; and it may be, indeed, that these letters served a special function for Smith, who early on, as one cannot fail to notice, had a firm sense of his own destiny.

4.

"There is nothing but soft cushions ahead."

EVEN BEFORE graduation from high school in the spring of 1936, Smith had been looking for work. The summer of 1937 was not auspicious for the country as a whole. In fact, in spite of the measures taken by Roosevelt and the academics of the New Deal, and although unemployment had diminished from 25% in 1933, when Smith was 15, it was still 14% in 1937, and would rise to 19% during Smith's next year in New York. Only World War II ended the Depression.

During this time, Smith tried to sell "the drowning pictures" to *Look* magazine. He had gotten some sort of promise from *Life*, too, but it was "a big bust." He was pleased, though, with his student work; he had convinced the Zeiss camera company to sell him equipment at 40% off, in return for a choice of prints at $5.00 each: "Very few such as Stackpole, Levitt, Bourke-White get this chance." And finally, he proposed that his mother—"Have you a good hold on your chair?"—hesitate no longer; she was to come to New York City right away.

On September 7, 1937, he wrote:

I think my "impossible assignment" operation pictures went over big with NEWSWEEK. Anyway the picture editor left a note for me at the Y and said for me to bring my samples to his office tomorrow morning. I think that can mean but one thing and that is that STEADY job . . . Hope you said your prayers tonite. Holy mackerel, my heart is pounding like a pile driver. Hold on darling mother.

He got the job; and his next letter was cheery indeed: "Dear maw: And how is my precious bit of gloom this morning? . . . Are you trying to tell me I'm deformed or something, telling me I have lots of backbone? . . ." And finally:

My working week is five days. My salary, that's a secret. We are on the way to a life of safety and assurance. It has been a swell battle, and I've enjoyed practically every bit of it. Have seen the "greats" of camera-journalism and I think that within five years I can top them all. That is not bragging, and means an even harder battle than the one that has ended. It will mean five years of unslacking, relentless work but nevertheless, I will make it. Enough of that, you hurry up and get here.

He planned to get an apartment for himself and his mother with a:

. . . permanent darkroom and not paper stuffed in windows, etc. NOW DON'T START AN ARGUMENT. Also am very anxious to have you get here and cook me a nice thick steak which for months my poor tusks have been pining to sink into.

The news was good now. His letters from the YMCA had a brand new rubber-stamped notice at the top:

ALL RIGHTS RESERVED. SALE OF THIS PHOTOGRAPH LICENSES THE PURCHASER FOR ITS ONE-TIME PUBLICATION ONLY. IT MAY NOT BE RESOLD, RE-USED, LOANED, OR SYNDICATED. AN ADDITIONAL CHARGE WILL BE MADE IF CREDIT IS NOT APPENDED.

PHOTO BY EUGENE SMITH

He was downright ebullient:

Will start off with a feeling of triumph and tell you that I have scored over Victor DePalma (*Life*) on the first assignment we were thrown together on. The second assignment will probably find him winning but not if I can help it.
I'm crazy about this position of mine and so far have received nothing but compliments. I have taken several hundred pictures for them and so far they have all been in good crisp focus and I have been shooting under trying conditions too. Honestly though, up to now I have been turning in a remarkable job and if I can keep it up, developing my imagination at the same time, I can take my place at the top of the ladder in a very few years.

By October, Nettie had still not arrived, though obviously she had promised to come; he discussed the disposal of their furniture and said :

Bring the hat of dad's with you when you come. Still need a suit very badly but can't get far enough ahead . . . Have you noticed that I haven't written for any money for the last few times and that this is no exception . . . There is nothing but soft cushions ahead.

He scolded her for listening to other people's fearful advice, and said that his decisions were "leading me to success at an early age." Finally, in a burst of surprising anger, he wrote: "that job will be as permanent as I want it to be as long as I do good work. You give me a pain."

November came, and his mother still had not arrived; her father had died in Greensburg, Kansas. Smith wrote his mother: "I am both glad and sorry that grandfather died. I hope everything goes off smoothly for you and for gosh sakes don't get into any legal delays about it." One is somewhat astonished at his lack of emotion over his grandfather's death; there is no question that, at this age, personal ambition dominated everything he thought and felt—even the blind power of sex. For example, one of his early friends was a girl improbably named Mary Joy. His mother wrote him about her, and he reacted crossly:

. . . you made me feel like the devil, sending me that article on dates. Of all the things to send me. I don't even know what a date is, I could count all I've ever had on my fingers. The companionship of girls I've never had, and I've missed it terribly. I've buried myself in my work, which, outside of you, is about all I have to live for.

There is a strange bitterness in his tone; he wanted to placate and defy his mother at the same time. A series of letters in the fall of 1937 shows his uneasy preoccupation with sex and forms an acute, if not always pleasant, self-portrait of Gene at the age of 19:

When the time comes when I find a girl that answers my own requirements, then maybe but not before. And don't try telling me the type, as I already know. I hope you understand that. I'm burnt up to tell you the truth, so hurry up and get here or you will probably be in need of a good spanking. And furthermore, I am not easy to land, as plenty of them have tried it here and other places. That really made me mad and I'm not kidding. I may not be a great photographer but I can assure you that no one can play me for a sap. Understand that and remember it. I have a mind of my own and I know how to use it . . . A cute little secretary came around and told me how glad and thrilled she was that I had secured a job . . . I find the secretary like all other girls, amusing, I get great enjoyment out of analyzing their techniques. I find it comes in very handy when securing pictures and also in saving my money. Furthermore, it safeguards me from being swept off my feet—anyway I would rather go to a camera club and talk about cameras. Maybe when I find a girl that comes up to my standards . . .

I am not in love, I am not engaged, and very emphatically, I am not thinking of getting married. . . .

I will tell you one thing, Mary Joy was very much in love with me. Think what you like about her, she is one of the truest sweetest kids in the world. If there were more of her type the world would be a much happier place. She has more decency about her than any other girl I have ever met. I do not love her and I know that she is of a temperament unsuited to my mode of life. . . .

I wish you really knew me, I can not explain why you should not worry about such things concerning me, but with me there cannot be such a thing as blind love or infatuation. I look at everything with a cold analyzing eye that does not figure, "well, that will probably work out OK." I do not think only of the present, but of the future as well. . . .

I have been having a grand time since I've been here, but there is a note of sadness in every event. When I get away, or am by myself with time to think, a great sadness takes possession of me. I long for what every young man of normal intelligence desires, the companionship of a girl. If I should go out now I would be at an overwhelming disadvantage. Where the girl would know what the score was, I would be very ill at ease. She would be secretly laughing at me, and why shouldn't she, a dumb greenhorn that hadn't tried to show a girl a good time over a dozen times in his life. It has got so that if there is a girl around I want to get away, because with a crimson face I can't hide my helplessness. Here they have passed it off as my merely blushing easy, or so they say, but I can imagine what they really say. But I shall go on and on like that, probably achieve the top in photography; kids may say that they wished they could be me and all the time my life will be lacking. . . .

Smith's last letter to his mother in this series was in late 1937. Soon after, Nettie Smith, obedient to her son, sold the family furniture, leased their house in Wichita, and finally moved to New York to share an apartment with Gene on 65th Street. She now became his assistant, carried his equipment, traveled with him on his assignments, developed his negatives, and spotted his prints. But he was a vigorous young man; work and love, two inventions of civilized man, were now his necessities. He had first tried to fill the lack of one with a consuming energy for the other; the effort, as he said, made him sad, even when successful.

He had gotten pictures published in *Newsweek,* covering the CIO and an American Legion convention, but he quit the magazine and returned to "the Syndicate"—his name for an agency called Newsphotos. His letters to his mother don't say why he quit, but in an interview years later, he explained that *Newsweek* insisted on larger negatives, probably for technical reasons, but he refused to give up working with his 35mm Contax camera; they fired him, and that couldn't have been pleasant. Yet his optimism was tireless.

In 1938 and 1939, he had had six successful assignments to photograph in the New York theater. There is a curious and significant error in his own memory of this period. He said that, by the chance of assignment, he had been sent to photograph a beautiful Spanish dancer. The only Latin performer in Smith's published work is Carmen Miranda, and she sang in Portuguese. From other evidence, the woman who entranced him—and whom he went to see every evening for two months—was a flamenco dancer whose professional name was Marissa. Whether he was sent to photograph her is uncertain. The courtship extended through two months in the early part of 1939; it was a year when there was a craze in New York for Spanish-American music.

Marissa was on tour with the guitarist Vicente Gomez, so the affair, if it was real at all, was bound to be brief. She and Smith exchanged passionate letters when she was away, but hers were in Spanish and his in English. Neither could really understand the other. Smith confided his problem to Ilse Stadler, an employee of the Black Star photographic agency, which was handling his work by this time. She had a friend of Spanish descent who offered to translate in both directions; the friend, Carmen Martinez, did so without meeting Smith in person. Eventually, Smith got Carmen's Brooklyn address from Ilse, and wrote to her on a piece of Black Star stationery:

Dear Miss Martinez:

I would like to express my sincere appreciation for your kindness in translating those rather delicate missles. I am also glad that I never have the opportunity of seeing you—from what Ilse tells me you would make a delightful acquaintance, but—I'm sure I would blush a very deep red.

As it is, every time I think of you reading them the tips of my ears begin to burn and turn pink . . .

When I received these I was in a dilemma. They either had to be translated or never understood. What was worse yet was the fact that they were so sentimental and I was never certain just to what extreme she would go. So altogether it gave me many bad moments. She is a very charming young lady though.

Again I wish to thank you, and hope that either you or I can think of a way to return the favor.

He continued this three-sided correspondence—to Marissa and to Carmen Martinez—for some months. He was trying to lower the flame of one romance and raise it on the other—a tricky business alluded to in one passage:

The letter from Mexico upset me a lot. I don't know what to say or do. I hope you don't think I'm some kind of two-faced rat. I certainly didn't think I was leading her into that impression.

Carmen Martinez met him at last; how could she resist such a romantic dilemma? They fell passionately in love with one another almost at once. Carmen was a dark, pretty, and intelligent young woman, daughter of a Spaniard who had lost ownership of three cigar stores during the Depression. He kept one of the business cars and converted it into a taxi; but times were still bad and he never really made a living. Malnutrition was typical in poor families, and Carmen not only had rickets as a baby, but a bout with polio as well. She didn't walk till she was six; surgery got her up on

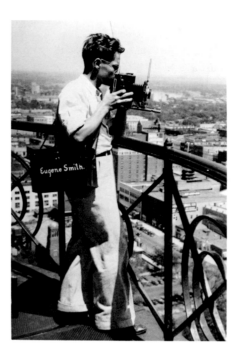

W. Eugene Smith with press camera, c. 1938. Photographer unknown.

her feet, but she wore braces till she was nine. She took ballet for the sake of her legs, and went to a parochial high school till she was 18. She longed to be a nun like her teachers, but one of them persuaded her to sample the outside world before she made her decision. Carmen Martinez found that world to be very exciting: "The music, the boyfriends, the dancing." She took training and became a nurse instead, first in the maternity ward; later she became a surgical nurse. Blood, mutilation, pain, excrement, and death became, as anyone who's worked in a hospital knows, a commonplace experience. One exhausts a native supply of pity after the first three hours of duty; one is left with the tenderness of skill. So, in a peculiar way, Carmen's profession would be suited to Smith's life and character.

He was neat, clean, and well-behaved when she first met him. Much of the courtship was spent in record shops, listening to new releases in a booth for two. They were mad about one another; when Carmen went to the country for vacation, Smith was miserable:

Dear Miss Martinez, or should I say, how are thee, my lovely, sweet, bright-eyed delight?

Somehow, today, I miss you more than any other time since you left. Somehow I feel that I needed you very much today, somehow I am desperately lonely without you. I feel battered and wounded, want to crawl into a hole and let the world go screaming on its way past me. Or better yet, to withdraw from the fray for a while, to live for a while away from the world with just one whom I could trust and care for. . . .

I wanted so desperately to come to see you today, to be with you. I wanted so desperately to feel your lips so gentle, warm, and sweet against mine. To hold you in my arms, so closely that our bodies melt into one. To know the ecstasy that would drive the world and its problems out of reality and replace it with heavenly joy. . . .

On the other hand, he felt the anxious sweat of caution:

Regardless of my intentions to make a clean break with you it seems a power far greater than my will is at work . . . All I'm doing is making a fool out of myself . . . Hope you don't get angry but I wish you wouldn't call me. It is far better for both of us . . . Goodbye forever.

Still, all the driving senses of a young man, all the customs and

expectations of a Midwest American Catholic, urged him to the desire—and fear—of marriage and family:

Dearest:

Night has fallen once again upon this section of a miserable world. Somehow it is more unfriendly tonite—it cuts me off completely from any warmth of friendship. There is a relentless feeling of dread and futileness encircling my heart. A crushing force that leaves me blind and weak, battered about in a tide of fate against which my pitiful struggles are a mockery.

One must pardon this extravagance of language; it is not meant to deceive, merely to impress:

Some of the happiest days of my life are responsible for my so utter dejection. I know it appears contradictory, but my entire life is one long contradiction. I will never forget our little trip together, all my troubles disappeared and joy came into my arms with you—I was so very happy my darling.

These two young Catholics went as far as Carmen would let them without violating the interdictions of her nuns, but Smith had broken with the moral precepts of his boyhood, and after a long and passionate description of Carmen's delights, he wrote:

A million voices kept calling—not to ever let you go. As each throb passed by into oblivion, those million voices screamed with every heartbeat—you love her, take her completely, it is not wrong, you want to have intercourse, go ahead and the world be hanged. Oh my darling, I would have given anything if we could have merged into one that nite in our own little heaven.

But, in the midst of this verbal orgy, he felt that "the horrible empty future leers at me, dancing and jumping around in my mind, following me through my every action, sneering at me—you fool, you poor helpless fool, what chance do you have of battling fate." He concluded, perhaps not too seriously: "This must be goodbye forever, my sweet one."

They didn't part; in fact, they decided to marry. Carmen's nuns were delighted; she was to have the ceremony in their chapel, and one of the partners at Black Star was to be the best man. The priest who officiated, suspecting haste, asked Smith and Carmen Martinez if they had been living together before this sacred

moment. Smith, furious at the question, quit the chapel with Carmen before the ceremony was performed. They got married instead in a civil ceremony at City Hall, on December 9, 1940. Three years later, when Smith was a war correspondent, a letter to Carmen referred to "my spending my honeymoon hanging out of a blimp and you in turn hanging onto my belt. . . ." It was true; these aerial photographs by Smith were published in *Collier's* in August, 1941.

The same year, their first child was born: a girl named Marissa, after the flamenco dancer that brought them together.

5.

"I pour my heart and soul into a picture."

IN 1938, Smith's work started to appear in some of the major publications of the time and was itself extremely varied: an old couple, soldiers in gas masks, and "Life Goes To A Rubber Ball" in Akron. His other published assignments were just as entertaining, but there were only ten. His income was therefore ridiculously low.

By 1939, however, his published work rose to 48 pieces in various publications. Wilson Hicks, then picture editor for *Life,* took the time to write him and say how much they liked his "Picture of the Week" of Irene Castle and put Smith on retainer for two weeks every month. Sharp, glittering, well-lighted, interesting enough to catch the eye and hold it for a half second but no more, Smith's work was ideal for *Life.* Smith, in the year that ended with his marriage, was published 55 times, not only in *Life,* but in *Collier's* and *Look.* In 1941, he had photographs published 82 times. He was known as a clever and industrious photographer; but he was bitterly dissatisfied. Even that early, he gave the editors at *Life* a lot of trouble, and stubbornly contested their choice of his photographs.

The truth is that Smith's work from 1932 to early 1942 is not very important. He himself knew that, and eventually destroyed many of his early negatives. There was no evidence that he was anything but, in his mother's phrase, a "dare-devilish" craftsman. He was only 24 in 1942; still, by that age Paul Strand had done some of the greatest photographs of his life, and Henri Cartier-Bresson had already accomplished work so brilliant that he never surpassed it.

The big European war assignments were going to men like Robert Capa, who had covered the Spanish Civil War, and to Carl Mydans and William Vandivert. Alfred Eisenstadt, who had covered the Italian conquest of Abyssinia, wrote: "I soon learned one thing, you couldn't earn much money just taking pretty pictures. Reportage of important events and people sold much better." Smith was always anxious about money; he never had enough, even when he was prosperous; but he was much more desperately concerned about his own fame.

The day Smith heard about Pearl Harbor, his frustration was so great that he went home to his 65th Street apartment and smashed his fist through a glass door. The next day he was due to photograph a fashion show; "composing nothing into nothing," he said. "I practically vomited, it seemed so damned stupid and useless." In January, 1942, he tried to get out of this pocket of triviality by writing to the famous Dr. M.F. Agha, the art editor for the Condé Nast publications and a patron of photography. Smith was not modest, either; he had a sharp sense of his own biography:

Dear Dr. Agha:

Several years ago, there was a boy and a camera. He was a newspaper photographer—a very young newspaper photographer. Of ambition, the boy had much, an ambition to be in on the making of history. Let others make the history—he would record it.

A few years passed, the young man was shaving now, and working for a great magazine. Hundreds of thousands of miles had passed under the shadow of his cameras. He realized now that merely recording people, events, and places was not enough. That it was far more satisfying to make fewer but finer photographs.

Photographs able to stand alone—which, for interest, did not depend upon the public importance of the subjects. Or, for a commercial reason, if something must be emphasized, to emphasize it in the most vibrant and pictorially exciting way. That is the way I try to make pictures today.

He never got the job, but his photographs, and perhaps also his passion for aircraft, were not unknown. And at the end of May, 1942, he got a letter from the Navy, offering him a possible rating of Ensign, with pay of $100 a month. It was sent by Edward Steichen, then a Lt. Commander assembling a photo unit for the Navy, which was traditionally more conscious of public relations than the other services. The Navy turned him down: he had poor eyesight and a broken eardrum. A review committee of three admirals, appointed because Steichen wanted him so much, stated that "Although he appears to be a genius in his field, he does not measure up to the standards of the United States Navy."

Smith's defective eardrum was the result of an accident that occurred during one of almost 60 assignments he had that dealt with the United States preparation for war. In this project, which was for *Parade* magazine, he came uncomfortably and yet conventionally close to the real thing "because he felt he must have at least one knockout shot."

During this time, Nettie Smith worked actively to augment her son's reputation, and in a letter to *Popular Photography,* she gave a detailed portrait of his habits:

No matter how long he works (and he worked 70 hours without rest and with little food) if a story develops out as he wants it to, he is suddenly rested and can keep on. But let it be a disappointment and the shortest one will leave him limp and exhausted. On most stories he drinks quarts of milk and pints of orange juice with almost no food. . . .

Nettie was particularly fine in describing the assignment for *Parade:*

So he asked permission to set up a bombing shot with at least 2 men in the picture. The powers that be said they could take no risks with their men in such a dangerous picture. Gene said, "Well if you will let me use a uniform long enough for the pix, I will be the Top Sergeant in the picture." Allan Sloane (now with AP) was the writer and assistant who went along with him, and Eugene & he then had an argument as to which should be in the most dangerous spot. Allan insisting that since he wasn't married he would get between the shots of Dynamite (they used 100 pounds) because Gene had a wife and baby and would be risking more. Gene insisting that the risk belonged to him because it was his job to get the picture. Gene won, so Allan in ordinary uniform and Gene in Top Sergeants set up their shot. They put part of the camera tripod in the ground, placed sandbags around to hold everything in position and with a remote control release held by Gene began shooting.

Tree stumps flew up 350 ft. into the air on some explosions, but finally they got the shot (which has been made into murals here in New

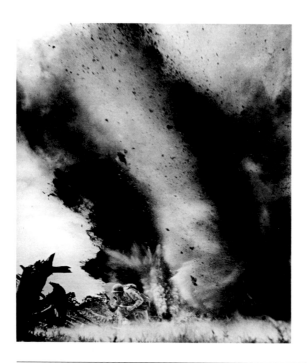

U.S. Military training maneuvers, 1942. Photographed for Parade *magazine, the explosion permanently damaged Smith's eardrum and won him first prize in a* Popular Photography *contest.*

York for display I hear) but the camera shutter closed shop for the day and had to be repaired. Gene got a terrific headache and was extremely deaf for several days. Later an army doctor told him that evidently he received a brain concussion at the time. The shot behind him was 8 ft. away and the other one was 12. The rest of that story is that when we were developing the film I heard a shout from the rinsing room—"Come take a look at this! I think I have my best picture of all time." I rushed in, he was excited and his tiredness vanished. Hurrying to get it washed and dried, he printed it. Soon he said "Darn it, such a dope I am. Somebody kick me. Here I just missed getting a wonderful picture, the best I ever made, by not raising my hand a little more and having my elbow bent more." Though everyone else has liked the shot he carries a peeve at it because it just missed what he expected of it.

The resulting photograph won first prize in the *Popular Photography* contest for 1942. After the assignment, Smith underwent a medical exam. The subsequent report by Dr. E.W. Saunders noted that Smith had difficulty in speech, ringing in his ears, and pain in his left arm; he was also suffering from migraine headaches two or three times a week. For all its cost, Smith later called his celebrated photograph "disgusting."

Smith spent the summer trying to find a way into the grandest guignol of all: human warfare. He had a natural fear of death and injury, but a stronger fear of not being thought manly. The summer months of 1943 were especially difficult for him in this dilemma, and he began a diary: "Dedicated to my wife and children but mainly to my beliefs and ideals. May it contain nothing to change them." Here is Smith on Wednesday, July 7, 1943:

I think this is as good a day as any to begin a diary. For it was today that I sat in the office of Fred Sparks (*Parade*) and heard him dictate a request to Washington for the necessary permissions to allow me to journey into "hell."

Parade was eventually turned down, but that had not happened yet. In his diary, writing in block capitals, Smith quoted Steven Vincent Benét:

Now for my country that it still may live,
All that I have, all that I am I'll give,
It is not much beside the gift of the brave
And yet accepted since tis all I have.

This quotation is from "John Brown's Body"—the story of a martyr for freedom.

The following day, he wrote of his dislike for the work he'd been doing the last six months for *Parade:*

In part (and this reasoning is merely a sketch and certainly not completed) I believe it is the result of trying to compromise my own wants and beliefs, to make them fit into the now stylized and routined *Parade* and yet retain some depth and originality. And as I compromised slightly on each story I tightened up a little more until I compromised myself right into a deep, stilted, unimaginative rut . . . But whatever the reason I am horribly depressed . . . I must get across; the change of scene, the enormous difficulties and the downright challenge of such an assignment I feel would bring me back onto an upward road.

On July 12, he signed a life insurance policy, the first he'd ever had, and noted that he couldn't remember his wife's middle name. He paid the agent ten dollars and then borrowed five dollars back from him. After this he went to photograph a secret plane, and chose to dramatize it by recording the tracer fire at night, on the ground, from its six forward machine guns. They blasted into a barrier of sandbags, and Smith stood on top of this heap with, as he wrote in his diary:

. . . two cameras whose tripods were buried in the sand. At least one tracer ricocheted close to my head. Bursting into a red ball of fire that shot up past my cameras and my face and then settled slowly back to earth, a glow bright enough to spread its light hundreds of feet. I knelt there, fascinated, then remembered the guns were still firing and others might come my way. The exposure being complete I dropped flat on my face—used 500 rounds of ammunition.

The following day, he detailed a quarrel he had over the reproduction of a photo on the cover of *Collier's*. A white-hot propeller printed yellow:

I am a little bewildered how far I have a right to carry such a fight. After the picture has been taken and turned in it should be their baby completely, but . . . after I pour my heart and soul into a picture it is awfully difficult to stand by and see it ruined.

On July 15, he went with his portfolio, "nervous as usual," to get an assignment from an ad agency:

I just looked as [the editor] slowly turned the pictures, and my heart was aching, and I felt so stupid, helpless, useless, and was sure he thought they were the worst excuse for pictures that he had ever seen.

But the agency liked his photographs very much:

This brought on another kind of feeling, that I was dishonest to take such praise, that I wasn't that good . . . I suppose I should feel very happy about the reception the pictures received. But it left me very blue.

One feels, again, the double bind in Smith's character; he demeans praise by measuring himself against perfection.

He visited Steichen's group of naval photographers:

I regret my not being with them more today than at any other time. But I am with them in spirit and ideals and before this war goes much farther I will find a way to be in this war—I must! . . . I must bring my cameras to this war.

Next day, he hated himself: "Shot cover for *Collier's* of girl pinning bar on soldier, a disgrace to photography." But later that day, William Ziff of the publishing firm Ziff-Davis called to offer him a position as naval correspondent in the Pacific. Smith of course accepted the assignment immediately; he had only a few weeks to wait for it to begin.

He was nevertheless irritable and impatient; and his domestic moods were stormy; indeed they always would be. "Marissa when I scold her has been saying 'No, my daddy.'—this morning she made it clear she wanted me to play the record 'Johnny Zero.' The first song she has tried to sing. And I wanted Wagner." Marissa was then only two years old. "Carmen doesn't feel too good, poor kid, what a heel she has for a husband." On Friday, July 30, after going to Washington and returning, he wrote: "Arrived finally at home 4 a.m., got to bed but no sleep. Carmie arrived hospital 6:50 a.m. Baby at 7:50 a.m., doing business." On August 6, a week later, he cleared his status with the draft board. His last entry, on the Monday following, is hurried indeed: "Passport. Two dentist sessions. Eleven fillings. New glasses. Sorting filters, expense accounts. Moving baby." He was off to the war in the Pacific at last—and to a self-created and stubbornly willed alteration in his destiny.

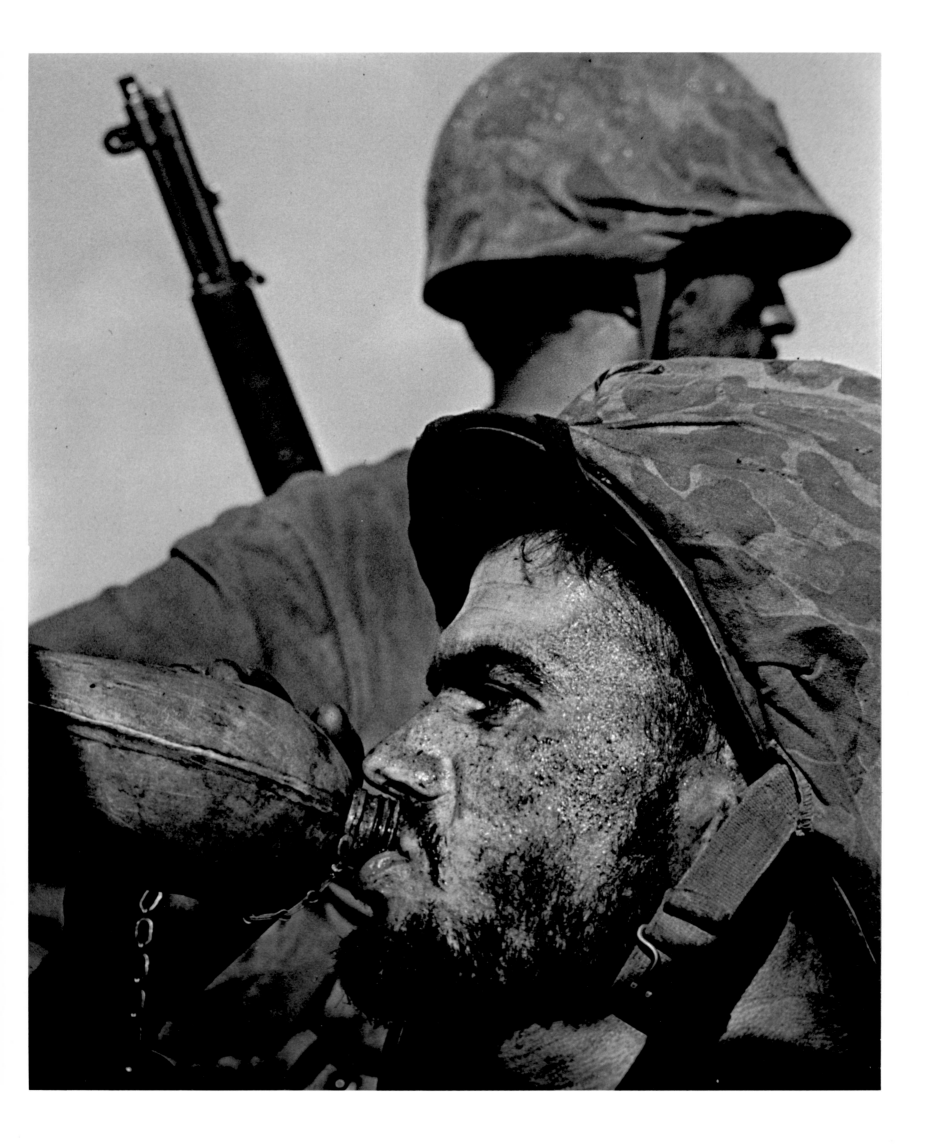

THE PATH was open: Smith was about to be thrust into the press of great events.

Early in September, 1943, already in the uniform of a Navy correspondent, Smith landed in San Francisco and wrote gleefully to his wife that he had bought a hand-forged hunting knife "good for Japs, underbrush, or steak." He then added a reassuring note for both Carmen and his mother:

Nobody bothered to make my bed today. I have one towel which is getting soiled, and I'm going out to buy some toilet paper . . . Can't think of anything else except thank you both for your struggles, etc. of the past few weeks to get me away all right. I love you all but especially Marissa, and have you got the littlest brat's head straightened out yet? Horrible looking child. . . .

His mother later sent him a photo of Carmen and the two children. In the photo, they are pictured listening on the phone to Smith on September 26: Carmen looks dark, intense, anxious, and beautiful; Marissa looks surprisingly like her; the new baby, christened Patrick, is indistinguishable from other babies.

Two days later, Smith wrote his family: "In the clouds for hours after the telephone call. I love you, you bunch of bums." He told them that he'd been hurt, but didn't say how: "Nothing serious except a few bruises—four cameras out of commission and at last notice Graflex almost hopelessly smashed." He was being brave and complaining at the same time. The letter continued with a curious paean to love: "Mate to mate; parent to child; child to parent; tenderly pure; adoringly possessive; powerfully passionate. It ruins the world—yet saves the world." He wrote to Carmen the next day, "Dear darling pest," and referring to the phone call, he said: "People have been half angry at my lack of excitement about supposedly exciting things during most of my life, but the other events were just never as wonderful." He was worried, though, about their apartment—was it warm enough? "We could ruin the kids for life by letting them get started with constant colds and worse . . . I have had two or three nightmares about that big living room window being left open without a safety screen on it." And finally: "Remember that in almost all cases, letters written to either of you are meant for both of you." Wife and mother he meant to be equal in his affection, a measure that was to dissatisfy both of them for years.

By October, Smith was at sea, aboard the aircraft carrier *Independence*. His enthusiasm for this assignment began to cool a bit. His photos of the task force raid from Hawaii to Wake Island were, he said, dull. He wasn't at first allowed to fly in the carrier planes so he could get authentic combat pictures, but an appeal by signal to the flagship got him permission at last. One of the ship's service photographers was hit by an arresting cable that was on deck during landings. The photographer's injury wasn't serious, but it was Smith's first sight of the profligacy of blood in a war.

Along with his four cameras—an Ikoflex, a Medalist, a Rollei, and a Contax—and along with assorted baggage, he had brought about a hundred of his favorite records. The ship's chaplain found a phonograph for him and, in a letter to Carmen, Smith wrote:

I always listened to a record from *Tristan* and a duet from *Parsifal* the night before impending battle. When I return to the States you and I are going to have new wedding rings made. Yours will have the opening treble notes from *Tristan,* and mine will have the bass. This is the only good idea I have had in years, and besides that I love you.

In November, 1943, he was transferred to the carrier *Bunker Hill*. He had resumed his diary on Monday, November 1, but had little to report beside a broken tachometer generator. Four days later, he noted: "I wish Tin Pan Alley would stop the phoney, nauseating nobleness they inject in every so-called patriotic song." He added that he had inspected the SB2C naval bomber to which he had been assigned as photo-correspondent to cover an upcoming mission. He had the "feeling this may be the last week of my life."

It's striking that on the eve of undertaking the dangerous job he'd so passionately sought, he stressed that he was afraid not for himself, but solely for the fate of his family. It's a neat and very human transposition: "When I think of what I will have done to my beloved family! Turn pale green inside." His diary continued:

I have tried to analyze my emotions, to see if I am using my family as an excuse for fear, but I don't believe so.

For in planning I am thinking in a perfectly normal way, then suddenly the always same vision of my children—miserably clothed, hungry, hurt little faces, and always in the background my Carmen—bro-

ken. There is no exact picture, it is an overall mood of my family being destitute.

It brings me to my knees and I feel no, god, please not to them.

There is no apparent thought of my own life, it is only in the welfare of my children. I am now sure of this. Carmen alone could take care of herself, marry again—probably to a much better provider and companion. She has been so impatiently patient—and I do this to her. She has been as imperfectly perfect wife as is humanly possible.

He was due to fly with a pilot named Wood, who had already cracked up five planes while landing on the carrier deck. "If it is the only chance I have of doing anything that will satisfy myself that I am doing the best job possible I am perfectly willing to take that chance." But the captain of the ship grounded him—no reason given; so Smith was deprived of a possible story on the raids on Rabaul. At the time, he saw no chance for powerful photographs, but his conscience did not let him rest. Other men would have accepted the decision of chance, and gratefully so. But Smith could not accept it. "Will leave the Navy at first opportunity," he wrote in his diary. "Didn't come out here for South Sea cruises, can get pictures with the Army, they do the dirty work anyway." Meantime he photographed planes coming in from the Rabaul raids, many badly shot up. On November 11, Armistice Day: "An SB2C lands, I see by the number it is Wood. I swallow hard, the gunner in my place is very bloody, is holding his throat."

He described the young pilots: "reenacting every roll, every dive, every movement . . . their faces are a remarkable emotional experience . . . to kill to live—to live to kill." Later that same day, 120 Japanese fighter planes circled in to attack the U.S.S. *Bunker Hill* for three-quarters of an hour. He took his first real combat photographs at last, and his diary account is worth quoting if only to demonstrate the quality of his detailed vision:

I . . . had been watching with complete fascination the downward path of the Jap, trying to figure out his release of bombs.

Out of corner of eye saw bombs plunge by. Dove directly under the fire of twenty MM guns (on adjoining platform) and desperately pressed release of Ikoflex as water spouted high on our port quarter. I now recoiled from the sharp crack-crack of the twenties so close to my head.

Glanced fore and aft—saw all guns were firing. More heavily towards starboard. Leaped from my platform to head for starboard side. As I hit the lower platform the metal fastenings holding the Contax to the strap let go, and out of the corner of my eye I saw it flash downward.

I didn't stop but continued to starboard nothing but burning planes on the water, too far for pictures.

After all the excitement of danger, there was, he noticed, the inevitable letdown, a habit of the mind infamous among professional artists: "My heart was breaking, with the lousy job I had done."

In these few days, Smith was learning the fearful morality of war. Once, when a plane mislaunched from a nearby carrier and hit the sea, he wrote:

The bombs exploded and a gigantic eruption of flame, and water, and men and machines filled the air for hundreds of feet around. People shudder and say it is a horrible ghastly way to die, but it is not—it is a preferred way to die. The only horrible part is death tapping those who are so young.

The death of others pained his conscience; he could not accept that his courage was less than theirs. He pressed again for per-

mission to fly and photograph in combat. Permission was finally granted, and he was strapped into the rear gunner's seat behind the pilot in a dive bomber:

As we pulled out spots danced across my vision but I did not black out.

I desperately pulled and pushed the camera towards the side he was banking to, it took every ounce of my strength to move it and just as it is in position he slaps the plane violently the other direction to avoid tracers pecking away at us.

Gritting my teeth I pushed the camera, banging it against the gun mount, to the other side of the cockpit and made a shot at the still approaching ground.

Then from the exhaustion of the effort I slumped for a moment, letting my body snap as "Temmie" shipped the plane erratically away from the island. I was hot and steaming from the effort and more so from the extremely fast change of altitude. Also I was sick (I knew I would be, from many past performances) and deposited my breakfast into the slip stream. Perhaps a last insult to the Japs.

To Smith, the enemy was only grudgingly human: "Little men with plenty of fight."

This war diary, running from November, 1943, to February, 1944, is a precise and fascinating document—naive politically, but more often exact, minute, and direct. During one photographic mission, he had hitched a ride on a jeep deep into the conquered atoll of Tarawa. He was furious because he had arrived three days after the main assault:

There were many burial parties wandering around hunting stray corpses. Many were dead without a mark on them, apparently our blockbusters. In most cases it had also left them naked or almost naked.

By now the bodies were starting to deteriorate quite badly. One sailor tried to move one of the bodies, the head fell off and then the brains fell out and part of them stuck to the helmet . . .

Breathing through my mouth (and thankful for my sinus trouble) I angled for an inclusive shot, finally decided I needed height. I started to climb the unstable looking wreckage which suddenly gave way with me. I crashed down among the [dead] Japs, dislodging the helmet of one which was promptly grabbed by a Marine as a souvenir.

He also recorded the common wartime guilt of sleeping in the bunk of someone who had died, his clothes still folded in his foot locker, and the spread of family pictures on the wall: "Wilson and I packed Higley's things to make room for mine. It made me feel very badly." Next day, he stayed below: "feeling so bad from my head as to be on verge of being out of commission." Could his frequent migraines, generally an allergic or genetic disorder, be the result of the concussion he received during that staged training photo back home in 1942?

In contrast to his diary entries, Smith's letters home were usually mock-jovial: "Dearest darling—ings: Had a little close fun since the last letter, some nasty people were throwing big things at us from out of the sky. . . ." He continued:

There will come a day, in the far distant future, when I will be able to come home, sit down quietly by the radio, relax and listen to some of my favorite Wagnerian music punctuated by the screams and howls of my darling little brats. Then I—always the gentleman—will quietly get up, move into the kitchen and gently slam the door shut with all my force. Outside of that I love you all and especially Marissa—ha, bet you're all jealous.

At Thanksgiving he remembered "that December day a small

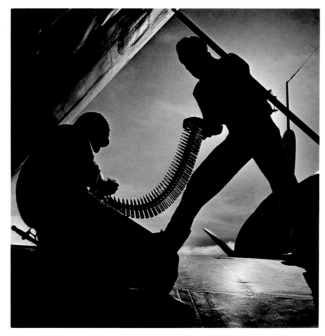

Aboard the
U.S.S. Bunker Hill,
1943–44.
The photograph
is part of Smith's
early war work
for Ziff-Davis
publications.

scared girl married a young nervous boy who had great difficulty putting a ring on the proper trembling finger of that scared girl, and they were man and wife for better or for worse." He described himself for her: "Someone looking at me draped with equipment said they knew which person would hit the bottom first if the ship went down." But at the moment, late November, 1943, he was:

. . . at the low point of one of my depressive moods . . . I have been unable to work because of my nauseating headaches, more than three hours at a time . . . As for myself, I have several stories to do out here that I feel conscience bound to complete. Then I will leave the Navy for good.

From this high moral ground, he criticized the American war effort as having "no single and relentless purpose." He praised the World War I flying ace, Eddie Rickenbacker, for his plan to exchange "lukewarm defense workers for the boys in the front lines . . . [but] I am bewildered and disappointed"—for to Smith the Navy personnel would be no better. He quoted one flyer, in a phrase that had wartime usage in every language: "What am I doing out here? I'm not mad at anybody." This letter was signed "Grouchy Smith."

Smith was too sensitive not to be just as affected by small, daily injustice. In a letter home, he raged at the mistreatment of a "colored" mess boy on board because he brought an officer water in a glass instead of in a cup: "I wonder if some members of our master race realize that after a few days of death we all smell equally bad!" He complained that his quarters aboard the carrier were too comfortable, the food too good: "I am a complete hypocrite if I remain with these surroundings longer than necessary."

Like anyone else, Smith could be manipulative, selfish, and even cruel, but his conscience did not, and never would, give him a moment's peace. He was, simultaneously, sensible and romantic. "I am scared," he wrote Carmen, "and have asked them that if I am killed to notify my family that I died several days before or after Christmas, I don't want that dark cloud floating over all future Christmas celebrations of my family." He had actually contracted to sell his Rollei, in case of death; the money would go to Carmen. But, contradicting himself a moment later, he wrote: "I have not really been afraid since on one assignment, a nite many years ago,

I was nearly killed three times in three hours." It's unknown to which incident Smith refers. In any case: "During a bombing run I am unashamedly enjoying myself"—all this on the day before Christmas.

On December 26, 1943, Smith wrote his family: "The moon was a rust blood saucer . . . for the cry of the night was to pierce all men, may the killing be good." He was ill with the flu and spared them no details: "I vomited what wasn't there." Smith regretted:

. . . not being able to find Mother a decent present or the kids and felt like a heel . . . The tears were suddenly there and I wanted so much to give up and come home—and was ready to. But suddenly I swore to myself and reminded of work of what I must do . . . I would return . . . in the hazy future . . . with upheld head and no shame in my spine. Or if I should die it would be with courage in heart and doing a job—there is no better way to die.

Throughout Smith's stint at sea, there were, both in his diary and letters home, echoes of that fist through the glass door following the attack on Pearl Harbor two years earlier. Two days before New Year's Day, 1944, he wrote:

Dear Bums,

The great tragedy of [my] wasted time has been the years of the war, starting with the Spanish Civil war, the testing grounds for the murder that is now. And think of the lost history in the magnificent complete struggle of the Russian sphere of war, and the early days of the fall of France and the staggering of England. I suppose I can weakly find reasons of forgiving myself for sitting these out. People who have failed usually have almost undebatable reasons instead of results . . . I have in the past been a washout, have veered far from what should have been my destiny . . .

This easy living Navy isn't the story that must be told.

By now, he had been a war correspondent for four months, but he still was nowhere near close enough to the real and often sordid drama of ground combat. His great war photographs were yet unborn.

Next day, the last of the year, "at sea," conscience-stricken about his dangerous ambition, Smith wrote a long love letter to his wife.

SMITH sat in the absent Admiral's quarters and wrote Carmen how much he loved her:

I cannot put into words the feeling of adoration that so completely overwhelms that I want to throw myself at your feet, to plead for the favor of a caress or a smile. I want to humble myself before you, to tell of my worship again and again. Beat me, kick me—but love me, darling, please, I beg of you, love me forever with at least a particle of the love I have for you.

There was indeed an ache of guilt in Smith's love for his wife. With two children, one newly born, he could easily have escaped combat. He chose not to, and for the simplest reason: he felt so much self-doubt that only perilous attendance at the war could make him famous. Besides, good honest American boys should not be cowards.

After pages of sensual memory, almost too intimate to read, Smith's letter to Carmen offered a promise and an apology:

And when the battles have died away; if I feel I must complete my historical coverage of the rehabilitation of the world, I will find a way for you to be at my side, no more of these long partings.

He signed off in his bad Spanish: "Te Armo mi Novia."

On New Year's Day, 1944, it was war as usual, and Smith lost three of his Navy friends in combat. He was amazed at the cool way in which the living treated the recently dead; he himself "bet with a photographer that I would get more lead in my pants than he." This joke must have made his wife cringe. He had already become famous in the Pacific theater for preferring milk to whiskey; he told his family he was resisting the temptation to change, even though there was plenty of whiskey around, but very little milk, of which he, like any healthy boy, could down two quarts at a time.

The practice of these moral virtues did not help him with the censorship board CINCPAC in Pearl Harbor, headquarters for the Pacific war; mostly he disregarded their rules for photographers, and in particular would not always identify his pictures with captions. His employer, Ziff-Davis, was displeased; in Washington, they wrote him, they were told that Smith was not cooperating with the Navy censorship at Pearl Harbor and that his time would be up unless he sent less spot news and more features; and they wanted all of his pictures properly captioned. For a long time, Smith never mentioned this rebuke to his family, but it must have galled his pride. Over and over again in his letters home, he apologized for his ambition:

I would fly every one of the darn things for just a miracle shot but I love my family too darn much, and those fears of them in need, hungry, struggling, is a ghastly picture that is searing my soul nite and day. If anything happens pick out about a hundred of the best classical records and save them. Then sell the others.

He wanted a few records left in case he didn't die but merely ditched. Finally he wrote: "Don't let the above junk worry you as I am just a pessimist from worrying about Mother, you, and the kids." Smith was sincere, but at the same time he was not above pulling a few heartstrings back home. He regretted that his job was so safe; all he had done so far were "saloon" pictures: "If I had gone in at Tarawa with the early waves you would have seen some of the great and brutal war pictures, in all of my gentleness and softheartedness—I am almost the only one to do such a job." But he felt better by February, "the heavy feeling lifted" because the carrier that had his records anchored alongside his

ship; and there was always Tokyo Rose on the ship's radio—playing selections from *The Mikado*! Still, his headaches sometimes lasted three days at a time. He never hesitated to tell his family about his illnesses, his loss in weight, his stolen teeth—for he already had an expensive bridge.

In April, 1944, he'd gone home on leave for a number of weeks. He repaired his teeth and his cameras in New York, got himself examined by Selective Service and was declared physically unfit for combat duty. He quit his employers at Ziff-Davis, who were mostly interested in aerial pictures; he wanted to get a lot closer to the war. He went back to *Life* ("which I will not work for in peacetime") and got accredited as a photo-correspondent with the Army. He was scheduled to return to the Pacific in May; he would soon see action on the ground, where death was not so clean.

For all his homesickness, he spent little leave time with his family, but did manage "a wandering little honeymoon" with Carmen for ten days. On their last day together, they apparently had a violent disagreement, the cause of which is not entirely clear. Some months later, after he had returned to the Pacific with his new assignment, he wrote Carmen:

. . . you have thoughts of rebellion that border on the hatred of . . . my controlling force . . . or rather of the tools of this force—which are, of course, photography and music. But you dare not hate it, for if you do there will arise a hatred of me and as yet, you love me too much to begin a hatred.

The following day he was more explicit:

I would also like to say, with the fullest of sincerity, that ever since the last day blowup in New York, I have been unable to shake my sorrow at the happenings. I regretted it then, I dwelt unhappily on it during many restless hours across the country, and it still bothers me. Please accept the apologies, the deepest that I can offer. And I ask you to here again examine the person, and know that I explode without meaning—even without anger, and rarely anger at the one receiving. By now you people should know enough to shed them like a short thundershower.

There are no letters extant from Carmen in reply to these troubled words; Smith kept carbons and often rough drafts of his own correspondence, but only rarely did the answers survive. One wonders what could have been the answer to this brief and guilty letter:

Dearest Pest:

In the time that I am away from you and cannot physically influence your thoughts, I wish you would sit down and write a long and careful letter to me. I want this letter to be frankly honest and complete. Sit down and evaluate me as a husband and a father—and a lover. Tell me of the shortcomings I have that made life a bitter problem to you. If there are things that I have done to make you happy, tell me of these things too. In my carelessness and my work there are undoubtedly many things that I have selfishly or unconsciously done that have been disturbing to you. Tell me these things and things you wish I would do for you that I never do, tell me of the little things that may mean so much and of the big things. Give me an evaluation of the success or failure of our marriage—in your eyes. Even include unbashfully, unreservedly about the success or failure of even our most intimate relations, perhaps there are things I do or do not do that could be eliminated or added to increase even this fulfillment. Now do as I ask—and tell everything that is good or bad. I will be returning some day and we must start off once again, and I wish after the misery of the pres-

ent years of war to make that a happy period in your life. The proposition of the above letter probably scares you a little but do it, but measure your words carefully and say what you mean.

Love
Gene

One's guess is that a wife would have to be a saint to answer it honestly. Whatever the quarrel, however brief that second honeymoon, Carmen was pregnant again. Smith was jovially convinced she would have twins and badgered her for proper names.

Smith's love for his children was as intense as every other emotion in his life; he wrote several letters to his daughter, "Meechie," as Marissa was called, and took care to pitch them to her comprehension: "Your daddy is going on another long trip in a big silver airplane." In some letters, one finds strict cautions regarding his children that were meant, most likely, for his mother:

Be careful with my brats and don't use the other one as an example of doing things right or you will find jealousy and a loss of love cropping up. I just can't see how those kids are going to be raised right if they don't hurry up and get this thing over with in time to do the main supervising job. Also, while I think of it, some people are awfully stupid to give people hell and say something shouldn't be after it has already happened and is past recall and I wouldn't want it recalled anyhow. No wonder I wake up in my sleep growling.

In fact, there were other broad hints at this time of Smith's growing disagreement with Nettie. At least twice in his letters to her he attacked anti-Semitism, and particularly the charge that there was a Jewish conspiracy to dominate the world. But his quarrel with his mother could never be entirely ideological. Basically, theirs was a struggle of wills that, by tradition and the lopsidedness of maternal feelings, she was bound to lose. He wrote and scolded her for trying to force his brother, Paul, to pay back some money he had borrowed:

There are times when that calm practical mind of yours is enough to scare people—if that mind of yours had only been turned into the proper channels it would have been one of the great women's minds in the country by this time, but unfortunately in some ways instead of being the great factor in your happiness it has been the cause of much of your unhappiness.

To compensate for his tone, he gave her a bit of praise, yet combined it with a defense of Carmen with whom Nettie was often vociferously at odds. He said:

You are so wise in many ways but yet there are so many things that you do not understand about human relationships. Such things as my taking time off to write an intimate letter to my wife alone and renew my pledge of love as if we were not yet married and I was afraid of losing her to some other person. . . . Oh she has faults—many faults—that you look at too critically, but when I start to do this I merely analyze myself and know that the scales are even. I love the little pest very much. You tell me that I aim for a too high perfection in photography—you aim or look for too high a perfection in people.

In the last words of this crucial letter, he tried to bridge the moral gap between them:

I am very sorry, for although we disagree quite violently about many things, I understand you and what hurts underneath and I think you are one of the grandest persons I have ever known, and without a doubt the best person I have ever known or will know—I love you with all of the love a son can hold for a mother.

Theirs was not a gap that could be easily spanned. Following his coverage of the invasion of Saipan in June, 1944, Smith responded self-righteously to a letter Nettie had sent in which she complained of New Yorkers who could not even speak English without a disgusting accent. Neither could the Pope, Smith replied. "No my dear people, my class system is built upon such things as honesty, tolerance, decency, fairness—in other words upon the evaluation of each individual."

This was not, from the evidence available, a new position for Smith; he held it, as he said himself, long before the war. But the horrors of battle now allowed him to say these things more frankly. There had been, in the years since he left Notre Dame, a significant change in his view of the world and in his moral perspective.

The historian is obliged to seek for connections, critical events and influences, to find the root of alteration; but sometimes that is all wrong. The change may come from inside, from the internal growth of a man as complex as Smith, to whose external intensity there corresponded an internal furnace. One does not have to abandon the perception that Smith's motives were deeply and constantly selfish. Indeed they were, but his identification with the victim and his hatred of the brutal were nevertheless—whatever their dubious origin—an admirable side of his character. He would have been a skillful but mediocre photographer without them; indeed, his very compassion forced him into the dark, dramatic, technical brilliance of his greatest photographs. He began to head his letters home with a quotation from his friend, the *Life* photographer Carl Mydans: "The direction of a war photographer's lens shows what he is thinking—his censored negatives, what he is trying to tell the world. . . ." As Smith himself said:

You can't raise a nation to kill and murder without injury to the mind—and the reams of written matter calculated to bring hates to the people of the world, with all of the stupid intolerances that cause the wars in the beginning—that is the reason it is up to some of us who have idealism and a sense of justice and honesty to live that idealism with our whole being and even into the face of death. It is the reason I am covering the war for I want my pictures to carry some message against the greed, the stupidity, and the intolerances that cause these wars and the breaking of many bodies.

Smith's hatred of war furthered his determination to make only photographs that would express his disgust. He experienced a sharper crystallization of his way of looking at the world, a view that conflicted more and more with all the training and prejudice he had had since he was a child. At the same time, his photographs of 1943 through 1945 show his swift development from talent into genius. The 1943 prints of life aboard the carrier U.S.S. *Bunker Hill* were skillful and accurate; the briefing and debriefing in the ready room show no sense of strain in the young men's faces—none of that group had yet been burnt alive. The counterattack after the raid on Rabaul (November, 1943) did give him a spectacular shot of an enemy bomb exploding just beyond the edge of the flight deck. His expedition to Tarawa, though days after its capture, resulted in photographs that went beyond mere clever information; they show the horror and sadness and anonymity of unburied corpses. A burial at sea gave him a striking shot, but as yet, in 1943, there were no close photographs. The invasion of Guadalcanal and Bougainville produced few photographs of interest, but the Marshall Islands campaign in early 1944 yielded Smith this ironic scene: the warship's chapel with a sculptured Christ on the cross, and, on the wall just beyond it, a scoreboard of rising suns, each one representing a kill in aerial combat. "Many call this my greatest picture . . . ," he said.

But it was only after his New York leave in April and his return

to the Pacific in May, 1944, when *Life* had put him back on the ground where he thought he must be, that Smith began to display the dark splendor of his perception. During the Battle of the Caves on Saipan, June, 1944, he took some extraordinary pictures: the soldiers kneeling and firing with an enemy sprawled dead across the foreground; the fiery bush of an explosion; the classic composition of two men's faces, one drinking out of his canteen, and both exhausted by combat; the flat field of corpses on their stretchers before burial, each wrapped closely in his blanket as if restless in his permanent sleep. There were photographs of the civilians, mostly Koreans and Okinawans: a mother and child emerging (the *Life* caption said "scampering") from a cave while, stretched across the foreground, is a horizontal tree broken like a human limb. There were other images of naked children of another race that Smith said reminded him painfully of his own babies; and the less celebrated but very beautiful photograph of an enemy woman, scared, passive, and framed against the luminous dust

and the palm fronds shredded by gunfire, looking toward a helmeted soldier as he stretched one hand down to help her. There was an extraordinary trio of shots on the same roll, picturing a tiny child with its clothes gone or blown off:

. . . writhing with the head as a pivot . . . that had somehow become lodged (probably by its parents to keep the child from giving away their hiding place) with its head straight down into the dirt, head almost concealed by being wedged under the edge of a rock . . .

The child was being lifted by one soldier's hand from under the debris. Smith made three exposures as the child was passed from hand to hand. It is almost unbearable to analyze, but one can eventually parse the composition: the triangle of faces, two soldiers and one child; the sense of death from the sheathed knife in the foreground and the cigarette in the mouth of the second soldier just below; and the baby, head toward the camera, stretched out across this narrow abyss, a space compressed and dark with pity.

8.

"There is no middle path with me."

THE INVASION of the Philippines in October, 1944, was a disappointment; Smith and the other correspondents landed days after the initial assault. He did, however, take a couple of shots at a hospital in Leyte; they show what would become his classic mode: a horizontal victim posed against vertical mourners or saviors, but nothing very unusual. Later, strapped into the narrow cockpit of a bomber, Smith flew in the daring carrier raid over the Japanese mainland on February 16, 1945. A curious story, related by Smith himself, was that he was the only photographer on the mission. Since he knew of the plans to invade Iwo Jima a month later, he promised that if the Japanese shot his plane down and he survived, he would kill himself to avoid enemy interrogation. "And I told them if I didn't have enough guts to do it, they could order the pilot to shoot me." A few weeks later he wrote a draft of an unpublished documentary story on the experience:

All the flights and the feel of death and no lover of this was he, and though this flight was to fulfill grim purpose—his thoughts, the sensitive heart of his mind, was full of a sense of misplacement, for though this was the war and was to be covered, it was the war of machines, where even the pilots became automatics in an impersonal spreading of death . . .

And this man in the cockpit was the war photographer Wes Foree—idealist, realist, bearing an intensive, some would say a fanatical, desire to show impartially to the world what war is.

The photographer is clearly Smith, but he had given himself an odd name: Wes Foree. The first name is easily decipherable: it is simply the three initials of William Eugene Smith. The "Foree" is baffling until one remembers that Smith was classified unfit for military service: 4F. 4E ("Foree") turns out to be the classification for Conscientious Objector. Smith loved this kind of punning mystification.

The raid on Japan had been as much a public relations event as it was a tactical move. Iwo Jima was quite another matter. It was a fierce, close, bloody battle, characteristic of the Pacific war, waged for possession of a shattered coral rock. Out of a hundred or so exposures in this series, there was only one photograph reproduced for his monograph a quarter of a century later: the double cone of a cave primed with dynamite and exploding in the middle distance, while in the foreground there are blasted charcoal trees and a squatting patrol of four soldiers. Smith captioned it: "Sticks and Stones, Bits of Human Bones. . . ." Yet Smith was

disappointed in his own work. To his family, he wrote:

And now as the brain clears I say the reason of my failure on Iwo Jima is that I have let too many well wishing friends talk to me and try to get me to take it easier. I now see that I unconsciously did this—took just enough of the edge off the drive that I failed completely. I do not mean that I ran, or hid, or really held back, I just did not press to the utmost, and as I have stated many times I dare not ease off or I slip completely to the bottom—and I now bear cold fury at ever listening slightly to these friends, and letting stomach, head, and arm deter me slightly. I am completely furious at myself—and ashamed—and now I build up to the high tension necessary to launch myself into the next operation.

To stand up under fire to make a true photograph was an intensely personal and moral decision; the consequence could be fatal. War correspondents argued the point over and over again. They were a cynical lot who knew too much; they were hard drinkers, most of them. In the interest of good public relations, the Navy had set up a pyramidal tent for these correspondents, with two bartenders and free liquor. Here they discussed everything from art to death in battle. To his family, Smith quoted a notice pinned on the tentroom wall:

A kind word. A friendly tone of voice. A worldly attitude about such things. We are all brothers. The end is death for each of us. Leave us love one another and try not to get excited.

The Sage

One's integrity and one's life were in opposite pans of the same balance. At the staging area of one atoll, the war correspondents Ernie Pyle and Max Miller, the UP correspondent Evans "Red" Valens and Smith once spent six whole days drinking and shouting at each other. Smith remembered:

. . . the answer I gave [Pyle] in Guam when nervous and frightened, and hounded by his friends to make no more landings, he asked me if he had to do it and be honest to himself and his job—I answered, amid the glares of his friends (and my friends), "Yes Ernie, even if you die, you have to make that landing, and the next, and the next."

There had been a briefing for the bomber crews before the raid on Japan, and Vice Admiral Spruance had given them a pep talk; he wanted them to deliberately set fire to the houses of the Japanese workmen. Even the war correspondents were shocked,

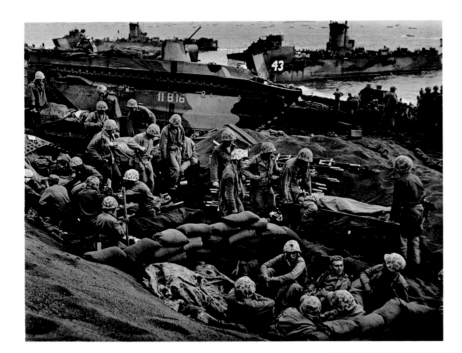

*Iwo Jima,
1945.*

and Smith was outraged. His view may have been influenced by guilt: he carried a gun, in defiance of war regulations for non-combatants. In the close quarters of front line combat, it was often kill or be killed. On the day of the Okinawa invasion, he was fired on from behind. Whirling, he saw a Japanese soldier 12 feet behind: "I let a wild shot go with .45 . . . which dropped him." According to Valens, Smith had become a convinced pacifist by now and hoped that his photographs alone would reveal to the world the true nature of war. Valens, summoned back to the comparative safety at Guam, wrote Smith:

I imagine you got (and I deeply hope you did get) one or two great pictures. But God damn you . . . you're not worth a shit dead but you're apparently too stupid to realize it. I understand your philosophy well, Gene, because it is similar in many ways to mine. . . .

Gene—This is no mothering attempt to make you take care of yourself. It is an honest statement of what I believe to be true and which to me seems painfully important . . . s'long guy.

Red

On Okinawa, Valens himself was wounded across the cheekbone, a narrow escape from death; he survived to cover the Nuremburg Trials. It was characteristic of Smith's relationships with his male friends that at intervals over the next few decades, he and Valens would meet and talk for hours. These discussions, renewed every few years, were impassioned and critical, at least to Valens. They were kindred souls, welded together in the fires of war. Valens was an intense and sympathetic man, much given to existential questions. He once gave (not loaned) $10,000 to Smith when Smith was dead broke and boasting of starvation. Valens never got a note of thanks, nor any acknowledgement, ever. "I suppose he thought his work was worth it," Valens said.

On the other hand, Smith could idolize a man extravagantly. He had met an Australian newsreel photographer, a Catholic as it happens, named Damien Parer, who shared his view that only by standing alongside the most forward troops could one capture the truth of war. In a letter to his family, he said about himself and Damien:

Damien and Smith had always said they would give their lives if necessary to try to capture that elusive something that they were after . . .

You had seen Damien holding a camera trained without tremor on the faces of men in battle, as they leaped to the edge of an embankment to shoot at the enemy below, as they ducked with the return crackle of fire and as they flinched and sprawled in the dirt as the whine of a shell swooshed over to explode behind them—and then Damien would rewind the spring motor of his camera, not having moved more than an inch during all of this. You watched, and were glad inside, for here was a man apart, here was someone succeeding in securing that which you too were after. He was modest, even in shooting great pictures, he would worry, would be unhappy, sometimes he would go as far as to say, "I think I got something worth saving today"—and with him, you knew that he did.

When Smith learned from casual conversation that Parer had been killed at Peleliu, he wrote his family: "I have not gotten over the death of Damien, in fact as long as I live I will not get over the death of Damien or Whitaker or some of the others but Damien's is the toughest one of all." Smith had learned that Parer had a bride of twelve days, and his wife was pregnant; he suggested to Carmen that they adopt the baby. "With Damien as a father, I think the kid would be ideal in our family—might even marry our coming daughter. That man was very close to me."

Smith's relationship with his family was, at that time and during the grisly drama of the war, only a little less important than the death of a comrade. He wrote them often, for only in his collective letters to his mother and to his wife could he have complained of his ills and deprecated his dangers:

To spike any rumors about my condition, and only for that reason, I will tell you that I was hit twice by machine gun bullets on Guam. One cut through my pants leg and stung my calf, the other cut across the small of my back and cut the straps holding my pants to my belt—therefore when I got up to run in the other direction I almost lost my pants. To those asking how badly I was hurt—I wasn't hurt—my heat rash bothers me much more.

He complained often about one of his arms, which was so painful that he had to work and type one-handed. He saw a military doctor who recognized the symptoms of a coming breakdown and suggested he take a long leave; but "the doctor with the commercial advice was a psychiatrist that a physical doctor slipped over on me."

There was an undercurrent of sadness about his letters to Car-

Okinawa, 1945.
The photograph
is among Smith's
last images of
the war.

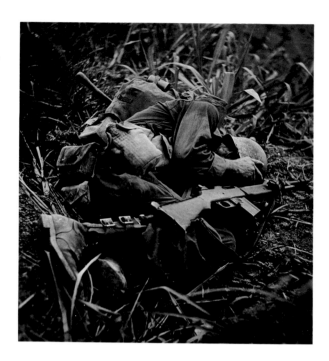

men; he complained that she hadn't written in weeks: "I wonder if my wife loves me anymore." He suggested bitterly that she go out with other men six nights a week and save one evening to write to him. He seemed not to remember that his wife was busy with a brand new baby, Juanita Lee Smith. Carmen eventually wrote him; she was worried about the baby's dark skin; Smith wrote quickly to reassure her that the color of his daughter's skin did not matter to him. But any lapse of time between Carmen's letters made him turn grouchy again:

I am going to be awfully mean and quote what I hope was a slight error in one of your more appreciated letters. ". . . I've done a lot of thinking and always the thought of you not coming back comforts me." You don't need to be so brutal—my little one—I'll go away, with some nice Japanese girl. But seriously, I understand and am glad and I love you very much. And my goodness, I have received two letters reasonably close together—I love you again, or I should say more and more.

By mid-April, 1945, he was in Okinawa, site of the latest U.S. invasion, on land that the Japanese had occupied since the Russo-Japanese War of 1906. There he wrote: "I freeze to the marrow of my bones. I have two blankets, I sleep in my clothes, two pairs of socks, a wool sweatshirt and a heavy marine jacket and still it hits." Valens described how he found Smith shivering in his tent, without the field jacket that lay beside him. He was saving it for 2 a.m., when it really got cold.

Smith thought out a detailed future, as men do in war; the fantasy dispelled the fact:

I want it understood once and for all that I will not be compromised with my beliefs or with the taking of subjects in which I find no reason—no point. I will not, I will never change this attitude, I will never go commercial. . . . I would rather call the whole thing off, go completely to pieces, and become a worthless bum. There is no middle path with me, as long as I must go through life on keyed up nerves to overcome my head, I must reach out and up, for without this search for the perfect—the ultimate—for the symphony which Beethoven was reaching for, I will not have the strength to combat the other and therefore will slip completely.

His determination and courage paid off in the Okinawa campaign. This whole series of photographs is exceptionally moving, for his compassion for the men in combat is equal to his compassion for the Okinawans caught in a war they never declared. Compassion, of course, is not quite an aesthetic term, but it ought to be because the magic line between reality and artifice is nowhere thinner than in photography. Smith, in extraordinarily vivid style, described the circumstances under which he made one image, and this story is now inseparable from the image itself:

Several patrols tried to advance down a road through a gap in a ridge and were badly cut up, one squad of 5 men completely disappeared, and it was impossible to reach the known wounded to evacuate them, because machine gun fire continually swept the road. Suddenly a man broke onto the road and ran frantically up the road toward us. Bullets plowed the dirt at his feet, we could see that his face was a mass of blood and he wobbled as he ran, but on and on he came and still the bullets cracked around him within inches of the safety of the ridge he was hit again and gyrated crazily into a heap behind the ridge. He lay there writhing and groaning, the last bullet had gone through his foot but was a clean wound, his head looked bad and blood poured from his mouth and nostrils, but he was conscious and fairly rational, asking how badly he was hit, saying that he was a new replacement, telling us about the hell up ahead.

Although in great pain they did not give him morphine because of the head wound, and as they laid him on the stretcher he grasped the neck of the medic and held on for several seconds. Then he lay there with his hands clenching and unclenching—finally he brought his hands together in the folded position of prayer, his lips began to move, he stopped writhing. They picked up the stretcher and as they carried him along the ridge his lips still moved and his hands were still clasped.

The picture that may be the one, unfortunately made on the Contax, is a shot of him laying there in the attitude of prayer. I had to compromise slightly in the composition which may hurt it some—however—if I had moved around the foot necessary to make it completely right, I would have had to step around into the line of fire that had just felled him. Now that I think back, I am depressed in my heart because it was so close, I know that I should have taken the chance for the second or 2 necessary for the completion—that lack of completion will forever haunt me or bother me.

While Smith was still covering the murderous fight at Okinawa, he got a cable from his editor at *Life*, William Churchill:

WHAT CHANCES YOU DOING PICTORIAL DAY IN LIFE OF DOUGHFOOT SHOW ALL HIS PROBLEMS LIKE HIS ACHING FEET HIS MOSQUITO BITES HIS DISGUST CUM KAY RATIONS HIS LONGING PROHOME . . . HIS SATISFACTION ETCETERA CIGARETTES EVERY LITTLE DETAIL . . . FRONT LINE LIFE ITS STORY . . . ALL HERE WOULD LIKE TO SEE YOU TACKLE . . . BECAUSE WE THINK YOU CAN BRING IT OFF STOP SHOOT PROALL THOSE LITTLE DETAILS THAT ERNIE PYLE MADE FAMOUS . . . BEST REGARDS

Smith agreed, for about ten days later he wrote his family:

Not quite as depressed as I was the other evening . . . Have another story to do for them which is going to be difficult and I'm afraid far from highly interesting, but with a great amount of luck it could be very good. Unfortunately it is strictly combat . . .

For his subject he picked young Terry Moore, an automatic rifleman in the 184th Regiment of the Seventh Division. Smith told Dave Holman at Tenth Army Headquarters before he went out on this assignment: "Look. I don't want to be dramatic. But I'm not coming back from this. Be sure my pictures get in, and tell Carmen how it was." Holman said, "I kicked Gene in the ass and called him every name in the book and told him to stop being both a fool and an exhibitionist."

The 184th was assigned to a night attack on Japanese fortifications some miles inland on Okinawa. To reach the forward positions, the regiment was conveyed in trucks and unloaded for the first night. Terry Moore and Smith spent the night in a foxhole. At four in the morning, May 22, 1945, they began to walk slowly toward their objective. Smith took a number of photographs that day, mostly of Moore. There is nothing particularly distinguished about this first series; they were not yet in battle. At three that afternoon the platoon was ordered to move out. They met heavy mortar fire almost at once; they were close to the Japanese positions. The men took cover behind a rise; Smith, anxious to get a shot of Moore with a mortar explosion in the background, stood up with the Contax at his eye. A mortar burst close beside them, creating a fountain of metal fragments, a few of which struck Smith with terrible force. He wrote to his family:

I would rather be blind than deaf, and as I regained consciousness on the muddy battlefield of Okinawa, before I was able to open my eyes, or to find out how badly I was hit, I heard someone yelling "Medic!" and I knew that regardless of anything else, I still had my hearing, and I was satisfied.

It was Terry Moore's voice that shouted, "Medic, medic! Over here!"

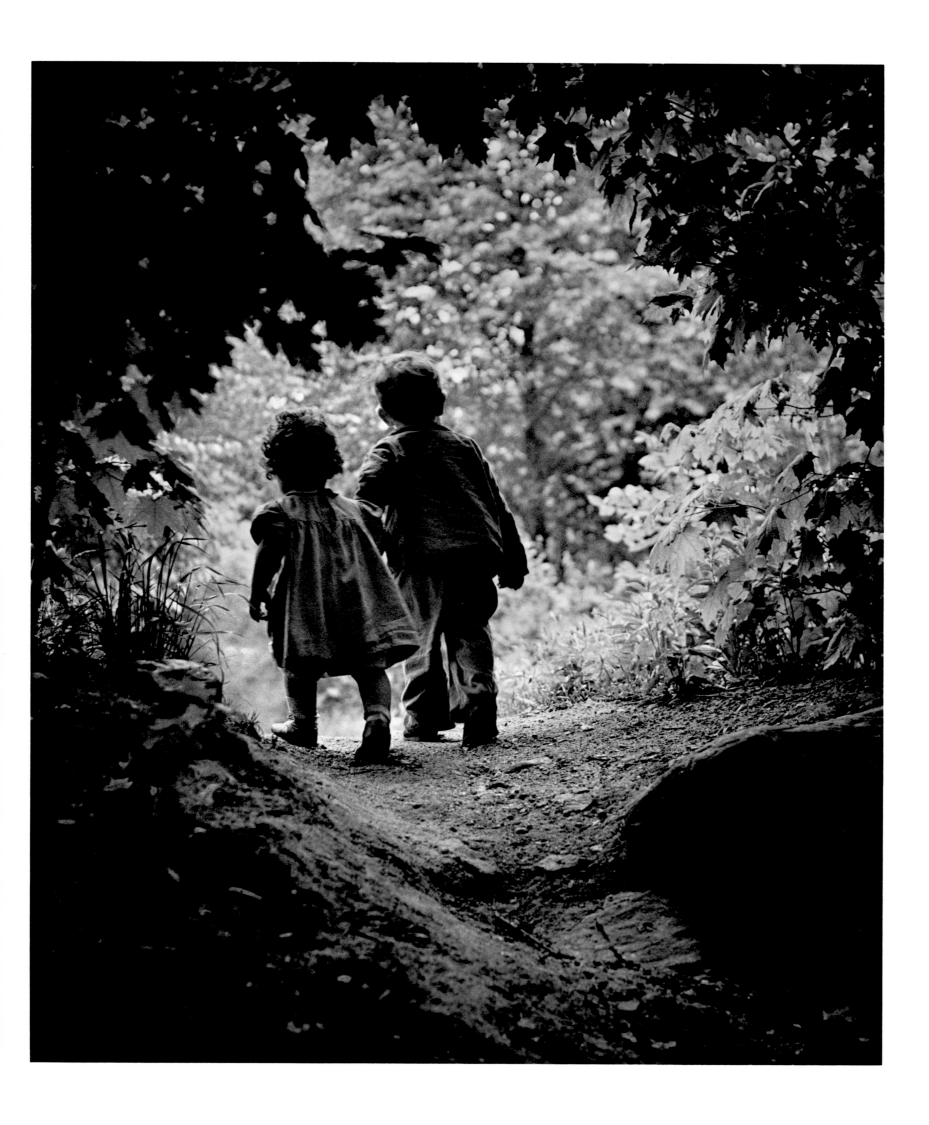

9.

TERRY MOORE gave Smith first aid, and he and a medic carried Smith back down the ridge. They had to carry the stretcher almost a mile before they could find a jeep. An hour later, Smith was in a field hospital, where doctors gave him several transfusions and patched up his wounds. Smith reported to his family: "The only bad night of treatment was an overnight stay at an evacuation station where I got very little assistance—and above us streamed a wild melee of tracers and suicide planes the fore part of the night." Two days later, May 24, 1945, he was flown to the Naval Hospital at Guam. Separate jagged iron fragments had hit his upper back, mangled his left hand, which had been lifted to focus, smashed the camera that was pressed against his face, struck his lower jaw, pierced upward through his lips, and broke the roof of his mouth. His glasses were shattered, and his left index finger was almost severed, hanging by a thread of skin.

Smith himself had a cable sent to *Life*; he was characteristically apologetic:

I BELIEVE THE FILM COVERING THE 24 HOUR PERIOD IS ON THE WAY. THE WEATHER WAS TERRIBLE AND THE PICTURES ARE RATHER BAD. SORRY. HOPE YOU CAN SALVAGE SOMETHING. MY POLICY OF NOT DUCKING FINALLY CAUGHT UP WITH ME. THE LAST PICTURE IN THE CAMERA IS THREE MEN FLATTENED, WAITING FOR THE SHELL TO HIT. I STILL HAVE TWO EYES, TWO EARS, TWO LEGS, TWO ARMS. TELL THE FAMILY I AM OKAY, JUST SLIGHTLY HURT.

Meanwhile, repair of the injured palate, both soft and hard, was the surgeons' chief concern. The nearly severed finger was sewn back on; and his jaw, cracked in several places, was splinted together with "a kind of plaster helmet and jaw sling." Smith felt fine, considering the injuries; the nurse reported: "He has a lot of bounce." On May 29, seven days after the wound, Smith dictated a letter to his family; it ended with a defiant paragraph:

And to all of those people who will and are saying "I hope he is satisfied." "I hope he has learned his lesson." etc., etc etc.—For that I have some words in answer— I know full well what war is and have known for a long time and know how extremely lucky I have been, and still am. I have always weighed the chances of each assignment and many times the chances were grim. . . . But this has never stopped me from trying to accomplish that for which I am out here. So the mere fact that I have been painfully hit could have absolutely no bearing on such decisions.

In one way, I have gained by this experience of being wounded and now I have even a greater understanding of the men in war, and though there are those of us sensitive enough to bridge these gaps . . . you are never quite sure until—

Who were "those people"? His wife? His mother? Other correspondents? Those at *Life?*

He cabled *Life* again on June 2, 1945, and said of his fellow war correspondents: "SHELLEY [MYDANS], CARL [MYDANS], PAIGE ABBOTT . . . AND ALL THE OTHERS HAVE DONE SO MUCH FOR ME SINCE I WAS HIT THAT I CANNOT THINK OF ANY OF THEM WITHOUT BURSTING INTO TEARS. WHAT WONDERFUL PEOPLE THEY ALL ARE." The tears were not metaphoric, either. In later years, he cried easily. His emotions were now closer to the surface; the war had broken through the clean-cut bravado of the all-American boy. And that was not to be the only change.

On June 2, he was able to write his family, with the hand that had not been hurt. As usual, he apologized for his delay: "I am very sorry—I just haven't had the stuff. . . ." He didn't spare them though:

Last nite was the first nite of sleep and not of agony since I was hit and it was a tremendous relief. Some of the nites have been rather bad.

Eating is very difficult, although now I can swallow fairly well—with constant danger of "Smith" choking—eggnogs (four times a day), the sweeter fruit juices, and water. It was four days from the time of being hit before the first liquid trickled down me little throat.

His last paragraph said:

Important: Get both of those phonographs in top working order—the one on 74th [his New York studio] has a changer in a bad way—maybe the other changer (somewhere around there) is in better condition and should be substituted.

Some days later, "June 4 or 5 or something," he complained in amazing detail (his mother must have loved this):

I drank a glass of warm carrot soup at lunch and almost liked it. But all meals are an ordeal of gagging and sucking and belching and drooling—and leave me pretty doggone upset. I'm going to be an awfull to live with (for a change).

And I am not going to particularly care whether I kiss you people or not. I have no feeling in my upper lip—and what is the purpose of kissing if there is no feeling.

He actually considered staying in Guam until he was healed in order to avoid frightening his children. "I can't be a pleasure, only a trial and a care . . . Darling people, I am scared to come home."

A week or so later, he had an allergic reaction to the antibiotic he was taking, and again he did not hesitate to tell his family all about it:

If I have anymore days as tough as the last four then I would almost like to cease to exist—Oh, that's not true, for things could have been ten times worse—but they were uncomfortable.

Yet the same letter was full of his persistent humor:

Henry Luce dropped in to see how I was getting along—my mouth is practically a reception committee anyway. People line up in single file and peer and they (visiting doctors) poke or the regular doctor pokes while they just peer.

He now expected to be home within a week, and:

My darlin's, I'll try to be good, I'll try not to be my usual grouchy self, I know one thing, I won't yell at you—at least for a while. Food is going to be a difficult problem—during liquid part of my future. Heck, darlin's, maybe I'm making a mistake to come home yet. (But being selfish I'll be there.)

Meantime he had the corpsman play his records for him: Beethoven, Brahms, and "Relaxin' at the Toro"—the Toro was an insane asylum in New Orleans. Through his long months of convalescence, Smith relied more and more on music to alleviate his boredom and pain. It held him together in a most unusual way. During his convalescence, he wrote a proposal to *Pageant* magazine, offering to write a monthly music column. Smith said:

I approach all music from the emotional side adding the intellectual when I may, but never listening to music for purely intellectual reasons. (Incidentally, if my library was reduced to one record album I think it would be a Beethoven Quartet Opus 131). Much of the music that I find deeply moving would probably fail under critical intellectual (Tchaikovsky) examination.

His closeness to combat did not stop him from pursuing this obsession. He had records and a scratchy record player on the U.S.S. *Bunker Hill.* "We would listen to music . . . especially after a raid . . . we pooled our records and had an agreement that survivors take all. . . ." And when he was on Saipan and later, on Okinawa, he would play the Prelude from Wagner's *Parsifal* the night before landings. And in his hospital room, of course, he had music with him 24 hours a day. He "had the machine turned on, a changer loaded, to be started as I was wheeled back into my room from the operating table."

Smith seriously divided his life into two parts: before music and after music. In his proposal to *Pageant,* he said that before music, he considered photography "commercial and fun." After:

. . . my photographs began to change as I tried to put a deeper meaning into them, my approach became less superficial. In short a vast change came over my entire outlook on life in its every aspect—in everything from love to intolerance and to integrity. But this inner revolution brought great emotional turmoil and periods of unsureness, of mental depression.

And then, he declared, that music would heal, comfort, and cure this very conflict. This transformation would have happened during his early pre-war years in New York City. But why did music have such a profound effect on him? One must conclude that Smith confused his own moral and aesthetic standards, binding the two together, making one the cause of the other, and thus ennobling each of them. There is something of a tangle of backward thinking in his statement, also in the *Pageant* proposal, that: "In the face of the present headlines, in the face of the battles that I am engaged in for a more honest journalistic approach by our publications, in the face of the struggle for the rights of men as against intolerance I might still go mad without [music]. . . ." But in the irrational realm of emotion, this was, for him, exactly true.

By mid-June, Smith had finally come home, but he had to go back to the hospital for surgery to remove a bit of metal that had:

. . . tickled and fiddled with a nerve controlling the two undamaged fingers of my left hand and had left them paralyzed. So, all four fingers are paralyzed on the left hand, and are causing me far more trouble than is my mouth. In fact they try to tell me the hand will prevent my returning to the war—I will admit that defeat only when the war is at an end and I am still in the states.

My mouth has all of the wires out of it and no plate. I talk just as mushily as ever, and am still on liquids—but my family have invented a way to convert whole meals into liquid—I topped off a recent roast-beef dinner with a piece of cherry-pie—to hell with you too. In a few weeks they are going to give me a plate to cover the hole that should help my talking and eating. They will not operate on the mouth for over a year.

He wore this prosthesis, with middling success, for the rest of his life.

His wife and mother took over the problem of how to feed him while he was healing. Nettie wrote, at Smith's suggestion, a long article on liquid diets and called it "Drink Your Roast Beef Dinner." It is specific, useful and grisly. By now, the entire family, including Nettie, had moved to a house in Tuckahoe, a New York City suburb, but Smith kept a studio with a darkroom at 105 West 74th Street. He could afford both because he had gotten a loan from his mother and because *Life* had kept him on salary during his long convalescence and paid his medical expenses. At about this time, he went to night school, taking a class in professional writing and another in directing for stage, movie, and TV. In fact, he seriously considered abandoning photography altogether.

The problem was again his left hand; four fingers were paralyzed, and they recovered very slowly. He was in pain and taking injections of morphine. It is almost certain that he did no work during the rest of 1945. Meanwhile, in April, 1946, 200 of his war photographs were exhibited by the Society of Magazine Photographers at the Camera Club in New York. A small corner was reserved for his mother's work. His photographs were acclaimed as the work of a new genius in the field, but photography was a career Smith might have never again pursued. But finally, in a crucial letter (unfortunately not dated) to one of his Army friends, Lieutenant R. J. Mitchell, Smith wrote:

In two or three weeks there will be a date that will go down in the personal calendar of the life of W. Eugene Smith as a day of significance. Good or bad, it will be a date to remember, along with May 22. It will be the day that I return to work once more, someone has suggested that I should take an easy, unimportant assignment for that debut, but that cannot be, it must be an important assignment, it must be a tough assignment. I don't know what the results will be, I haven't really touched a camera since that day, some special equipment has been built to give cameras steadiness in my left hand, I am lost in the weight of the things I must try to do . . .

In the spring of 1946, Smith would often lie in bed and watch his children playing in the back garden; more than once he saw them go through a clearing in the bushes and disappear into the woods nearby. One day, stimulated perhaps by the great success of his April exhibit, he decided to try his hand—his left hand—with a camera. His mother, too, may have photographed the chil-

dren that day: her prints show the same clothing as his. Smith loaded the camera, went down into the yard, and had Patrick hold Juanita's hand as they walked, beautifully backlit, toward the grove just beyond. Dissatisfied, Smith had them walk back and forth five or six times. There is no way to measure the degree of pain or effort involved. What is certain—because any photographer would have experienced it—is the enormous effort of will, after a long or infertile period, that it takes to start all over again.

Smith himself, long afterward, wrote a detailed account of this return to his art. It is amazingly, almost grotesquely, dramatized: "The children in the photograph are my children, and on the day I made this photographic effort, I was not sure I would be capable of ever photographing again." He said it was "two years of negation . . . of impassive, non-creative suspension" since he had worked with a camera. He was in error, because two years from his injury would have put him in the late spring of 1947. By this time he had done six theater assignments for *Life*, two of which were printed: in August, 1946, and December, 1946. Therefore one must conclude that Smith was exaggerating the delay in this first painful effort by at least one year.

A review in *Time*, on February 8, 1971, recounts an interview with Smith on the occasion of his great retrospective of that year. It repeats the legend that he had not held a camera "for two pain-wracked years." Smith's own written account is very specific: "It was a warm day of lilt without drag." He had arranged to have Carmen, Marissa, and his mother out of the house. "As the car pulled out of the driveway I stared through the window after it, my vision blurred by thin curtains." The two smaller children were playing in the room next to his "with music the only and welcoming intruding sound (for at the moment the children were silent)." He compared his problem to the threat of deafness to Beethoven. He went to the closet and "taking a roll of film I struggled to tear open the cardboard container, and then struggled to open the camera and insert the roll." Now the drama really began:

I fought to give my mangled left hand a strength and control it didn't have, and to which I tried to add by twisting my whole body in awkward leverage behind it, the pain and the nerves and the fear and the inadequate fumbling left me trembling, sweating, and coldly hunched in cramp. The taste of this passion mingled with the ugly taste of infection serum that, constantly draining from my head injuries, flowed down inside my throat, and that outside flowed down my cheeks and across my lips. My nerves harshly screamed to my mind to fling the camera down, to shirk the damn trial, to run out of the place. I held quiet, holding in, holding on; the children in the next room were laughing. I whispered out, silently, to myself, and I let the quieting strength of the still playing music rest me another moment. Finally the camera was loaded.

He said he took the children outside:

As we walked I tried grasping the focusing barrel of the camera with my contorted left hand, going through all of the motions except for the actual taking of the photograph. Each time I bent my head forward to focus, the infection drainage would splash into the camera, obscuring the clarity of the image on the groundglass.

He thought back to his war experience, and interrupted his account with a passionate oration against human combat:

. . . those tortured photographs I made of the lone survivor of a patrol, jabbering his madness, pounding the air, as unrelenting bombardment and sniper's cymbals scored his staggering dance of incoherency.

Such passages remain, at this distance, very moving, if only by the intensity of their exaggeration.

In contrast, he described his own happy children. They were,

he wrote, discovering a world of wonders in this path through the woods:

They approached a clearing roughly arched by the trees, and I became acutely sensitive to the lines forming the scene and to the bright shower of light pouring into the opening and spilling down the path towards us. Pat saw something in the clearing, he grasped Juanita by the hand and they hurried forward. I dropped a little farther behind the engrossed children, then stopped. Painfully I struggled—almost in panic—with the mechanical iniquities of the camera . . . I composed the setting as I labored . . . tried to, and did ignore the sudden violence of pain that real effort shot again and again through my hand, up my arm, and into my spine . . . swallowing, sucking, gagging, trying to pull the ugly tasting serum inside, into my mouth and throat, and away from dripping downward into the camera where it would obscure the clarity of the image . . . preparing, testing, checking the approaching merger of the subject factors . . . tensing tighter and tighter the delicate pressure on the shutter release, trying to anticipate in time to defeat my reaction lag . . . and as the children stepped in space to complete my foreseen composition, I pressed the camera release to retain the image of that instant—to hold secure on film the vision of this minute fraction of time floating within eternity.

The photograph was submitted to *Life*, and according to Smith, it "was turned down by one of the *Life* editors on grounds that the kids were walking out of the picture and this made it lack those compelling qualities needed for a cover." But the print was published in the *U.S. Camera* annual for 1947, more proof—considering the lead time for the annual, which actually appeared late the previous year—that the photograph was made in 1946. Smith titled it, after a composition by the neo-Romantic English composer Frederick Delius, "The Walk to Paradise Garden." The photograph did not become famous until early 1955 when it was included in Edward Steichen's immense exhibition, *The Family of Man*, and repeated as virtually the grand theme on the back cover of Steichen's book by the same title. Smith's lurid account of this photograph was first printed (and later extended as quoted above) in a local newspaper, the *Croton-Harmon News*, on March 31, 1955. It was undoubtedly Smith's response, nine years after the experience, to the astonishing fame of this photograph.

"The Walk to Paradise Garden" is a fascinating example of how certain photographs, especially the popular ones, have a lifetime of their own: a rise, a climax of fame, and a decline. Of course the picture itself has not changed. History, and particularly the instability of taste, has changed it for us. The picture struck the public with the symbolic force of "Washington Crossing the Delaware"—and the General never stood up in a rowboat either. Smith received thousands of requests from everywhere in the world, asking for a print. A copy negative had to be made, since the original negative roll had been somehow lost. The Ford Motor Company used it in their national ad campaign and entitled it "Their Future Is At Our Fingertips"; but perhaps they were referring to power steering. Ford boasted that the photograph probably caused more comment than any other picture they ever ran. People saw it as symbolic of a better life for coming generations; as an opening in the darkness; the nostalgia of the future. A critic wrote that Smith "sees, dazzling but ever so distant, where only innocent children can safely go, an earthly paradise from which he is barred." The U.S. Information Service used it to illustrate their book *What Is Democracy?* In 1956, a couple in Pasadena, California, were certain the children were theirs, and the girl was their daughter, 18, who was dying of cancer. A French poet wrote verses inspired by the photograph. A municipal court judge in Dearborn, Illinois, wanted a copy to be carved on his wife's tombstone. A woman wrote she had seen the photograph in the book, *The Family of*

Man, and there was "something supernatural about it." She thought it was a portrait of her two children—born in 1960 and 1961! Smith replied very gently and generously to people's requests. He wrote one family: "When lithe young dreams are held honest against the years, when the hacking of disillusionment, and the flabbiness of frustration have failed to dent the honesty of the original dream—can the truth, as conceived in dream, be untrue." Today, some photographers, particularly the young, consider this photograph to be Smith's worst lapse in taste, but the general public still loves it.

One would be badly mistaken to discount Smith's words as inflamed rhetoric with little substance. In fact, behind his lofty speeches often were courageous acts, which he performed throughout his life. In the late forties, for example, he joined the National Film and Photo League (originally a part of the Workers International Relief) six months after it was listed by Truman's attorney general, Tom Clark, as subversive. The Photo League was an interesting and important group in the history of photography. It had been established in 1934 as an organization for left-wing filmmakers and photographers and had branches nationwide. This was a time when artists of all professions were profoundly angered by the miseries of the Depression. A leftward movement was inevitable everywhere in the world; it was in the air, the subject of every lovers' quarrel, every shouting discussion over lukewarm coffee and Horn and Hardart beans.

But the narrow fury of the earlier thirties had given way to a much broader and more popular view—the intellectual equivalent of the Popular Front in France. A similar change had taken place in the left everywhere in America. The New Deal itself encompassed people to the left of center, collectivists if not socialists or communists. And with the invasion of Russia, the war, too, had magically changed from the last armageddon of capitalism into a just crusade against Hitler. But with Nazism defeated, the uneasy alliance between Russia and the West fell apart, and each side began a cold war against the ideology of the other. In America, this virtuous idiocy turned cruel and even paranoid; lives and careers were smugly destroyed.

On December 4, 1947, the blow struck: the Photo League was declared "subversive"; it began to lose frightened members by the score. In June, 1948, and perhaps for that very reason, Smith

accepted the presidency of the League, and remained in office until the League's last publication, in the spring of 1950. It was an act of courage, certainly, and Smith himself could not resist the temptation to dramatize the consequences. In a letter to his mother, he summarized his dilemma, unusual in 1948, but sensationally common in the next five years:

A decision had to be made, on the one hand there was the safety (temporarily at least) of keeping my mouth shut, of bowing without a question, and of dropping my not very close relationship with a group of young people that I felt were working hard to advance their art and needed encouragement. I didn't agree with all of the artistic or political beliefs as held by the individuals in the organization, but then I don't always agree with you—the point was that they were sincerely searching and trying for improvement in their craft of photography.

Smith actually went to Washington to try to determine the specific allegations against the League. He cornered not Attorney General Tom Clark, but a female assistant, who said that the charges against the Photo League could not be disclosed, and that Smith would be making a "dreadful mistake" if he stayed with the League. "Let me repeat," Smith answered, "although I have little in common with most of these people, I now must remain with them."

Smith's stand did not affect his relations with *Life;* his quarrels with the magazine during this period were usually about something a little more basic: dollars. One conflict centered around the issue of compensation for Smith's war wounds. *Life* had covered its losses from death of, or injury to, its correspondents by a policy with Lloyds of London. In trying to get more money than *Life* was willing to give, Smith stressed that he was now famous and that if the magazine wanted his work, it would have to pay him a cash settlement for the pain and suffering of his wounds. On August 29, 1947, he got $25,000, a nice round sum at that time, which enabled him to keep both his house in Tuckahoe and his studio and darkroom in New York City.

The latter must have been a refuge as well as a convenience, because life at home had become noisy with growing children and with the increasingly bad relations between his mother and his wife. Carmen was by no means a weak person. She was tender and sweet, but she could be very tough, too. Nettie Smith, already

Smith's maternal slave, could no longer count on him for help in her struggle with Carmen. Nettie had a sharp old hometown tongue, accurate enough when she scolded Smith for spending money on records and books: "You can set a book on a plate, but you can't put gravy on it." Her feelings were deep, angry, and terribly hurt. She left, in a safe deposit box to be opened only at her death, an extraordinary account of the family's domestic life. It is also, naturally, a self-portrait so acute that only a great novelist could have invented it:

11½ months ago, I gave in to help Gene and Carmen buy a house by loaning them most of the down payment. Carmen being sure that "If I only had a house and yard I could easily take care of things and save a lot of money. By combining the 2 places it would save so much.". . .

From Gene: "I think there will be enough left from *Life*'s $500 per week to pay for it all." "I owe it to the kids to do this for them."

The fact that they are spending now from 200 to $1000.00 per month of my money instead of theirs seems to make no difference to Carmen tho it is bothering Gene very much. That they both got me into the mess under false promises of going to be careful and to save makes me feel that I am going to be welcome there just so long as I am busy doing things for them and so long as I have money and am useful, both as to finances and as to taking care of the children. . . .

I am going to put this in the safety deposit box. I want to see how much of this sort of thing I can take before I move out. I went in on

this deal because of Gene. . . . Today I only hope I outlive the bonds put in their name as beneficiary. I swear I will only leave them enough to buy a black band for Gene's arm so she can show off to the Lancasters and the Puglisis how much she (didn't) love mother. That is a laugh.

I almost decided to buy the place and let them just pay rent for it and then leave it to them. However I would just get insulted out of the place when that happened, so better read this over and over if I get soft hearted and start to think of doing it again. I feel I should try for both Gene and the children's sake to stand it, but really it is driving both Gene and I nuts, and her dissatisfaction—that I don't just go buy her everything she asks for when she asks for it, is making her nag us both and scream at everything and everybody until I can't hardly stand it. Am choked up inside all the time. I dislike living away from Gene but think that again that is what she wants but if I do she is going to pay and so are they all and plenty. And MAY GOD pay her back in the same coin. She has 3 to do it too. I certainly am paying heavily for the few hours I spend with Gene. My car, my things, my son and I must be accused of having my way. Dam anyway. If I had had my way I would never have been into the mess in the first place. Soft in the head and heart. Poor Gene I did spill over a little this morning on the way in and from what he said, "I hear both sides and know both sides but don't know the answer." He looks so bad and I should have kept it to myself but he blames me for saying anything at all so felt I had to say a little.

That is that.

10.

SMITH'S RESUMPTION of his relationship with *Life,* however uneasy, now led to one of the richest periods of his career. "Country Doctor," "Spanish Village," "Nurse Midwife," and the Schweitzer piece are not merely collections of single, powerful images, but groups of photographs that he meant to reinforce one another and grow out of one another so that however *Life* arranged them or Smith arranged them or the viewer arranged them, they remained organically connected like fruits on a tree.

Smith's first extended assignment for *Life* was to do a story on New Mexico in early 1948. It was to be part of a *Life* series on the (then) 48 states, and he was urged by *Life* to make it a vacation with Carmen, too.

The breadth of Smith's exploration produced many images: the dry brilliance of the countryside, horns and skulls, cowboys, artists, warped fences, clouds, dust, cemeteries, shadows and sun on the adobe. It was lovely, calm work, not monumental like Strand's churches and carved santos. They were not remarkable either in content or composition, and *Life* never printed the story.

This is not an endearing trait of contemporary culture: the censorship by omission of an artist's original labor. But *Life* was not an organ for producing images of truth and compassion; it was essentially middle-class entertainment. While it pretended to share some of Smith's values, it was also obedient and listened keenly to its audience. Smith broke this connection with his more powerful and sensational stories, but a large part of his output, whatever he claimed, was in the more acceptable form of portraits of celebrities or performers in the fashionable arts. It was commercial work, though of a high technical quality, and never flashy or phoney.

One thinks of Beaton with his cynical, razor-edged, chic and tricky portraits; of Steichen's cool romanticism; of Karsh's faces as if sprayed with preservative; of Avedon's corrosive images of the great and the celebrated; and Cartier-Bresson's cruel richness

of detail. In contrast, Smith's work is far more patient, admiring, and benevolent. He rarely made "Portraits" as such; they were generally part of a larger assignment. Yet they represent a large part of his work: Lena Horne, Grandma Moses, Truman grinning with triumph like a lottery winner, and—the most striking of this series—the quizzical, eccentrically American Charles Ives. A later group, made in 1950 and 1951, includes Wanda Landowska, Marion Anderson, Igor Stravinsky, Paul Robeson, Maurice Chevalier, and Frank Sinatra. Among them there is no magnificent or even startling image, but they are honest, lovely, respectful, and self-effacing. The same is true of a 1947 series on folk singers. Here there is a smiling mutual respect between Smith and the musicians. They are the people living next door, not the dry, sharp objective images of Walker Evans' Alabamans, or the tragic, impressionistic prints of Doris Ulmann's black back-country women. Smith was at home with his folk musicians, in that deeper sense of not being really at home anywhere or a genuine part of any society. Smith was always the friendly loner, and it gained him acceptance everywhere. A photograph is a cutting intrusion into one's life, but Smith, even with celebrities, would wait till the horrible bright eye of his camera became as familiar as a chair or a shoe. He would wait out the embarrassment, the anxiety, and get, finally, the simple portrait he wanted. Only much later, in the wild labyrinth of his mind in the sixties, did he make portraits that had more of himself, more darkness, and more intrinsic if morbid drama: like the great image of a young jazz pianist leaning into the blackness of a loft.

Smith's years from 1947 to 1954 were notable for his great, extended photographic documentaries. One of these is extremely well documented in a memoir by his assistant, Robert Harrah, who gave, with more detail than one can comfortably absorb, a marvelous picture of Smith during this period. Harrah first met Smith in the naval hospital in Guam in late May, 1945. A handsome, vigorous man, Harrah had been trained as a medical corpsman,

Igor Stravinsky, 1951. From the "Recording Artists" photo-essay.

with some instruction in photography. The wounded man from Wichita, Kansas, and the medic from Indianapolis, Indiana, quite naturally became friends. When Harrah, with the G.I. Bill to pay his schooling, decided to learn photography, Smith sent him a generous and charming letter of advice. It was a year after Smith's wound:

They are still trying to patch me together, having just completed an unsuccessful operation on my mouth. I still haven't much of a voice, and milk still comes easily out of my nose. My left hand is somewhat paralyzed but not impossible. I have managed to "gold-brick" for over a year now—it was a year last Wednesday (May 22).

The letter was dated May 26, 1946, and there was no mention here of the traumatic "The Walk to Paradise Garden"; perhaps it was taken shortly afterward.

In a letter two months later (still no mention of "Walk"), Smith recommended seeing other people's photographs, and wrote in capitals at that: "KICK YOUR OWN PICTURES APART—DO NOT LET ADMIRING FRIENDS TELL YOU THAT THEY ARE GOOD!! FOR THEY ARE NOT!! FOR THEY ARE NOT GOOD!! REMEMBER THAT YOUR PICTURES ARE NOT GOOD." And furthermore: "The sweat and tears, the personal danger, or personal interest, add nothing to a picture. There is only one thing that counts on that final little slip of paper—is the picture good?— did the photographer succeed to perfection in getting what he set out to get?"

Smith suggested that Harrah attend the New York School of Photography, but Harrah chose to study in Santa Barbara, California. In the late spring of 1947, he offered to send some samples of his work to Smith, who accepted, but said that he didn't expect that he would like them. "I hate 99% of all pictures and would indeed be surprised if you (or anyone else) were that brilliant a beginner. See—I'm a rat." He also explained his own situation at *Life*:

The fact that I am now completely a rebel even threatens my ability to make a living in photography, and I find it more difficult every day to . . . find editors willing to print my pictures—in fact, today, *Life* is just about the only publication in this country that will allow me to do photography at all in my way. They fight it very much.

However, he needed an assistant, and offered Bob Harrah a job at $30 a week if only "to drag me home from bars, protect me from pretty sluts, etc." Harrah accepted the job; meantime, Smith wrote him that he was going to the Royal Victoria Hospital, Neurological Department, in Montreal, and would be out by January 3, 1948. He wanted to see whether his migraines had worsened due to a bit of shrapnel still left in his skull.

In early January, 1948, Harrah arrived in New York, and went to Smith's house in Tuckahoe where he met "Gene's spirit-building mother" and his "lovely wife Carmen." Harrah described the walls of the living room and dining room as being so crowded with records that "the overflow was neatly stacked on the floor." He also saw Smith's 74th Street studio, which was a rear apartment on the ground floor, converted into a work room; it also had a kitchen outfitted as a darkroom. It was "furnished with klieg, flood and spotlights, heavy electric cords like spaghetti on the floor and cameraless tripods spread about before the paper backdrop." And there were more records and "leftover coffee was still on the stove; milk and half a pastrami sandwich were still in the refrigerator." Several days later, Nettie Smith appeared, lugging camera cases and electrical equipment; she was obviously part of Smith's professional life—not as a true partner, but as a veteran assistant who knew all about Smith's photographic habits; and she was also in firm charge of the money. Smith appeared a few days later:

Grinning, with a twinkle in his eyes, laden with two arms full of boxes, packages, and a camera dangling from the strap on his shoulder . . . I looked at his left hand, which was crippled and awkwardly holding two boxes of 250 sheets of 11x14 paper wedged against his hip.

But his left hand, Harrah noticed, had a good strong grip. A few days later, Smith introduced Harrah to Steichen, to the staff at *Life,* and to Lincoln Kirstein—with whom Harrah was to have some long and difficult discussions about the aesthetics of photojournalism.

Smith and Carmen departed for New Mexico without Harrah and returned a few weeks later. Smith then took some photographs in a ballet studio for *Life* and shot several others as filler for a story about Wall Street. The next day he and Harrah set out for Indiana, where Smith photographed a typical Midwest trial for robbery. Forty of these photographs would be published by *Life*

in May, 1948; some were actually Harrah's, though he received no credit. Smith thought all of them, including his own, were weak. After that, *Life* wired Smith to go to southern Indiana and photograph a goat whose distinction, for *Life,* was that it had given birth to four kids. "We corralled the goats in a small section of the farmyard and chased them for hours trying to get them all to pose in one spot." Having cracked this difficult problem, they drove back to New York City, and then up to Riverdale, at Lincoln Kirstein's suggestion, to do a picture story on the dead sculptor, Elie Nadelman, in whose house were hundreds of unsold pieces. The situation put Smith "almost in tears"—perhaps because Nadelman had been a suicide.

The miscellany of Smith's work at this time did not yet seem to annoy him. He and Harrah did a story on the new scholars at Cornell University; a photograph taken there by Harrah was accompanied by his observations of Smith:

At twenty nine, close trimmed hair that accentuated the receding hair line, trim moustache and wire frame glasses gave the appearance of a much older person. His left hand still deformed, with less than normal functionability, and a very loose watchband that didn't irritate. The buttoned sport shirt and tie with two breast pockets, one for cigarettes and holder, the other for the spiral-bound note pad and pencil that he was naked without—the hand-tooled sterling-buckled western-style suspenders held up his beltless tweed suit pants—this would be considered normal attire for Gene. His long-time favorite camera, Ikoflex twin lens reflex, had been emptied and reloaded from the day's shooting. The portable typewriter, records and record player were as much a part of his journalistic photography as his camera gear. The poured brandy held by stained fingernails from photographic chemicals was sometimes used instead of the ever-present Benzedrine inhaler to offset the many pains that seemed to be a never-ending plague.

There were also many discussions between them, man to man; in one such discussion, according to Harrah, Smith said, "I wanted to jump into the lake the other night! *Life* is destroying me. I don't know what to do with anything!" Melodramatically, he jumped up on the bed and recited, "Oh agony, oh agony! What will happen to my wife? What will happen to my child? Oh agony—quote the drunkard, never more." Then he said, in mockery, "Please go on."

Smith was jealous of the *Life* photographer Leonard McCombe: "He had more pages, twelve to my ten, and he had the cover in addition. Space counts more than numbers." On the other hand, in the summer of 1948, Smith was assigned to go to Colorado and do a story on a country doctor, a subject that was typical of *Life*'s program of middle Americana. Smith had already done two such stories five years earlier: "The Small Town Doctor at War," for *Parade* magazine, and "A Doctor For All Of Us," on a nurse's aide, for *Collier's.*

Smith and Harrah drove with their jeep all the way to Kremmling, Colorado. On the way (Harrah was driving), they overturned in a ditch. People stopped to ask if they needed help, but Smith turned them away with back-country wit. "Have an accident?" they asked. "No," he said, "we decided to save the tires, we're going to use the roof for a while." When they arrived at the town, up on a high plateau, Smith made arrangements to be with Dr. Ernest Ceriani day and night, whenever he was on call. According to Harrah, "Gene seemed to be a new person through all of this. . . . The music from the turntable almost ceased and the inhaler and brandy weren't used at all."

Smith thought that the best "picture sequences" were of an old man whose gangrenous leg had to be amputated, and of a small girl who had been kicked in the forehead by a horse; he noted that Dr. Ceriani "takes care of anyone who comes along. They

sure love him around here—he's a legend already." Smith had two psychological habits on such assignments, and both of them were very helpful to him. The first was to fit with gentle ease into people's lives, never demanding or obtrusive, certainly not right away, until they grew to like and trust him. The other habit was his curious but natural tendency to idolize his subject. Dr. Ceriani was not the first, of course; Smith had been dazzled by Msgr. Sheen, by the dancer Marissa, and there would be more illustrious idols in the future. Perhaps he identified himself with these heroes and heroines; they would, in any case, give him the inner energy to continue an arduous search for a depth of understanding that had been lacking in photojournalism up to that time.

"Country Doctor," the story about Dr. Ceriani, was at once brilliant and moving. The famous scenes included Dr. Ceriani, weary, having coffee and a cigarette in a hospital kitchen; and the patching of the head of a small girl who had just received a nasty gash. Smith was, according to a house publication at Time-Life:

. . . out fishing with the doctor the evening the town marshal raced a long freight train to the crossing to bring Ceriani back to treat the little girl . . . Gene wept throughout the subsequent operation and wondered if his own children were all right.

Maybe he was, again, shooting through tears, but the photographs he got are particularly strong and beautifully composed, especially one of a father and mother embracing as they watched the doctor at work on the child. Smith himself was "not unhappy with them." When he brought them in, the people at *Life*—who had repeatedly urged him not to spend so much time and money and to return immediately, and had gotten the proud reply that to do so "would jeopardize the story"—greeted his entrance with considerable anger. Smith, still in the doorway, took his bundle of prints and hurled them 20 feet into a wastebasket, and left without a word. He boasted, later, that his years of backyard basketball had come in handy. It was a retractable gesture, of course; the prints were rescued, and the story with 28 photographs was printed in *Life* on September 20, 1948.

Though he celebrated this publication with champagne, he wrote a long letter two weeks later to his immediate editor at *Life,* Wilson Hicks, reminding him that he had said, "Anything you need from *Life* shall be yours." Smith complained that:

There's been much behind-my-back criticism by many people of the fact that in the earlier days this assistant was my mother—with too much talk about that relationship. Regardless of many factors, good and bad, entering into this relationship, she happened to be an excellent photographer in her own right and a very tireless and extraordinarily good assistant.

My assistants are no longer free, due to the aging of my mother.

Four pages later, full of technical detail, he said that what he wanted was for *Life* to pay Harrah ten dollars a day, increase the limit of $100 for repair of equipment, and raise his own salary. It is not known whether Hicks acceded or not. However, Smith did several more assignments for *Life* that he must have considered less than important: a rehearsal story for a Broadway play, a Bowery celebrity, portraits of a clutch of generals in the Air Force. On the latter job, Harrah had noticed the segregation of the races in Washington; it shocked him, and according to Harrah's memoirs, Smith said:

It's rotten, like a lot of other things in this world. That shows what I should be doing with my camera! I'm wasting my talent on these everyday nonsense assignments—I should be doing essays that save

men from their misery. There's a lot of rot, corruption, prostitution, exploitation, and most of all bad journalism, controlled by money-mad magazine factories . . . I'm tormented with my ideals—I almost want to run free of so-called civilized shackles.

In 1949, he became deeply involved in a project for *Life* that would be called "Hard Times On Broadway." He identified bitterly with both the efforts of young people to break into the theater and their problems with the complex oligarchy of agents and producers; he said, "We can't just expose the system—we must beat it." He was particularly interested in one young and unknown actress, and, quite possibly, the friendship was reciprocated. He bought some of her wardrobe; and one of his photographs, the famous print of the mother and child from Saipan, was on her wall. He called her the day she was scheduled to read for a part, but she was literally sick every time she tried to get out of bed. Smith went to her place immediately with, according to Time-Life's inter-office circular:

. . . a thermometer and some pet remedies. At [her] apartment he administered the following medication: Pepto Bismol; Cremalin (an ulcer medicine); aspirin-codeine pills; phenobarbital. Several hours later [she] was on her feet, and they read the play together. On the way to the tryout the cab's motion made her sick again, but "Dr." Smith was ready—this time with a vial of double-strength ammonia. When they arrived, the young actress was pale but ready.

Some weeks later, Smith arranged for Harrah and his future wife, Julie, to meet him and Carmen in Philadelphia; they were to cover the tryout of a new play, *Death of a Salesman.* Harrah and Julie were having dinner in their room in the hotel when "Carmen came screaming and sobbing to our door, 'Bob, Bob, quick, Gene is going to kill himself!'" They were on the eighth floor of the hotel. At the end of the hall, Smith, drenched with sweat and wearing only his shorts, was trying to jack open a stuck window, so he could jump to the concrete court below. Harrah tried to calm him, but Smith seemed too enraged to hear. Harrah asked Julie to bring him a camera, so he could take Smith's picture as he leaped—"for posterity." Smith felt the sting of ridicule and sat back morosely on the floor. The crisis was over, and the next day Carmen said not to worry, she'd been through this scene before. Smith himself admitted, "I probably wouldn't have gone through with it that time—I don't know for sure."

The reason for Smith's pseudo-suicidal fury was that he found out that *Life* had used as the lead to his Broadway story a photograph from the Morris Agency; only four pictures of his young actress appeared, and not on the cover, as he had wanted. As it turned out, a longer essay on the young woman would be published by *Life* nine months later; but at the time, Smith said, "I was torn apart between desire and hate." In view of the authentic death by suicide in the play later that evening, this incident has a certain weird validity.

11.

"Crouched in horse dung on a street in Spain."

THERE WAS no way to end the contradiction between the commercial ideas of *Life* and the social and aesthetic views of Gene Smith. Each story was, in his own phrase, "a tightrope." For five more years, he suffered one angry compromise after another. In one letter to Joseph J. Thorndike Jr., the managing editor of *Life*, Smith wrote:

Photography, and to me this is photo-journalism, is a serious matter, and my integrity and sincerity might be called my religion. This is not a new attitude on my part, and most of the researchers and editors with whom I work, if not always in agreement with my attitude, at least are aware of it. In fact, I have had the word "idealistic" tossed sneeringly into my face on more than one occasion. When I give myself to a story I give myself to it completely—until publication do us part—and then frequently I grieve (and without exception for the failure that is Smith's), and never quite forget.

Thorndike thought perhaps that Smith should not be working for *Life* at all. Nevertheless, Thorndike answered cordially enough: "Your story on the country doctor has become a classic example of what we are trying to achieve."

Toward the end of 1949, Smith managed to do a couple of interesting stories: one was coverage, very like a newsreel, of Senator Robert Taft's campaign for reelection in Ohio. The amiable, old-fashioned Republican had a mixed constituency of farmers and mill workers. Smith found the candidate plainly boring; he was far more interested in the voters, and he made some skillful portraits and at least one marvelous industrial landscape of the sort that early 20th-century masters like Stieglitz and Coburn found murkily romantic. The other essay was, again, on a medical subject; Smith had kept up his contacts at Notre Dame, and he went there to do "Life without Germs," a piece on their germ-free lab. The portraits of the scientists in their sterile helmets are certainly better than competent, but the studies of the rabbits and monkeys,

imprisoned in their bolted steel chambers, have an eerie human appeal. One suspects that Smith identified with the victims.

Finally, in late 1949, he was dispatched to England and Wales to document another election. By this time, he had a new assistant, Ted Castle, a photographer whose studio was next door to Smith's on West 74th Street, and who had once assisted Smith in Philadelphia. In late December, they went to England and rented an apartment together. There Castle had a more intimate view of Smith's personality: "an impatient man—he never did nothing." Smith used his Benzedrine inhaler to pitch him up, and alcohol with music to pitch him down; he had a selection of records and a wind-up portable player and carried them everywhere. At about this time, he wrote to his wartime friend Valens:

I am in love with someone with whom I could talk of this story for many intense hours—yet would be so understanding of me that she would know my complete intentions if I were to no more than say—I am going to do a story of a town in Spain.

One is curious as to whether, in this letter, he was talking about his young actress—or someone else; for one need not be too wise about human behavior, and about Smith, to realize that for every love relationship that is known, there are likely to be several too transitory or too secretive to be noticed. It is certain, however, that when Smith was in England he had another affair, this time with an American woman working in London. How long this relationship lasted is not known. One cannot overlook the extraordinary glamour attached to any *Life* reporter; it was a world-famous magazine, with a circulation of many millions.

Although Smith's *Life* assignment was to cover the English elections from the point of view of the Labour party, he tried, characteristically for this time in his artistic and intellectual development, to go deeper and look at broad causes and effects, as well as the visual expression of these great connections. He

From "Life without Germs," 1949.

searched both for the logic of events, and their images, and blended the two together into one process. His camera became the probing extension of his restless, powerful mind. In his notes, he wrote:

I worked with a spread on Labour in mind, with certain photographs specifically in mind for the spread. These are: three miners—a strong symbol of men born into poverty or near poverty in this long depressed area of antiquated mines. They live a short childhood before entering the diggings to work. They constantly face death or disablement by accident, the accident rate being high. They face almost certain disablement from the occupational disease of pneumoconiosis. These hazards frequently mean a very early loss of earning power.

In Wales, he made a very beautiful series of photographs that documented the lyric smoke and the melancholy mists of the industrialized countryside, the charcoal faces of the Welsh miners, and their houses in sloping rows like the barracks of a prison camp. One is reminded of similar studies by Bill Brandt; there is something in this grimy corner of England that affects all emulsions in the same way. Alas, typical of *Life's* folksy triviality, this assignment also required Smith to find some trace of Harry Truman's ancestors from Wales; he located a headstone with the right name, but had to emphasize the letters with black watercolor.

In the meantime, Clement Attlee, the Labour Prime Minister whose post-war rule was now being seriously challenged, had become Smith's newest hero. The old pattern of secular worship was a comfortable way to work:

I watched this man of heart, this Prime Minister, and confidence of victory had its effect on him. Each mounting vote of majority seemed to sink him further into contemplation of the future. . . . It seemed now, as victory appeared more secure with each new count, that this hard road, these obligations were a cross of great weight for him to bear. His face took on the quality of a man almost spiritual, with the haunting burdens of millions upon his shoulders. It was a disturbed face, but disturbed in a way that moved me deeply in my compassion for him. My whole body trembled as I watched with my eyes, with my heart—this man and his load. I photographed, not with a camera, I forgot it was there, I photographed with my heart, and I was trying to capture his soul upon film.

The photograph of Attlee is a moving revelation of the Prime Minister's character, not in defeat, which was to come soon, but at

a moment when there appeared some slim chance of victory. Smith watched an old woman, a local supporter of "good old Clem," shouting up to the window where the election results were being appraised:

Some bystanders laughed, they were not of the poor. Some jibed at her. A photographer made fun of her, played at taking her picture, this frightened her, she ran to hide in the crowd. The photographer making cracks followed her. The emotions of the old woman tore at my heart, the photographer outraged it. Instinctively I moved toward him, felt the heavy end of my flashgun case and eyed his skull. The hotness boiled within me—I shouted to him, "Leave her alone you damn bastard!" He jerked up, looked at me strangely but said nothing.

Later, Smith and the people with him continued to listen by radio for election results. They ate dinner, and Smith drank four triple scotches in a row, went back to the office, and tried to write. It became clear, through the night, that the Labour Party no longer had a working majority. "We tore into a bottle of scotch," wrote Smith. "It made us wobble, but could not befog this out of our minds."

Smith had only accepted the Great Britain assignment so he could get to Europe and especially to Spain. Spain had always been on his conscience; he cherished a vain regret that he had not been able to cover the Spanish Civil War in 1936, although at the time he was barely 18. Smith was, of course, on the Loyalist side. Following the completion of his assignment in England, he wrote his mother:

Before I left I was first most violently busy and then to complete exhaustion, and in exhaustion and in fights with *Life* I was really shot and close to breakdown and suicide.

At the moment life is almost worth the living for I have an assignment to go into Spain and to try to show what living is like under the heel and the police of a dictator. It is an impossible story to do, but one that challenges me like no story has in a very long time. I must give it everything, and a little bit more. If you should write to me and there is a chance it might come to me in Spain, be slightly careful in what you say. I don't know whether I can get away with this story or not, or how watered down it will finally be—I shall try.

His reputation, and *Life's*, was already such that he and Ted Castle had no trouble getting a letter of introduction (May 2, 1950) from

Spain, 1951.

the Spanish Consulate in Paris. Certainly they were not aware of Smith's purpose: "My story is the struggle for food, with political overtones." Once in Spain, he connected this experience with an earlier moral choice—his decision to stand up under fire in Okinawa. To his mother, he wrote:

Five years ago today I was speaking from my camera soapbox when a heckling shell exploded into my body and temporarily muffled but did not silence me. This afternoon, at the anniversary minute of a quarter of four, I was crouched in horse dung on a street in Spain trying to translate my indictment of the Guardia Civil (and powers above) into photographic image.

Smith did not get to his Spanish village easily. He had done his usual research, and in Paris he had hired Nina Peinado, daughter of a painter, to serve as interpreter.

For a month, he and Nina and Ted Castle drove 10,000 kilometers through Spain, looking for a town that Smith could use. They were driving back to Madrid one afternoon when they saw a sign, turned off on impulse, went ten kilometers, and knew at once they had discovered what they needed: the ancient village of Deleitosa. The village had been founded earlier than the 12th century, the great period when learned Arabs ruled Spain. Smith's interpreter answered for him a typed series of Smithian questions; Smith was particularly interested in the local doctor, who had come to the village five years before, but was in despair about the conditions of health and sanitation. He fought, according to Smith's notes on the assignment, "a constant battle against superstition; forked sticks are frequently hung around necks as protection against the aches caused by the moon . . . Small biting animals such as fleas, bedbugs, etc. are no longer really felt by these people." They were also exceptionally poor. Maria Ruiz, age 33, was asked if she and her husband owned property; she said, "When I close my eyes, we own all that I can see." The people of the village were staunchly, and secretly, anti-Franco; their real opinions were expressed only after Smith and Castle had gotten the generous cooperation of a widow (she appears in several of Smith's images) whose husband had been killed on the Loyalist side; she personally went around and assured the villagers of Smith's good intentions, becoming the key person, indeed, in the success of his month in this village. Smith noted:

As the villagers began to know us and trust us they began to confide in us; later, among themselves, they began to worry that they should not have done this, for if we were indiscreet or were not friendly, they would suffer serious consequences.

Smith had already made a hundred or so exposures, before arriving in Deleitosa, in places as far apart as Merida, Guernica, Barcelona, and the neolithic site of Antequera. He was fascinated by a sign in Talavera: "Stalin Cultivates the Material Life and Franco the Spirit." The major part of his extraordinary essay—the natural marriage of his art, mature at 32, and his settled moral convictions—was done in this month in the village of Deleitosa. It cannot be said that he lived as they did; there was no place to stay in the village, so the crew came every morning and left every night.

The hotel we happen to be staying in unfortunately is one of those of sheer murder—also bedbugs, fleas, etc. We are now buying bottled water which frequently is as dirty as the other but we hope it hasn't come from a well that also acts as a cesspool. We purchased $40 or more of canned fruits etc. today, hoping this would hold us at least on an even keel for the two or three week duration in the village. Unfortunately from the fever and the cramps that have developed this evening I am afraid that for myself I am too late. I am at the critical time in this story and I intend to continue it without the luxury interruption of a bed for the sick. It is the hardest story that I have ever done, and to search for facts is very difficult, and to make fine creative and truly interpretive photographs is even more difficult—the impossible takes a little longer.

So Smith wrote his mother, who had sent him pro-Franco clippings from the Catholic press; it's a frank and patient letter. He described the difficulty that Protestants faced in Spain, but added:

I possibly am confused about many things, I am most certainly in a most horrible mental turmoil, about how to do my part for the good—I am not confused by any question of my stand (for myself) on religion. I still do not know whether I will survive my heartbreaking, illhealth efforts to follow through on what I believe is right.

And he felt "a deep, desperate depression" in trying to be fair and balanced, but his despair might have had a more profound and less religious cause:

I have a guilty conscience, but I also know that my nervous turmoil at present would do more harm than good. As for [the young actress], I am deeply in love . . . yet for right over emotions and need, I deliberately tried to smash that beyond all repair in December, ended up by almost smashing myself, deliberately engineered this European trip in trying to hold on and come back, and intend to stay until I have it under control and that I can do what I feel is right for four people against two.

He defended Carmen against the presumed opinion of his mother:

I have the greatest respect and admiration for the courage and fairness and sweetness that is Carmen. She is probably the least vicious and the fairest person I know . . . and the other would never have happened if I had had a home I could come to without being torn into bits. . . .

Such was the more personal background of his escape to Spain.

In Deleitosa, Smith's methods were rather more deliberate and careful than ever before. In making the beautiful street scene in which a woman carries baked bread with a great metal tray on her head, Smith asked her to walk her accustomed path over and over again in order to get just the precise light on the circular breads against the black and featureless form of her dress. The general shot of the village had to be carefully choreographed and took two hours to do. The photograph of a seven-year-old girl crowned for her communion is lovely not for herself alone, but for the naked child and the barefoot sister and the mother locking the house door, with its rusted iron bolts. The famous threadmaker, possibly the most beautiful image Smith ever made, exists in several versions, but in only one, as she turns her head to one side and moistens the thread from her spindle, do we feel the freezing tremor of a classic; what echoes in one's memory, perhaps, is a Renaissance drawing of one of the Fates spinning the flaxen thread of life on her fatal spindle. Antique Fate is naked, though, while this woman, with a face just as dark and strong, wears the black cloth of village women, a costume of perpetual mourning and subservience. Almost as well known as this image, and almost too theatrical, too perfect to be quite real, is Smith's photograph of the wake for a dead father. In Smith's words:

I was ill with stomach cramps in a field and a man who was a stranger to me came and offered a drink of wine which I did not wish, but which out of courtesy for his kindness, I accepted. And—strange coincidence—the next day the man again came to me and said, "Please, my father has just died. Because of the hot sun and the nature of his illness we must bury him quickly. Would you be so kind as to take me to the place where they fill out the papers?" I took him there and then returned with him to his home. I would not intrude and I remained outside seeing through the open doorway and I was terribly involved with the sad and compassionate beauty of the wake, and when I saw my friend come close to the doorway I stepped forward and said very quietly, "Please sir, I do not wish to dishonor your father by disturbing this moment, yet, would you allow me to come in quietly to photograph?" and he answered, "I would be honored." I entered, worked without sound, without words, touched nothing, no one, and then—although I did not wish to—after the three exposures, I left.

The dead man was Juan Carra Trujillo, aged 75, who had been paralyzed for 17 months. In the last month, he had fallen and broken his leg; he died 20 days later in the Caceres Hospital. Because he was known to be anti-Franco, there was a delay in getting permission to put him in the Catholic cemetery. This postponed the funeral service itself, even though, noted the interpreter: "The dead shall be buried after twenty-four hours, but people in general are afraid of staying with the body and always want to do it right away."

Even in this poor village, there were three classes of burial ceremony: one for 500 pesetas, which included a brand new robe for the priest; or 300 pesetas, with two religious chants, from 9 to 10 a.m.; or the cheapest class, 75 pesetas (it actually cost 80) for one chant, from 8 to 9 a.m. The family chose the last; and (since by ancient custom only men went to the interment at the graveyard) the male cousins would dig the grave for nothing.

In the front room of the house, before the priest arrived to sing outside at the door and entered to put holy oil on the corpse, the grandfather lay in his best dark suit. The body, because of the heat and the delay, already stank. The women, mourners by tradition—the youngest was his granddaughter—sat in the same and the adjoining room. Dark clothes soaked up what little light there was. As one can see from another, outside angle (which also yielded a very emotional photograph), there were, visible past the son in the doorway, some 12 or 15 women inside the house. But the final arrangement, by Smith's choice of angle, included only six. Smith asked them to sit there, closer to the body; the scene was lit by one flood in the same room and another from the next room; and in the final print Smith had to bleach in the eyes of one of the old women. The result has that velvety dark of Rembrandt's "Hundred Guilder Print": *Christ Erect and the Dead Lazarus About to Rise*—an etching with which Smith was long familiar. Here again was Smith's most powerful and natural composition: the interlocking triangles of space, the victim horizontal, the mourners vertical. He had used this probably unconscious principle at least once before—in the photograph of the baby rescued by two soldiers in Saipan—and would use it again in the last project of his life, in Japan.

The trio of rural police, the Guardia Civil, was photographed with venom. They had examined his document of permission and, smiling, told him he could photograph but could take no notes. Smith disregarded this narrow rule, but they watched him and queried the villagers to whom he talked. They asked, "Why are you taking pictures of the poor people?" In response, he asked them to pose for a photograph and had them turn and squint into the sun. "It makes you look handsome," he told them. Indeed, they do: handsome and brutal. One day, a plainclothes official came with the Guardia Civil and demanded to see Smith's papers. He went inside to get them. Smith wrote:

I walked past the man and back into my own room, I shut the door quietly in the face of the uniform that had followed me. Swearing at the possibilities of this being a disastrous break I moved quickly to grab the sack of film and thrust it into a slop bucket. Pulling my papers out of my pocket I casually sauntered out.

The main character had Nina's Spanish passport in one hand; kept drumming it against the other. His tone was rough as he questioned her and then both of us. He tried to trap, he tried to insult, he tried to threaten. He questioned where the films were, when they would be developed, who would develop them, who would see them, who would pass upon them. We parried, pacified, threw false scents, said the film was almost all in Madrid (which it was). He made many notes. Abruptly he turned and left, so did the uniformed men.

We stood staring at the emptiness. "Nina, dear child, may I make a slight suggestion—let us pass up our remaining, rather unimportant pictures, and get the the hell out of here while I still have the film."

Meanwhile, Ted Castle, who had been ill with tonsilitis, was lying feverish in a pension in Madrid. He had processed all the 35mm film there, developing in a container "two rolls back to back" and rinsing in a toilet bowl; the 120 size would be done in London. Smith woke him at 4 a.m.; they were headed for the border. There was unexposed film in open cans for the police to examine at the Spanish-French border; the good stuff was taped

to the underside of the car. There was no trouble though; they drove through without a real search. Smith reported to Nettie from London: "It's been since the 1st of May without a break of a day except for sickness . . . I am leaving tomorrow for a week in Germany." He was typically discouraged:

Spain's story quite mediocre, and you won't believe this but one of the main reasons was I was bending so far over backwards to be absolutely fair—so that when he howls, the truth does hurt him, he can howl without a chance of refuting me. . . .

Life will probably like the story and depending upon their policy of the moment the story is liable to end up as one long plea for a loan to Spain—that would be a bit of mockery that may bring my resignation. . . . The Smith family may be facing a nice long stretch of poverty—that is, if I have any guts to stay with "right," and my guts are not as strong as they once were. . . . The complete set of prints [are] being hailed as classic, great, unbelievably magnificent. But I know what the prints should have said to interpret what is Spain—I still chalk it as one of my worst failures.

He ended with the usual physical report: "Had three teeth explode the other morning just before I got on a plane—whammo, out they came, zoomo, off I went." Castle stayed in London and printed most of the chosen negatives, enlarging them to 11x14. Smith left England in September of 1950 and went to New York to write the text for the Spanish story.

Alone in his New York studio, Smith had some sort of mental breakdown; he was found wandering in Central Park and was arrested and sent to Bellevue Hospital. Castle, back in New York with the negatives, visited him there; Smith complained about the bars across the windows. Through the influence of Edward Thompson, then Smith's editor at Life, Smith was transferred to the excellent Payne-Whitney Clinic, presumably for addiction to amphetamines and alcohol. This is uncertain, however, because Smith's medical records, as of now, remain privileged. The effects of alcoholism are only too well known; but amphetamines also have long-term effects that include malnutrition, paranoid schizophrenia, hallucinations, and psychoses; judgment is impaired, the heart is overtaxed, and exhaustion results from the stimulant.

His letter from the clinic to his mother was addressed to a box number in Greensburg, Kansas. During Smith's absence in Europe, Carmen had a more or less amicable showdown with her mother-in-law, and Nettie Smith, who really had little choice, moved out of the Tuckahoe house and went back to her own mother's home. Smith wrote her there on October 12:

This coming Monday will mark my fifth week in a mental institution. I intend to resign from it within ten days, even though they want me to stay for many months. The bills of course are plunging me thousands of dollars into debt, and I will have to sell a great part of my equipment to keep going after my departure. However, I will retain the essential and basic necessities of equipment.

This is the most rest I have had for several years, and physically I feel fine. I am trying to educate myself into a new career, for I simply will not be able to stand Life much longer. It will probably be in the field of documentary films.

Please do not write any preaching letters, I want no advice from anyone—friends, doctors, mother, from no one. I shall do my own working out of this, if it is possible. My weight was down around thirty pounds, I have gained about ten of it back.

He wrote, too, that Life, which he considered pro-Catholic and pro-Franco, had not yet decided whether to use the Spanish story.

So he was depressed, "as usual," and scoffed at her advice not to worry about the bills:

How stupid do they think I can be to sit here giggling into my milk while bills pile up so high I will never get out from under them. However, if I do leave shortly I believe I will be able to handle it.

Smith did leave the clinic occasionally to get his cameras in order and work on layouts for the Spanish essay: "supposedly one of my finest stories." He had jaundice and dysentery, but expected to leave the hospital for good on December 13. He complained about the house his mother had helped him buy:

It is in bad shape, almost all of the wiring has gone to pot, and termites nearly ruined the whole structure in the playroom—that alone cost three hundred without restoring floors, walls or plaster—would have to be further repaired before selling. I dread the thought of bringing the kids back into New York.

As for the family, he reported:

Don't expect letters from Carmen, she has been so torn and upset she is practically incapable of writing; she almost hasn't been able to function with the kids and has been ill a lot of the time, including a bang on the head in a taxi that put her to bed with an icepack (for a hemorrhage at the other end) and has been leaving her with terrific headaches. I haven't seen her very much, and have seen the kids a lot less, so haven't had much chance to kiss the kids for myself, much less for anyone else. I think they are well, with the usual colds, and doing fairly well in school; Marissa is becoming quite beautiful and without the clumsiness that has long been hers.

Other things are over, I am both sorry and glad to say . . .

He was almost certainly talking about his affair with the young actress.

Life paid for his stay at the clinic—technically it was a loan against future salary—and on April 9, 1951, Life published the Spanish story at last, using 17 photographs, a moderate spread considering Smith's magnificent work. The story made him famous all over again; the letters to Life were ecstatic, even when critical about its views on Spain; his friend Lincoln Kirstein was especially moved. Ansel Adams wrote him a letter of praise, which he carried in his pocket for nearly three years, unable to write back and thank him. On the other hand, a Spanish weekly published a reply that was a masterpiece of bad rhetoric:

The mendacity of this North American magazine is further exaggerated by a puerile subtlety, of a poor talent, rancorous and damnable. Its photographs, while authentic, still contain false information and, instead of alleviating the deceit, only make it more evident with poisonous premeditation.

—Semana, Madrid, 7/24/51

The author pointed out that Spain had bread factories and textile factories and suggested that one could do a piece on the poor in the United States—which was true enough, if hardly to the point.

In retrospect, now that Franco is encased in his ghastly memorial, Smith's "Spanish Village" photo-essay seems not only apolitical, it no longer even looks like a judgment upon Spanish poverty and oppression. It now has, and perhaps always had, an air of archaic and severe elegance, like the Dorian mode in music: the circles of bread, the burdens carried on the heads of women, grain tossed in the wind to cleanse it, the solemn children, the spindle and the spinner, the ancient jugs of water, and the blindered horse in his circle, treading out the chaff, and the women, laboring as they had since the Christian conquest, in the false shadow of their black linen.

EARLY in 1951, after his discharge from the clinic, Smith got another studio at 126 West 104th Street. He photographed a number of musicians at their gigs, hoping someday to make a book of such portraits. He wrote his editor Edward Thompson, looking for a new story to do for *Life:*

. . . a project I can believe in, can give to—for if it were not to be of my mind and of my heart the mechanical camera in my hands would remain inarticulate, giving little better than sterile technical excellence. My health is in the best shape it has been in since the concussion of 1942—my health should not be a factor in the selection of a story, for it is no longer a problem. I am trying to say I wish to plunge deeply into stories that are of the very guts of our times.

In view of such times—Senator Joseph McCarthy was waving bits of paper at the TV cameras—Smith was cautious enough to write a postscript to his letter, in which he said he might be critical of the U.S. government; "however, there is no existing form ⌐ . . . I prefer," and he hoped for a world government:

Although I would not say I am a follower of Ghandi or Schweitzer, I have enormous respect for both of them and find much of good example in both of them—also in the ten commandments, and much in the basic teachings of Jesus Christ—whether he was God, or whether there is a God. I remember about four years ago when some young person asked me if I were a communist—or rather he said, "you are a communist aren't you?" I replied, "I am not a communist as it is practiced and distorted today—if I believe in communism, it would be the communism as taught by Jesus Christ." This in no way alters my feelings toward churches and religions as practiced and perverted by men today.

He was amazingly frank with his mother's persistent obsessions, way off there in Kansas, separated from him:

I don't see why you continue to worry about Franco and his ruthless group, and as for the church, it should clean its nose, instead of trying to bluff and lie about its doings in Spain.

He was obviously a long way from his college crush on Msgr. Sheen. And, dealing with Nettie's other mania, he wrote:

And as for persecution, I wish you would please get that complex out of your mind—flatly, bluntly you are absolutely wrong when you say that we are trying to get the children to forget you . . . anything that is said between us seems to be misunderstood or greatly exaggerated.

An undated maternal reply from that period:

Anyway I was glad to hear from you even though the answer to the first letter you sent is still lying here with a question as to whether I try to give you the shock treatment, which you seem to need to bring you to your better thinking self.

Considering Smith's recent stay at the clinic, this was a cruel sentence; but consciously all she meant was that the Catholic God would bring him to his knees with some tragic event, a prospect which, though he did not believe in it, genuinely frightened him. Smith wrote her again after the publication of his "Spanish Village":

[That] which has been ruled unfair by one group has, on the artistic level, received a reception so overwhelming that I am completely staggered . . . the criticism and the praise have been quite overwhelming . . . I would even say that it was worth three months in the hospital . . . The conservative suffers from constipation, the radical from diarrhoea—me, I just like a good movement. (Serious joke.)

And a month later:

I am working rather well, and fighting rather well, and since I am at least temporarily away from the dangerous depression, it has been a rather interesting life these last few months . . . I believe as I believe, I work for my beliefs and I would quite willingly die for those beliefs. So, why did you spawn Smith, W. Eugene, that is, a mortal human with all human weaknesses, yet a legend, a myth to the good—the man who knows no fear, yet knows all fears . . . Frankly, I feel there is no such thing as the absolutely right, so I am an island unto myself and I shall work for what I believe is right—so, condone or condemn, I am your son . . . deny me or accept me.

At about this time, Smith began another emotional commitment that was to endure, with some lapses, for the remainder of his life. Margery Lewis (who later legally took the surname Smith) was a young woman just beginning what came to be a distinguished career in photojournalism. She had heard that Smith was looking for an assistant; she phoned him and he asked her to dinner. By her own account:

We went to a Spanish restaurant where he proudly showed off his knowledge of Spanish food and wines, and described his experiences in Spain. He also told me that he was separated from his wife and had moved into his own lodgings on West 104th Street. After dinner, he showed me the studio, told me the stories of all his photographs, and we began a relationship notable because it combined a love for photographic reportage with a love for each other. Gene and Robert Frank and a couple of other people were about to have a photographic exhibit and we plunged into the work of whitewashing the walls of the gallery, hanging the pictures and working together to make the show a success.

We were standing on the edge of new visual territory, and every day was full of excitement and expectation. This was particularly so, because Smith repeatedly told me that he was planning to get a divorce from his wife, and I believed him.

In fact, Smith did not get a divorce until 1968.

Margery described her first impression of Smith:

He was wearing a Spanish beret and his usual black shirt with a "bolo" [a Western string tie with an ornament]. He was reticent, soft-spoken, and his wistful half-smile and violet eyes of a trusting child were fetching. He was graceful in movement and even through his clothing you could see that he had the form of a Greek athlete. We discovered that we both loved music, literature, theater, photography, and journalism, and thought the same things were funny. It was much later that I became aware of Smith's self-destructive pattern of behavior.

About mid-April, 1951, he left for the South to find a subject for the story on the nurse midwife. Margery Smith accompanied him on the way down and visited him several times during the course of his work:

I was astonished at the number of hours he spent testing and re-testing his cameras, lenses, and film in various motel rooms, and I thought it extraordinarily obsessive, and just one more form of self-torture.

But his obsession was a cover for his deeper anxiety, because the subject was one he had chosen himself. In Smith's account:

As near as I can remember—the first idea came in Wales. I wanted to do a midwife essay there. Went to Spain, however, and tried to incorporate midwife as an element there. This ended when we fled the country. I left more hurriedly than I intended.

One night I wakened to the fact—what better country than the U.S.?—idea of the common midwife.

I approached the magazine and got an agreeable answer. Kenneth MacLeish of Science Dept.—I have done several stories with him and it's been most rewarding. We tried to find out about midwife programs and found the best one in S. Carolina. . . .

I traveled around S. Carolina about 750 miles just talking to people. I could not find any conflict. I finally went to midwife inst. for 2 weeks. This is where I legally qualified. I established a link between myself and people (fact of having delivered a baby in the Philippines). I went to see Maude Callen. I had blinders on. I was disturbed, it was not right. I had not found the right person. But I turned back and asked if she minded my haunting her for 6 weeks. She truly did mind. There was no false modesty. But I told her of my own dreams and finally she consented. . . .

She began to trust me and merely introduced me. This is Mr. Smith and he is working with me. That's all there was to it. I went everywhere with her and at night I made layouts. It's like a play. The ingredients, cast. So that it had meaning beyond the people involved. To do something with sincerity that would take away the guns of the bigoted.

As it built I continued with layouts, theme. No one thing can be resolved in one session. You can't learn from one evening and state it with clear conscience. I talked to people and talked to doctors. I could think of only one person I could compare her to, Albert Schweitzer. And when I saw Schweitzer, I realized she was incomparable. She is the greatest person I have ever known. She left an indelible imprint on me.

He knew, of course, that his subject was black and therefore, at this time, a rare choice for a hero; whether it was his choice or *Life*'s is unclear. It was a logical choice because there was, and had been for generations, a whole network of black midwives in the South. There was already a fine documentary on the subject, "All My Babies," by George Stoney.

In May, he was in Columbia, South Carolina, and went—it must have been open knowledge in such a community—to a Saturday night open-air Klan meeting "and photographed by the light of the flaming cross." While his assistant Bernie Schoenfeld developed the negatives, he played a Bartok concerto in the hotel, "shaking the walls." These photographs of the KKK eventually became famous; particularly the anxious, sweating Kleagle in his satin robe, cursing Catholics, Jews, niggers, and foreigners, and calling "upon God as a pure-blooded Christian gentleman." It was, he noted, a strong dose of poison to get at the beginning of the "Nurse Midwife" project.

The midwife, Maude Callen, was orphaned at seven and raised by an uncle in Tallahassee, Florida, who was a doctor. She married and went to South Carolina where, at the request of the Episcopalian Church, she became a missionary nurse—converting the country people of rural Berkeley County into what the missionaries themselves called "iodine Christians." Mrs. Callen moved into that neglected area and set up a clinic in her own house. There were already midwives delivering babies, but they were incompetent and superstitious. The image most people had when they saw the full story in *Life* was that Maude Callen was a heroine sprung up like Joan of Arc, from deep among her oppressed people; but she was a middle-class black girl, raised by an uncle of professional standing, who was shocked to find such ignorance and such needless suffering. Later, she was trained in obstetrics at Tuskegee; but in the desperate need in the countryside, and with "a quiet, passive aggressiveness," she actually practiced medicine and established the first V.D. clinic and the first pre-natal clinic in the county. But her money was scant, her equipment meager, the pressures of work immense. Yet she would find time to intercede for her patients with the County Relief, and even with the Sheriff himself.

She exhausted Smith with her long schedules, up before dawn and working into the evening darkness. Smith went everywhere with her, as he had done with the country doctor. One of the curiosities of Smith's expedition into the South was that he was accused of changing his name, that he was really a Jew; Smith took pride in not denying it.

He said: "This is the toughest story I have ever tried, and I think it might end in complete failure." This disclaimer, repeated on every assignment, was meant, one supposes, to excuse himself in advance, for at the same time he boasted: "Bourke-White wrote her husband [Erskine Caldwell] after one of my recent stories that she felt she should throw all her knowledge and technique away and begin again after seeing the sensitivity and beauty of my work."

Smith was actually feeling a lot better; he was putting on weight, and Carmen joined him in South Carolina while the children were away at camp; so obviously they must have had a fair amount of money; and "I feel it is a good story, one that I will not be ashamed of." The photographs—there are hundreds of them—are a rich experience for the viewer. Though his strobes and cameras gave him incessant trouble, the technical quality, the complexity of detail, both interior and exterior, is very fine. It's difficult, and pointless, to judge these prints one by one; compositionally, they are never merely formal; they flow from one to another by an inner connection. And the drama of dark and moody areas is forgotten in Smith's effort to understand the persons and the place; one feels as if Smith had become extremely sane; there is no morbidity even in the birth and the cutting of the cord. The three children looking in at the window at their newborn sister, tiny in her farm box crib by the two-lid iron stove, is simply very lovely.

One incident is particularly revealing of Smith's character. A mother had brought a seven-month-old child just before supper to Maude Callen's house; the baby had a fever of 104°, and Smith went with Mrs. Callen as she drove the 27 miles to the nearest hospital—which was white. The baby, whose temperature was now 105°, needed an immediate transfusion. The two blacks who were present, Mrs. Callen and the baby's mother, were the wrong blood type; the right type was available, but it was forbidden to use white blood for a black child; a "visitor from the North" (he didn't say so in his own account of the incident, but from later evidence one knows it was Smith himself) knew his own blood type, which was identical with the child's. The white nurses audibly disapproved. In any case, the child died. Both Mrs. Callen and Smith were "damnably angry." It's interesting that it was not merely the apprehension of Smith's genius; it was his quality of moral rage that made people love him.

On December 3, 1951, *Life* printed 30 of his series on Mrs. Callen. The public response was extraordinary. Lincoln Kirstein wrote him in admiration; many thousands of dollars came in to found a Maude Callen Clinic; and by May of 1953, at a modest cost of $25,000, the clinic was opened at Pineville, South Carolina, with Smith present at the ceremony. At last, instead of the vague moral effects he had sometimes claimed, his photographs had now made a direct improvement in people's lives. On the basis of two successive triumphs this year, Smith began to renegotiate a contract with *Life*; he felt he was a poor bargainer, and could have won ownership of his negatives as well as more money. He compared himself to Beethoven and Michael Angelo [sic]; such arguments must have irritated the people at *Life*. The final contract provided that his pay would be $2,000 less a year, and he would lose various fringe benefits too; but he was no longer on staff and on call, and so he could legitimately refuse the assignments he didn't like. But the real problem could never be resolved. Henry Luce's children, *Life* and *Time,* were born with a tough and in-

Last visit with Maude, c. 1962. Smith photographed the clinic built with donations inspired by his original "Nurse Midwife" photo-essay.

telligent attitude toward reality; their prose was smart and aggressive; and their purpose was to delight their vast middle-class audience with articles just slightly above their knowledge and their feelings. In *Life,* photographs were only deceptively primary; the real criterion was always the idea: what does this layout say? Their editors, far less Henry Luce himself, could never give up their ownership of the main idea, of the editorial thrust, the vector of public interest, the weekly choice of what to publish and what to forget. The impossibility that Smith was demanding, and he said as much several times, was the authority of the author, the creator, and *Life* would be obliged to accept it wholly, or reject it.

It was a fight that could only be won if the stakes were small enough. One could write for the *Atlantic Monthly* and be printed without serious change—or rejected. At ten cents a word, or less, the loss or gain didn't really matter. In the mass media, though, the serious world where millions of dollars were gambled on the wheel of public choice, the creator is just one step in a collective process; lucky, like in movies or TV, to get his or her name legibly on the credits; what is left is responsibility without power. And this was what Smith resented to the very center of his soul.

Smith was certainly one of the stars of that decade of photojournalism; he worked hard, but slowly, on large, often self-enlarged projects. *Time* and *Life* were not only a rapid money machine, but had become a cultural giant. And the tautology of money and power created a euphoric atmosphere in the staff. Success had a measure: whether or not your work was published; but it was the public impact of Smith's work that made him a celebrity.

He was shrewd, too; he covered himself with several approaches to a story, active as well as posed, and framing that was tall as well as wide, to fit any possible format. Smith knew that layout was critical, not merely in order to tell the truth, but to insure its impact upon the public; and therefore he fought, no matter how sincere his denial, to increase his allotment of space. When Smith submitted his prints to *Life,* he would take care to put his best half dozen on top—and often the editor would need to go no farther.

"Dear Gene," wrote Edward Thompson, a large, calm, decisive man, born in North Dakota, who was Smith's extraordinarily tal-

ented editor during the prolific and troubled paradise of Smith's post-war years with *Life*:

I'm glad you liked the layout. The pictures were wonderful so not too much credit attaches to the guys who made the arrangement.

I might as well warn you though that I am not so happy about the experiment of letting you do your own research. I don't think the writing came up to the pictures and one reason was inadequate or over-emotional research. I think that next time we will have to work out some compromise whereby you direct the development of the story, which of course suggests the research, but have an experienced reporter either go along or follow you.

Under all this sincere tact, there was the reality of power. This letter, like many others, was embellished by Smith with handwritten arguments in the margins. They were words, so to speak, shouted in an empty room, for rarely were such marginal comments ever typed and mailed.

Thompson not only had to guide and mollify Smith—"Every managing editor tried to rehabilitate him"—but restrain him as well. Smith wanted desperately to go to the fierce encounters of the Korean War; Thompson refused: "I won't have you commit suicide on a *Life* expense account." Thompson also had to deal with Smith's mother, who, before she was banished to Kansas, would call *Life* to complain: "What are you doing to my son?"

Still, in spite of his pride and resentment, Smith did five large projects for *Life* in the next two years, 1952 and 1953. The first sounded ideal. Smith, with his love for the drama, was to photograph Charles Chaplin at work on his new film, *Limelight.* Smith began his assignment in the last few weeks of 1951. He wrote his mother from Hollywood:

This story not going well, having to be on the edge of things, unable to take over to set things photographically right; due to having always to give way to their problems of making the picture around a $15,000 daily expense doesn't give me enough chance to function. Have gotten on well with Chaplin, he has a great respect for my work—he doesn't care at all about publicity—but he is an emotional man completely given to his work, while working, and I have too much respect for the image of myself at work (knowing how I hate to be interfered with) to really intrude.

He felt he had to defend Chaplin against his mother's accusation that he was a "Red" lecher:

He is no saint to march along with Schweitzer, but he is no devil, communist, cheat, woman destroyer—or is it that designing women have devilfied him? . . . Man of that fame cannot be completely normal.

On Saturday, December 29: "I decided the whole story was off," because there was no time for him on their crowded shooting schedule; but it turned out there was an extension of ten days.

An artist intruding by work into the creative life of another artist is with perplexing choice. To intrude enough to properly interpret, to translate, necessitates (at least when time is limited) a forcing of the situation in a way that may be damaging to the thin, intangible creative thread of the other artist. Yet to not do this is certainly frustrating and damaging to the depth and success of the interpretation by the intruding artist. Especially if the two artists are of the involvement, emotional, mental makeup of Charlie Chaplin and W. Eugene.

In short, Chaplin would not allow him to restage events in the way he was used to doing, when he photographed theater. Smith's relative failure upset him; but his mother's stinging and sorrowful complaints depressed him more. He wrote her:

You try to go through the wars, the desperate struggles for beliefs, the deep exhaustive pouring out of work—from guts and soul—trying to stave off destruction in the world, trying in a way to help with understanding—always horrified at the rottenness of the world I am trying to help heal—while all the time I do not know how to even begin this, am no model of the good I believe in—forever to be sick in body and mind.

Was he really as ill as he said? It's improbable. During the five-week period of the Chaplin assignment, he was accompanied, once more, as he was on some of the "Nurse Midwife" project, by Margery Smith, and her account does not square with any imminent disaster to "body and mind." "He was in great spirits the whole time," she said. On the last day of filming on *Limelight*, according to Margery:

Chaplin walked over to us and quietly invited us to "a little shindig at our house tonight." The house was more like a palace, and the dinner

was a black-tie formal celebration. I was entranced by Chaplin's enormous library of books and spent most of the evening talking to James Agee . . . who had worked for Luce for many years . . . Gene was furious because at the party he had missed out on a chance to meet Agee and exchange Time-Life gossip.

Those five weeks on the Chaplin set, sticking like a burr to Chaplin and working with Gene on the story were a turning point in my life and my photography.

Certainly it deepened their relationship, which in turn must have put a strain on Smith's conscience; though one must admit that men find it easier than women to compartmentalize their experience and alternate between one love and another. Later that year, on December 25, 1952, he sent Margery a two-page telegram that spoke of a deep sorrow over his inability to give to those he loved "a greater measure of tangible fulfillment."

His opinion of the Chaplin assignment, incidentally, was that it was one of his poorest stories, but he said that *Life* was happy with it nevertheless. But in Margery Smith's opinion:

The real problem with the Chaplin story was that Gene never had a conversation with Chaplin. There was no relationship. Gene was making pictures and I personally believe they are among his best. On the personal level, there was a blank. The two personalities could not understand each other. They barely spoke!

It's evident that Smith was, in Chaplin's view, simply one more still photographer on the set. He wanted Chaplin to see his photographs, but did not approach him directly; instead, he asked Chaplin's cameraman to show the photographs to Chaplin, who went through them rather quickly, handed them back and said, "Very nice."

The Chaplin story was printed on March 17, with 31 Smith photographs. Smith wrote to Chaplin: "The story by my definition was a failure; my tribute—a drooping rose; my attempt to unmuddle some of the misconceptions with a sensitive penetrating story had the persuasive power of cottonball artillery." Smith was right; except for the well-known studies of Chaplin at his makeup mirror—the clown gloomily examining himself—the essay is a technically competent record of a film in production. It happens that a movie studio is a particularly baffling place for still photographers: its space is mostly occupied by machinery, and only a tiny portion of the vast, hollow movie stage is that vital bit where

the actors work. This crooked balance takes years to understand, and other photographers have taken refuge in the grotesque or in the surrealism of the banal. Smith used his disappointment to make a remarkably clear statement of his method:

When I am charged with doing a story, I must produce; certain situations I know are necessary for the story. In the beginning I may photograph these even though I am not happy (even before taking) with the situation as it may stand, but I do this to get them under my belt; then I keep on searching for a better way to make the same point. Perhaps I will make another variation, will keep on searching, photographing the same point many times, discarding the thought of having to use the poorer interpretation each time I am able to lock up a better version . . . I even chart the day's shooting, marking after each subject, impossible, poor, fair, or passable—no higher marking than passable. I will then work to eliminate those with a rating lower than passable, and if possible work to improve even the passable.

At the same time, Smith would write an outline of the story as it developed:

. . . stalling as long as is possible in the making of my first photographs, or at least making the least important ones first, hoping that I gain a greater and greater understanding before the key interpretational pictures are made. In fact I sometimes say my photographs are made in the month or two months of non-camera work, with the final improvements only when I finally am working with camera. Then I search for the situations within the actuality to make what I feel to be the honest point.

It is necessary to constantly think in terms of layout, and this may mean variations of the same point in way of vertical or horizontal, and that pictures that may counterpoint each other or be played off against each other will have richness of variety gained in many ways. I work entirely different than in my pre-war days, and I hope in describing my approach and way of work you are aware of this. I intrude as little as possible, re-arrange as little as possible, seldom use flashes, trying to do it all as much as possible without physical or mechanical distraction. Thus the small cameras, fast film and lenses, and the light already available—or by merely lifting the light level of the rooms by floods or so. I, of course, also make my own prints to be sure my intention is carried out as far as is controllable.

If it said nothing else, this description, so conscious, so exact, so practical, and so ambitious, showed that Smith, in 1952, had every intention of working with Thompson at *Life*—and indefinitely. But he kept searching for something better to photograph:

I'm tired, disgusted, practically panic stricken at these days of sterility of no new ideas, no new stimulation, no theme for my next story. But I need a rest, which I cannot even consider . . . One good idea of real depth and value, the quick full challenge of a new story of real content would probably lift me, free me from this and sing the zing of the thrill of creative, positive direction.

From his studio at 126 West 104th Street Smith wrote to Richard Simon of Simon & Schuster, proposing a book; there had been books by a number of photographers whom he respected, including "Abbott, if not Costello." In his proposal, Smith wrote:

Smith's stories have not been of phony love; of good, easy Frenchman laugh; of shock appeal; or of presentation of tourist city; not even of the high individual beauty of someone like Weston. Smith's stories have been serious, thoughtful, not a nude among them; none of the usual ingredients of fair commercial success—some of Smith's pictures have even been accepted as art, accepted by the narrow-minded highbrow.

The proposal is self-conscious and occasionally pompous; he suggested that his book contain:

. . . my Spanish Village; my Nurse Midwife, the Chaplin story; and one other, the naming and discussion of which I prefer to leave until later, should this project ever reach the discussion stage. I think the above to be the richest in content balance: the Spanish Village for its artistic and emotional acceptance; the Midwife for its presentation of humane nobility and warmth; Chaplin (although I consider this story of lesser stature than the others) for the cult Chaplinistic; and the fourth as a powerful catalyst to the others.

Though Simon met with Smith, the book was never done.

Smith did two more assignments for *Life* that year and next: one on the Metropolitan Opera, backstage; and one on a family of white migrant workers who picked seasonal crops in Michigan. He wrote his mother in Kansas:

[I] have been attempting a dawn to dusk story, and sometimes starting at 3 a.m. and sometimes continuing until 5:30 the following a.m., the tail end of it usually being when I have been developing film two rolls at a time in the shower stall of a motel.

It is a story on Migrant Workers, or probably on their children, it will be a second-rate story, for I am too tired, too depressed, too dazed in mind to think it through. All of the jerking little threads of demands have torn away the worn-out coverings of my nerve ends and they are frayed to the breaking point. I'm burnt out, worn out, and possibly on the way out, at least it will be a sellout of my talent and my integrity—both by my doing a shoddy job on the work I believe in, and by the necessity of taking "legitimate" but dishonest work to gain additional money. If I am not too tired even to do that.

The Millers, in spite of their poverty and their dislocation, had strong family bonds; and Smith's portraits, particularly the double ones, are very beautiful and very personal; Smith was always very much at home in the culture of the poor. The Metropolitan Opera story, though, is curiously unfocused, and Smith's monograph of 1969 shows only one picture from this group. Neither essay was published by *Life*, but overproduction was part of their system; various departments, Science, Art, etc., would compete with one another for space in the magazine. In Maitland Edey's words: "Luce hired men of talent and let them fight it out." This method was especially cruel to artists like Smith, who so strongly identified himself with his work that it tore at his guts to have it forgotten.

One surprising essay of Smith's did appear in *Life*, in the issue of January 5, 1953. "The Reign of Chemistry" was a grandiose title for what was really a bloated puff for the Monsanto Chemical Co. Again, the prints are technically superb and conventionally empty, like good illustrations for the annual stockholders' report—a specialized form that finances a good many superb photographers today. The assignment was distinguished more for its logistics than for its art. Smith and his assistant, Bernie Schoenfeld, took along nearly half a ton of equipment and supplies, including 13 cameras, and they worked, Smith boasted, "933 hours out of 1128 in six weeks, leaving us an average of about four hours sleep a night." Heat in the phosphorous plant ran up to 600°; Smith and Schoenfeld wore asbestos coats and gloves, the latter with the tips cut off so they could operate the cameras. Both of them got blisters on their fingers, and Smith fell into a drain hole and got badly bruised. They had, at the end of the job, 5,000 negatives, out of which they selected 100 prints; 18 were printed in *Life*. And all this fuss about nothing had a foreseeable consequence: an exchange of nasty correspondence between Smith and *Life* about his profligate expense account.

Smith proposed that his next project might be "a great city at night, Rome." Instead, he was sent to Chicago to photograph the Brodie twins, born joined at the heads, one of which was already dead. *Life* printed the story, June 15, 1953, with 11 photographs.

ONE NOTICES that the obverse of Smith's canonization of his heroes was his lifelong hatred of authority; which, since it acts in its own interest, seems arbitrary and stupid—though it may be perfectly sensible in another system of values. It is curious that although Smith said he no longer believed in God, he kept his belief in a devil, who was generally housed in the Time-Life building. Smith could never accept indifference; he saw himself in the world as the hero-martyr—Parsifal in search of the Grail, the Prometheus of photojournalism—bound, of course, and tortured for his integrity.

A man's vision of himself at work, however distorted, is still partly true. What is more obscure was his inner profile during these fascinating years that began in 1947: his relationship to his wife, Carmen; to his complex and recalcitrant children; to his mother, now reduced from tyrant to slave and finally to exile; and to his more obscure and guiltier loves. Smith, one knows, began to spend less and less time at home, and more and more in his work-apartment in New York City. Maitland Edey, a friend though not a close and intimate one, went to visit him in this decade, often with Connie D'Amato of the news bureau at *Life*; they would simply drop by, not necessarily invited. Smith would have turned on the New York "classical" station, WQXR, while he was working in the darkroom; he would emerge at intervals between prints; they talked about women, sports, and jazz. They would stay until 2 or 3 a.m.; Smith moved slowly, "floating," as if slowed down by fatigue. But what was his inner vision at this time? One may discern its outline by quoting from a draft of one of his replies to *Life* regarding his expense account:

I regret the fact I cannot slip quietly through life without friction, and that somehow there must always be a storm cloud spewing at least thunder, for I am shy and quiet, regretful of any frictional complications, yet I am impractical with the showman's surety of values and with the way to reach men's hearts. And I am interested in shaking man's heart just a little, for he loves it.

For all his humility, he had begun to think of himself as a great and important photographer, whose work, known and unknown, would one day be famous. For example, he had a friend in a lab at *Life* go through their files and give him contact prints of 127 rolls never printed before—mostly from his trip to Europe in 1950.

In early 1952, there were inquiries from four countries for his prints for various exhibits, and he was interviewed on an American radio program, "in my masterful, nasal, saliva-drowned voice," complicated by a loose plate in the roof of his mouth; and somebody wanted to do a TV series on his life. With all this, he was trying to schedule one day to spend with his three children. He was frank about them to his mother:

Marissa is getting ready to pass her girl scout merit badge in photography. An amazing child in some ways, although both she and Pat are extreme misfits in school, but what can I say as disciplining father, for I certainly was the same way. Only Juanita, for the most part, seems to be capable of a fairly easy adjustment to almost any situation. Pat is a sensitive and worry bringing problem, wonderfully intelligent but just out of place. I wish he could have special teaching, for his can be the most wonderful or the most tragic life.

He was, by April, 1952, planning to move from Tuckahoe; Carmen thought it was because he disliked the neighbors; but he said he wanted a larger house, that would be part home and part work place, and further from New York. He wanted an isolated place where he could work peaceably, because "this phone rings 20 or 30 times a day," and where he could experiment with TV, but:

. . . mainly because the whole situation has become more and more impossible for me to work efficiently in. Mainly, because I wish to have a closer influence with the kids, good or bad to inestimable degree, because I am depressed and lonely, and so are they, and for many reasons, and many shades of reasoning, facts and perhaps fancies all considered, I am trying to find a place suitable for work quarters and home, and room to experiment with television movies. Maybe I'll even be able to stop eating so much chili. Maybe it will accomplish nothing—my crystal ball seems to have burned out a tube, and who knows the future anyway. I have to try it anyway, this search for a little peace, this hope to soften the tension of my nerves, to help me work more efficiently, to search new paths of communication, to perhaps be some semblance of a father.

Carmen and he found a house in Croton, New York, about 30 miles north of New York City; he wrote his mother for $6,000, and urged her to send the check right now, before the mortgage paper work was quite done; she did, of course. Though he complained, as ever, about his various aches and pains, he was busy remodeling this huge, gloomy mansion in Croton. "The house is wonderful in its ugly way," he said. It had been a nursing home, had stone walls a foot and a half thick, and massive locks on every door. Smith again:

It has a little patio with cement table and benches underneath a grapevine canopy, and with a bit of French bread, a bit of cheese, a little sausage and wine, I can almost delude myself into believing I am where I am not. In some weather it has some of the qualities of a Smith print, including the need of spotting.

His assistant, Bernie Schoenfeld, was building the darkroom; he was mason, carpenter, and plumber. Smith paid, or so he said, little attention to his children. Pat was "taking piano," and Marissa, art; and Juanita was interested in dance: each child had lessons an hour a week, like any child of the upper-middle class. As for Carmen, she was ill, anemic, and pregnant; so she could not yet have the cyst operation she required till after the baby was born. Nettie Smith complained, as ever: "Couldn't one symphony go unplayed a week and we hear from you?" But the Monsanto schedule had exhausted him. He had developed:

. . . all day Saturday, all night Saturday and began to print without going to bed. I printed all Saturday night, Sunday, Sunday night, Monday was sick and vomiting from exhaustion and Benzedrine . . .
I am desperately near to complete physical (at least) breakdown.

His mother's letters were no help; he answered:

I hate the whole damn world that is killing me, I wish I were through with it, for it gives me nothing but hurt and misery . . . I regret that I am not the routined punctual son to always do as you desire or think that I should do—I regret that my love for you must always be overtoned by two-way hurt.

Work, that normal discharge of energy generated by creation, now made him ill. He felt that the Monsanto story, which had just come out, was bad; *Life* liked it, but he despised it for its "shallow insufficiency." He described his backaches, his exhaustion: "I am bitter to the point of a desire to plunge wildly screaming toward that blackness, running at intensity to suck out the last breath and leaving no strength to suck another breath in." Instead of the euphoria one normally has on completing a piece of work, Smith felt desperately ill, and what is extraordinary is that he seemed to know precisely why:

From "My Daughter Juanita," 1953.

I am depressed by my deficiencies, the rigid morality of the code I apply to myself is so strict, I cannot but fail in it and be unhappy at the failure . . . It has cost me considerably, in many ways.

He thought he was in collapse, "but forgot to let go." He thought he might have cancer of the liver, and if so, he would welcome death. He wrote Nettie:

The shock treatment I need, in your opinion . . . how brutal you must wish it to be; I, too, hope it does not affect the children adversely . . . Add a prayer that they do escape with only minor harm . . . The nature of this shock—I find it frightening . . . This bit of illumination into your mind. It fills me with sorrow and pity for you, how bitter, how twisted you are becoming.

On Christmas day of 1952, he sent his mother a long and sorrowing telegram: "I AM CAPABLE OF ONLY SO MUCH TANGIBLE EXPEND-ITURE FROM MYSELF TO THOSE WHOM I LOVE." He repeated once more his feeling that his work was murdering him and that he had little left to give to his family: "MY HEART IS SEARED AND HEAVY WITH SORRY AND IN LONELINESS FROM MY KNOWLEDGE THAT OTHERS MISUNDERSTAND."

There is no question that Smith's attachment to his children and to his mother were all very deep and sincere. But his expressions were so extravagant that one, unfairly, pictures him with alcoholic tears on his face as he sends this message to his mother at ten o'clock Christmas morning of 1952: "A FUMBLING LURCH OF EFFORT TO TOLL OUT AT THE FINALITY OF MIDNIGHT STROKES OF TWELVE, THE TRUTH OF MY HEART OF THE MEASURE OF MY FEELINGS FOR YOU, THAT ARE FOR YOU ALONE. THIS DAY AND ALL DAYS. LOVE."

Nettie's reply was long but unimpressed: "Well your telegram came the next day after Christmas and now today is New Year's—am I ever off to a bad start. Set my alarm to get up early and the darn thing was pushed for off." She thought the Monsanto story was a nice change, as it got him out of the "ashcan stuff" and it would be good for his children to see other prints beside "the seamy side." She would continue to pray for his redemption: "Saint Augustine's mother spent twenty years praying before he came back"; but on the other hand, that sainted woman wore a hair

shirt, and Nettie Smith would not do that, she said. One speculates whether she knew—as she did about his earlier affair—of Smith's intense relationship with Margery Smith, who was an exceptional and gifted woman, in every way his equal intellectually, and somewhat similar in temperament. "Very gung ho," one acquaintance said; she had a photography studio in New York at the time.

So Smith's personal life was rather complex; back at Croton, his new daughter was born on January 20, 1953. It was a difficult birth, and Carmen could not take drugs for her pain. Smith had made a long list of possible names for the baby, including Shana Foree Smith. Shana Lee was the final choice. Lee was his mother's middle name. He reported to her: ". . . the child does raise its voice in protest, and it is true it could very likely be against the fate that gave it this family. I might editorially add that if it does not protest against its unluck of family, it should."

Smith hired a local girl to help around the house; her name was Jasmine Mosely; and she was to become a powerful member of the family. Carmen continued ill, and went back to the hospital, where Smith acted as her nurse one night, changing the IVs, etc. His chronic fatigue never slowed him down: when he had to drive to the railway station in Croton to go back to New York, the kids would beg to go along; they knew that he drove so fast it was as if they were on a roller coaster. But Smith lost his license after "persistent violation" of the speed limit; *Life* got it back for him.

During this time, he took a good many pictures of his children; and a selection limited to the effervescent, dramatic Juanita was printed in *Life,* September 21, 1953. The pictures are fine—nothing wrong with them, and *that* is what is wrong with them; it's hard to photograph people one loves, and particularly one's children. In December, he wrote his mother that Shana Lee had just taken her first step, a date notable also because it is the thirteenth anniversary of his marriage. And he told her he might be going to Africa to do a story on Dr. Albert Schweitzer. Smith had met Schweitzer in Aspen, Colorado, in 1949, and taken a marvelous and unusual portrait of him: outside, with his head bent forward, and his gray hair hanging down toward his great moustache. After that, Smith had accumulated five books by the good doctor on his shelves. On September 21, 1953, Smith wrote to Schweitzer at his home in Switzerland: "I have not the ability to in any measure

repay my indebtedness to you for the inspiration that has flowed from your music, your medical work, your writings, and through this your living, indirectly to me." He sent him the Aspen photograph, and tearsheets of two of his *Life* stories.

He heard nothing from Schweitzer for several months until finally, in February, 1954, Smith got a long reply in French. Schweitzer remembered "the wonderful hours in Aspen," at the Goethe Bicentennial Convocation and Music Festival; at the time, Smith had been far more impressed with the philosopher José Ortega y Gasset. His assistant Bob Harrah met Schweitzer by chance: the doctor had arrived late in the proceedings and was watering the roses in his guest house; Harrah got hold of Smith and the two of them listened to Schweitzer play the piano, and Smith took a number of photographs. Dr. Schweitzer apologized for delaying his answer and urged Smith to come to Africa. "You photograph whatever you like" but "you are not allowed to film [movies]"; as for the rest of the letter, he advised Smith on what to wear and how to keep his film dry in the tropics. Finally, he wrote: ". . . and above all: nothing in your text about me as the greatest man. This word must not be found in the text."

On March 2, 1954, Smith wrote his mother a strangely apocalyptic letter, even for him:

Fate is trembling a decision upon her balance scale, and it is my work, perhaps my life that is suspended there, while she measures the folios of the countering pressures for a rending of immediate judgment.

This story on Schweitzer, he thought, might be his personal salvation, and yet he might fail to do it:

I know that I am an individual of severe maladjustment to the evilities of a malformed society, and I am tortured with the guilt of being a sometimes accomplice to this evility—and yet I firmly believe that rationalized and smooth adjustment to such a society is in itself a dangerous form of illness. I cannot relinquish integrity to my work, and thus suffer the loss of my soul to gain the preservation of my body; and if I did relinquish the one to gain the other, I would but lose both. I believe that somehow both can survive, even to solving the financial.

In short, he needed money for the house repairs and alterations, and for Carmen's pregnancy and illness; worst of all, he was obliged to pay $3,000 in income tax by March 15. Would Nettie send him a certified check? It would be a loan, naturally: "Though I may have haunting sorrow if you refuse there will be no bitterness." And finally, he warned her: "My time is rushing to an unyielding deadline." Smith was right as he often was about himself; the Schweitzer story was to be a mountain in his life—not easily climbed or descended without catastrophe.

Nettie Smith sent the money; how could she not? And on April 21, 1954, he thanked her from a "second choice" hotel in Brazzaville in the Congo; "If I die, I shall die an honorable man"; he complained only of going through customs; one pities the officials—Smith had 50 pieces of luggage. He got to Schweitzer's hospital for lepers at Lambarene, though "hospital," he pointed out, was the wrong word: "It is sometimes difficult to tell whether it is a native village or a farmyard." Furthermore:

. . . the Doctor believed that part of all illness, and therefore part of all cures, is in the mind, and so the patients and sometimes their wives, or husbands, and their children are with them, and they live almost as they would in their own homes. Even with goats, and I never saw so many goats running around, and pigs, and flea-bitten, sorry-looking dogs and cats. Then we become exotic, for it is also like living in a zoo, with chimpanzees sometimes opening your door and walking in, or red-tailed parrots sitting on the railing in front of your door, making an infernal racket when it is light in the morning—and the pelican named Parsifal that during the day sits in a tree outside of the din-

ing hall, and at night sits near the Doctor's door, a better watchdog than a watchdog. And so on to mosquitos, the ants, the lizards, the spiders, etc. Although I haven't seen them, there are elephants and hippos in the lakes not far distant, and for supper the other night we had swordfish, caught in the river in front of the hospital.

And on the banks of the river, one could get fresh crocodile steak. So he wrote to Marissa, who was already 14 years old: "I miss you very much, sweet and darling Meechie—many hugs, many kisses." He wrote letters to the whole family, but separately. To his son Pat, he wrote a jovial account of how he was faced by a giant spider while seated on the toilet, "and that is the story of why I have had a severe case of constipation." He wrote to Juanita about how, half asleep, he scolded her for stealing his tripod—except that the criminal was "a poor sweet little chimpanzee." He wrote to Jasmine's daughter Terrell, in the vein of "I am a handsome spider," etc. And to Jasmine herself: "When day is done, and shadows fall, I think of you, baseball and all. Night is here, you are out of beer, don't you dare go near, where I have some. It's morning time, and television too, my heart fund is throbbing, won't you have some boo, hoo, too." And no one brought him, as she did, orange juice with egg in it in the morning. The letter to Carmen from his busy week of correspondence began: "Dearest darling" but it was mostly about unfinished business, and a request for a print of the Spanish death scene. "You must fix the eyes, especially of the widow, the old lady on the left in the first row"; and the letter ends, almost, with an awkward, one might almost say embarrassed, paragraph: "Have ta, must a, quick a, go—so fair now is to you a good well—well, well, well, with a kiss and a cuss but not a cuff, and a good big load of the rough ore of love for thine own and from my own it has been mined."

Three weeks after his arrival at Lambarene, he was more than characteristically discouraged: "It is a strange and complex story of paradox . . . the heart is missing." He kept a notebook full of doubts and queries in his printed handwriting:

It is a hospital, dirty, chaotic and rugged—despicable by comfortable European standards, even as practical—yet it serves more, pitting its practicality against the engulfing, and it will confound foreigners. . .

About Dr. Schweitzer himself:

A remarkable undefinable—a materialistic idealist, a theologian whom most theologians disagree with, but cannot prove him wrong . . . a conservative (even an imperialist) embraced by the racial progressive.

And then this insight: "And throughout his writings there is self praise in humble cloak."

Smith found that there were places and persons in the village that no one would let him photograph, much less rearrange and "direct" as he wished. He wrote in his tropical journal:

If I sing sad songs it is to mandrake a journal and American consequence. And it is a serenade. Strange that I must attempt to do them justice in spite of themselves. Strange also that on a story open to greatness I have come so close to resigning in bitter failure. I am not sure at times whether staff is coy or overly modest or just plain terrified of camera. Anyway, Dr. Schweitzer's kind words . . .

Smith spent one night writing a note to the doctor, explaining his motives and offering to leave if his presence was disturbing:

I must leave Lambarene, for you restrict me and force me to omissions, which indirectly make other photographic statements sometimes impossible, and this can lead but to superficiality, an unworthy essay, untrue by its very slightness. And thus—because I have respect for you and your work, and for those who aid you, and those whom you would help—I must leave.

I too seek truth. I too aspire to making of my life, and of the work of my life, a force of and for good—a force that does no injury, other than to evil. I have done evil, and I have hurt innocent—this from the weakness inherent in most who are mortal—I am aware of many of my faults, and I am sickened and torn that I possess them, and that sometimes too often they possess me, and this drives me on to try to overcome them, and in my work it drives me to seek a perfection unobtainable; and to me, perfection is more than artistic perfection, more than technical perfection, it is moral perfection as well. And moral perfection is more than good untainted by wrong, moral perfection must be more than neutral good, it must be affirmative. I do not speak of the term success, for this is too easily obtained, its values are pagan, its practitioners too often (although they would deny it) surrealists.

Dr. Schweitzer relented, luckily, for Smith's series on the Lambarene leper settlement is one of his most imposing essays. It is less the study of a hospital than the poem, ardent and intimate, of a Congo village. Among the men and women, often disfigured, the old white man walked in his sun helmet, restless, tireless, or played Bach chorales on his untuned piano (awkwardly, Smith thought) for recreation, pushing the Africans to build and enlarge whether they had agreed to do so or not. Smith wrote:

A man strong with and for work, he believes that this is also part of the medicine for cure, that sickness, even leprosy, is partly in the mind, and that work of the mind and body adds a measure of cure to the medicine of science . . .

But he also quotes one of the villagers: "We came to be cured of sickness, not to die of work." Smith's own work was prodigious; he did thousands of negatives, and together they had an inner consistency, a perception that is deeper than any text—even his own. It should be noticed that Smith's writing, with some weird lapses, had become mature and precise, as if he wrote with his eyes:

Goats, and chimpanzees, ducks, chickens, and a pelican (named Parsifal); Negroes weaving palm-leaf mats, negroes carrying wood, fruit, and bananas on their heads, children frequently carried on their back, crossing the place in their own slow rhythm; a woman, white and in white, was giving orders for the handling of food, of handling the laundry, being washed and hung over a considerable area to dry, while that which had dried were being ironed by clumsy heavy irons that were charcoal heated and rested between strokes on old tin cans.

Smith stayed well beyond *Life*'s estimate of the job; there was nothing unusual about that, and as usual, he was producing a large volume of work. Yet at the same time he was burdened with a new personal problem that was to be his secret pride and uncertain responsibility for many years. Back in 1953, by Margery Smith's own account:

I informed Eugene that we were going to have a child. I told him that I wanted to keep the child and that I planned to move to some other city (not yet decided) and raise the child away from New York. Smith was in total agreement with the plan, and it was he who suggested that I move to Philadelphia, because it was close to New York, where my photographic assignments generally originated.

When I told my friend and mentor, Edward Steichen, that Gene and I were going to have a baby, he looked at me with pain in his eyes and said sadly, "But he's so neurotic."

In early 1954, I rented a house in Germantown (Philadelphia) and

Gene left for Africa on the Schweitzer assignment. While there, he wrote me that he had had second thoughts about having a child. He was still married and was frightened at the thought of his wife and child making the discovery. He rightfully gathered that my opinion of these letters was that he had "a certain basic but elusive dishonesty disguised as righteousness."

When I became ill and was about to lose the baby, I believed that he would be relieved at the news. I wrote to him, and was surprised to receive a telegram from Lambarene containing only four words: "HOLD ON TO OURS."

When Margery sent him some portraits that Robert Frank had taken of her, Smith sent a telegram from Brazzaville on June 3, 1954, a month before the child was born. It said:

ROBERT FRANK HELD THE MOON, THE WARM, THE GENTLE, THE LONGING SOFTNESS IN HIS IMAGERY OF YOU THAT ARRIVED LAMBARENE AS EYE DEPARTED. AM IN BRAZZAVILLE DEPARTING FOR ROME AND SHORTLY NEW YORK. LOVE, SWEET LOVE, PERPLEXING LOVE, EYE LOVE.

Her account continues:

Returning from Africa, he came immediately to Philadelphia to see me a few weeks before the baby was born. When the baby, a son, was born on July 5, 1954, Eugene came to the hospital. While he was sitting in the room admiring his son, a hospital administrator came into the room with the Birth Certificate in hand, asking for the baby's name so that it could be completed. Eugene signed the birth certificate and said: "Kevin Smith." I immediately corrected it. "Kevin Eugene Smith," I said. Gene gave a wistful half smile and said softly, "That has a nice ring to it!"

There was never any doubt of Smith's deep love for his new son; nevertheless, the job of bringing him up fell to Margery, not to Smith. She went about it with characteristic energy and courage:

I made a 17-year-plan for my son, part of which was that he should be raised in an old-fashioned house with a big backyard, in a family neighborhood with a small town feeling, and that he should have every cultural and educational advantage possible and be prepared with the kind of classical education that I thought necessary to be accepted to the best universities.

In June, 1975, he and his second wife, Aileen, went to his son Kevin's graduation from Stanford University and stayed to visit for three days; he was particularly proud that Kevin was the editor of the *Stanford Daily*. Kevin Eugene Smith had graduated "with distinction" and went on to obtain a law degree from the University of California at Berkeley. However:

It wasn't until our son entered law school that Eugene offered financial help. On several occasions, Eugene received checks from Lee Witkin for privately printed portfolios and sent the checks to Kevin. I was gratified and surprised that this periodic windfall came at the end of my twenty years of going it alone.

The love that Margery had once shared with Eugene had turned to friendship, a friendship that was to last until his death. One wonders, though, whether Smith's consequent burden of attachment, guilt, love, and anxiety, all inextricable from one another, did not add to the tension of that crucial year, 1954, when he would once more make a decision, not presented by chance but determined by his inmost character, that would skew the rest of his life.

WHEN THE Schweitzer assignment was finally completed in late spring of 1954, Smith left Africa. Before going back home, he spent eight days in Rome and three in Paris, where he met the gentle photographer Edouard Boubat. At about this time, he learned that Robert Capa had stepped on a landmine near Hanoi, and died; Smith sent a cablegram to Capa's agency, Magnum:

ONE DOES NOT GRIEVE FOR CAPA AS ONE GRIEVES FOR THE ORDINARY MORTAL TRICKED INTO TRAGEDY FOR HE WAS A MISSISSIPPI GAMBLER IN A SHAKESPEAREAN PLAY KNOWING THE HEART THE CHALLENGE THE ODDS OF EVERY THROW AND PERHAPS THE LONELINESS HE WAS AUTHENTIC AND I LOVED THE GUY.

The language is odd, but it does show another aspect of Smith's pessimistic network of values. He delayed going back to "that horrible old darkroom," as he wrote to Marissa, adding a gentle reprimand for her bad report card, and a rather heavy lecture on the virtues of the work Schweitzer was doing; it was "ugly, even repulsive," because "so often, the jobs with glamour founder upon the rocks of unhappiness." Yet he had lots of unsettled opinions about the good doctor; and thought previous journalists, like Joseph Wechsberg in the *New Yorker*, were careless with the truth and were not cautious about the tricky gap between fact and legend. He sent a long note to Gjon Mili, saying that he was exhausted, "so aching tired that it is difficult to lift even a careful thought." Caught in a metaphor that says more than he intended, he wrote:

I began the casual pickup wooing of defeat, and with effortless ease brought her nearly to myself. A dawning brought revelation and revulsion but not release, for abruptly, she entwined me down into her flabby, shapeless, smoothering: and now, as I writhe to free myself that I may drink again of cherished hope, she holds hotly to me and with her naked truth taunts me even worse of incest, for she has proved that defeat is me, and no other one can do it.

All this was written on July 1, 1954, when he was back at home, making prints for days at a time, the largest set of prints for one story that he had ever made. He used the assistance of his wife Carmen, who did a set of 5x7s, so he could do scores of layouts for the Schweitzer story—even though he knew that *Life* would insist upon doing it with their own staff. A famous print that gave him a great deal of trouble was the portrait of Schweitzer in his cork hat, with a brawny patient behind him, during construction of a new building at Lambarene. Unfortunately, Smith had shot into the light, and a bad flare darkened the right-hand lower corner of the negative. He fixed the print by cutting out of paper a hand and the handle of a saw, double-printing it in a natural shadow. There are those who believe he did this as a reference to Jesus the carpenter; if so, and certainly it's possible, it was surely an afterthought.

The hundreds of photographs Smith had taken at Lambarene include only a dozen or so that are notable as single images. Schweitzer, writing at his desk or walking about and working under his cork helmet; the animals and birds and scorpions, all quite at home in this village; the surprisingly undisfigured lepers at their daily labor—all of these mean less as single prints than they do when they are put side by side and grouped in such a way as to comment upon one another. They are informed by a photojournalistic idea: Smith's idea, of course, was to bring the viewer into the village as if he lived there. Yet it is in some ways an invented place, certainly by African standards; there are no ancestor figures in these houses; no communal dances invoking the spirits of the bush; no sculptural objects; no sculptors, indeed; and no chief nor shaman beside Schweitzer. So the composite picture Smith gives is true, fascinating, handsome, and a little troubling.

It happened that *Life* editor Edward Thompson, with whom Smith had many disagreements and many successes, was on vacation for one week during the course of Smith's submission of the Schweitzer story; his replacement was Robert T. Elson. Faced with an opening in a forthcoming issue, Elson simply took the layout done by the *Life* staff and approved by Thompson and sent it to the printer's. On November 2, Smith verbally resigned; and no storm having arisen, seven days later, sent his formal 60-day notice of resignation required by contract. Smith wrote Ansel Adams that he had resigned in order to force a change in the Schweitzer story; but the *Life* decision remained firm and 26 of his photographs appeared on November 15, 1954, under the title "A Man of Mercy." This event, for both good and bad, chopped his life into unequal halves.

His response was frenetic: by the 20th of November, Smith had written scores of letters, mostly to advertising firms, but also to the film and stage director Elia Kazan, to Fleur Cowles at *Look*, and to the American Meat Institute. Having lost his fight to pre-

serve what must have seemed to *Life* a vague and uncertain and prolix truth about Dr. Schweitzer (Smith was shocked by how brutal Schweitzer was to his leprous workmen, reported Ed Thompson), Smith rushed back toward the easier assignments of commercial camera work. Yet, he still had a choice: Thompson wrote him on December 2, suggesting that "we leave the door open . . . I think we can work out something." Perhaps Thompson felt uneasy because the break had happened while he was away; and perhaps there really was a possible compromise. Smith wrote a friend on December 6: "I have resigned from *Life*—I think for good." And even three days later, he thanked Thompson for his kindness:

Let me remain on "Ponder Plane" for another few days before I face a final door of decision. The decision I made that day was not heatedly arrived at, and to me the ensuing weeks have not diminished its validity. Neither does this diminish the rightness of much that you say in your letter, although the alternatives are not necessarily bleak—and I know, or think I know the odds.

And to his mother he wrote: "Austerity! That is the program for the Smiths for Christmas, 1954." One wonders how he went bankrupt so quickly; but Smith's arithmetic is still mysterious; he was not supporting his infant son and his son's mother in Philadelphia. As Margery Smith pointed out:

Although Gene said that *Life* had blackballed him with other magazines following their quarrel and his resignation, this was not true. I was still in Philadelphia when Gene came down for an appointment with the *Saturday Evening Post*. They offered him an assignment at a high fee. When they told him that they would have to keep his negatives, he turned them down. I was working for the *Saturday Evening Post* as a photographer at the time and was told by my editor that the "six-part story on Arthur Godfrey produced the biggest sales the magazine had ever had in its history." I casually mentioned this to Eugene, who turned his head sharply and stared at me. "Was that the story you turned down?" I said slowly. He nodded, yes.

On December 28, he got a final letter from Dick Simon of Simon & Schuster, which politely turned down the notion of publishing a true book on Schweitzer. Two days later, he wrote to Thompson again, a closely argued, single-spaced eight-page letter. Some passages are familiar; his back hurt him—the result of a smash-up (in Portugal in 1951?)—and he wished it had been fatal. But, getting to the point by page two, he defended honesty in journalism:

The gravest responsibility of the photo historian or journalist is the search through the maze of conflicts to the island of intimate understanding, of the mind, of the soul, amid circumstances that both create, and are created by—and then to render with intelligence, with artistic eloquence, a correct and breathing account of what is found; and popular fancy, myth can be damned. Meaning: get to the guts of the matter and show the bastards as they are.

Finally, in the same letter, he offered to return to *Life*, but set so many conditions for his return that the offer was not accepted. The contract had expired on December 31, yet the goodbyes dragged on, like guests in a lighted doorway. Henry Luce himself wrote him his regrets: "Don't blast the hope that sometime in the near future you will want to join us again on this side." It was signed: "Harry." Thompson, on January 14, 1955, wrote a forthright letter to Smith:

No one will give you anywhere near the leeway you had at *Life*. You may decide that you can do a potboiler here and there to keep going financially while you do a non-profit book or movie. If you do that I will have to conclude that all the thousands of words you have put out

about your integrity are phony and represent a deluded type of posturing on your part.

In reference to his troubles with *Life*, Smith wrote his mother that it was his name that carried the moral responsibility, and that "my resignation has never been a bluff, therefore I had to continue it in force." As for his debts, he wrote Thompson, he thought he might sell the house, rest two weeks and begin again. "In the meantime it is possible that I may even return to *Life*, if it is sufficiently assured that the past will be corrected . . . It is still my $8 against their 8 billion, my guts against their power—they crush too many people." He signed it: "AND DON'T WORRY."

Late that year, his mother died in Kansas. One looks in vain for any outcry of grief, despair, anger, or even resignation. One finds, instead, a kind of bitter distance from the event; in a letter to Margery Smith in December, 1955, he said, after referring to his son Kevin as "that beautiful creation":

My mother died yesterday and I have had to borrow money to fly to the funeral. I am leaving right away. In a bit of perversity, in the light of my desperate financial situation, I hope she stayed with her beliefs. I hope she wrote all of her money and holdings over to charity and the Church. The thought of the vultures ones greedily hovering for their "share" and the profane shock of their disappointment is a pleasantly just one. Or is it? What is justice? Well, I hope she is either at peace in death, or happy; poor, great, self-misled woman. I think I have less sorrow than I should in that I look to the quiet of death, selfishly, for myself, as a blessing.

It's fascinating that when he returned he told Margery that his mother had acquired over $1 million in farm property by foreclosing on poor farmers during the Depression and subsequent years, and that the first thing he did was to look up all the former owners and give the land back to them. Many years later, when Smith was in desperate financial straits, Margery reminded him of what he had done, saying: "But didn't you think of your children's welfare?" Gene wept and admitted that he had made a mistake in not keeping some of the land for himself and his children.

Saints, martyrs, and angels, one cannot help thinking, don't make good family people.

Several months before his mother's death, two important events occurred. Several of his prints were included in Steichen's *The Family of Man* exhibition at the Museum of Modern Art, and one of them was "The Walk To Paradise Garden"; and, during that same period of time he found a gallery, Limelight, to hang his prints. And now there was a third success: a new project was planned for Smith, through an international photography agency called Magnum, which was founded in 1947, as a cooperative of photographers who shared capital and distribution. The first members were Robert Capa, George Rodger, David Seymour ("Chim"), and Henri Cartier-Bresson. By talent and outlook, Smith was an ideal member. He joined the agency on April 5, 1955—but there had been important contacts several months before through John Morris, who had known Smith as early as 1939, when Morris was a young writer on *Life*; by now he was administrator for Magnum; and the agency was responsible for getting Smith an assignment with a well-known figure in photojournalism, Stefan Lorant. Smith wrote Stefan Lorant in Pittsburgh on February 26, 1955:

I who discipline excitement with scepticism, at least until the details are in—I am excited. This, although I was unable to determine the photographic scope of your new project from either the letter or from the little information my wife could give me. This, strictly from know-

ing the excellence of your past work, and the potentials of Pittsburgh. The relationship of industrial to man, theme and counter-theme through the history of such a city, can be a wonderful challenge.

Lorant was a Hungarian journalist, born in 1901, who was a photographer in his twenties and became the editor, finally, of the *Munchner Illustrierte Zeitung,* one of a number of Central-European journals that featured photographs. His innovation was the clever construction of a photographic layout, so that the viewer followed a preconceived pattern: a method systematically exploited by *Life* editors ten years later. The very placement of photographs, using their internal composition as well as their content, forced the reader to follow a story, rather than let the eye wander from one sensation to another. This was not so very different from the structure of a documentary film, a form that began to flourish in the late twenties, thirties, and forties, along with, and feeding upon, the dramatic events of that period.

In 1940, Lorant came to the U.S. and continued his career as a writer and book editor. In 1955, he was commissioned by the Allegheny Conference to prepare a book of text and illustrations, for publication in the fall of 1956, to celebrate the centenary of the City of Pittsburgh the following year. He chose the famous Smith to do the photography; and no choice could have been more natural, for it combined the talents of a fine photographer and the famous and innovative editor who had invented the mature form of the photographic essay. Lorant told John Morris that only Smith could do the job; at a breakfast conference in New York City, he made the following proposal to Morris, who conveyed it to Smith: he was to do a photographic profile of modern Pittsburgh; the pay was $2,500; the work was estimated to last five weeks; and Lorant wanted 100 final prints. Smith accepted the offer; and Lorant offered Smith the free use of his house in Pittsburgh.

The assistant in this modest but interesting venture was James Karales, a tall, dark, good-looking young man who had just graduated from Ohio University. He came into Magnum simply looking for a job, with his main interest in photography. "Smith had just called me," Morris remembered, "and told me how desperate he was, and he had had some bad news financially, but he just did not have the strength to work in the darkroom, he needed help there." Karales had seen both "Spanish Village" and the Schweitzer story in *Life* and was thrilled to be working with Smith. He took the next train to Croton that afternoon and stayed almost three years. Though he was hired at $50 per week, he was never paid. "He got his room and board—more room than board," said Morris.

During the next few years, there were ten people at mealtime in the house at Croton: Smith, Carmen, the four children, Jim Karales and his fiancee, and the maid Jasmine ("Jas") Mosely and her daughter Terrell. Jasmine Mosely was a tireless, witty woman, with a marked limp. She, too, was rarely paid, and would actually go out and work for other families and bring money back to loan to the Smiths. She told the Smith children, "I'm your Technicolor grandma." Smith would come out of the darkroom suddenly and unexpectedly, intoning like a traditional black preacher and holding an imaginary Bible in two hands, and Jasmine, frightened, or pretending to be frightened, would run away from him and hide. This family, tied together by the force of Smith's personality, and through him, to his obsessive work, were in fact rarely without food, no matter how often Smith wrote about hunger at Croton. Carmen was too responsible a parent to let the children go hungry; she worked nights and weekends as a nurse, and Jas attended to the children. But Smith often went for several days without eating; and whatever the rationalization, his real reasons were somewhat different.

Smith did not drink, or not much, during his first stretch of work on the Pittsburgh project. He relied instead on Benzedrine to keep his energy high, though in a letter billing Wayne Miller of the Museum of Modern Art for prints used in *The Family of Man* exhibition, he complained that "There is nothing left in me for even Benzedrine to awaken." One of the effects of any amphetamine is to kill the appetite; in the long term—and Smith's use probably goes as far back as 1944—the common result is malnutrition. Still, there may have been a touch of conscious martyrdom in his abstinence: since there was no money for the bills, he would renounce both alcohol and food. Carmen would try to make him eat, and he would go into shouting tantrums. According to Carmen, he was never physically violent to anyone, but Carmen would hide the kitchen knives when he threatened suicide. Money was certainly scarce: the Pittsburgh stipend was yet unpaid. It would not, in any case, have supported a household the size of Smith's at Croton, plagued as it was with swarms of nagging bills: insurance, taxes, plumbers, doctors, dentists, plus money for repair bills for Smith's numerous cameras, which always seemed to suffer, as he did, from more accidents than normally expected.

An unhappy example is the incident in Pittsburgh, on May 20, 1955, abouth the fifth week of his work there. Smith had parked his car and left it unlocked. A thief stole, from the backseat, five cameras, ten lenses, and some 150 rolls of exposed and developed negatives. The thief was caught; he had pawned the equipment, but had tossed the rolls of negatives into a street trash barrel. It was a celebrated event in Pittsburgh; the loss made all the newspapers; and the police spent days churning over the garbage in the city dump with a bulldozer; the film was never found. Smith had to start the project all over again. Much later, Smith was asked if he objected to parole for the thief, Wilbert Strothers; he wrote a sad, hurt letter, but no, he could not oppose the prisoner's release.

The air of frenetic disaster in the Croton house—Smith called it "the withering rock"—was not a result of one of Smith's unlucky accidents; it was a true case of character choosing its own history, and it follows a sinister logic. The poverty in Smith's house was a consequence of his resignation from *Life*; there was no more salary and no generous expense account. In response to *Life*'s calm refusal of his ultimatum—did he ever mean it to be final?— Smith was determined to prove them wrong. The Pittsburgh project, inherently small, if respectable, was now enlarged, without Lorant's consent or even knowledge at first, into a gigantic study of the city itself. Lorant asked for 100 photographs; Smith made at least 13,000, a ratio of 130 to one.

So instead of a job that was scheduled for a month or so, it became five months work; and that was only for the shooting; the printing would take him the next 18 months. Stefan Lorant himself had a deadline for his book and was naturally furious. The heat of the controversy took a farcical turn around an item of repair of a water heater, for which Smith paid $8.90. And even the guaranteed $2,500 was not paid because Smith did not send Lorant the final prints; in consequence, Magnum had to loan Smith money out of its capital resources; and as this ran into thousands of dollars, and Magnum was financed by the purchase of stock by its members, this collective agency was strained well beyond the limits of the admiration that its photographers (Cartier-Bresson, Cornell Capa, Ernst Haas, "Chim," and others) had for their friend Smith. The intervention of John Morris, executive editor of Magnum, was crucial during this period. Though between two fires, Morris was the one who went to Croton himself and, reporting that there was no proper Thanksgiving dinner, went out and got the food for them. About another occasion, Christmas of 1956, Morris states: "When I realized they had nothing to eat, I drove over to Croton from my house with a Christmas dinner, the whole works."

So the poverty was real, not rhetorical, though it was that as well. Smith wrote to a Mr. Hall, to whom he owned a small debt, on which he had already made a payment of $190:

This, the carnal house, is a hungry house. A house filled with the physically hungered, and so am I. I am weak with the physical illness-es of exhaustion and hunger, and of owing . . . I was locked in this last relentless climax to the Pittsburgh project . . . when the Pittsburgh project went finally mad in effort and in time involved beyond every singleness of tenacity with which I could claw and grab and pound and twist and wrench of last resort . . . Enclosed is a check . . .

15.

"I am the storm and I war with eternity."

SMITH WAS suffering, at this stage of his life, from a combination, not all that unusual in an artist, of simultaneous depression and grandiosity. Each fed the other; to solace his interior darkness, his sense of loneliness in the midst of his noisy family, and to assuage his failure to be a normal mid-American man, he had inflated every project he had ever worked on to some degree. In Pittsburgh, though, the enlargement was grotesque, and guaranteed, certainly in the short run, to fail. This failure, pressing upon him daily with a mailbox full of unpaid bills, made Smith all the more determined to make his view of Pittsburgh not a few pages of illustration in someone else's book, but his own, his very own, and gigantic beyond any other photographic conception. He had written to John Morris from Pittsburgh on April 20, 1955:

This project goes slowly, and as yet, not well. Although there are slight indications that Lorant and I are with differences in direction and intent, so far, the relationship has been pleasant. It is going to take at least four more weeks to finish here—damn it. Financially of course this makes it a bad deal; although we knew that financially it was a bad deal from the beginning.

He wrote an imposing memo, "From W. Eugene Smith, to—W. Eugene Smith. (1955)":

My intention for result—a strong example of an individual and functioning American City.

And that city as a living entity, with its being an environment for—and in turn, an environment being created by—the people who give the structural image of static stone and bracing steel the facts of heart and pulse. I will observe, with intimate photographic scrutiny, these individuals as I encounter them during a participation in the daily life of the city. (Yet, I will respect their ethical right of non-invasion of true privacy.) In this essay (photographically, that is), and unlike other essays of mine (such as the Nurse Midwife), I will not search to know any individual as a complete person. For the individual, in this present essay, is a part of the teaming into the whole that becomes a city, singular—and Pittsburgh, the City of, is my project and is the individual to be known.

The more the project was enlarged, the more difficult it became; and as it became more difficult and at times, impossible, the more he was depressed. He wrote one of his rare letters to his brother and his sister-in-law, Paul and Dean, on May 17, 1955, from Lorant's house in Pittsburgh. It's worth extensive quoting because it is one of the few doorways that open directly into Smith's subconscious hell:

For I wasn't sure that death wasn't around for me last night, looking me over on a take-it-with-you basis—and this morning I'm still not sure. And beside me on this table is a note I scrawled last night. Something about my feeling very strange and believing I might die, and a few more scrawled words of yearning and sorrow and love and apology, make the apology plural. I assume that I wrote it sometime between the time I conked out and pitched into a pile of discarded film cartridges and papers on the basement floor (which I am using as a darkroom) and the time I managed to crawl up and crash on the bed with all of my clothes on. . . . I'm sure doom and his knockers are patient and waiting, knowing their bird is drifting their way. And so I gambled a few more hours to try to save, and as I was loading film in the dark, or faintly green-lit room, I suddenly realized I was standing strange, that the top of my body was bent almost sideways parallel to the table, and that I was having clumsy difficulty in loading the film. With this realization I forced myself upright, forcing a greater concentration, and tried to continue—for I needed the holders loaded for the following day, or more lost time.

It became a horrifying experience, of me knowing the mechanics of what I was doing, with difficulty and fogged effort of concentration—and a kind of amnesia, or hallucinations, or something, for I could remember what I was doing (mechanically), but a strange unawareness of where I was, what place and for whom, and why, and the place, the basement, was a hundred vague locals, and there were people surrounding me—just vaguely, talking to me, or making walking sounds upstairs, or somewhere expecting me. These people, all of my life, my family, my subjects, all somehow from the fusion of my history, more of them dead, frequently and almost invariably needing something from me, or of my obligation, or of my love. And I kept on trying to load, and trying to realize where I was; slowly sorting out that this person was dead, that person was out of my life, that these were my kids and couldn't be here. And that vaguely, tomorrow, I had to be doing something with great urgency. This kept on, I couldn't straighten out people, or place, or situation. Strange movements flickered in the faint green light and I slowly analyzed that it was the room moving, and in the fog dream reality I tried to shake it off to complete the remainder of the small task—for I could fumblingly realize that this was the come-uppance of exhaustion, though from the heavy erratic pounding of my heart, and the way little spasms kept running counter commands to my body, I felt it likely that I was going to die.

Perhaps I did, for I was laying on the floor, looking at the near bright spot of the green safelight, I was aware and unaware, not knowing it time or place or reason, but knowing I was now there, when I hadn't been in my last, nearly connected thought. Somehow I got upstairs, somehow I wrote the farewell apology for my failure to, I think especially the kids, and somehow I got almost all the way into bed.

It is now morning, and I feel horrible, hopeless, futile in my inefficiency, fearing to demand of my body what should be demanded of it, must be demanded of it if I am to fulfill my word to this present project . . .

The demand, of course, was one he made upon himself, and certainly not part of the original contract. But the risk of gigantic failure hung over him, and so the cycle of Smith's life ran on and on—with, which is more astonishing, so many other people running breathlessly after him.

Sadness and immense ambition, each generated by the other and at the same time, is not an unusual phenomenon in creative people. Smith's son, Patrick, had a bedroom directly above his father's darkroom at Croton; he would often wake up at night and hear his father sobbing down there in the semi-darkness. Smith wrote, in a letter to himself on October 15, 1955:

I anger at the spiritual and character flaws, and, of course, at the lack of talent and brain that keeps me from the furtherest horizon of ac-

*Pittsburgh,
1955–56.*

complishment and that sometimes prevents me from fulfilling even minor responsibilities.

He had already sent a warning to Lorant by telegram on September 2, 1955:

WHO MADE THEM IF I DID NOT. MAILING FIRST PACKAGE SLIGHT BEGINNING BY 100 OR SO OF IMAGE INDICATING PROOF PRINTS. THESE IN PRIMING OF CONTINUALLY ACCELERATED FLOW WITH PROOFS BEING DONE BY SPECIAL ASSISTANT AND FINAL PRINTS BEING DONE OF COURSE BY ME.

EVEN ROUGHEST FIRST EDITING OF THIS RATHER MONUMENTAL SET IS MONUMENTAL TASK AND IN SPITE OF HAVING LONG KNOWN PITTSBURGH PROJECT AS INFINITE MISTAKE DANGEROUSLY AND PROBABLY NEAR TRAGIC I MUST QUIETLY STATE AS SET IT IN MANY WAYS MY FINEST. REGARDS.

What he had sent him were beautiful proofs, quite usable by Lorant except that Smith had stamped them "NOT FOR REPRODUCTION"; more were still being done.

He was, he said often, working 30- and 40-hour shifts. He suffered pain; his feet were weak and shaky, so he couldn't stand up very long at one time. He was making 4,000 5 x 7 proof prints, an average of something less than a third of his total negatives. He would get up at three in the afternoon and have breakfast, which was generally a raw egg in milk—the sort of food he had gotten from Nettie Smith when he was wounded in the mouth. Then he would work till five or six the next morning, and then all day and into the next night. Sometimes he would stay awake for four nights. He would tell his assistant Jim Karales how he wanted the prints dodged, and Karales would follow Smith's orders. In the darkroom, now the center of Smith's enormous labor, there was always a supply of candy; the children would run in and out if the door were not locked. He had erected stands made out of wallboard, and a maze of these extended into the living room, and when that was full, into the dining room. On these he would arrange and rearrange the layout without pretense any longer that it was solely for Lorant.

On November 6, 1955, he wrote Lorant from Croton:

I will predict no final outcome, though I do—quietly, sadly, without melodramatics, could predict such outcome, all but the most precise details—know that I had to make a decision today that almost demands in retribution my career—for both my health and my home are almost sure to be gone by the time I carry out my decision. . . . And

so Lorant is spared, at least by technicality, from being wrong. No, only Smith is wrong, and always wrong, the criminal and the shirker—Smith, who made his infinite mistake, with Lorant, and with Pittsburgh.

But this sad humility was not quite accurate. Two days later, he wrote to a friend in Pittsburgh that to abandon his project would be like depriving Beethoven of the means of writing a final symphony.

Was the result worth the agony? The first thing one feels, on viewing the multitude of prints, is a sense of relaxation in the faces—not tired so much as sleepy, a dullness, a customary boredom. The council members, the business executives, the saleslady and the shopper, the charity luncheons, the people lounging in the summer streets, the pickets on strike—all seem impressed with the comfortable sense of their own unimportance; Pittsburgh was simply not exciting. As Smith himself said: "One morning, looking out of a window, I wondered what the hell I was doing in Pittsburgh. Mine was no love affair with this city, and I felt no crusade for the Mellons to give me cause and desire." The easy irony of funny street names in the poor Black districts (Pride Street, Loyal Way, Climax Street, Dream Street), twin babies in a carriage, and lovers crossing the street—did all these mean a lot or nothing to Smith? There was always a certain corny streak in his taste, though rarely expressed, and there is some evidence (even about "The Walk to Paradise Garden") that he disliked it; but he let it happen; and accepted the inordinate praise.

But then, also in Pittsburgh, there are his truly beautiful passages through the Bessemer Works: the dance of craftsmen with liquid fire; sparks like sudden rain; the sweat and glare on the workmen's faces. And there is the smoke, steam, and night illumination over black water, and the burning lines of steel rail; industrial beauty that no one likes anymore, but which has the appeal of the early part of the century, when soot meant prosperity. Most fascinating of all are the photographs of certain districts at the edges of Pittsburgh: black stone, black hills, black walls, black houses with glaring windows; or simply an alley with trash and a worn wooden door. And there are scores of other scenes, aberrant from his stated purpose; they say nothing; they convey only a kind of modest beauty, a gentle and melancholy lyricism that is another face of Smith's genius.

By late 1955, it was obvious that—with the Lorant stipend still being withheld—the whole project had to be financed in some new way, particularly to repay Magnum the money it had loaned to Smith. John Morris first took the project to *Look:* "Allen Hurlburt was very impressed"; the magazine made an offer of $20,000. There were two obstacles: one was with Stefan Lorant, who still retained first rights to the photographs and whose permission was needed to reproduce any of them in the magazine. The other problem was with Smith's reputation. According to Morris: "They didn't want to give him control of the layout." As it turned out, Lorant refused to sign the letter of agreement which provided (really a kind of blackmail) that in return Smith would give him the prints he wanted "no later than February 1, 1956." *Look* would not assume the responsibility for printing without getting Lorant's permission.

Smith wrote to Morris on February 29, 1956:

My friend's greed got the better of his welfare to the result that it may cost us both close to tragic—ah well, a walk on a bed of roses should not be attempted when barefooted. . . . The pictures are tremendous, and I'll have to truthfully admit that a magazine length (my length) layout I made also looks powerful like a lot of quality. But that is all for the waste way, and I don't think I have health or strength or heart enough left to finish it. . . .

In view of *Look's* hesitation and probable refusal, Magnum proposed to take the project to *Life* and filed suit against Lorant to obtain serial rights for Smith so that he could publish his photographs outside of Lorant's book. Smith, on the other hand, wanted to be careful how they fought Lorant: "It simply would make us no better than [him] Perhaps in pressing suit, we damage much more and gain nothing." There is an ironic twist in these nice ethics since, in the same letter to John Morris, he said:

Let it be clear, that from that first breakfast I had an essay—for itself, and as a tool against *Life*—as my driving ends, regardless of my conscientious respect for my obligations to the needs of Lorant.

The lawsuit dragged on for months. Smith's mood may be deduced from a letter written March 20, 1956:

I am the storm and I war with eternity. There is no Goddess as prize though I protect the emptiness from the fiery dragon. St. George, second floor, inside room—and a bottle of gin. . . . Is the far curve steeply banked, is the room well padded—. . . no sir, I ain't got a nickel, I ain't got a dime . . . I am tired and in deep trouble.

He had applied for a Guggenheim fellowship, but hadn't heard yet whether he would receive it. Stefan Lorant was in trouble, too; he had a deadline for the book, but had received very few reproducible prints. Meantime, the lawyers dueled with one another, though not in the courtroom. There's a curious, undated document, probably meant for John Morris at Magnum, that has the acrid taste of paranoia:

Things to think of regarding possibilities for suspicion and for procedures—and to guard against. . . . Lorant and *Life* people were often together in Pittsburgh—did *Life* buy off Lorant to delay potential use?—They have sat on other picture sets with a hunk of cash, I doubt if there would be much reason to believe them above it on this set . . . The virtue of dishonesty and the defenseless position of the well intended. . . .

In late 1956, Lorant agreed to a deal at last. Smith got the right to publish photographs apart from the book, and Lorant finally got the requisite number of prints, which Smith, whatever his conscience, had so far withheld. While Smith did receive money from the Guggenheim Foundation, as well as the $2,500 from Lorant,

Look had by now withdrawn its offer. It was, all in all, a gloomy year. On his wedding anniversary in December, he wrote Carmen a strange note. Under all the flowers of rhetoric, there is a marriage already dead:

This is not a day of celebration, this I know. Whether it is a memorial day is not clear—for indications frequently are passages negotiable into quite variant destinations. I shall try not to predict, today, of the seas (or, of the roads and the inroads) we are now transmigrant of, nor of the variant end zones that could await us. Fierce torrent volumes of confliction hurl to burst—to burst against my mind, and would rupture my heart mind: yet, the gentlest that any human being is capable of preserves itself intact within me, somehow unrivable under the curse of the most tyrant pressuring within chaos. Intact even amid the wasteblood of breach. I wish, and work for the both of us (the six of us), for the love, the luck, the courage, the compassionate and strong wisdom—and, all of more—necessary to preserve, and to restore our battered and ruptured state into a liveable health. Sixteen, this day, is still a groping age of adolescence—with the future, never more than begun.

By this time, he was in California. So that he could make some money and continue repaying his debt to Magnum—which at one point was $7,000, almost their entire capital—John Morris got him a commission from the American Institute of Architects to do a study, in color, of important examples of American architecture. Though Smith distrusted color and was generally unsuccessful with it, he went ahead with the work, which required him to travel West and particularly to California. He took Jim Karales with him, and in fact a good deal of the work was done by Karales. The only other photography Smith had done that year was a news story, also urged upon him by Morris at Magnum, on the arrival of the survivors of the ship *Andrea Doria,* which had sunk on July 26, 1956. These photographs are quite unusual in their understanding of emotional stress—one of Smith's intuitive talents that connects some of his work with Cartier-Bresson's. Though *Life* turned them down, they were published in the European press. The photograph of the nun, shy and frightened, later became famous, but the image of rescued men crowded into a porthole to see the safety of land, is perhaps even more remarkable; one is tempted to see them, in their cramped hope, as a metaphor of Smith himself. Cartier-Bresson had written him of his admiration for this series; and Smith replied at last from California on the day before Christmas, 1956:

. . . and my left eye is to the sea, the Pacific . . . I'm fumbling in trying to find the truest way to express my embarrassed disappointment in having been of little value, and worse, a cause of grave apprehensions within Magnum . . . I am trying with all possible effort to disentangle from destructive circumstances.

And he wrote to Carmen, probably the same day, and began the letter with the same phrase, though it continued on somewhat differently:

My left eye is to the sea, the Pacific. There are onion stains, and stains from chili sauce in my right pocket.

This year . . . I cannot bring myself to call, for to do so would be filled with hypocrisy that could but aggravate the painful and the numb. I trust also that there will be no such inconsiderations as a stacked up delayed Christmas to be thrust upon me when I return.

He warned that he might send presents to one or another in the family, but separately, and hoped:

. . . there is not the usual amount of jealousy and pouting by others who might be left out . . .

I can almost assume ill feelings and resentments will be an involvement of my desire to cause simple delights. Is this bitterness?—Not truly, finally—it is more of a deep grief and a helplessness and a destruction that is of a climate of that place.

Early in 1957, he was still on the road photographing architecture, Jim Karales driving, with Smith just "picking sensuous forms from among the rolling storm clouds." He was rarely without three or four cameras dangling from his neck; he wore an old army fatigue jacket whose pockets were filled with lenses, light meter, and film. He was home by April, at latest. His heading for a letter written on "April 5-6-7 or 8th, 1957" was the usual keyed-up, strident joke:

From WES: Studio Perhaps
3rd Flight Place
Strapped-O-Feared, Incineration

He also called the house at Croton: Studio Redoubt (surely a pun was intended), Monstro Rock, Cave Inn, and Credo Place; he noted the "giggles and screams and washing machines" and the TV on all day. He had to overcome his inner revulsion and write to Edward Thompson at *Life,* to convince him of the value of the layout he had labored over so long in the noisy rooms of his fortress at Croton; this ten-page letter to Thompson relates, with considerable digression, and somewhat vaguely, his life from boyhood on. Thompson replied to Smith's viscous prose with cool and practiced patience; he had looked at the photographs and thought that while the Pittsburgh essay was very good, it was not in a class with the "Nurse Midwife" or "Spanish Village." He still thought that publication in *Life* was possible, however:

I can only say that Bernie [Quint] and I worked on this with all the sympathy and understanding we were capable of. . . . If you decide to withdraw the essay I will feel sorry but not entirely inconsolable. . . . And as I said to John [Morris], I think that if you expect editors, art directors and writers—all of whom have some necessary qualities which you haven't—to abdicate completely, this does not seem to be consistent with your concept of yourself as a generally agreeable, human guy.

Smith's original layout would have required 40 pages. Thompson's opinion, expressed later, was that "Gjon Mili was a good self editor—Smith was not. He would imagine overtones and connotations that nobody else could see. Gene's idea was to have an idea, but he really didn't have one." Bernard Quint at *Life* had worked out a Pittsburgh layout of 13 pages; *Life*'s payment would be $1,000 a page—less than *Look*'s offer, but still substantial. When Smith inspected the layout in Thompson's office Quint said, "Are you happy now?" Smith got up, and without a word, walked out, according to Thompson, "not having said no, but not having said yes, he was so upset." Thompson took it as a refusal to accept the terms.

By August, 1957, Smith felt that "the decline and fall of Smith was about complete." He was living on Magnum's money, mostly, plus Carmen's and Jasmine Mosely's earnings. How desperate was the situation? One doesn't really know; the arithmetic is missing. Magnum held an executive meeting, and after hearing John Morris's account of hunger and despair at Croton, voted yet another advance. The Pittsburgh essay was still unpublished: "an infinite failure." Smith had almost certainly separated from Carmen for good by this time, and he had rented a large studio loft at 821 Sixth Avenue, between 28th and 29th Street. It was up one flight of stairs, and his door had a sign with an enlarged thumbprint and the words: "NO ANTICIPATION ALLOWED." It was, and was to become even more so, a bitter refuge, a self-imprisonment for his failures:

I have a dirty loft sort of workroom in New York City . . . This place I use for trying to do layouts and otherwise to keep thought grips a 'movering. For all that I have accomplished in it I should call it slush-pool and think of it as filled with honey and sludge. My life has become a curious mockery of strenuous effort amid worthless result based upon some of my gentlest and finest work. My life has become of dank despair from the corrosive elements which hobble it and which cost it the strength to utilize its strengths.

By the end of September, incapable of remaining passive, he had begun a lyric essay on what he could see from this downtown city loft. What made it interesting to him was that, in the course of this work, he knocked a tripod down and smashed the window; and he was charmed by the pattern of splintered glass and void. He wrote Allen Hurlburt at *Look* on September 26, 1957:

I have not forgotten of that window from which to glance (and as you shall see, sometimes to crash through); and now, finally, after turning the music up to a volume sufficient to at least confuse the sound of other demanding voices, I have managed to pay an insistent attention to the singular intention of defining and confining within a short essay something of that which I have experienced through glancing from this particular window. A window which is, of course, merely a specific physical location for observations blent from all of the window-window-less sense-forces ingrained into the perpetual formation of my life. And the essay, although done with keen delight, is a fully serious one.

He called this new work "As From My Window I Sometimes Glance."

John Morris gave the work some mild criticism; he thought the frame of the window ought to be partly visible; to which Smith replied in his now characteristically turgid style: "In this essay as held by me with its inter-modulating fragility casting a spell it is essential that the crude four square dead point inferiority of such an intrusion should not be allowed to harshly intrude." The little essay was taken to *Look,* which turned it down. Smith's son, Patrick, won prizes in two teenage photographic contests, but his father had a very lean year indeed. Aside from eight photographs of architecture in *Life,* and one in *Fortune,* and a few oddments elsewhere, Smith had no public career. His photographs from the height of the loft down to the New York street are only physically focused on the outside world; in their melancholy tone, they look inward, in the sense that a prisoner looking outward through the bars really looks inward at himself. So Smith himself wrote in a fragment on October 9, 1957, unfinished and probably never meant to be, and addressed to:

Dearest—all of you are! . . .
 The dead frog's legs did jump in the frying pan. I am still full charged, eager and anticipating, rucking up a high thrust fling—tang these coattails for they have a flirtatious arrogant lilting fling. Fling—as in flang as in flung, and with this of the senseless we are hung . . .

In its merry play on words, the fragment of a letter is heartbreaking:

A giggle is no evidence of happiness . . . I am a robber—I have never known an individual I have not been the richer for—but who is to relieve me, how am I to escape from such owing that I cannot survive.
 I glance from my window, but I cannot go out; I cannot go out!

His grandmother, whom he loved almost as much as he did his children, died in Kansas; she left Smith a $500 bond. Smith did not attend her funeral. He wrote to his cousin, the country lawyer James M. Caplinger:

From "As From My Window I Sometimes Glance," 1957–58.

Somehow this has reminded me of my little-boy-visiting-Grandma time and the fact that a great love of mine was to get away into the parlor and play that old piano-organ that she kept there for many years. I would play until the torture of it upon the nerves of the adults made them come and order me to stop and to forbid me to start again. Long I had wanted and asked for—that someday I might have that piano-organ.

And about the bond:

In the present situation, which is as immediately desperate as is the loss of home, the pawning of my working equipment, and of actual hunger—I wonder (I hope not greedily) about the bond you did men-

tion. It might for another few days stave off a foreclosure, or keep some equipment from pawn—it would work no miracles but it could be of help.

Although he had gotten a second Guggenheim, it only postponed the crisis. By Christmas time, he wrote to his Uncle Jesse in Kansas:

I sit here, very near the final shattering unless a couple of mankind of miracles can be worked, and I am sick soar and desperate, whithered in exhaustion and daze and despair. . . .

I am so desperately tired, so doubtful I can continue much longer for them—perhaps as short as tomorrow.

16. *"An artist must be ruthlessly selfish."*

EARLY IN 1958, the miracle happened. Bruce Downes of *Popular Photography* had seen some examples from 13,000 5x7 proof prints in the still unpublished Pittsburgh project and had offered to publish Smith's prints with his original layout and text, without change, in their *Photography Annual* for 1959; the contract insured that Smith would have to approve the captions. There were only two difficulties: Smith's layout had all too many prints that on a crowded page would be too small to be effective; Downes wanted to have larger and somewhat fewer reproductions; Smith was properly furious, but eventually came around and agreed that Downes and his co-editors were right. The second problem was that Smith was supposed to write the text to go with the layout, but delayed so long that the editors of the *Annual* were truly frightened. Smith wrote: "I am quite desperate in tiredness." It is difficult to know why he was so fatigued, for his output that year, too, was negligible: a short piece on children, mostly his own, playing in a summer lake, for *Sports Illustrated,* and the brief *Life* essay, with portions from "As From My Window I Sometimes Glance," done in 1957. One guesses that his exhaustion had deep physical causes; and one of them was that the remedy became the problem. He would prolong his supply of mental energy with chemical energizers, and then, unable to sleep or rest afterward, would wind down with still another chemical, alcohol; and the cycle was ab-

normal and exhausting.

Downes must have criticized Smith's original text, still incomplete; he said it was not English; Smith was bitter about that insult and compared it to the pretext given by *Newsweek* when he was fired 17 years before; but eventually two other men, Hershel Sarbin and H.M. Kinzer, plus Sam Holmes of the Magnum staff, rewrote and finished the text for the *Annual.* Smith hated the result:

I dislike being ridiculed for that which my name is hung on but which has been improved until it no longer actually represents me. Yes, I shall swallow pride and integrity.

And he quoted what he should have said, thereby saying it, of course:

My available words are the only damned available words in all of the obscenity world, in being available as Smith words. If you find these ludicrous, impossible, beneath the greatness of your standards—well, by damn, I should say I don't care what your deadline problems are, you're not going to pervert my words into the intelligence necessary for your magazine.

His literary ego, a trait of all writers, but particularly novices, was injured as was his integrity. He was caught in the old dilemma of the artist working, not merely for a patron, but for a patron who must then resell the work to the public. The job of the editor

is doubly difficult, because he is cursed by both sides. Bruce Downes said, some years later, "My experience with Gene on the Pittsburgh story in the *Photography Annual* was excruciating." On the other hand, a publication more courageous, because less dependent on sales, might have boldly let Smith's text stand as it was, turbid and emotional and sometimes impenetrable, because it was a kind of poetic chant whose overtones, if not the central meaning, were characteristic of Smith's genius at this period. The final text, though, was a compromise, and Smith was "not happy with it nor with himself." He wrote to his friend Ansel Adams, in November of 1958: "A personal apology to you (and thus to photography) for the final failure, the debacle of Pittsburgh as printed . . . after four years of excruciating effort . . ." He had written, during this crisis, a most extraordinary letter to Nancy Newhall, the photographic historian, which could not be called lucid but which is touching because it is so brutally self-perceptive; it contains bitter puns:

And lived is the devil, backwards—and the same can be said of live evil. Dam, mad, tug, gut, eros, sore . . . Nema—he who does live the evil ways of Eros the Sore, having lived thus, is to be consigned to the devil. Amen.

And finally: "Purely, can it not be seen, insanity's bright blight?????"

The published essay has Smith's characteristic flaw: too much weight of moral meaning on too little visual support. Still, Smith's view of Pittsburgh does convey something else: a city that for all its mechanical energy lies soporific in its banal culture. Indeed, according to Aileen Smith, his second wife, this is what Smith really intended. Robert Harrah, in his memoir, recalls that in 1948, "Gene told me to turn off at Pittsburgh, saying, 'There you are, Robert, the man-breaking city,' "—or was Smith more explicit?

In May of 1958, Smith was, improbably, at work in Haiti. Through John Morris, he had got an assignment from Dr. Nathan S. Kline, a psychiatrist at the Research Facility of Rockland State Hospital in Orangeburg, New York. Dr. Kline's interest was in research with psychotropic drugs, and he was establishing a free clinic and hospital in Haiti, with that government's assistance, in order to pursue his experiments. Smith had certainly had experience as a patient, and not only for his physical ills; in April of that year, he wrote a strange apology to Dr. Frederick Wertham, a famous psychoanalyst of the time, for not telephoning him "during the morning of Wednesday, Thursday, or Friday for reason of having worked late each previous night." This suggests that Smith had a whole series of appointments; was it for consultation on the Haiti project? Perhaps, except that: "I did not telephone for no truly helpful rest can be achieved." On the other hand, Dr. Kline remained Smith's friend and physician for many years, and prescribed amphetamines for him when he needed them.

Smith was impressed with another doctor: François Duvalier, President of Haiti, whom he described "with an open and read Bible on his desk, and a history book and a book of medical reports—and on a table directly at his side, on a white cloth, a holster and the pistol from it laying neat and close and turned for quickest use." The plain truth is that Dr. Duvalier was a cynical dictator who had imposed a regime of poverty and murder exceptional even for the Caribbean. Did Smith know or even suspect this well-known fact? He probably did, for at this time he wrote: "One, who leads the good life, an honorable and faultless pillar of righteousness [is] decadent before a less perfect life that is of a living even flawed. . . ."

As ever, Smith's Haitian prints go a lot deeper than any possible caption, even his own. They were published, obscurely, in the *Roche Medical Image* for April, 1960. The schizophrenics squatting on the wet concrete of their sheds; the catatonic woman in her torn blanket, lying awake on the bare springs of her cot; an extraordinary lunatic man looking through bars with a stone tied to his face in some private magic—all those people were possessed, not by the benevolent African pantheon of voodoo, but by their own hideous imagination. All these images, this theater of the diseases of the soul, move and frighten us—perhaps too much. One of Smith's prints has become especially famous: the face of a woman staring upward at nothing; the print, which originally contained a half dozen other figures, was manipulated by Smith so that a single face is isolated against total blackness. It is debatable which print, before or after this darkroom dodging, is the more truthful; the altered print is certainly more theatrical; and one rudely wonders if Smith did not see himself in this person, rendered heroic in her lonely madness.

In October of 1958, he wrote to George Hunt of *Life*, apparently in response to hints that they might rehire him:

The thought of again doing any work with *Life* brings the dry acid ash of discoloring apprehension to any thought of the potential that the magazine's "greatness" might appear to offer me.

But he was willing to try, provided that he have control of his own published work. *Life* refused:

I have read and reread your projected "contract," and I must say that such an agreement based on both tangible and intangible matters of editorial judgment is virtually impossible to draw up satisfactorily. In a way I think that such a document makes a kind of mockery out of the very basic tenets of responsibility and integrity.

Smith wrote several people, asking for money in his desperation; he wanted anywhere between $5,000 and $30,000. His begging letters were swollen litanies of pride and despair; one letter he wrote to Leopold Godowsky (March 17, 1959) contained 16 single-spaced pages and some 8,000 words: the egotism of the victim. Smith could not tell anything, at that period, without telling everything. He owed money to Magnum, of course, or he could not have gone to Haiti several times; and it hurt his conscience. On Christmas day, 1958, he wrote yet another four-page chronicle, to John Morris, that began:

The mimicking spleen, the manners and the corruptions; the wringing thoroughness of the perhaps mad, within vanity and the Absurd: the lusting and wresting and shunning within dreams gendered and engendered: the disfigurement of those rivened by an absurd edit of alive eros has been purchased through the tide of an evil sore inspirited into a tragic proof.

And he continues with the mortification of the true sinner:

Threnodic castigations by the gravely depressed, manic-manifesterings, breast beatings—mea maxima culpa—melodrama from the long drink: no—I do not learn, or love, or close out beliefs through gentle process . . .

—and so on and on for another three pages, a veritable (to invent a Smithian phrase) toxemia of words. And all of this was a preface to his resignation from Magnum—although he'd still want them to place his photo-essay on Haiti. On December 30, 1958, John Morris was understandably saddened:

My dear Gene:

Often I cannot understand you with my mind; but I feel I do understand you with my heart.

So it is with the letter which came from you today. I do not entirely comprehend your words, but I knew, almost even before I opened the envelope, what you were going to say.

One great satisfaction, during these next years, was Smith's experience as a teacher. He had always attracted, and been attracted by, young people. There was something of the battered old saintly prophet about him, especially in this youthful decade of the late fifties and early sixties. Helen Gee had a show for him in 1957 at Limelight, her modest gallery in Greenwich Village. (The show took place a week after the scheduled opening, incidentally, because Smith had not delivered the prints in time.) Helen Gee was astonished at the thousands of young people who came. "He was a hero to them." To his students, he was invariably patient, witty, inspiring; he enjoyed them and helped them. As anyone who's taught seriously knows, students force one to clear the fog of one's own assumptions—as well as theirs. The course Smith gave at the New School in New York was brilliant; he called it "Photography Made Difficult." The ten sessions began in October, 1958. His opening notes have been preserved:

One of the reasons I say difficult or complex—is that one can do with quick seeing—or cleverness of seeing. We can be considered successful. He who sees so quickly will finally not penetrate beyond outward physical characteristics.

This is the effort I strive for finally, to see beyond the physical characteristics. Philosophy I evolved during the war. That the mission was bound to be a failure, but failure as small as possible. It prevents me from becoming lazy and carries through to everything. A good print will take a long time. 300 prints are possible in routine work. All is an attempt to give more meaning.

The second session, a week later, still scintillates with photographic ideas:

The highest function is to make people see things they have not seen before. . . .
 To achieve, an artist must be ruthlessly selfish. I wish I could put this into effect. To be as selfish as my passion demands.
 I don't believe photography has to do with realism. Because form is recognizable does not mean it is reasonable.
 I will try to be honest; I don't know if I can be truthful.
 Keep tension up. Sometimes it is necessary to shoot several rolls to break down defenses.
 The final moment is something you build up to and accomplish quickly. This is true of people and wilting flowers.

His assignments were not easy:

Light reveals, light blinds, light is warmth, light is spirit. Light has meaning. I would assign to you the effort to give me an iota of the meaning of light to you.

Students very often attached themselves to him after the course was finished. He himself said, "It's hard to get rid of me," but he advised them to leave after a year. They didn't always behave very well; there was a peculiar ethic among certain disciples of the sixties that anything they really wanted or needed, they had a right to take. They swarmed all over his "dirty loft of an ivory tower"; and many, he thought, behaved badly:

There have been those who have come to my door, usually seeking help and advice, but my doors literally have been broken down only by thieves—and some of the thieves have had keys, and have gone forth crying that I have injured them, possibly by not bleeding totally for the satisfaction of their wanton greed. I have had students who insisted themselves upon me who later have said that my very place with all it contained made it almost impossible not to steal from me. And they, I guess of this age, did not seem troubled or ashamed of such confession. I have let known thieves off, hoping that kindness and friendship would give them a faith in decency. This seems to have led only to a situation in which they ridiculed my "weakness" and convinced others

to likewise "take-me," as I "would not prosecute them." I should have killed them for what they were, and are. I didn't, but I thoroughly warn others who may attempt to follow that they do so at their own risk. Certainly I am going to thoroughly prosecute.

But he never did. His version of these robberies may not be accurate; it's more likely that some were the work of the addicts who visited with the jazz musicians jamming in the loft upstairs.

In one case, though, his trust in the young was rewarded, and generously. Early in 1959, he was looking for an artist who would help him with the layout and preliminary sketches of a large book he hoped to have published by his old employer, Ziff-Davis. A friend named Eve Young, ex-wife of Dave Young, the painter who lived upstairs, mentioned this opportunity to a young student at Cooper Union, who had already done scenery and costumes for the stock company that was later to produce the musical *The Fantasticks*. This gifted artist, Carole Thomas, was only 17, and at her first meeting with Smith was overwhelmed by his personality, a singular combination of the mild, shy, and intense; she was strongly moved by his photographs, which she had never seen before. The book he planned would contain a large selection of his work, not, he said, to celebrate himself, but to "show the state of the human condition," and demonstrate that "we have a choice as to how to live." Carole Thomas, brought up in a cultured and middle-class family, was characterized by Smith's old friend, Valens, as sweet, pretty, exceptionally bright, with a strong will of her own, "and not easily kicked around." But Smith's personality was powerful and persuasive—and charming because it was leavened with a playful sense of humor. Quite naturally, the intellectual attraction merged with the physical, and eventually Carole Thomas came and lived in Smith's loft where she stayed for the next eight years. He gave her cameras and taught her to print; she abandoned painting, and her own young career became absorbed into his. Smith demanded more and more of her time and attention as the association went on. One can deduce the change from two notes—probably months apart—that Smith kept in his files. The first is all business, and hand printed:

Dear Mr. Smith,
 I delivered your "note" to Schiffer. He is a bit upset. He was infuriated enough at one point (while saying he couldn't put up with it anymore to be exact) to pound his fist lightly on the nearest wall. Then he quietly and sullenly sat in a corner and typed this letter. I fear it is a "Dear John" letter.
 Carole

P.S. Seriously, I hope it's not another bad turn.

The reference is probably to the ongoing arrangement with Ziff-Davis. The second note, about a year later, is financial, too, but the tone has become considerably more personal:

Jeff called at four said you should try to get in touch with him tonight . . . Must know what happened about check before that time. I will be there (ungrouchly—okay?!!!) toes and all by 9:00 to shake you awake. There is a peanut butter sandwich and a make believe malted in the refrigerator.
 Carole

Certainly by mid-1961, when she wrote "Gene and I" in a business letter, Carole Thomas had become deeply involved in Smith's money problems. He had never been able to handle them by himself, whether he was prosperous or not; it is after all a matter of simple arithmetic to put debt against income and arrive at a minus or a plus, so obviously there was, for Smith, a tangle of emotional barbed wire around the subject.
 The death of his mother in 1955, and that of his brother, Paul,

in 1958, cut the last intimate ties with his boyhood family. Nettie had written from Wichita (not dated, but probably about 1954): "Dinner at Paul's last night. He is, to say the least, 'mentally disturbed.' Were I not sorry for him—though he is getting what he deserves." The truth was that Paul was suffering from the brain tumor that killed him at last. Again, what were Smith's feelings? He wrote, probably to himself, because the fragment is undated and unaddressed:

Twice in two years I had now returned to the city to see my brother there. Twice now at the edge of a grave. It was bitter cold two years ago as my brother stood at my side, wearing a thin jacket worn with its purpose in work. In this cold and this thin jacket he stood with me watching our mother quit to her grave. Numbly, I wondered if the grave could reconcile her with the man that had been of her life.

There was still the miserable problem of whether the money he had borrowed from his mother, and scarcely repaid, was a loan or a gift; he wrote that he always felt it was a loan, but quoted others who had assured him Nettie had always meant to give it to him; "Damn money!" he wrote to Uncle Jesse. Yet money, unfortunately, is more than a symbol; it's the lubricant of modern life—a fact that Smith could never really accept.

He wrote a letter to Carmen (a draft, and possibly never sent):

Dear Carmen,

Tragic souls, spirits, wrecked on frustration rocks of their own inability, or unable to cope with the continuing complex bindings of existence, are invariably demolished in the tempest between the plague of "requirements" for living . . .

You are a good woman, whatever your inability to help me in certain vital areas—you have tried, and basically are a good wife, you have stood and suffered much you should never have had to.

Meantime the payments on the mortgage on the Croton mansion were chronically overdue; Carmen carried the burden of trying to postpone them. At last, she made the inevitable move, and sold the place for $27,500, in late October, 1960; she spent most of the money paying old debts (one bill, to Peerless Camera, was overdue four years) and moved herself and the children to a farmhouse near Cold Spring, New York. Smith, more and more absent from his family, was generally certain to be home at least for Christmas. Shana, the youngest, thought he was Santa Claus, because this visiting stranger had a white beard and drove up to the house in a rented red Volkswagen with assorted gifts. But he didn't arrive at the new house for Christmas, 1960. His self-portrait, written to Carmen, was black with guilt: "Fused and confused within me, was the stuff of a man of greatness—or of a distorted, monster of madness. Madness is my rendezvous."

One forgets, in the morass of Smith's letters, how simply other people wrote and thought. His oldest daughter, Marissa, who was married by then, wrote him four days after Christmas:

Dear Daddy,

What happened to you Christmas Eve? Everyone waited for you . . . till after 12 o'clock but you didn't even know, let them know what happened. We had told Shana that you were coming and she waited for a while but then she went to sleep and she was so disappointed to find you not here. No one expected you to bring anything so if that was the reason you didn't show it was a pretty stupid one . . . Everyone is mad at you for doing that to Shana but I guess no one has to tell you that. We are going to have a small party for Shana's birthday if you want to get her anything she wants a bicycle two wheel and a record player with all the speeds. And if you wanted to get Mommy something in the future when you do have some money she needs and wants a gold wedding band size 4-½ it doesn't have to be expensive but the one she is wearing is from the 5 and 10 and is going to turn her finger green. The one you gave her is too big for her.

Well that's all for now.

And then, to add to the spurs of his conscience, there was his son in Philadelphia, now six years old, and unknown to his half-brother or half-sisters. Smith escaped all these problems, in 1961, by going to Japan with Carole Thomas.

17.

"You do pay your plumber more."

IN JANUARY of 1960, Smith got a letter from Richard Okamoto in Tokyo. Smith had been recommended to him by his brother, who was an editor of *Esquire* and an admirer of Smith's work. Okamoto was associated with a new firm in Tokyo: Cosmo Public Relations. Hired publicity of this sort was still unusual in Japan. They were trying to put together a campaign for one of the giant Japanese corporations, Hitachi, and needed a photographer. The fee for Smith would be $25,000, and they also quickly agreed to pay living and travel expenses for Carole Thomas as well. Okamoto hoped to have an international exhibit, plus a book illustrated by Smith. He accompanied this proposal with a more personal note, reminding Smith of a 10% agent's fee of $2,500 that, at Smith's insistence, he reduced to $2,000 when Smith pointed out he was obliged to pay the Japanese tax of 20%; Okamoto also offered to underwrite repair of Smith's teeth.

The contract negotiations took a long time, and there was no signed agreement for a whole year. The reason lay in the structure of the Japanese economy; the government had to approve anything Hitachi did because, in fact, the distinction between government and industry was and is rather blurred in Japan. "The Ministry of Finance expresses awe at the substantial sum," wrote Okamoto. The contract provided that Smith get to Japan by the middle of March, 1961, and begin photographing on April 1. Hitachi had meantime agreed to all the other provisions. They stipulated that Smith would deliver his prints and negatives to Hitachi by May 31 "or as soon thereafter as possible." However, Smith was assured he would not be held to any rigid time schedule, a limit which he feared and detested. By midyear, Okamota had quarreled with Cosmo Public Relations, claiming he was being brainpicked and slandered; but he got to keep his share in the Hitachi deal. He pointed out, in a letter to Smith, that the idea of Carole accompanying him was incomprehensible here. The Japanese feeling, of course, was strong that womanly attention was anything but lacking in Japan. A new contract was prepared and signed by Smith on August 1, 1961—19 months after the initial proposal. The delay was due to a confidential report to Cosmo in Japan that Smith "could not be relied upon, etc., etc.," and to the rumor that Magnum had offered one of their own photographers for less than half of Smith's fee. However, the advance of $10,000 had already been given Smith, though what he had used to live on during the long delay is still unclear.

Smith and Carole Thomas flew to Japan on September 25. Smith's cable was strictly in character:

WE ARRIVE SOMEWHAT APPREHENSIVE OF THE SITUATION STOP REMEMBER I SOUGHT NOT BUT RECEIVED THIS INVITATION WITH TRUE DELIGHT

IN ITS CREATIVE CHALLENGE STOP I BRING TO IT THE KIND OF SCARED INTEGRITY WHICH IS EVER MY COMMAND . . .

Carole and Smith spent a full year in Japan; the assignment turned out to be very imposing, because Hitachi, the largest firm in Japan (and the seventeenth largest in the world), had at least 25 factories and two large research facilities. Smith was not too happy, but was he capable of happiness any longer anywhere? His letter to Richard Okamoto, four months after arrival, played the usual adagio expressivo:

Seldom during these wary, oft sad, mixtured days do I dare the time for a letter . . . or for matters of sleep or health.

It has been a regretful year for many of us . . . Never have I departed on a major project . . . with such a foreboding sense of apprehension and sorrow.

But he was:

. . . quite determined that if winged "integrity" is feather burned and grounded it shall persist in mind and heart and prevail even if on crippled legs.

And after your accusations against Magnum's part in the situation of delay I called Magnum (and in trust of you accused them according to your claim) . . . Fortunately I recorded these conversations and have them all on tape.

For one of Smith's grim amusements in the loft on Sixth Avenue was to record his phone conversations.

The work itself, accomplished by Smith with Carole Thomas' assistance in developing and printing the hundreds of negatives, is a superior form of commercial photography. He chafed against the task; his moods were stormy or sad; and his way of working was naturally erratic. Though the Japanese had given him an advance man to calendar his appointments, Smith ridiculed him as "Mr. Schedule." Yet the industrial interiors, particularly those with illuminated dust or mist, have a romantic quality that anyone who's worked in a large metal factory will recognize as truth; the cataract of noise is naturally missing. Whether these prints show Smith's "inner truth" is questionable. In this series, workmen and workwomen are almost anonymous, without the personalities he discovered in the Pittsburgh steel foundries. His studies of people, not in the factories but in homes and village streets, are more respectful and more beautiful than his brilliant abstract patterns of machinery and merchandise. The work was made permanent in a book paid for by Hitachi, with an ornate introductory text by Smith, and with the strange title, *Japan: A Chapter of Image.* It was published in 1963; *Life,* the same year, used 13 photographs in its issue of August 30, and George Hunt, an editor of *Life* at that time, prefaced it with a portrait of Smith and the note: "To Gene Smith: Welcome back!"

On September 18, 1962, Carole Thomas and he took a Japanese steamer back to the United States. Still on shipboard, October 8, 1962, he wrote:

It has been a curious three month year—but in one way boring—for I am returning in much the same condition of tired, tense, and apprehensive—and, I might as well say it, broke. To shrug my shoulders sums it up as well as anything.

The letter was to the husband of a Mrs. Ruth Fetske, a plump, exuberant woman who had been a student in one of his classes. Mrs. Fetske, without compensation, and out of the admiration and affection that Smith got everywhere, had taken care of Smith's affairs for nearly a year, seeing that his rent was paid on time, and moving his stuff into temporary storage in the freezing weather. Smith felt he had cheated Carole by promising a leisure period just beyond the next task—"but somehow it takes me much longer

to achieve my mediocrity than it does most." But he must have rested on the long voyage to New York, for he now had time for puns: "Hitachi (and she ran). It's a joke. Isn't it?" And: "Enough of this lead kindly blight" for "I cannot depend upon diplomask or mythconception—nor can I be sure between the deft and the dumb . . ." He also wrote the date and pier of his arrival in Brooklyn, and warned Mr. Fetske that: "I really would feel embarrassed with any big welcome . . . and I would like to come in as quietly as is possible . . . If you know anyone with a few extra Dexedrines I could use them upon landing—the Japanese substitute has been murderous." What's more, there were 89 bags and boxes and Smith hinted that he didn't have enough money left to remove them off the pier; why he should be so poor after getting all expenses paid by Hitachi, plus a $25,000 fee before taxes, is, like Smith's finances in general, obscure. But it was a thoroughly Smithian way to come home to his "Loft of no anticipation."

During different periods over the next ten years, Smith used various combinations and levels of the loft building on Sixth Avenue, but it was not a mere convenience. Like everything else that Smith touched, including other people, it bore the marks of his rich and passionate and confused and selfish character. The staircase up from the street door had a wall that Smith decorated with a broad Magic Marker; there were drawings on the walls upstairs, even (a sort of black octopus) on the floor. The cruder, less skilled drawings are Smith's, although he let anyone draw anywhere they liked; his children had scrawled over the walls at Croton, too. More skillful drawings, generally of nudes, were done by the upstairs tenant, David Young, an artist and composer. In the wider and longer loft space, there were vertical boards set up to display the layouts of Smith's prints. All the space between was cluttered with camera equipment, assorted magazines, and 11x14 and 16x20 Varigam boxes containing his prints. Smith saved everything, but could rarely find it afterward; the order may have been in his head, but his head was often unreliable. At one time, there were seven cameras on tripods facing outward and downward through a window; his eye was always on the alert for something happening down below. He was said to have exposed a thousand rolls through the windows into the street.

There were many prints of his own strewn over the couches, tacked to the walls, and even taped to the ceiling. One had to thread one's way through a confusion of thousands and thousands of phonograph records and old magazines stacked in piles so high they seemed to support the sagging ceiling. Several microphones were taped to the ceiling too. One of his telephones was wired for recording; and old tapes were strewn everywhere. Smith was fascinated by the random arrangements in the loft, and they represented a good cross section of Smith's life. One of the photos he took shows a drawing at the left, then an enlargement of the famous Spanish death scene, and below that, an overstuffed open file, a live black cat, and a pair of earphones. Another arrangement has a fan-shaped broken piece of mirror reflecting a mike hung from the ceiling, a drawing of a nude on the wall, the printed words "TRAUMA" and "GOYA," and the admonitions "Anything Is Possible" and "Anger Has No Real Drama," plus a music stand, and a violin bow.

Smith did attempt to learn the violin, but could never master any instrument: a cue, perhaps, to how he listened to music. But, in that typical realm of the amateur, he did some hundreds of paintings during his decade in the loft; they are crude and mock-ferocious and have some resemblance to the Haitian voodoo carvings; one, in thick impasto, has the ironic title "Good News, God Is Love." A living space, and particularly a working space, becomes a projection of one's self as time goes on, of one's desire and one's neglect. The profligate confusion, and the outright dirt, garbage,

old forgotten sandwiches, and the consequent evil smell in the loft, struck every visitor as if with the force of a personality.

James Enyeart, who eventually became the head of the Center for Creative Photography in Tucson, was taken to visit Smith by Lee Witkin; Smith sat in one corner of the loft, spotting prints. He would put the small brush into a glass of scotch, then into his mouth, then into the spotting fluid, then onto the print, then into the scotch again, over and over as they talked. Smith, once the shaven and showered all-American boy, now wore one shirt and one pair of trousers for weeks on end. His mind, in this large overcrowded space, wandered around inside its internal parallel; his crowded brain created in all directions and in several art forms, though not necessarily well. He wrote at least one play, which exists in summary, about "Wes" and "Jean"; there's a good deal of honest fact in this fantasy, though very little dramatic talent; it was written, one expects, to purge old feelings. That was true of another undated fragment:

He crept up the stairs, the flame liquid consuming his guts and life, he reached two-thirds, and if he could still see would have been able to sight the little room in which he was spawned from a God-fearing, sex-hating mother. In the morning they found him, they called him coward . . . this man that murdered himself, or did he?

He had created, however awkwardly, a fantasy of his own suicide, instead of his father's, in the boyhood home in Wichita. He also wrote several short stories, more words than narrative; but what was far more interesting is that he began to do a whole series of experimental photographs. Some appeared to be the traditional darkroom manipulations, the flow of chemicals across a print. Others are darkly symbolic, shadows bent across a floor and a reflecting wall; and one is of a man's hairy crotch, legs astride, with the penis thrust into an old-fashioned meat grinder, with the ribbons of meat flowing out into a bloody pile; the latter he referred to as a valentine; its date, and therefore position in his amatory life, is not surely known.

He did a tender series of portraits of Carole Thomas, including nudes and semi-nudes. One shows an amazingly orderly room behind her; she had, out of desperation about putting in order the rest of the loft, cleared this private space for herself. She had tried hard to make life regular for Smith: daylight work schedules,

dinner on time, and some degree of discipline in his possessions; but the system broke down over and over again. Nor could she get him to cut down on his heavy consumption of Dexedrine; he would grow furious at what he considered her interference with his way of life, which, in her words, leaped "from crisis to crisis"; and the very strain of such an existence, she thinks, may have actually energized him to work.

During the same period, Smith made a surprising series of erotic photographs: he hired a couple as models, who were accustomed (and used by other photographers) to stage vignettes of this sort. One admirer, "Marsha," wrote on July 31, 1970: "I was so moved looking at your things at random—particularly those few small erotic ones." In one photograph, there is a pair of steel handcuffs, leading one to conjecture, not irrelevantly, how strong the color of masochism was in Smith's humanity. The famous collector Arnold Crane loaned him $600 on January 27, 1969, taking Smith's pawn tickets for cameras as security. Their rather harsh agreement was that if Smith could not pay interest on principle on the loan, Crane would keep the prints he had taken on consignment. Almost a year later, Crane wrote that he was indeed keeping the prints, since Smith, naturally, had not paid. Crane added: "Have even shown your erotic photographs to the delight of many and my wife the most." Smith was furious:

If I made photographs you weren't a damn bit interested in perhaps I would have had enough money to spend Christmas yesterday with my children and my grandchildren. I might not be now expecting my lights and heat to go off perhaps even before I finish this letter. Perhaps I might not be dreading the ring of the telephone (while hoping the telephone itself has not been disconnected)—dreading that my landlord will legally threaten my very existence here.

Smith's just complaint was really that Crane was buying his prints at only $30 each: "You do pay your plumber more."

Smith's aesthetic rambles after his return from the Hitachi project are not particular to him. Many photographers reach a slack period in their professional lives, almost as though the very multiplicity of their images has exhausted their capacity for seeing. Their creative drive is still healthy—stronger, indeed, for their frustration. They do other things, often incompetently, till they regain their grasp of the visual world. Smith, in his long exile in

the loft, had already begun "The Book," for which Carole Thomas had been originally co-opted. In time, there was a great deal of interest at the Swiss magazine *Camera,* especially by its prominent editor, Romeo Martinez, who even put up some of his own money in vain to get "The Book" published. The project was very large and its language very strange and elaborate; it remains unpublished; one day, perhaps, it will be printed, like the *Jerusalem* of Blake, as the idiosyncratic proof of an angel wounded by the world.

Smith embarked on a second venture with Carole Thomas: it was to be a magazine of the arts, but particularly photography, splendidly named *Sensorium.* Notes for the magazine show it to be a journal to exploit Smith's lifelong ideas:

This magazine—let it be understood: its clearest birthright is from photography . . . its dialogue is of human affairs . . . its most personal language is the word and the photograph. The single photograph, and the photographic essay.

The first number was to include a reprint of Smith's operatic explanation, again, of "The Walk to Paradise Garden." Though they worked at this project for at least a year, it was abandoned when they couldn't even raise enough money to pay the layout designer, William Booth, an overdue $280.

There is nothing special about this sort of disappointment, though it is more exhausting than successful work for, again, every creative person has many plans, but only one lifetime. Smith felt these efforts to be progeny of himself, and it hurt when they were aborted. His physical pains and ulcers and ulcerations were recurrent throughout this long decade; he was hospitalized for a bad leg on September 7, 1965; and he spent time at Bellevue Hospital, in late 1967, possibly for addictive problems. He would deny the latter. On February 22, 1966, he wrote to the layout editor at *Life,* Bernard Quint, who had worked with him and who had been quoted in an interview with David Vestal, one of several journalists fascinated with the puzzles in Smith's life:

As for my being "sick"—I can't prove it for you or against me. I did take the article to a research psychiatrist with whom I have worked over a number of years—as a photographer not as a patient. Dismiss this as evidence but I am not displeased with what he said.

But Smith doesn't reveal what the psychiatrist said; the reference is undoubtedly to Dr. Kline, who was the source of the anti-depressants Smith was using. Still, Smith managed to do a small amount of paid commercial work, including photographs for Jack Daniel's, International Nickel, and a whole series at the Hospital for Special Surgery in 1966. In spite of its narrow subject, this series once more shows how Smith innately identified with the sufferer, the patient, even the dissected and bloody interior of a patient—and far less with the masked surgeon.

He did portraits of the jazz artists Buddy Rich, Duke Ellington, and avant-garde Stan Getz, and the great trumpeter Miles Davis; he also did some phonograph album covers of Earl Hines and Thelonius Monk for Columbia Records; all these were a special pleasure to him. Smith had loved jazz since the forties; it's worth remembering that this was no longer strictly popular music—it was an intellectual's joy: an advanced literary journal of the period, published by Parker Tyler and Charles Henri Ford, was called *Blues;* the early blues of the twenties was admired for its literary merit; second- and third-hand records were eagerly collected by intellectuals all over the world. Smith made a unique entry into this realm of jazz: David Young and Thelonius Monk were in the loft just above him, in the heat of a jam session, when they saw a one-inch auger biting its way up through the floor; Smith was drilling a hole in the ceiling so he could put his mike up into a better position to record.

In 1967, the publishers of *Aperture* agreed to do a monograph on Smith's work; and they met his customary delays, based less on simple inefficiency than on his lifelong hatred of authority; Smith had once again plunged into a vague and bitter controversy. His letters to the executive editor, Michael Hoffman, were more like manifestos:

I'm tired of politely swimming in the gulfs of mediocrity. I'm tired of knick-knack thinking [he had this obscure slogan Magic Marked on the wall of his loft] . . . I'm really no longer interested in allowing this book that you so politely and subtly insist must be synthesized with your continued effort to intrude those capable of giving me a beautiful book . . . I am perfectly willing to drop out of sight . . . I do not intend to suck the wounds of Christ in gratitude that I have been so honored with this chance.

In spite of all this fury, the book, with the aid of a third Guggenheim of $12,000, in April, 1968, and with a unique text by Lincoln Kirstein, was published in late 1969; it remains an extremely valuable study, with a lot of Smith's words, because it generally represents Smith's own painful choice of a hundred or so prints out of his scores of thousands. It was too much to expect that Smith would be happy, though; he wanted more photographs, and more money, and sooner.

In the fall of 1968, he was offered a job teaching photography at the School of Visual Arts in New York City, and next year, at Cooper Union. At neither place could he manage the two or three hours per week:

My failure as a "semester" teacher was even worse at Cooper Union than it was at Visual Arts. Those times I needed to attend to vital personal work became just as big a hang-up. The cost of these failures, and the time given to them, are just too much when I am in such a despairing state that all my off-duty hours are filled with squaring a few things away for suicide . . .

Let a wreck of a man drink his sulphuric cocktails.

The reason for all this acrid chemistry was not mysterious. In 1967, Carole Thomas, now 25 and no longer the naive teenager she was when she met Smith, had finally had enough of a life of bitter and continual crises. She decided she had better get on with her own life and career; she was exhausted, physically and emotionally, "tired of the darkness," and Smith no longer paid much attention to her needs. Yet he bitterly opposed her decision to leave him, and fought it with the two heavy weapons he had always had: pity for his miseries and fury when this plea did not work. Smith threatened her physically; she moved to her own apartment in New York City.

Smith had gotten, meantime, a surprisingly empty assignment from *Life,* in 1968: he was to do a study of hands. Smith convinced them that, for this project, it was essential to travel to California. Carole Thomas was reluctantly persuaded to give him some assistance there. And about the same time, he took the opportunity to fly into Mexico and get a fast divorce from Carmen on the grounds of "incompatability"; perhaps he hoped to "consummate the marriage that has been delayed for nine years." He wrote *Life* that "the 'hands' are going well," and that he had lost $2,600 in equipment stolen from his car, needed $3,000 for three months' rent and phone, another $1,000 for his divorce, and $2,000 to get his equipment out of pawn. *Life*'s reply was that they had already paid $8228.27 for his expenses and had advanced him $6,000 more against his eventual fee.

The divorce was granted December 19, 1968, and he kept, in his files, the car rental receipt and the airline ticket via El Paso —as if they were souvenirs. But the project for *Life* was never

published, and a New York City application for a marriage license was never used. Back in 1962, he had written about Carole:

She has worked a near miracle in restoration of my will to live, giving life back to my dead inner heart which has prevented me from sinking into that deathlike despair from which she raised me. There is nothing of convenience about the situation, the emotions have been honest ones—with their own qualities of health and unhealthiness.

That was still true seven years later, as Carole Thomas would confirm:

I knew both the best and worst side of Gene, not just the extremes but the nuances. There were contradictions—lovable qualities and the monstrous flaws in him that, finally, I could not tolerate. Yet, I also have memories of him as a tender, gentle and loving man—that I think is evident *through* as well as *in* his photographs. I knew the man with his child-like, electric delight in seeing and recording what he saw— yet he photographed not so much to celebrate life, but to challenge its conscience. I think that continuously looking at the dark side finally got to him, which is our loss as well as his.

She was forced, in order to avoid the persistence of his love, to leave New York City; and with $60 as her sole resource, she moved, in March of 1969, across the continent to California. Smith wanted her desperately to come back to him:

My health is running very rapidly downhill since Carole is gone—she is (was) so much more than just a love. Yes. My weakness of character. To be able to come home to such a beautiful co-working encouragement and sexual fulfillment of Carole—to be a partner with someone so much an only one as she was. With such a one it was very workable for one as shy as I to fight the right fights in a hostile world, and never to misplace integrity. To know that no matter how battered you were there was a beautifully compassionate understanding awaiting you . . . I do appreciate that she so wonderfully stood me and helped me for as long as she did. She somehow gave me the ability to fully love, unselfishly—she may need more experience before she can do this. That is my loss . . .

I doubt I can find another Carole to keep me alive. I doubt if I can find another individual strength. I know how battered and ugly my body is—shot up, crippled, so disfigured . . . that I have lost that love, have hurt my family as it has cost me. I must pay, I guess—but it is a damnation.

He wrote a former student, Wally Mac Gaillard, in California (August 5, 1969) on the letterhead of *Sensorium*:

Dear Mac,

I am so tired I don't know whether I'll last the night.

Carole is so far from me that there isn't reason to speak—but I still love her deeply—I am terribly concerned that she have every possible chance.

I have sent her enough darkroom equipment to set up a workable darkroom, I had to pawn cameras, write difficult checks, and rob my own darkroom to get even a minimal situation working for her.

The enlarger I think is wonderful as a traveling standby. The rest I have done the best I can.

The fact was that he gave Carole Thomas this enlarger (he had nine of them!) rather reluctantly; she had to press him for this equipment repeatedly, because it was the only way she could support herself. His letter to Mac Gaillard continued:

One other thing, I don't know whether I'll live or not, very lonely, and very depressed.

I'm trying to live, why I don't know.

I would if I could like to come to L.A. and try to set something going for Carole.

A deep enough story might even give me a reason to live. However—the point.

Is there any group in L.A. that might be willing to pay me enough to comfortably pay my expenses for a showing of slides and an expression of my still fervent dying ember?

In my dying embers I have enough sparks for another couple days of sheer relief.

All of this, somehow has to do with Carole, it mainly is that every integrity, every relief, for the past 10 yrs, has been an offering to her.

Help her Mac. I can't, I only love her.

Gene Smith

He went to California again in 1969; Mac Gaillard had got him several lecture appointments, to which he was invariably late an hour or so, and introduced him to his friend Dr. Schlesinger, who specialized in treating suicidal patients. The two men became good friends, and the doctor offered Smith his house for six months while he was in Costa Rica; but Smith refused. He had a crucial lunch with Carole Thomas, hoping to persuade her to come back to him; but she said no, again, quite firmly. From her mature point of view, she now saw him as a genius haunted by demons. But genius and demons, like one's dreams, are the invention of the self, and one is finally responsible for both.

Smith went back to his loft in New York City, in despair.

18.

"I love you all. I really do."

A YOUNG MAN, in a pink hat with a long, drooping feather, was introduced to Cornell Capa in the New York offices of the Pix photo agency in 1938; this improbable and unknown news photographer, a recent arrival in the big town, was Gene Smith. Capa saw him again in London, where Smith was reporting the Attlee political disaster while on his way to the Continent to do "Spanish Village." Cornell Capa was an excellent and humane photographer, who learned darkroom technique in Paris in 1936, using that famous device, the bathroom of a small Paris hotel; he did enlargements then of Cartier-Bresson's amazing early 35mm negatives and of his brother Robert Capa's first work. He joined Magnum after his brother's tragic death; and after "Chim" lost his life in Egypt in the 1956 Suez war, Cornell became president of Magnum. Now a small, plump, cheerful, energetic man, with a kind of Central European tolerance and sophistication, he founded the International Fund for Concerned Photography and edited their early publications. Hine, Bischof, Bob Capa and Chim—all photographers with a conscience—were promoted by the Fund.

Smith belonged with this group (though none were his close friends) so it was quite logical that Cornell Capa should propose a large retrospective of Smith's work to his friend, Karl Katz, at the Jewish Museum in uptown New York City. In March of 1970, he was able to write Katz that Smith "has risen from his period of hesitation and is ready to break through his cycle of the last fifteen years of going around in circles." Smith would perhaps not agree that he had lost his way since 1954, the year when he broke with *Life* about their treatment of the Schweitzer story; but he agreed to the exhibit enthusiastically. In the midst of long prep-

aration, hampered by the fact that many of the past negatives were filed somewhere in the loft and could not be immediately found, or found at all, Smith suffered still another not quite fatal catastrophe.

Smith had gone to Philadelphia to visit his son Kevin, then a bright 16, and looking remarkably like Gene himself; the resemblance was far greater than between Smith and his other four children. On the morning of August 3, 1970, Smith was walking back to the railroad station to return to New York, wearing, as usual, a couple of cameras hung around his neck, when he was captured by a black street gang. They dragged him down into a basement, tied him up, and took turns beating him. The event has suffered the normal distortion: some reports say he was hung up by the feet; other reports say he was tied upright and hit with chains. He himself wrote, in a letter to his landlord: "I was mugged a week ago Tuesday and my well-being seriously tampered with." Smith was rescued by the arrival of an older man, who put him in his car and drove him all the way to New York. He refused to go to the doctor or to a hospital and insisted on treating himself. He would go to the men's room when he wanted "to drain," as he said, the inflamed wound in his groin; there is some doubt about the extent of the injury, none about the pain. He told a number of people about the beating; for example, he phoned Carole Thomas in Los Angeles; his voice, as she well recognized, was choked with anger at the assault; Smith had no forgiveness for his assailants—that came later, in a curious form.

Did Smith actually go back to Philadelphia, as he said many times, and invite the young men who had beaten him to come to the show at the Jewish Museum? He reported that two of them came; one instinctively doubts the story because one refuses to accept that even Smith could be so saintly; but it might be true.

Through all this, the more critical problem remained, as ever, the question of money for the project. The contract with the Museum and the Fund specified $5,000 for the expense of printing and mounting, and $2,500 as an honorarium. Smith must have known at once that the money was inadequate to the cost; but he didn't try to raise additional funds till August, when he could dictate a number of letters to a secretary. Perhaps it was her influence, or perhaps her text that appeared in these amazingly plain letters; there is no trace of the ornate and impenetrable style of his appeals for money two years before. The most unusual of these forthright letters is one apologizing for a $75 post-dated check to a law firm upstate that had done some work for him:

If my finances were as healthy as is my reputation I would not have such difficulty in paying you. At present, I am engaged in the design and preparation of a major show of my work at the Jewish Museum which will open in January. It will have the entire first floor of the museum and be with about four hundred photographs. Completing this exhibit is in itself a financial ordeal. If you are at all inclined to support the arts then I wonder if you would consider canceling the rest of this debt as a donation towards the completion of this exhibit. . .
And there I've done it, asked for a donation for the first time in my life.

Mr. Siben of Siben and Siben replied rather tartly: "I have a large organization and I practice law as a vocation. I am not in a position at this stage in life to do Legal Aid work. I, therefore, must reject your suggestion which you so sincerely and aptly made." Smith had the last reply in this comic dialogue by hand-printing in the margins of the Siben letter:

How strictly right. . . . I had a grandfather like you. . . . You make a quick wild profit on human misery—congratulations. . . . I also at this stage in my life—like you—consider that I have no further time for "human aid". . . . Profit is the motive, since sending you the check I

have been viciously mugged for racial hatred reasons. . . . I fully appreciate your heading "People vs. Smith". . . . No—I can't sustain it, I'll be as humane in the future as I am now.

His appeal for money to Arthur Goldsmith at *Popular Photography* has an interesting finale: "What more can I say except that I love you—no Arthur, not you, but for the typing interpreter of this letter." The "interpreter" to whom he refers was one of the most fascinating women in a remarkable and patient series who were in love with Smith and were—for all the good will on both sides—his unpaid disciples. Aileen M. Sprague was the daughter of a Japanese woman and an American advisor who was sent to Japan in the early fifties. They were divorced when their daughter was six years old, and Mrs. Sprague raised Aileen in Japan up to the age of eleven; but the racial prejudice in Japan against children of mixed background was so great that she and her daughter moved to the somewhat sunnier climate of California. Aileen had high enough grades to be admitted to Stanford University, where she spent two years pursuing a rather vague program; she simply didn't quite know what she wanted to do; but her new stepfather, Mr. Winkelman, felt she should go to college. In the early summer of 1970, she got a job as interpreter and coordinator for a visiting Japanese T V crew working for Fuji Film; they did a piece first on the photographer Bert Stern, then went to interview Smith, who was already fairly well known in Japan. Aileen Sprague found Smith shy, charming, lean, bearded, bright, and intense. A week later, he asked her to come and live with him; she accepted; her feelings were partly maternal; she hoped to be his savior. She was immediately thrown into the enormous labor of preparation for the Museum show—and into the whirlpool of Smith's habits, addictions, and emotions.

She, too, like Carole Thomas, tried to impose some degree of order and cleanliness on the embattled loft. The task was, almost literally, Augean; she took 20 loads of sheets to the laundromat and filled 50 black bags, rented, with the accumulated garbage; she had also to clean up after his cats. One was named Tiko—after a famous Japanese sumo wrestler. The mother of several kittens had been named Brunhilde, and this Wagnerian animal would charge the refrigerator when she was hungry, hook one paw around the handle to open it, and scrounge for food. When supplies got low, she abandoned Smith and left with her kittens. Smith had his memories, though: he had taped her cries during heat. Smith loved these animals; called himself a "double cat"—with eighteen lives. When Aileen came, there was already one assistant at work, Leslie Teicholz, a forthright and vigorous young woman, again exceptionally bright, who had the great advantage of a family rich enough to support her. Smith had met her at the famous Woodstock Festival in 1969.

Smith was not political in that he belonged to no group or party or persuasion, but he was extremely interested in politics. His letters to his mother had lengthy paragraphs of political discussion: another point of disagreement, for Nettie was sturdily right wing. Smith had not, however, gone to the wars again, neither to Korea (though he tried), nor to Viet Nam, nor to the bloody Civil Rights marches in the South, nor to any of the Israel-Arab campaigns. As he wrote in an undated note:

For why am I sitting here in this lousy firetrap of a New York Loft? For the sheer bare guts of my profession, and my particular place within it, demand and make necessary—should have made it necessary, that I, with fully working mind, and with fully working cameras, and with fully working intent—that I be working among the fleshed facts and feelings of the recent Selma to Montgomery "civil rights march," photographing it, reporting it. . . .

Last year I stormed at myself to move into the situation though I had a leg ugly with ulceration and pain—and damn, I tried. This year the leg is at least usable, but one more time my cameras have been stolen, and I am impoverished even as to a potential of a next meal.

But he did manage to go to the Woodstock Festival of 1969; it was the climax of the love-and-flower movement of the sixties, and drew 400,000 young people to hear Sly and the Family Stone singing "Higher." Leslie Teicholz was then working for radio station WNET and was recording in the performers' tent. She smoked pot for the first time in her life, and after two drags, passed out on the grass floor of the tent.

When she woke, Smith was stooped down and talking to her; he had gone back to taking photographs for the Black Star agency again, he told her, and had come to the celebration with his 15-year-old daughter, Shana. The crowds had been such that he had to drive all the way north on the shoulder of the road. Teicholz agreed to represent him. In the last ten years, he had parted with two previous agents, George Orick and Henrietta Brackman, the first after bitter personal exchanges, the second more amicably. When the Jewish Museum show was proposed, in February, 1970, Leslie Teicholz said she would help him. The task was formidable: to find, print, spot, and mount upward of 600 prints; and, more than that, to lay out the exhibit in its proper sequence—which, for Smith, was not mechanical nor even necessarily chronological. Her help was threatened by the inevitable consequence: Smith fell in love with her and wrote her scores of love letters. Teicholz said, "I couldn't imagine it." He threatened suicide, of course; but she still refused.

During this period, the atmosphere in the loft was thick with "love"; the very term had become amorphous during the sixties. A number of former students came in at times, as many as ten, to put together Smith's exhibit. "The crusade was the show." Smith himself left a charmingly sinister note:

Dearest People—

I love you all, I really do, and that makes it all the more horrifying that I have dragged you into this excruciating situation made brutal by my own incompetence.

Sincerely,

The Torture Master of Folly Place

Meantime, Smith was receiving large quantities of Dexedrine to help him cope not merely with the volume of work but with fear of failure.

Because the work was going slowly, it would sometimes take four days to find a single negative, and in the clutter of the loft, many negatives were never found; therefore scores of copy negatives were made. Luckily, a good many prints had already been made—11x14s, mounted on board.

Six months went by; prints were hung everywhere in the loft, suspended by clothespins from a spaghetti of long strings. Cornell Capa and the museum director Karl Katz were nervous and unhappy. Three days before the scheduled opening, set for February 2, 1971, Aileen and Leslie arrived with the prints; all 600 had been mounted in a marathon session the night before. Smith was in a wheelchair, having trouble with his feet again. On January 31, only about a fifth of the prints had been hung on the walls. Smith and his crew stayed on, sleeping on the floor of the museum, sometimes as little as two hours a night. Smith would get up out of his wheelchair and "dance around," supervising and revising the layout on the walls. This took the largest part of the time; he judged by "the lyric inner connection—the tension—the rhythm of music." Many of the photographs, in a nice form of revenge, were those

that had been turned down by *Life*. At 10 a.m. of the very day they were scheduled to open, Katz called Cornell Capa in a panic: only one gallery room had been hung—the Schweitzer story. There were only eight hours left till the six p.m. opening; on that day, all the remaining 400 prints were hung—from floor to ceiling. Many could not be seen properly at all; they were at one's feet or far above one's head.

But the exhibit, entitled by Smith *Let Truth Be the Prejudice*, was a marvelous success. The dark power of Smith's vision redeemed and made irrelevant, except in a human sense, all his tyrannical affections, his drunken, pompous elegies, his embarrassing humilities; a lifetime of hard and stubborn work had its climax on these overcrowded walls. Many thousands of people came to look, to strain and stoop if necessary. Smith's essential humanity, his feeling of identity with the subject—not hostile as in much of Richard Avedon's work, or sardonic as in Cartier-Bresson's—gave his photography its true third dimension: emotion. Cornell Capa, the progenitor of the exhibit, thought the result was "overwhelming." The New York critics agreed. A.D. Coleman wrote in the *Village Voice:*

Quite possibly the most overpowering one-man show ever mounted, it is an unashamedly autobiographical statement, though entirely devoid of self-aggrandizement.

. . . a great photographer's spiritual autobiography. It is an awesome reaffirmation of the vitality of the documentary aesthetic, and the tradition of concerned photography. It is a brilliantly designed and executed exhibit, complexly conceived but devoid of gimmicks, artiness, cleverness, and curatorial sterility. It is at once personal and universal, a burning record of our times as seen through the eyes (and felt in the viscera) of a major American photographer . . . It is a profound and deeply moving statement about life, about photography, and about the interaction of the two in this tormented century.

And Hilton Kramer wrote, in *The New York Times:*

Mr. Smith is, above all, a photographer of action—vivid, highly particularized human action—which he renders with a razor-sharp emotion. Rarely does one feel in his work that the impulse to design is uppermost. The primary pressure is on the human connection in all its homely, quotidian detail.

Yet the esthetic force of Mr. Smith's work is, in the end, deeply indebted to a rigorous sense of form, though we are never made to feel that this sense of form is the main point. What does impress us as the main point, once we have recovered from the sheer human spectacle in these photographs, is the extraordinary tension that is articulated in the work—a tension between the "still" nature of the medium and almost uncontainable momentum of the emotion it captures.

Only critic Gene Thornton, always an anti-romantic voice, managed a few qualifications:

The arrangement of the pictures, though often eccentric, is beautiful, but it is hard to tell what is what.

One suspects him of a profound dissatisfaction with his actual career. One suspects that he sees himself as something on a far higher plane than a mere photo journalist, however great; something more like a visionary and a seer. One suspects that he has come to see photography not just as a way of recording appearances, however finely, but as a means of snaring essential truth in a net of light . . .

There remains, however, scattered throughout this show, the handful of photographs that put Smith among the greats, and these pictures embody a vision that is distinctly his own . . .

The exhibit drew such crowds that it was extended five weeks, to May 9, 1971.

THE DRAMA of the poisoned fish really began in the fifties, in a small fishing town called Minamata, on a beautiful bay on the west coast of the Japanese island of Kyushu. A very large chemical firm, Chisso, had a plant nearby, which used mercury as a catalyst for acetaldehyde, which was the basis for the manufacture of that universal relic of the 20th century: plastic. The waste water from the plant was discharged directly into the sea, from which it was absorbed by the plankton. There it was changed from its original inorganic mercury into an organic poison, and so up through the food chain into the fish and, therefore, into one of the two chief sources of protein for the Japanese. The amount of mercury was enough to kill great numbers of fish and shellfish; and if they didn't die soon enough, but were netted and eaten, the ordinary Japanese got with his meals about one tenth of the dose needed to kill him, too. This amount was considered safe by the Japanese Government; and, of course, by Chisso, too, and therefore by the town that depended upon Chisso for jobs and money.

But the effect of this non-lethal dose of mercury was to damage the kidneys, and then the nervous system; it crippled its victims, frequently crossing the membrane barrier of the placenta, striking into the womb so that the child could be born crippled, too. The Minamata disease was diagnosed in the mid-fifties, and Chisso had made a settlement, though a poor one, with the fishermen in Minamata who were particularly affected. The mercury continued to pour into the bay, and there was a new outbreak of this sinister industrial disease in the sixties. By May, 1968, mercury was replaced by other catalysts; but no one could replace the 600 tons of mercury in the silt at the bottom of Minamata Bay; nor could they cure the cripples left from the previous years of pollution. Chisso knew all this; the head of their factory hospital had reproduced the disease in cats by feeding them comparable doses of organic mercury; but Chisso closed down and locked up the result of Dr. Hosokawa's proof.

Smith knew nothing of all this before 1970. In Aileen Smith's words:

Gene and I first heard of Minamata in the autumn of 1970 . . . The person who told us was Kazuhijo Motomura [who] was a friend of Jun Morinaga, the Japanese photographer who had been one of two assistants when Gene was in Japan in 1960 doing a project for Hitachi. Both Motomura and Morinaga knew that Gene loved Japan and the

people there and that he wanted to return. Gene had written Jun, asking if it would be possible to take the retrospective to Japan. Motomura came with good news. He would produce the exhibition in Japan and wouldn't Gene like to come over with the show, staying in Japan a couple of months, perhaps photographing a story.

But it took almost a year to get the project going. They wrote to the J.D. Rockefeller "Third Fund" and asked for a $40,000 grant, which seems large for a two-month project; but no doubt part of it would pay Smith's chronic debts. Smith, like the rest of us mortals, wasted a lot of time and energy on trivial problems. But he could not simply pay his back rent: he had to enlarge the transaction into a sad and ludicrous drama. He raged at his landlord:

Dear landlord Al,
 Well.
 As I promised, the halls were cleaned within hours after your last complaint.
 It was at grievous cost to the recovery of my leg wound. It set that recovery back by perhaps two months . . .
 Did you ever thank me for the several times but the one time in particular that I worked (even while exhausted) all night in brutal cold to shovel off that lower back roof of piled snow and frozen drain pipe from the high roof and clogged drain from the lower roof because I was trying to help out you and Bernie . . .
 And again I remind you of the fire escape repairs and how your unrepaired fire escape nearly cost me my life when I stepped on a rung and the whole rung broke loose leaving me dangling by the accident of my arms on the rail.
 In a place you saw fit not even to install a mail slot in the door.
 But let shit be for the fans.

Smith could never resist a turn of phrase. Furthermore:

 I don't want murder committed on my rights and works while I am in Japan struggling for the rights of many to live who are being polluted to death. The work I will be doing truly will even benefit you . . .
 PS: How about going up to the Jewish Museum and seeing the facts that are the contributing factors that are my life . . .

But eviction was inevitable.

Gene was, as usual, broke; and the customary sources of money were no longer available. He had contracted with Lee Witkin and

Witkin's former partner, Dan Berley, to do a portfolio of 25 prints. But, as John Morris later reported: "Gene didn't have the strength to do it . . . His legs were in bad shape, he would have headaches . . . he always tormented his body, and the other thing is that he drank a lot and he was diabetic, terrible combination, he drank all these sweet drinks." Smith's friend Dr. Kline had sent him a telegram on April 14, 1971: "YOU WILL DROP DEAD IF YOU DO NOT CONTACT A FAMILY PHYSICIAN OR INTERNIST RE YOUR DANGEROUSLY ELEVATED LAB RESULTS."

In July, Aileen and Smith packed the contents of the loft and piled them into a tractor trailer, and hauled it (Juanita's husband drove the outfit) to an empty house, formerly a bordello, but now owned by Berley and situated near Swan Lake, a popular resort area about 110 miles upstate from New York City. Here Smith and Aileen lived until early August, waiting for visas to Japan. Much of the precious material was piled into an open carport. There was another kind of nasty difficulty, for Dr. Kline was asked to write to Motomura, who would be their sponsor in Japan, that:

I was indignant to learn there are rumors that W. Eugene Smith is using "hard drugs." I have been Mr. Smith's physician for the past dozen years and know him as a colleague and a friend . . . I am happy to state that there has never been any evidence of such drug use.

Smith eventually got an authorization, addressed "To Whom It May Concern," to carry supplies of Dexedrine and Trilafon, and signed not by Dr. Kline but by a registered nurse, one B. Madden. This last obstacle gone, Aileen and Smith were in Japan by August 16, 1971. They were married in Tokyo in a civil ceremony on August 28; W. Eugene Smith was 52, Aileen Mioko Sprague was only 21. Smith was tremendously happy; he insisted on wearing a Japanese kimono, and he danced with Aileen's tiny, wrinkled grandmother, swinging her around and round and lifting her off her feet; though not a traditional Japanese greeting, she was immensely pleased.

The trip to Japan was paid for by Motomura, who also rented a Tokyo apartment for them for several months. The great Jewish Museum show had been dismounted and shipped to Tokyo where, at the Odakyo Department Store, it occupied an entire wing. It had become traditional for Japanese department stores to sponsor cultural events, and no one objected when Smith had the walls of the gallery repainted in various colors: silver gray for the Pittsburgh series, for example. The show, including the re-edited war slides, opened September 3. The average daily attendance was over 3,600, more than 8,000 on the last day, September 12. One of Japan's great newspapers, *Asahi Shimbun*, had done an interview with Smith. The translation is preserved as transmitted to America:

He found out very strong responsibility to duty, and love to the nature from his old enemies in 10 years ago when he visited Japan. Very warm looks to birds that staying under the roof of farmers houses, and factory labours love to various machines they have made by themselves . . .
"My feeling to Japan is not a ROMANCE but a LOVE. I am in home sickness to Japan. I wish I could live in Japan forever," says Mr. Smith.

Smith had become a Japanese cultural hero. He was in a forgiving and triumphant mood; he wrote Michael Hoffman at *Aperture,* on the news that *Look* was dead: "What photographs by what photographers do you remember in recent years that the magazines would publish could have caused that intensity of attention? I am terribly sorry that the magazines have simply proved my point."

Smith had been paid by Odakyo, but, as ever, he was short of money; the Rockefeller Fund turned him down in November; and in December, he was forced to write from Japan to his New York pawnbroker (named "Mr. Harlem"). After four pages of explanation of his mission in Japan, including a denunciation of the chairman of the Chisso company, Smith asked the pawnbroker not to forfeit his camera equipment; it would be a biographer's dream to stand behind Mr. Harlem as he opened and read that passionate document. While the show began its tour in Japan, the Smiths went, on September 3, to visit Minamata itself. Aileen had a lovely description of their appearance in this provincial town:

A middle-aged-to-aging white-haired journalist who spoke no Japanese told puns in English that did not translate, and was almost always smiling, often skipping around and dancing, sometimes serious with furrowed brow, dramatically moving his arms, twisting his wrists, expressing himself in pantomime. The partner was a rather serious-faced woman of only 21.

The Smiths moved to Minamata six months later to begin their project. There had been photographs done on the poisoning once before: Kuwabara Shisei had published a book in the late sixties, rather harshly printed.

In Minamata, the Smiths found a young local photographer, Ishikawa Takeshi, who volunteered to help; they got an empty barn to serve as darkroom and work place, and the young man lived there. The Smiths went back and forth by train between Minamata and Tokyo, until the impulse of the work itself kept them at the bay more or less permanently. The house at Minamata was small, and the rent was relatively cheap, about $15 a month, which was lucky, because they had only two sources of income: Japanese TV interviews and loans from friends in the States. One of their constant expenses was a bottle of cheap Japanese whiskey, which Aileen would buy every morning, when she didn't buy the larger bottle, which would last two days. They lived on something like $50 a week; on rice, canned milk breakfast, vegetables from an old patch near the house—which Aileen would cultivate, at night, after work, with a flashlight—and they ate gray mullet for dinner, fished out of the bay. These were pretty much the foods eaten by the villagers themselves; and no one knew how much mercury was still in the fish, nor indeed, what the minimal safe dosage would be, if any; there were still many miscarriages in the village.

Both Aileen and Gene Smith photographed; they visited the victims who were still alive and exposed about 100 rolls of film. The most famous of these photographs was that of the crippled, staring-eyed, 15-year-old Tomoko Uemura; she was the daughter of a woman who had nursed her all those years; many parents would not keep their defective children. Smith had observed Tomoko's mother bathing the helpless girl and decided that would be the most dramatic way to photograph her. Smith went day after day to visit the family and check the light and decide the best hour. Long afterward, he wrote:

As we photographed other things, things around her, and even the family, it grew and grew in my mind that to me the symbol of Minamata was, finally, a picture of this woman and the child, Tomoko. One day I simply said to Aileen that if everything is alright up there, and they are not too busy, let us try and make that symbolic picture. Now this does not mean in any way I was posing the picture in the sense of posing a picture. It meant that I was interpreting what by now I knew full well to be true, because I would never have done it otherwise. And so we went there and we sat; and we talked for a while; and, I actually explained what kind of a picture—I didn't explain that I wanted that look, that look of courage—I simply said that I wanted something in the caring of Tomoko. I thought maybe perhaps away from the bath would be the picture that might show Tomoko the best as to just what had happened to her body. And so the photograph. We started. The mother herself suggested that the photograph should be in the bath;

Minamata,
1971–75.

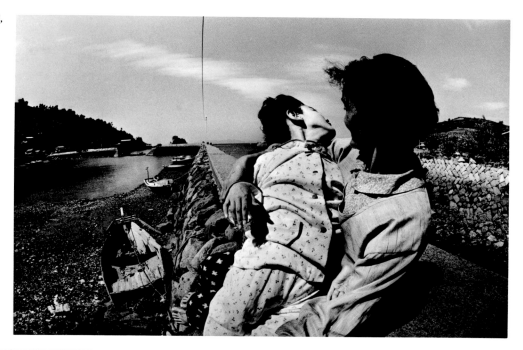

so we decided to try that. The mother went through her ordinary bath routine with the child, and this was the result.

When the light was precisely right, they went back to the house and took the first exposure outside; then, with the mother's agreement, they went into the room where the bathing was done; it had high windows that back-lit the scene, but Smith added two bounce strobes to get shadow detail. He took two or three more exposures—"building up to the climax"—and asked the mother, as she bathed Tomoko, "to lift her left hand." Only three more exposures were made. The photograph—Smith knew at once it was marvelous—is the pieta of this century; for all its universal meaning, it reveals something of Smith's deepest and most private desire.

At Minamata, fact and the photograph of the fact were intimately connected from the very start; for example, one must not only look at Mr. Ikeda but read the text about him as well:

Yahei Ikeda became bedridden six years ago. A year later he no long-er was able to feed himself. His small statured wife sometimes cares for him as she would a baby. At other times she strains to bear his weight and be his strength as he struggles to his feet. Recently even that has become impossible. Although he too retains awareness, he mainly just lies there.

Smith printed more and more darkly as time went on; the prints got more dramatic, less journalistic. Smith was creating another true legend. His sense of identity with the victim, as a fellow sufferer, gave him a special vision, as if he were photographing, so to speak, from inside the subject's mind. But this very attitude, when expressed in words, not film, sometimes went to the ro-mantic extreme:

JITSUKO-CHAN: a vibrant child who has become a still-born adult. A loved beautiful human being aborted from useful life by the waste products of industrial progress. A breathing, haunting, beautiful 18 year old young lady who will never know a lover. A still complex and remarkable human being unable to function in any of our accepted nor-malities. She cannot walk. She cannot talk. It is said that if she were to fall into a fire she would not realize her pain.
JITSUKO-CHAN: no involvement with a human being reacting to their world ever has disturbed me as do you. Trying to photograph you, Jit-suko-chan, is to be reaching towards a mind that shades its passages

so rapidly I am frightened I am making grievous perceptive mistakes. I do know, that to me, every photograph I have made of you is a failure.

Jitsuko-chan—I love you.

About 10,000 people had gotten ill, and it was estimated that at least 100,000 had eaten poisoned fish. In spite of the earlier, stingy settlement, a group of victims were suing Chisso again; its chair-man agreed that the company was morally guilty, but declared he would fight the charge in court: a curious distinction which pre-serves conscience and saves money at the same time. One of Aileen's best photographs shows the anguished president as he listens to the victims, while his aide, standing behind him, pats the sweat on his employer's face with a nice clean folded napkin. The victims sued to get compensation for the lost years and care for the congenitally handicapped—and they wanted the bay filled up so that the mercury at the bottom would not go up the food chain and end in a human being. Still the trial of this civil suit, as such things are arranged everywhere in the world, dragged on. A group of victims, headed by Teruo Kawamoto and Takeharu Sato, were supported by what the Smiths described as:

. . . the oft shrill, oft vulgar chorus of young people who were a disci-plined and fluid mob . . . giving weight to the sit-ins, . . . crowding the negotiation rooms with additional psychological tensions. At times, it appeared they could be doing more harm than good, might be alien-ating the public as "irresponsible radicals. . . ."

They swarmed around the gates of the chemical factories, shout-ing, "Kill Chisso, kill Chisso!" or sat on the floor of the Central Pollution Board till they were dragged off—and into the front pages of the Tokyo newspapers. These were direct confrontation tactics, modeled after those of the American social activist Saul Alinsky, and were intended to raise the level of negotiation to unbearable decibels. The Smiths followed this group everywhere, and, along with the Japanese press, photographed what happened; whether Smith knew it or not, these images (many were done at the same time by Aileen), requiring action in the very heat of action, were renewals for him of his earliest action sports photographs. He wrote:

I, unlike some photographers, when I'm photographing, I'll *never* get

so carried away—I may be crying and it's hard to photograph through tears, in some situations, some of the pictures in Minamata and other places—but I never get into it actually when I lose track as to what I am doing, a clear mind as to what I am doing. . . . For instance, the picture of the mother and the child from the Minamata series, when I built to the tension of that, I was at a very high tension. I turned to Aileen and I said, "Well, okay, I have the photograph," and from that exposure on I got sloppy in my focus and sloppy in my lighting. And so, actually what I was doing was trying to keep enough tension going so that if anything else developed, I would be prepared to come to full tension again.

An interruption to the work at Minamata came very soon, on January 7, 1972. The Smiths had accompanied the militant Kawamoto and his fellow victims, plus their young supporters, to a face-to-face meeting with the head of the union local; it was to take place at one of the Chisso petrochemical plants at Chiba, very near Tokyo; and the question they wanted to ask the union leader was why he had allowed his men to be used as company bodyguards. The group was not permitted inside the plant, but instead crowded past the gates into the small guardhouse; here they waited about 30 minutes for a phone call from the union leader, who had failed to keep the appointment. Now some 40 or 50 men came out of the gates from inside the plant itself; they were company employees and members of the union local; and they included a number of former corporals and sergeants in the Japanese army. Five of them came into the guardhouse and told the patients: "You have three minutes to leave." No one left. One of the union men then shouted, "Charge!" whereupon his fellow employees, milling around outside, stormed into the guardhouse, pulling the protesters out by the hair and the clothing. Gene Smith was attacked, too, and punched in the stomach so violently that the back of one of his several cameras was flung open. He reached for the cameras, fell, was dragged roughly over an overturned chair, and was shoved outside, where several attackers seized his legs, lifted him, and jammed his head down on the cement pavement. The incident was photographed by Japanese reporters, who were personally enraged at this violence. Yet it was only too logical: the union workmen, culturally attached to their employers, were also worried that Chisso would go bankrupt because of the civil suit, and they would lose their jobs; indeed, throughout the world, most unions have fought pollution controls, simply in defense of their jobs; it's difficult to keep both trees and lumber workers alive. The real world does have irreconcilables, and hideous violence is only too often quite reasonable.

The suit was settled on March 20, 1973; but the consequences of the January, 1972, assault were to follow Smith for years. He had left the scene of the attack by train and felt well enough, or dazed enough, to attend a local jazz concert; but he soon felt ill and went home. After that, he had recurrent dizzy spells, and drank heavily to kill the increasing pain; he could eat little, "about a fifth of normal"; and when he did, the tooth powder he used to fasten his artificial pallet would sometimes spray out of his nostrils. He also had pain in his left eye and blurred vision in the right. It is possible that the assault had altered the position of the vertebrae of his neck; and he still had a piece of Japanese shrapnel lodged in that area, too close to the spinal cord to remove. If he lifted his hands to use the camera, he would sometimes faint; he tried to work by pressing the cable release with his tongue. His pain and despondency were so great that he begged Aileen to kill him with the ax they used to chop firewood for heating water. Sometime about this difficult period, he called Carole Thomas in California and actually proposed that she join him and Aileen in Japan, presumably to help make prints; it is hardly surprising that Carole refused.

Nevertheless, once again, he survived; he boasted ruefully to Aileen that he had already lived longer than his father—as if he somehow deserved not to. He was getting pain killer injections at the local hospital, and even went to Tokyo—they were so poor at the time that he had to borrow $80 from a Japanese newsman for railway fare—to get treatment from a chiropractor. Yet both Smiths continued to document Minamata with less and less financial resource. One day, Smith felt he was being strangled and went to Tokyo by himself for diagnosis; he collapsed in the fast "bullet" train from Osaka and was bleeding from the mouth. He was diagnosed as having cancer of the esophagus, and judging from the size of the shadow in the x-ray, he had only three months to live. The absurdity of his lifelong melodrama, in which Smith had always played his part to the hilt, had its mock climax when further examination with a bronchoscope revealed that there was a nodule of compacted food in his throat; it was removed, and Smith was saved once more—though not from the sequelae of the Chisso attack.

In May, 1973, "after a near suicide from the pain," he flew to the United States by himself to seek better treatment and had a complete examination; the physician said his health was "fairly good but that an operation on my jammed neck was too dangerous." He found, or was recommended to, a New York osteopath named Dr. Valli, and he began treatments up to July, which relieved his pain and restored his blurred vision to its normal degree of myopia. But by April of the next year, both the pain and the poor vision returned, in both eyes now, and he had to be guided across a room. He went back to Dr. Valli for further treatment. On June 4, 1974, he could no longer focus; but slowly, and with many regressions, he began to improve; the osteopath was hoping only for "stabilization." Smith wanted Dr. Valli to write a report, but "it is not for the purpose of suing. The most money I hope to get out of this is payment of what it has cost me and a nailing down of moral and legal responsibility." Smith was once more taking over the moral high ground.

His ancient battle with *Life* was resumed from Japan. They agreed to do a piece on Minamata, and Smith picked out a stranger, an American tourist, to carry the photographs to their office in New York City; he was determined "to win my battle with *Life*." But here was a major work that they could not possibly ignore, whatever the difficulties. They printed it in their issue of June 2, 1972 (which had Raquel Welch on the cover) under the title "Death-Flow From A Pipe." Aileen Smith thought the treatment was crude and gross, but Smith was much more lenient. "Gene was very practical," Aileen stated, "a mouse, not a lion."

20.

"She is the one I want in my arms."

THEIR SITUATION had begun to improve during 1974, their third year at Minamata. Smith had been earning money from the TV commercials he did for Minolta Camera; he had gotten $10,000 from the Rothko Fund in New York so he could return to Minamata; and that was not the only grant: he got money from the National Endowment for the Arts, from the Guggenheim, from the Win Woodward II Foundation; and, as he said, Leslie Teicholz had collected money from the sale of his prints. She was his agent

while he was away, paid his bills, got his cameras out of pawn, and still had thousands of dollars profit. And in April, 1974, the magazine *Camera 35* printed almost three dozen of his photographs on the Minamata story, with a fine text by the Smiths. The book they had planned for publication in Japan was still being prepared; they had changed publishers; but the work, what with Smith's several trips to the U.S. for treatment, was going slowly. Now they got an unexpected and generous offer of publication in America. An aggressive and, some say, flamboyant entrepreneur in Los Angeles, Larry Schiller, who had published a series of photographic books on Paul Fusco, Bert Stern, Mary Ellen Mark, Annie Leibowitz, and others, was contacted through Jim Hughes, then editor of *Camera 35*. Hughes, along with John Morris (then picture editor at *The New York Times*), had heard that Smith was again in serious trouble: starving and going blind.

The truth was a bit more complicated. There is a curious note, written in Minamata:

Dearest Aileen,

I really am in deep despair. Chisso's deliberate brutality may still cause the end of my career. I believed my eyes were improving and that the terrible pain in my head had been made quiet so that I would not consider suicide.

Four days ago the pain returned and my ability to see became worse. I do not know what is happening and neither does the doctor.

I will try to return to you soon but I cannot return this way.

This ambiguous note implies some sort of separation between them. In fact, Aileen, worn out by the Minamata project, which had been stretched from two months to three years, and by the strain of daily living with Smith, now wanted to be free to do her own work. And she had many doubts about the final form of the book itself. Smith, in a 1974 letter to his daughter Juanita, wrote:

Aileen and I are having a kind of sad quiet (for the moment) battle about this. She has said that some people are turned off by poetry and drama, she wants something different for the book. My poetry is not poetry, it is a short-hand kind of expression (for short writings) that I hope wraps the mind of fact and the heart of emotion in the shortest possible space.

And there must have been other and less intellectual reasons. Aileen had been so desperate during this period that she had climbed the fence to the railroad track and was going to kill herself; Smith ran after her and stopped her; he said if she wanted to commit suicide, he would show her how. He said he wanted children with her; but she refused: "You have five children, and you don't see them." This particular storm passed; but she decided to divorce him.

Smith was adored in Japan; he complained they were making him into a god—presumably a Shinto god, of which there were already well over a million. The Japanese had, between 1962 and 1974, published and exhibited Smith at least 75 times. Why didn't he stay in this country he said he loved so much and which answered his affection with adoration? Mostly, he didn't stay because Aileen was going to divorce him—although she had not yet actually left. He could hardly stay in Japan alone; always poor at languages, he had learned no more than a couple of Japanese phrases in the last few years. Also, one must not neglect the possibility, always stronger when one is away, that Smith was homesick, perhaps for his two sons and three daughters, but maybe even for the long, comfortable years of martyrdom in the loft after the grandiose campaigns of Pittsburgh. In those last days in Japan, he wrote to both Shana and Juanita and encouraged them to keep writing poetry. He had four grandchildren by now, and actually thought of bringing them to Japan; he sent for their school records. In any case, Smith had stayed in Japan far longer than he had planned. And with Aileen no longer his nurse, cook, gardener, mother, lover, devoted assistant, and interpreter, he must have looked back to the United States for a substitute. In fact, he'd already found one. At an exhibit, he met an attractive and intelligent young photographer, Sherry Suris, who had gone to the famous New York High School for Music and the Arts. She had just taken her first pictures: interesting and talented amateur scenes of greeting and departure at an Israeli airport. Smith's medical visits to the United States had taken on a quality of manic excitement, as if he were on leave from somewhere or something; he had stayed with his friends, Patricia and Paul Fusco, and made "international and long-distance calls like crazy." Larry Schiller, a shrewd and daring investor, had paid Paul Fusco to bring them back from Japan. Fusco flew 24 hours on this mission, there and back; during the flight to the U.S., Smith sat drinking, announcing at intervals that he was about to die. Later, Smith wrote a postscript to Aileen's letter of thanks and apology to Fusco: "Me dumb guy," and said he would always suffer embarrassment "when I think of how I trampled your lives."

Aileen was full of serious doubts about whether they could meet Schiller's deadline for publication—January 1, 1975. She wrote Schiller herself in July, 1974, in her neat, round, schoolgirl's penmanship hand:

Next subject. Gene's health. It is very difficult to understand Gene's body . . . It is a medical miracle that Gene is still alive after all the beatings his body has gotten in the 55 years. I'm not talking about just the most recent problem. Dr. Lalli, osteopathy, etc.—but the whole pile up of past problems. Miracle or whatever, he is very much alive and therefore very much in pain. There is an almost constant running on of explainable or unexplainable symptoms and pains. Most of them are explainable, from that injury or that but his health is spasmodic. And being or not being in the U.S.A. doesn't mean much either way.

I'm not talking about procrastination. I'm talking about getting a good book done. We all three know that this may well be the last major thing Gene does. Gene is having climax pains. He may live longer than both of us, but he knows pretty much he can't last much longer in workable working condition.

And so I am scared shitless. If only I knew something about layout! If only I knew something about writing!

By early October, 1974, the Smiths were planning to leave Minamata and come to Los Angeles, where Larry Schiller had his headquarters. Aileen promised to stay with Smith until the U.S. edition of the Minamata book would be finished; Smith was despondent, sweetly and rhetorically, but not tragically:

I create only when I have the spirit and spirituality of life that love gives me. I guess I am trying to say that my lovely and remarkable wife and I are weeping in each others' arms as we prepare for divorce I don't think either of us wants. I was afraid this would happen within the cruel pressures of doing a book, her first book, and it is. We will divorce halfway through the book. Then I hope she proposes to me, or that she will accept my proposal. I have held others, but she is the one I want in my arms. Four years after the first time, and for forty years to come.

He still had some 35,000 words to write, and the layout of 180 prints to do. On the same day as the letter quoted above, October 3, 1974, he wrote (typed no doubt by Aileen) to American Pharmacy, in Tokyo, enclosing 10,000 yen (about $50) for "the final 500 tablets of Ritalin 10 mg.," plus "one Benzedrex inhaler." The Smiths flew to Los Angeles in November; he wore a black patch over one eye, to help him with his myopia; the story got into the news that he had been blinded; it helped Schiller get publicity for the book which was scheduled for publication by Holt, Rinehart and Co.

Schiller rented an apartment for the Smiths, paid them living expenses, and assigned one of his staff writers, John Poppy, to work with them. The deadline was January 1, 1975, in order to make the Spring list, and in Schiller's opinion, "This time I've got a big one," provided it would be "entertaining"; he was afraid, from Smith's reputation, that the book would be too obtuse for the public.

John Poppy, the writer assigned to the Smiths in Los Angeles, had gone to Smith's legendary loft when he was only about 20 and a researcher at *Look*; but he had never forgotten its rich disorder. The Los Angeles apartment, with two baths (one converted to a darkroom) and two bedrooms, to accommodate their separation, was a good deal more livable. Smith and Aileen wrote in separate rooms, doing separate portions of the Minamata text. The schedule was rough: seven days a week, from morning till 11 p.m. or even midnight. Smith drank, but never seemed to be drunk: a common effect of alcoholism. He had with him a cuff to take his blood pressure; it was dangerously high, 240/180; there was a constant line of dialogue in the daily drama: "I want to get this book done before I die." Smith was very protective about his portion of the text, knew exactly what he wanted to say, and fought against any change: "That's not me—it's not my voice." And Poppy would answer: "But this is not English." And Smith would bang his left hand on the refrigerator door: "I can't do it! I can't do it!" And he was jealous that Poppy spent too much time with Aileen in the next room; Smith said: "I'll be dead by morning anyway. You've taken the book away from me. It's yours and Aileen's book. So take it." Poppy replied: "Absolutely not. I'm going." He went and opened the door to leave and quit the project, but Smith seized Poppy's arm and held him back: "Come back inside. Don't be so serious about this." The experience was exciting and exhausting; nothing new about that—it was like any other Smith enterprise for the past 30 years.

Smith never loved anyone who was not unusual in some way; he snobbishly chose women of both talent and beauty, a combination of traits that are less unusual than common sense would have one believe; nor did Smith seem to have much difficulty in finding such women. When the text of the Minamata book was finished, on January 7, 1975—with Carole Thomas' assistance in the layout, the presentation boards, and the design of the cover of the final draft—he and Aileen formally separated. Smith went back to New York and lived in another loft, formerly owned by a young photographer: "Harold Feinstein, who is no longer my friend, was a brilliant, undisciplined near genius"; Smith moved in with young Sherry Suris; he had once supported her application for a Guggenheim fellowship (February 1, 1974):

She is a rather pretty girl, but that should not be detrimental. If I remember, I first met her photographs in a lab, and they were good. A few minutes later I met her. We talked for quite a while and I was moved and impressed. Some of her photographs are quite remarkable in the sense of how I would use the word remarkable . . . Later I saw many more of her photographs. She has talent and they have power. What she is trying to say is important.

The new loft on 23rd Street was, not unexpectedly, as confused as the fortress on Sixth Avenue but much smaller; it had none of the old unkempt charm. Smith was exhausted; for three months he did little except sleep. There are some remarkable photographs taken by Suris of Smith during this period: a portrait, without glasses, weak, sad, vulnerable; another of Smith lying curled up, asleep, on the bare floor of the bathroom where he had sunk down to rest; and a third photograph of his gleaming and ulcerated leg. Sherry Suris got him to her doctor, and Smith was officially diagnosed, probably years too late, as a diabetic; the disease is a

general one, and affects many organs, but is particularly destructive to the smaller blood vessels near the skin. Suris fell into the old role: she was his nurse and his mother and his lover and his assistant; she gave him insulin injections until he could learn to do them, would make him take the medicine, and tried to stop him from drinking—about the worst habit a diabetic can have. He concealed bottles everywhere—another traditional alcoholic habit—and she smashed the ones she could find. He would get furious, of course. In spite of the osteopathic treatments, his vision was still bad; he needed a dioptic lens to see through the finder; and he had the old difficulty of standing in the darkroom for hours. He and Suris were working on a portfolio for the Lee Witkin Gallery: 300 prints for 30 folios. Smith had estimated it would take him six to eight months to prepare, but he told Witkin 60 days; in fact it took him a long year and a half. He was also making 85 prints for his Witkin retrospective show that ran from September 8 to October 16, 1976; and some of these prints took a full week to make.

Smith was unbelievably careless with his own creations; there were cat scratches on the prints left over from the old loft; and he would leave the spotting bottle close to a fresh print where it could easily topple over; he "courted failure and disaster." In May, 1976, he was admitted to the critical ward of the Mother Cabrini Hospital, suffering from pulmonary edema—his lungs were filling with fluid.

Despite Smith's chronic weakness during these years after his return from Japan, he often appeared as energetic, lively, and dramatic as ever; he resumed his friendship with Lee Witkin, and they "palled around together"; Smith "was a gentleman," and fascinated by ideas of all sorts. In 1975, they had gone together to the Overseas Press Club award meeting, where Smith and Aileen got the Robert Capa medal; in the audience, Smith and Witkin were "clowning around, shouting with laughter; then Smith got up and delivered a talk on Minamata; people cried—so did Smith." According to John Morris: "Minamata renewed his audience . . . he went from one place to another, talking to photographers in colleges and to press groups. He was broke and ill. I remember talking with someone who had heard Smith lecture . . . on Minamata, and it was the greatest, most moving thing he had ever heard."

Cornell Capa was anxious to hang the Minamata show at his International Center for Photography. There was some trouble about that, too; Smith wanted large fees, about $5,000, but Smith was also constrained by the terms of a contract with Schiller, who wanted to deal Capa out. Schiller told Smith that it was Capa who spread the rumor that he was faking blindness; it was all cleared up when Smith called Capa all the way from Minamata. Margery Smith noted that: "Gene often spoke of Cornell as the true photographic genius of the Capa family and said it was a shame that so much professional acclaim had gone to his brother Bob 'because of his personality.'" Smith inscribed the book:

To Cornell:
It takes a long pull, it is a tough pull, the travel road, the travel load is heavy, the road is long, it often seems so lonely, yet I know we share it.
Love,
Gene

The book was reviewed and praised everywhere in the world; indeed it is a unique marriage of text and photograph; it justifies, in Smith's final work, his theory of one creator (in this case, two) as the source of both word and image; and it is more than that: it is moving in a specific and a universal sense at the same time, and therefore truly classic. Nevertheless, the Minamata exhibit,

from April to June, 1975, was a financial failure; attendance was poor, perhaps because the interest in pollution—almost a religious crusade in the late sixties and early seventies—had, like other contemporary phenomena, unaccountably subsided.

Smith's many friends—particularly Jim Hughes and John Morris—were increasingly concerned about Smith's rapidly declining health. The University of Arizona had established a Center for Creative Photography, which would acquire, for example, all of Edward Weston's negatives and master prints. But the University didn't have quite enough money to buy the Smith archives. Morris, through Ansel Adams, was introduced to John Schaefer, President of the University, who agreed to bring Smith out as a guest lecturer. Morris worked out an arrangement whereby various of Smith's friends would raise $15,000, and the University would match this sum; and this $30,000 would suffice to pay off Smith's debts and move him and his enormous files of his life work from New York to Arizona. In return, the University would get all of the Smithiana except some master prints which would be kept for the family; in addition, Smith was appointed to a joint position in the Art Department and the Department of Journalism at $30,000 a year. Though Smith himself was reluctant, he finally agreed to the proposal in November of 1977.

Meantime, it must be remembered that he had been visiting his son Kevin Eugene Smith and his son's mother, Margery Smith, at intervals over the crowded years since 1954; he considered it his second family. There is no doubt of Margery's and Gene's long admiration and respect for one another; but they had become simply friends. As late as 1977, she affectionately offered to bake his favorite cake for him; he chose angel food with caramel icing and told her that his mother had once sent it to him overseas during World War II—it took three months to arrive, it was shriveled dry, but he opened and devoured it in 20 minutes. Margery and he had dinner together the evening before he finally left for Tucson; it was a farewell for both of them.

She said she "felt despairing when I would go to that filthy loft where he lived and saw that he had no bed, that he was sleeping on a dirty mattress on the floor." But on the other hand, "you could pour your life and heart and guts out trying to save and help him and it would all go down the drain."

This was said with a certain kind of dispassionate resignation and acceptance of the "sorrow and the pity, the lost ideal and the lost promise."

"But that was in another country and besides, the wench is dead," she thought, when she thought of herself and Eugene.

She "did not think of them often."

21.

"You can't photograph if you're not in love."

SMITH and Sherry Suris went to Arizona by car, stopping by Wichita, Kansas, to look at Smith's boyhood home. The ties between them had become very close, very tender; when the prints were being selected at the Center, Smith insisted that Miss Suris be present, not to help, particularly, but simply to be there. They took a house in Tucson and stacked it with a good portion of the mountain of material that had been shipped from storage in the country house, some of it already suffering from wind and weather. There were tons of magazines, records, books, prints, negatives, paintings, letters, manuscripts and camera equipment; much of this material was stored in a converted junior high school building. There was also, found later when material was transferred to the Center, a cardboard carton containing 500 Ritalin pills. Visitors reported that the Tucson house, itself crowded with cartons, stank, once again, with the effluvia of numerous cats who sharpened their claws, in accordance with their ancient custom, on the shredded curtains at the windows. Also in storage were two cartons of camera straps and a pile of 100 lens caps for cameras that Smith did not have, nor never had. Smith had brought the drama and chaos of his past with him.

Smith arrived—feeble, white-bearded, and emaciated. James Enyeart, director of the Center, and others insisted he have a thorough medical examination; he went to the University of Arizona Medical Center to have it done. By an odd coincidence, shortly after Aileen had finally sued for divorce, and on his second day in the hospital, and two days before Christmas, 1977, he suffered a severe cerebral stroke. Aileen, still technically his wife, had to be found, to get permission for surgery; the operation removed a clot from the brain that would have been fatal, but recovery was complicated by renal failure. Gene Smith was paralyzed, unable to move his limbs, unable to speak.

All of Smith's children, including Kevin, came to visit him in the hospital at Tucson. Amazingly, slowly, his right side first, he began to recover. Lying in bed, he was able to manipulate the TV control; he would change it rather rapidly from one channel to another.

"Anything wrong?" he was asked. He said, "No. I'm making a movie."

On one visit to the hospital, James Enyeart brought a tape recorder and a tape of Beethoven's Quartet Opus 131, which he'd heard was Smith's favorite. He rested the recorder on Smith's stomach, and played the tape. When the music began, Smith cried and laughed at the same time, a frightening bit which Sherry Suris said he often did. The doctors at the hospital felt that recovery of his left side was impossible; the damage to the right hemisphere had been so extensive. Yet the nurses had seen some movement on the left side. Enyeart asked Smith about it; he wouldn't answer, but Enyeart noticed him crooking one finger on his left hand— the same finger nearly severed in Okinawa more than 30 years ago.

As he slowly recovered, Smith insisted he at least be allowed to sit up, since standing was still impossible. Enyeart lifted him up from the bed and into a wheelchair. Smith said, "Just like Tomoko"—the 15-year-old victim in her mother's arms. At this, both men cried. Eventually Smith was able to get about pretty well in his wheelchair; his false teeth had been removed after the stroke, and with sunken lips and cheeks, "he," according to his first son, Pat, "looked 100 years old." But Smith persisted: his speech improved, he was able to get about now with a cane; and he even gave several lectures, which were so impressive that they are still remembered by the students who had been there. He had once written, in a bitter mood, "Love is one of the four-letter words"; but when a young Tucson student showed him (as hundreds of others had done) her portfolio, he was kind, patient, and perceptive, as usual; and he asked her if she were in love; she said no; "You can't photograph if you're not in love," he told her.

According to William Johnson, who was then his archivist at the Center, Smith had four projects in mind: the completion of his autobiographical "Book"; the publication of *Sensorium,* the magazine he had failed to establish in the sixties; the resumption of

his own photography; and, of course, his teaching program. It was an heroic effort. As Johnson wrote:

Smith proceeded with an iron tenacity and a grim will to attempt to implement each of these self-imposed projects, or to meet the responsibilities of his contractual arrangements in spite of the enormous burden of his illnesses. Smith did not simply lie down and die or simply drink himself to death during his last year. He fought against his illnesses with every tool and weapon in the makeup of his character. He fought Enyeart, he fought Suris, he fought me, he fought the bureaucracy of the university, he fought the 110 degree heat, the virtual isolation from everyone he knew, the fact that he could no longer drive, the chaos of the move and of his illness. He cried, he drank, he cursed, he longed for a past that seemed better now than when he had lived it, he fought the fact that he could no longer talk or even think as clearly as he once had, that he couldn't even physically open the boxes that contained the detritus of his life's work, that he could not be guaranteed the right to walk into a classroom without collapsing as he once stated "like a horse shot through the head."
Yet he continued to grimly struggle to accomplish these aims right up to the day of his death. It was an exasperating, frightening, at times horrifying and ultimately ennobling experience to watch this man continue to try in the face of all the odds.

From Tucson, Smith called everyone he knew, long distance of course, and would talk for an hour at a time. People later thought he was saying goodbye, but the truth was he was very lonely out there in Arizona, though he would do much the same on the phone from his loft in New York City. Like Kafka, he insisted he wanted all his work destroyed after his death. But he also called Aileen in Japan and asked her to remarry him; she refused; he hung up and went to his favorite Tucson bar. He had never stopped drinking once he got out of the hospital. About a day or so later, there was a problem with one of his cats. In New York, during his last stay, he and Suris had 16 of them. In Arizona, he was reduced to three, one from New York, and two adopted in Tucson. All were presumably spayed or neutered, but one went into heat, anyway, and disappeared one Sunday morning. Smith went to find her; he stopped at a supermarket to buy cat food, but while he was there he had a second massive cerebral stroke, fell down, struck his head, and died the next day, Sunday, October 15, 1978. Statistically, it was 15 or 20 years too soon; he could have lived, had he lived differently, to be a Verdi or a Picasso.

Something is especially shocking about the end of genius. One sees, in this event, the heroic vanity of human effort, the Shakespearean sense of how the self engineers its own tragedy; but finally, one balances the loving tyrannies and the stubborn addictions against the sheer weight of his accomplishment. This is not measured merely by a prodigious number of negatives—because these are, in a more precise sense, as in Dostoevsky's or Beethoven's notebooks, sketches for the climactic, not necessarily the last, exposure—but by the enormous aesthetic and emotional force of his photographic essays. He did not invent the union of word and photograph; its history is at least as old as the popular American novel of the early 20th century, with their posed illustrations of event and character in photographs; but he brought the form to a degree of delicate complexity that matched his own mind. Of these, the book *Minamata* is the final, the best, and sharpest expression of Smith's art in behalf of humanity. And it was done in the last decade of his life, after he had been beaten and half blinded by the force of authority that had been his constant and gigantic enemy.

The life of an artist who must deal in the bazaar of commodities is inherently perilous. Will he conform too much, or too little? Is there a time to agree and a time to resign? The small daily decisions and the larger choices that an artist, like a gambler in an unknown game, must make in the heat of work and that will often alter the rest of his life, for good or bad, impose cracking strains on the integrity of his inner self. Smith, like any artist, and neurotically more so, longed for approval every day of his life; his stimulant, pills or inhaler, and his depressant, alcohol, temporarily relieved him of these black tensions; but when they had been metabolized away in the secrecy of the body, Smith was left with himself again: desperate and sad and angry, even in the time of his greatest success.

The magazine *Life* had been the best source of his money, and it was also the source of the public's admiration for him; but this was ephemeral, and indeed no fame would have wholly satisfied Smith. In business affairs, one is measured by one's salary and stock options; in show business, that caricature of corporate life, by one's weekly salary; in journalism, though, the pages one gets printed are the generally accepted measure; and Smith did not really despise this rule. There is a sense in which *Life* became his mother, and he fought both of them; in the inner circles of the mind, one wins such encounters at a depressive cost. Smith needed human love to heal these cracks and chasms in himself; when he had such love, he gently but certainly tyrannized it, till it, too, collapsed and split away.

His mania for suicide was a longing for love and more and more love; it was the complaint of a child in the costume of a man. It was romantic, not factual; he wrote on the wall of his great, famous, filthy loft: "He walked into the ocean and washed his breath away." As one writes about Smith, affection alternates with pity; disgust for his exploitation of people who loved him alternates with admiration for the dark and glorious prints that were the product of this collaboration; and as one continues to write about him, the egotism of W. Eugene Smith takes over, page by page, and insists on writing its own strange account. And his view of himself, in that torrent of words, is by no means wholly admiring; it is sharp and cynical and even distrustful in some paragraphs, and then humbly boastful in the very next. His voice is crafty and insistent in all those typed carbon copies and rough drafts of the immense letters he kept in his files. And in those hand-printed capitals on oblongs of notepaper, the letters largest when his hand was weakest, he compels the reader, who would rather rise above him in sympathetic irony to go past the special Smithian amalgam in his words—of the fake indistinguishable, sometimes, from the sublime—and to live Smith's heavy life along with, and almost inside of him, and to die a small death when he dies.

Smith's eyes were to be donated; but the telegram of permission from his son Pat arrived too late. His wreck of a body was cremated in Arizona and shipped to New York. A memorial service was held in public; the editor from *Life* said, "Smith always won just what he wanted"—which was not quite true, even of his demands upon himself. The ashes were buried in a private service at the grave site in Crum Elbow Rural Cemetery, Quaker Lane, Hyde Park, in upstate New York, at 11:00 a.m., Sunday, October 22, 1978. Present were his second wife, Aileen, and all his children, including Kevin Eugene Smith—whom his first wife, Carmen, met for the first time—most of his 13 grandchildren, and Sherry Suris, his last companion. His daughter Marissa read a poem that everyone still remembers as deeply moving. And a cable came from Japan, signed by three men in Minamata: the young photographer who had helped him, a local doctor, and a supporter on the city council:

WE COME UPON THE UNEXPECTED NEWS OF YOUR DEATH AND PROFOUNDLY CANNOT ENDURE OUR GRIEF.

YOUR HISTORY IS OUR COURAGE ITSELF.

WE PLEDGE OUR INHERITANCE OF THE MIGHTY FOOTSTEPS YOU LEFT BEHIND AT MINAMATA.

WORLD WAR II

Until he was 25, W. Eugene Smith's work had been remarkably consistent. It was clever, interesting, quick-witted and quick-eyed, and skilled in a narrow repertory of compositional habits. It reflected his moral and intellectual development up to that time and with a few exceptions, it was competent and ambitious. Though Smith must have seen the work of the Resettlement Administration photographers, he was too busy making a living and a reputation as a dependable, hard-working magazine photographer to pay much attention to the icy compassion of a Walker Evans or the romantic and maternal warmth of a Dorothea Lange.

World War II would change all that. He was plainly shocked, like any American whose country had been safe from war for three generations, by its real blood, madness, pain, filth, and horror. He felt it first in the death of strangers, young Navy pilots burned alive; and ultimately, in the death of courageous friends. He smelled the stench of war from the air where he was strapped into a torpedo bomber. And he heard it discussed by fellow war correspondents, of every degree of cowardice and conscience, as they drank and argued the issue of, quite literally, their own life or death.

Characteristically, he sought to get closer to these mortal questions, to photograph on the ground, in the dirt of combat, alongside the point platoon. Despite these risks, he was always dissatisfied with himself, always looking for the perfect image that would sear the minds of the people back home. In the furnace of Saipan, Leyte, Iwo Jima, and particularly Okinawa, where he was wounded, Smith became a moral photographer.

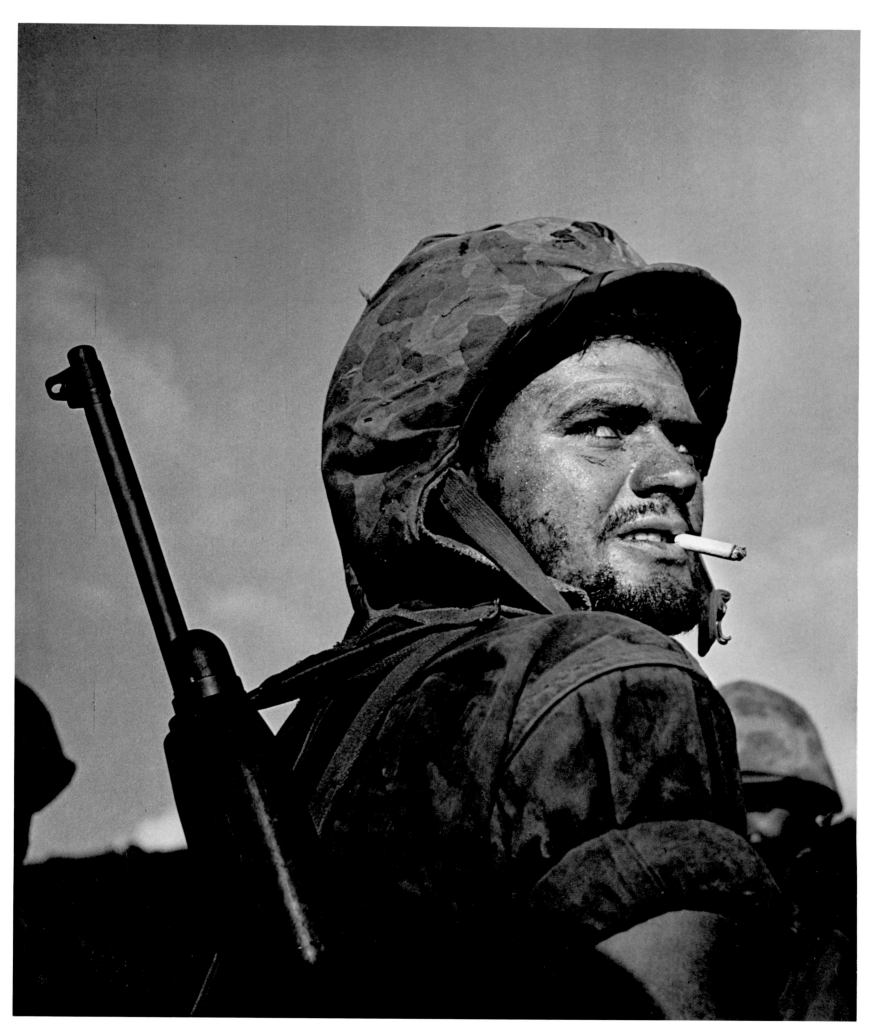

MARINE UNDER FIRE. BATTLE FOR SAIPAN, JUNE 27, 1944

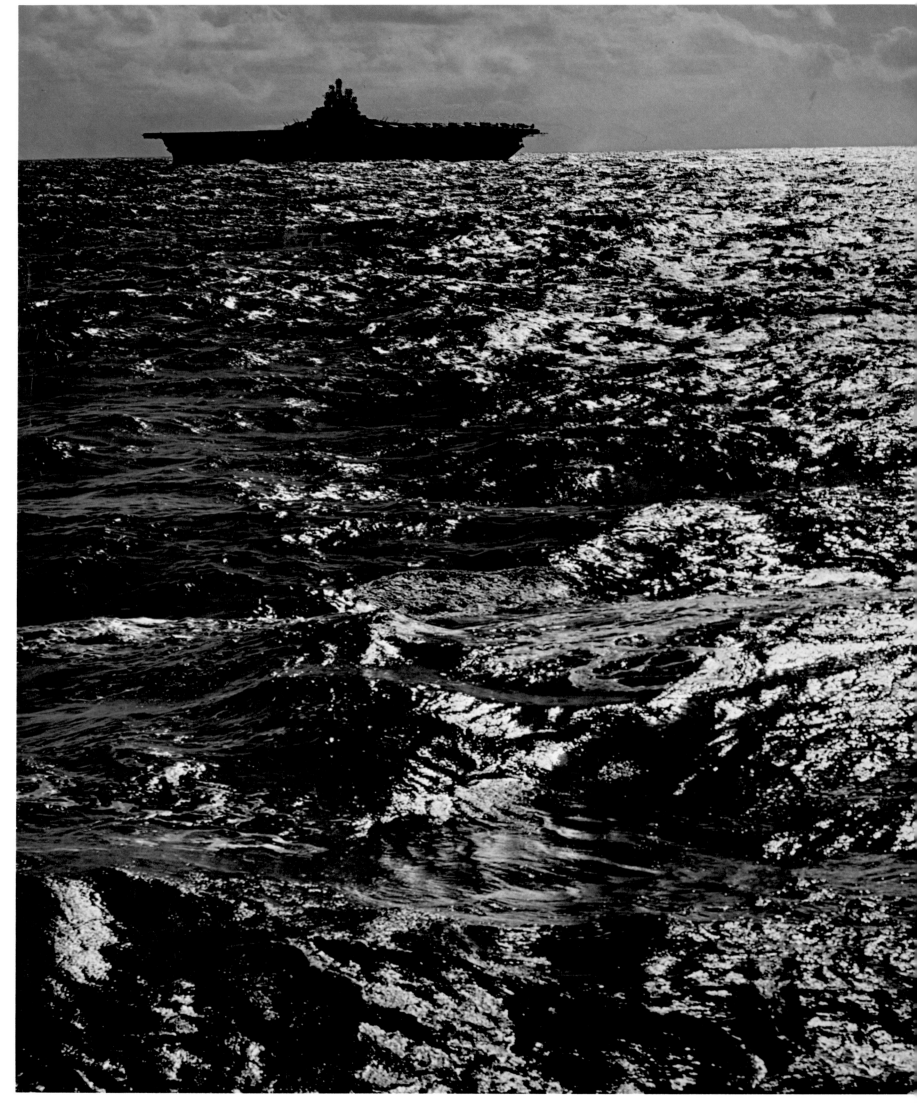

AIRCRAFT CARRIER AND DESTROYER OF NAVAL TASK FORCE 58, THE SOUTH PACIFIC, CA. NOVEMBER 1943

". . . my assignment was of the air war, and the carriers that based the planes that fought that war. These, unless hit by catastrophe, are beautiful by nature, and trying to gain a feel of combat flying in powerful planes is your only choice: to deliberately ignore their beautiful features (ships and planes) would be as much of a lie as the hack portraits of Broadway. And if you believe that Naval war in the Pacific does not have its long moments of sheer beauty, then you are trying to imagine a constant grimness that just doesn't exist."

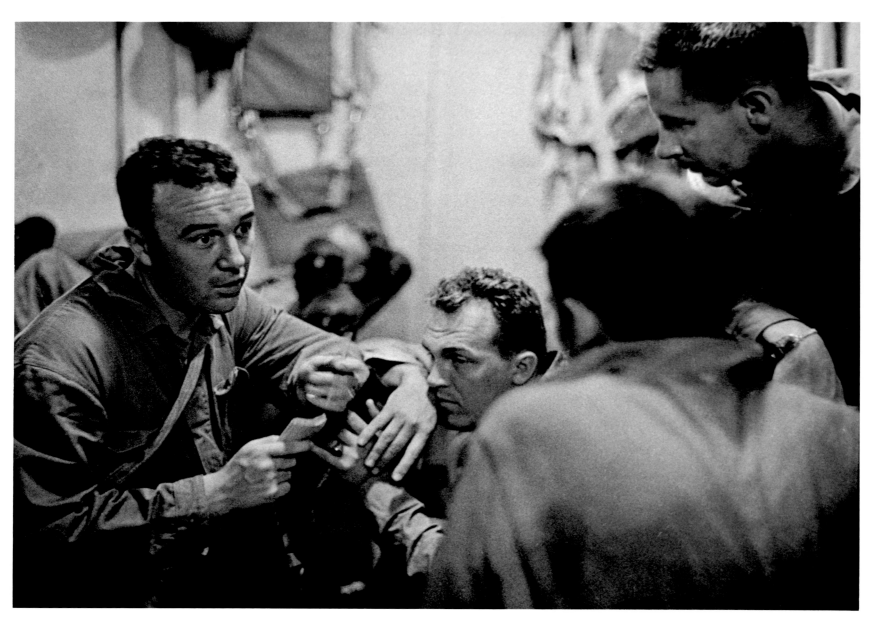

NAVAL LIEUTENANT COMMANDER EDWARD "BUTCH" O'HARE ADVISING PILOTS IN CARRIER READY ROOM BEFORE WAKE ISLAND RAID, OCTOBER 1943

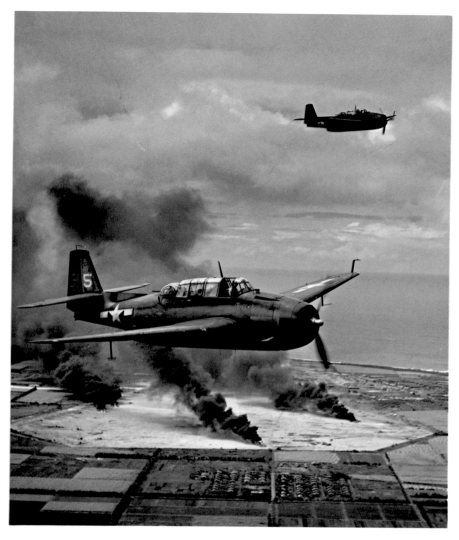

NAVY AVENGER TORPEDO BOMBERS HEADING
OVER TINIAN ISLAND IN THE MARIANAS, FEBRUARY 22, 1944

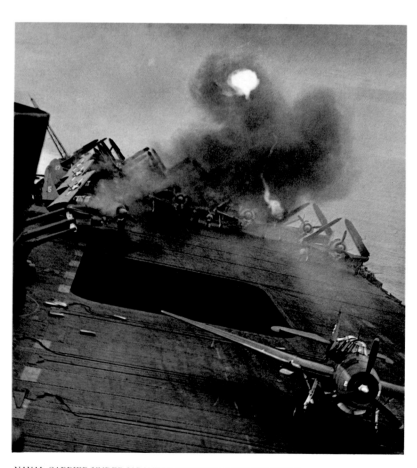

NAVAL CARRIER UNDER JAPANESE COUNTER-ATTACK DURING
THE AMERICAN RAID ON RABAUL, NEW BRITAIN,
NOVEMBER 11, 1943

"The carriers were in the process of launching a second attack on Rabaul when the Japs struck with fighters, dive bombers, and torpedo planes. Thirty-three Jap planes in formation were headed for this carrier, and as the last fighter hurled off the flight deck, the fire from the carrier's guns was blasting across the deck . . .

The thirty-three planes were now engaged by the American fighters who so completely broke up the attack that only 4 or 5 of the Vals were able to launch their bombs. Four of these bombs were very near misses. Two hitting on each side. The torpedo attack was broken up [by] the fighters and the heavy fire from the carrier . . . I am thoroughly disgusted with the pictures, and believe any intelligent man could have gotten at least one superior shot out of the mess. I smashed one camera, ruining the first few exposures that I made, when the metal fastenings gave way and it plunged two decks below. I doubt if they were any better."

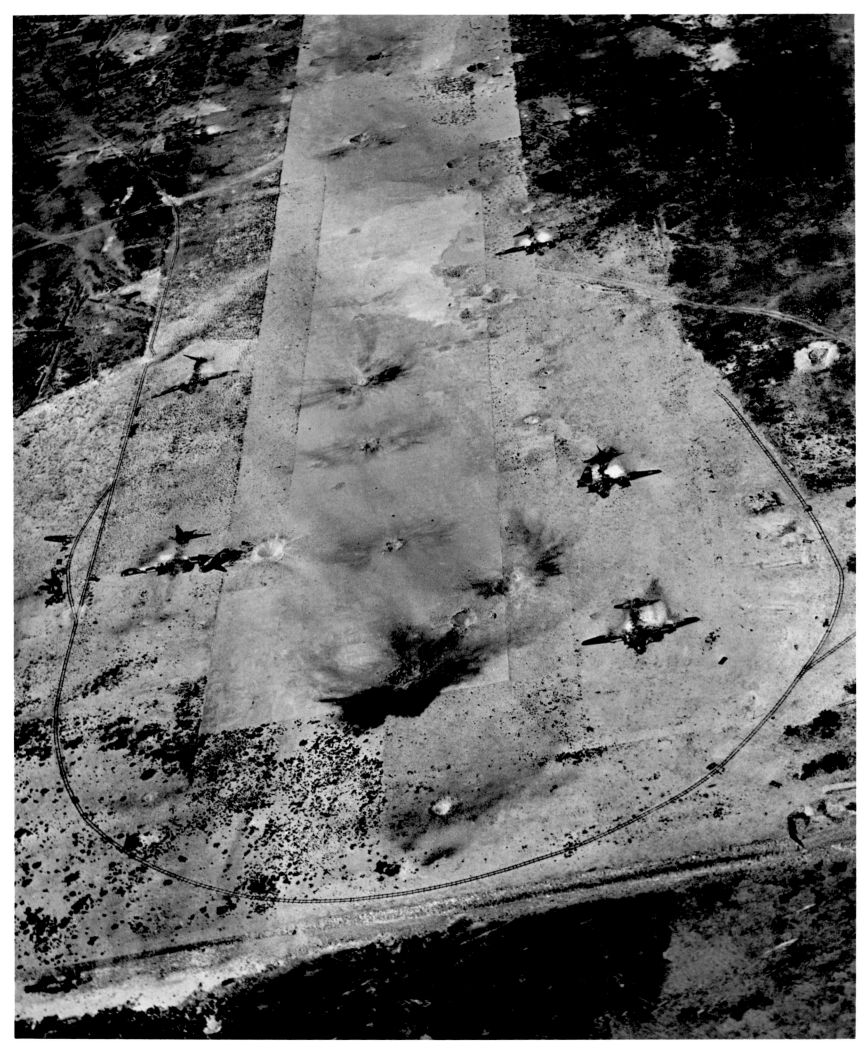

BOMBED JAPANESE AIR FIELD, ENGEBEI ISLAND, JANUARY 1944

"I had covered the early pounding of Tarawa and D-Day from the air, and this hour was utilized to shoot just as much damage assessment as was possible. . . . Heavy shadows were an honest representation of the burning sun that hurried the rotting of human bodies until the stench was strong even in a plane several hundred feet above the island.

That I was not there at the right time, was in the air when the hell was breaking loose, is my very great regret—for when I arrived with the first planes, the climax of the ground fighting was of course over. And after a battle there is a horrible serenity—a dead island covered with dead trees and with dead or exhausted bodies can be very serene. . . ."

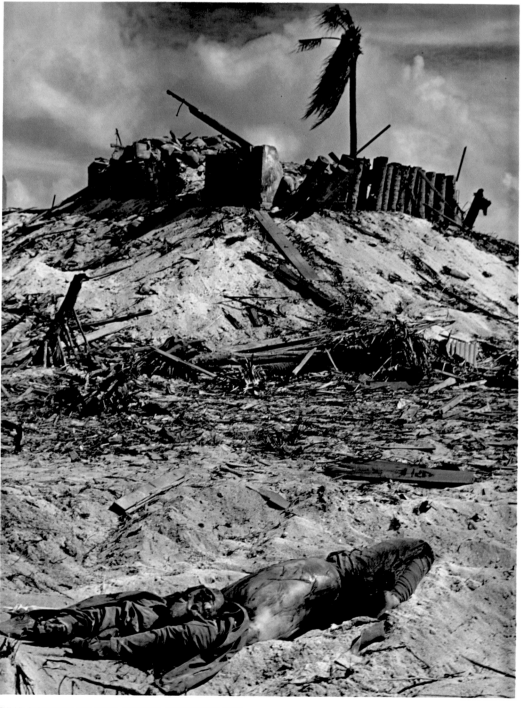

DEAD JAPANESE SOLDIER, TARAWA, NOVEMBER 1943

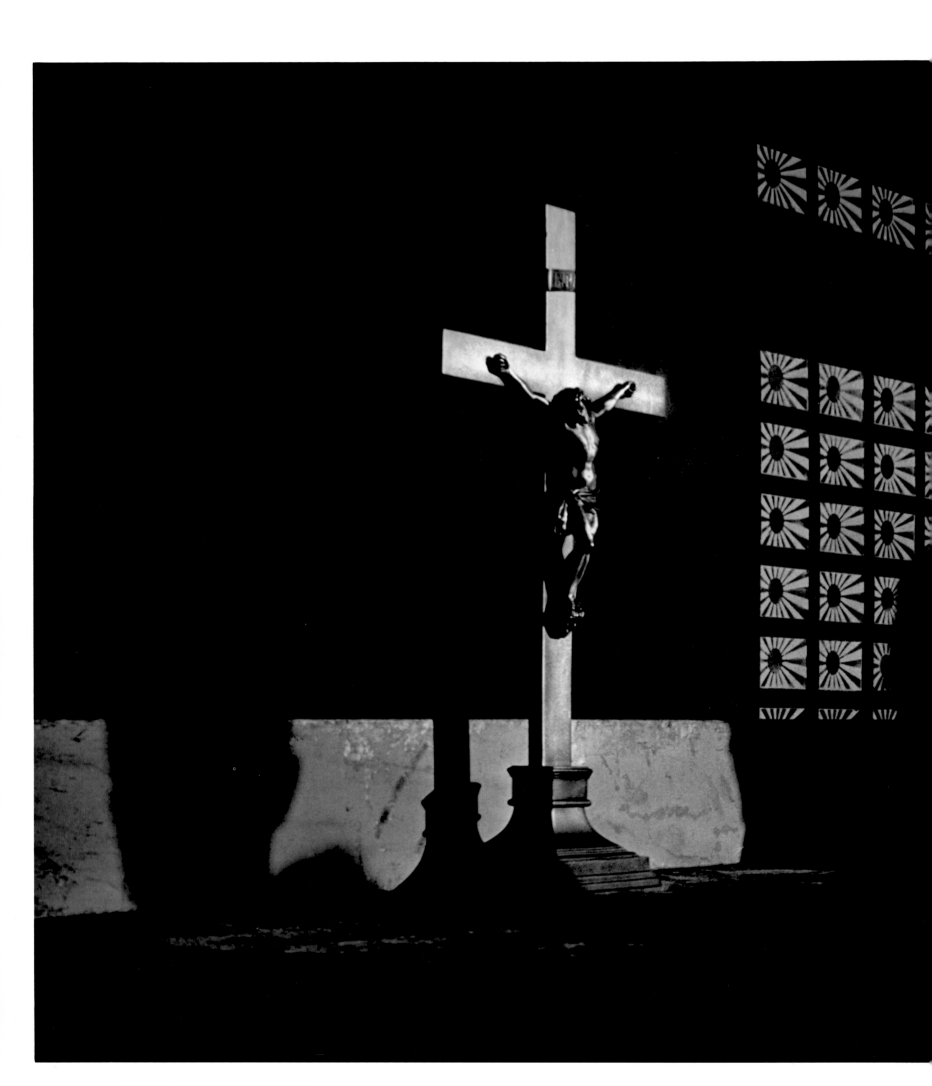

MEMORIAL SERVICE ON U.S.S. BUNKER HILL, FEBRUARY 1944

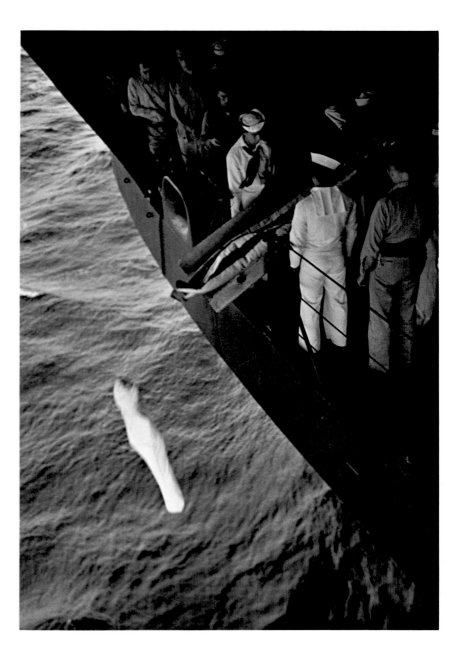

BURIAL AT SEA FROM THE U.S.S. BUNKER HILL, CA. FEBRUARY 1944

". . . very slowly the head of a dazed old man appeared. Then the rest began to follow—but OH! how slowly, and how pitiable they were as they emerged from the smoke—weak, sick from the smoke, guts simply twisted from the fear they felt of us—and of their possible fate. Tiny babies on the backs of their mothers, older children, fathers, grandfathers—all human lumps of fright and terrible weariness—young and old so helpless.

With sickness and realization that was sour in my throat, the scene pounded home to me that but for the luck of U.S. birth—my people could be these people, my children could be those children . . ."

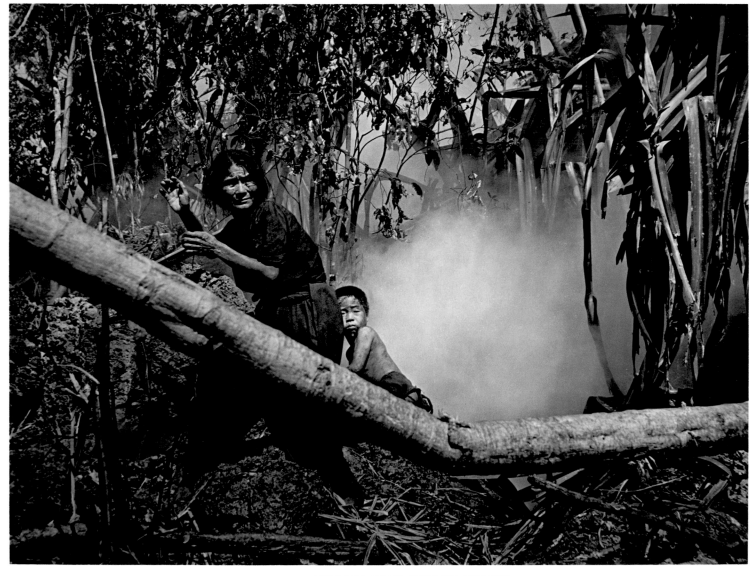

CIVILIANS DRIVEN FROM NATURAL CAVES IN THE SAIPAN MOUNTAINS BY U.S. SMOKE GRENADES, JUNE 1944

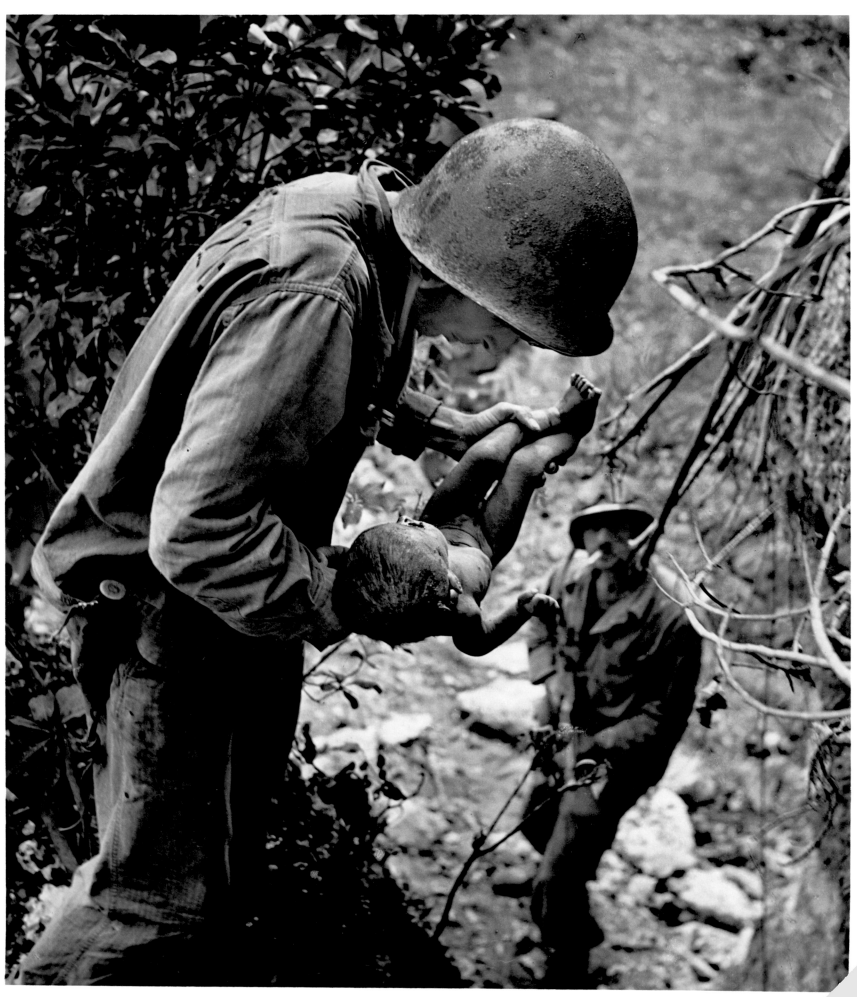

WOUNDED, DYING INFANT FOUND BY AMERICAN SOLDIER IN SAIPAN MOUNTAINS, JUNE 1944

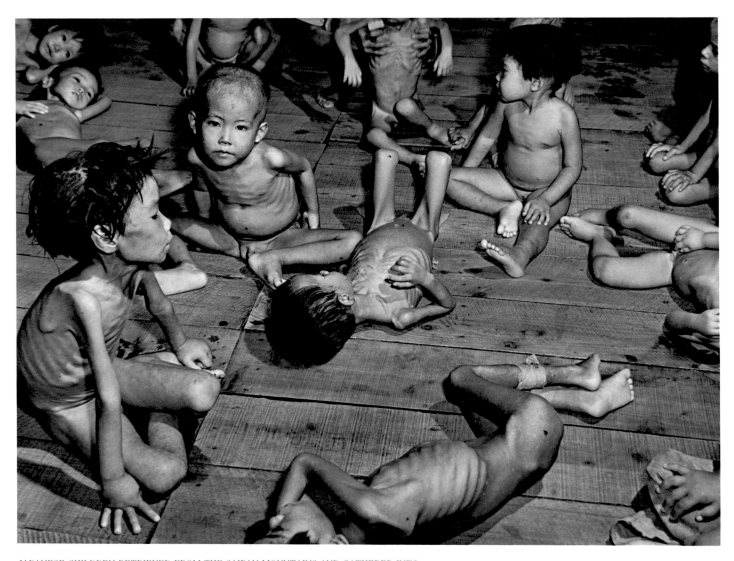

JAPANESE CHILDREN RETRIEVED FROM THE SAIPAN MOUNTAINS AND GATHERED INTO
A CIVILIAN COMPOUND BY U.S. SOLDIERS, JULY 1944

". . . I saw my daughter, and my wife, and my mother, and my son, reflected in the
tortured faces of another race. Accident of birth, accident of home—damn the rot
of man that leads to wars. The bloody dying child I held momentarily in my arms
while the life fluid seeped away and through my shirt and burned my heart into
flaming hate—that child was my child. And each time I pressed the release it was a
shouted condemnation hurled with the hopes that it might survive through the
years and at least echo through the minds of the men who will sit down hence to
plan the next period of liquidation."

"These pictures were made mostly on the very front lines during the great upsweep of attack that saw the Marines of the 2nd and 4th Divisions smash from the hills in the middle of the island down across the shelves of level ground and drive the Japs into the water . . . This drive really started immediately after the horrifying onslaught of the last counterattack by the Japs which did manage to break through our lines and cause many casualties, but ended with hundreds of Japs dead, sometimes piled ten to twenty in our own foxholes."

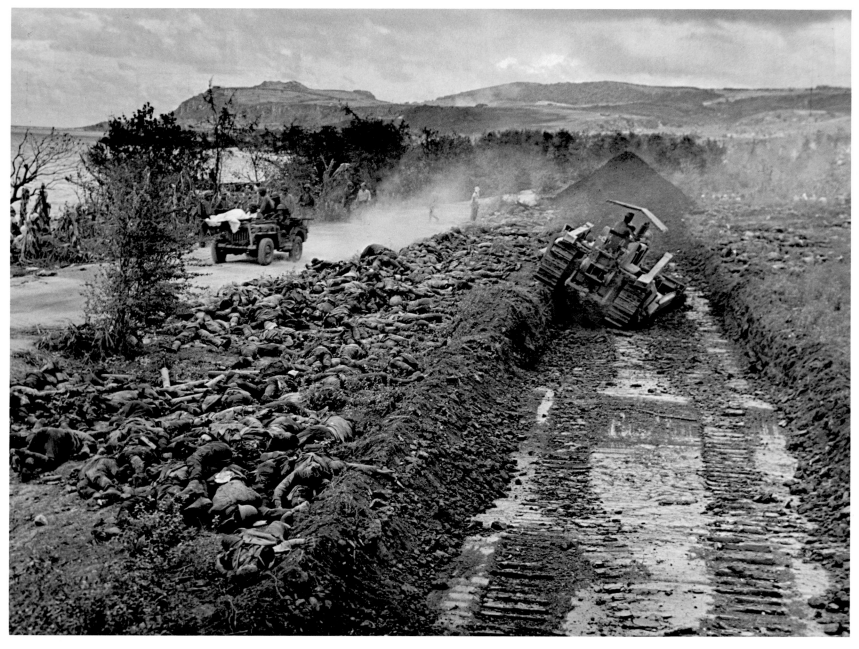

BULLDOZER SCOOPING OUT MASS GRAVE FOR 2000 JAPANESE SOLDIERS KILLED IN FINAL BANZAI CHARGE; JEEP IN BACKGROUND IS CARRYING AMERICAN WOUNDED TO AID, SAIPAN, JULY 7, 1944

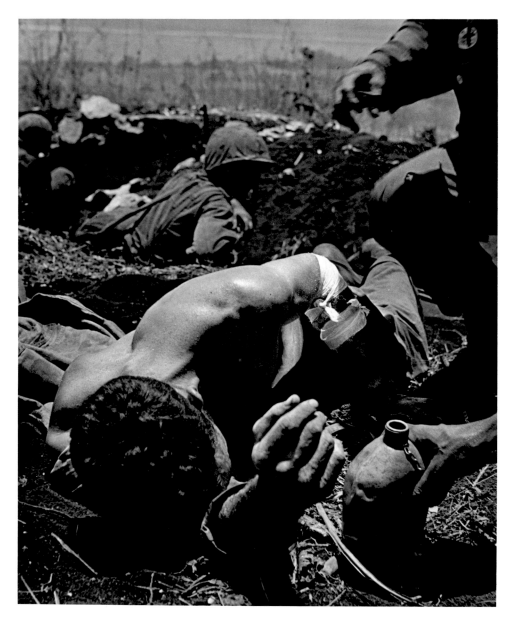

WOUNDED MARINE RECEIVES AID, SAIPAN, JULY 8, 1944

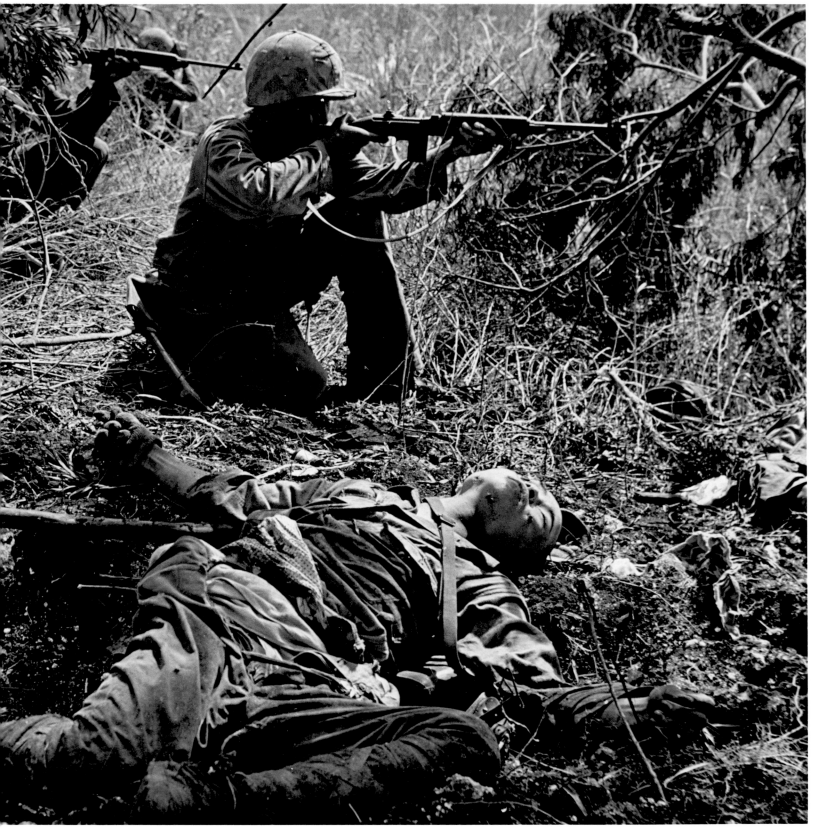

MARINE MOP-UP FOLLOWING JAPANESE SUICIDE CHARGE, SAIPAN, JULY 7, 1944

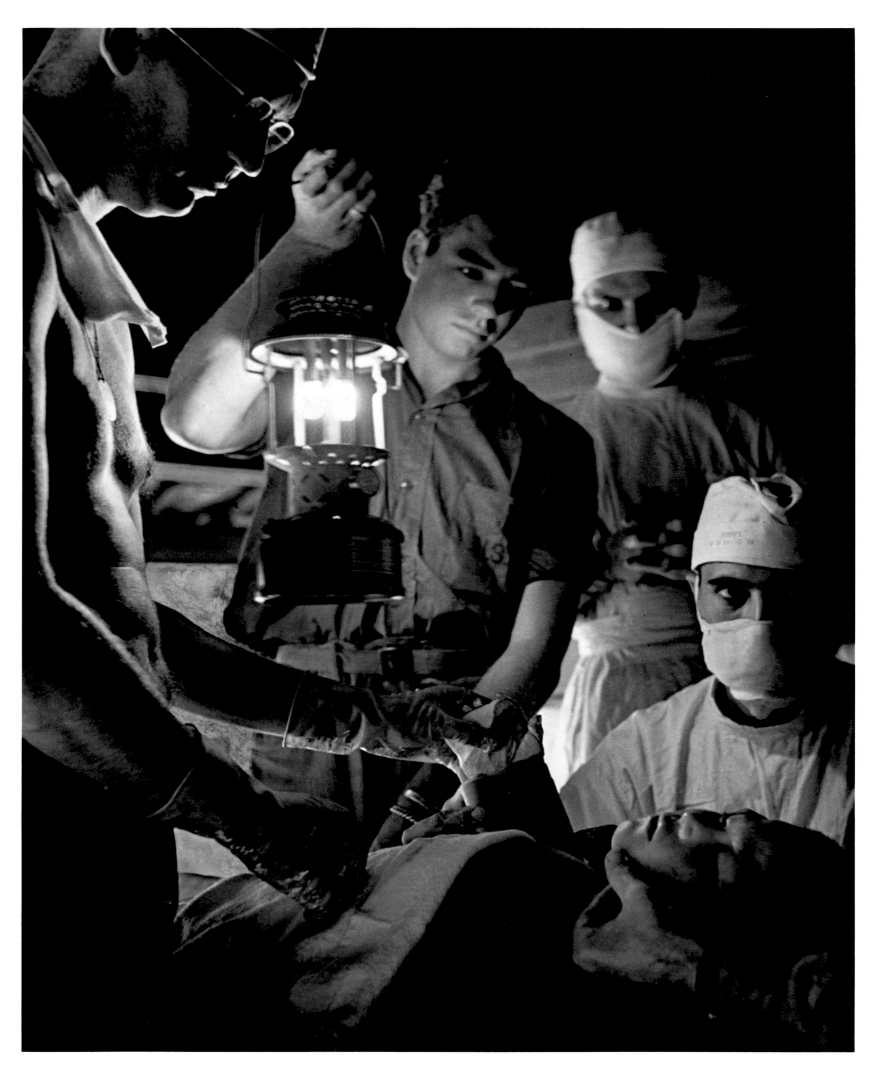

TEMPORARY HOSPITAL IN THE CATHOLIC CATHEDRAL ON LEYTE, NOVEMBER 1944

"Have been in the hospital for the last few days . . . taking pictures. . . . Very carefully, very slowly, I worked and sweated and pulled a hospital story together that I feel may be one of my best stories of the war. I say this before the negatives are developed, I say this knowing that the lighting of the place was atrocious and that I took long technical chances to try to secure that which I was after."

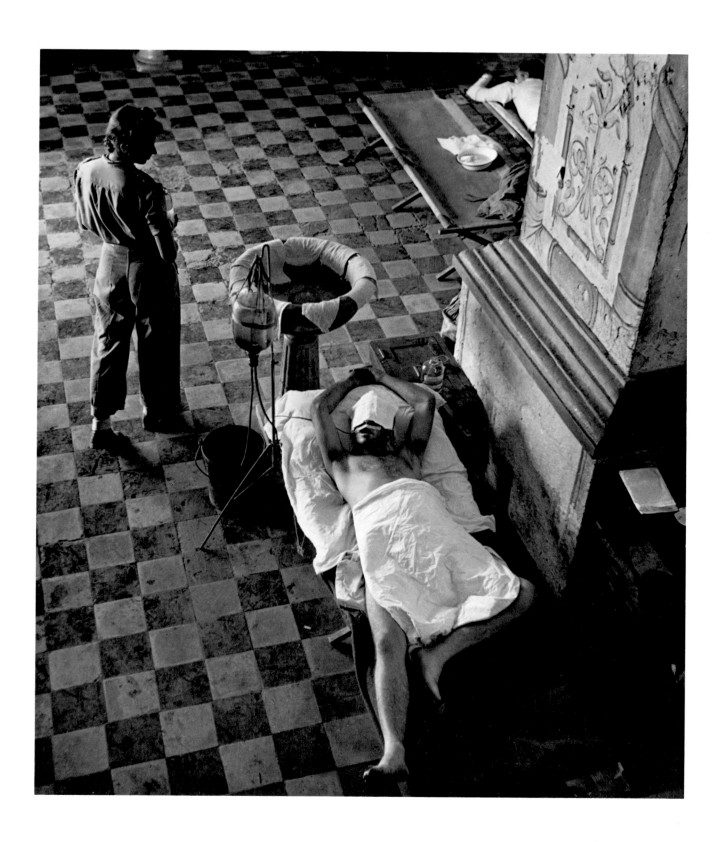

MARINE DEMOLITION TEAM BLASTING OUT A CAVE ON HILL 382, IWO JIMA, MARCH 1945

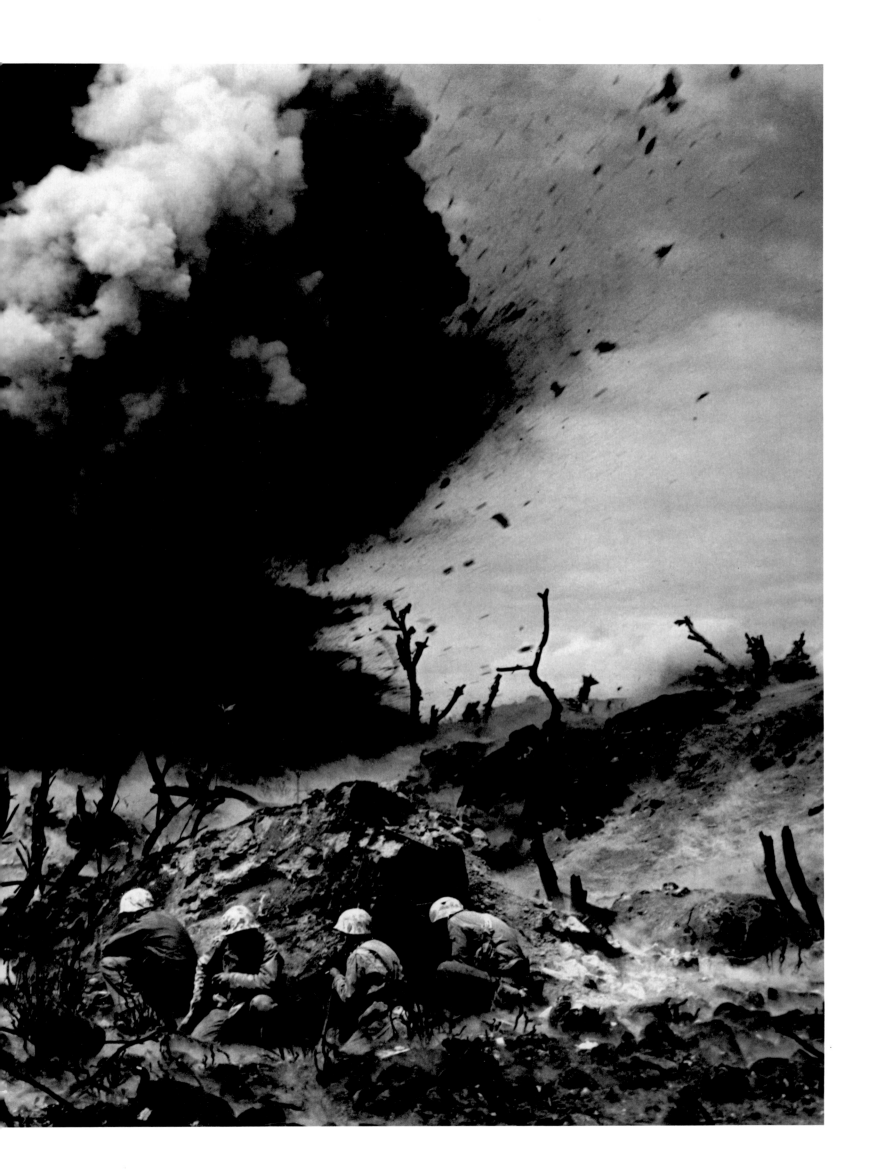

"The battle of Okinawa has now become the bitter, brutal, inch by inch battle that everyone expected it to be before D-Day. After several days layoff to rebuild strength, the army divisions, facing thousands of yards of fortifications in the southern sector of the island, launched the heaviest land attack of the Pacific war in an effort to crack the foremost lines of defense. It was the same old story—the Japs deeply dug in, and only the infantry could dislodge them."

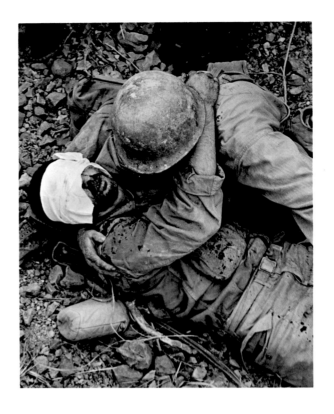

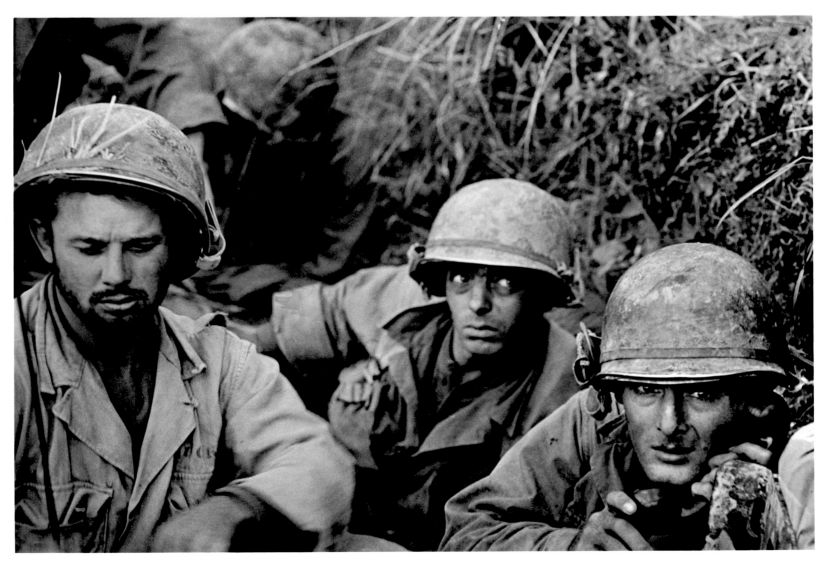

OKINAWA, APRIL 19, 1945

"Suddenly a man broke onto the road and ran frantically up the road toward us.
Bullets plowed the dirt at his feet, we could see that his face was a mass of blood
and he wobbled as he ran, but on and on he came and still the bullets cracked
around him, within inches of the safety of the ridge he was hit again and gyrated
crazily into a heap behind the ridge. He lay there writhing and groaning, the last
bullet had gone through his foot but was a clean wound, his head looked bad and
blood poured from his mouth and nostrils, but he was conscious and fairly rational,
asking how badly he was hit, saying that he was a new replacement, telling us
about the hell up ahead.

Although in great pain they did not give him morphine because of the head wound,
as they laid him on a stretcher he grasped the neck of the medic and held on for
several seconds. Then he lay there with his hands clenching and unclenching—
finally he brought his hands together in the folded position of prayer, his lips began
to move, he stopped writhing. They picked up the stretcher and as they carried
him along the ridge his lips still moved and his hands were still clasped."

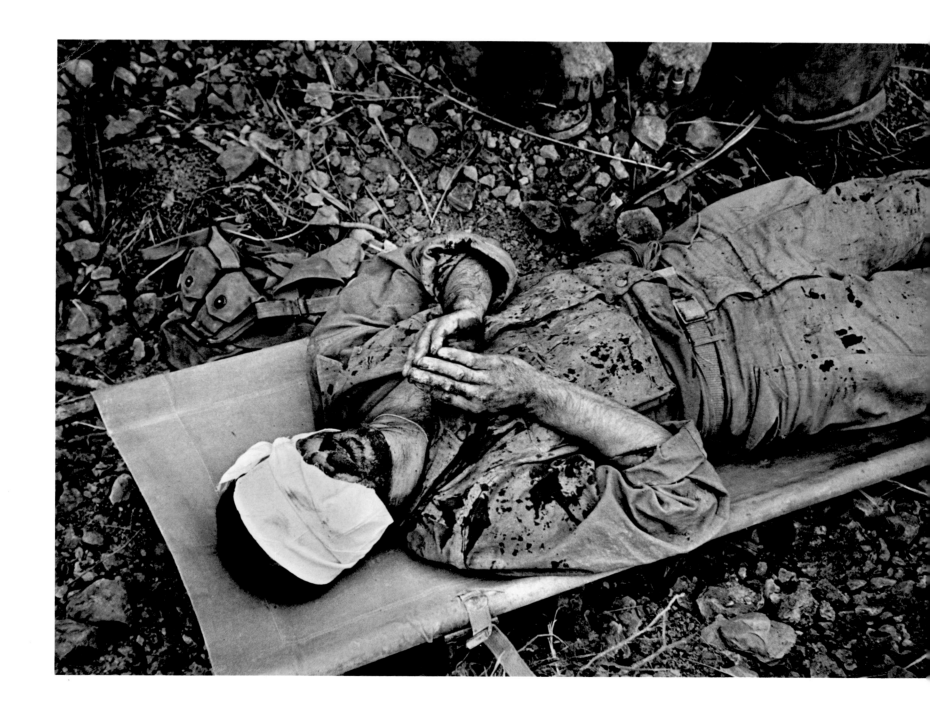

"I was after a set of pictures so that when people looked at them they would say, 'This is war'—that the people who were in the war would believe that I had truthfully captured what they had gone through . . . I worked in the framework that war is horrible. I want to carry on what I have tried to do in these pictures. War is a concentrated unit in the world and these things are clearly and cleanly seen. Things like race prejudice, poverty, hatred and bigotry are sprawling things in civilian life, and not so easy to define as war."

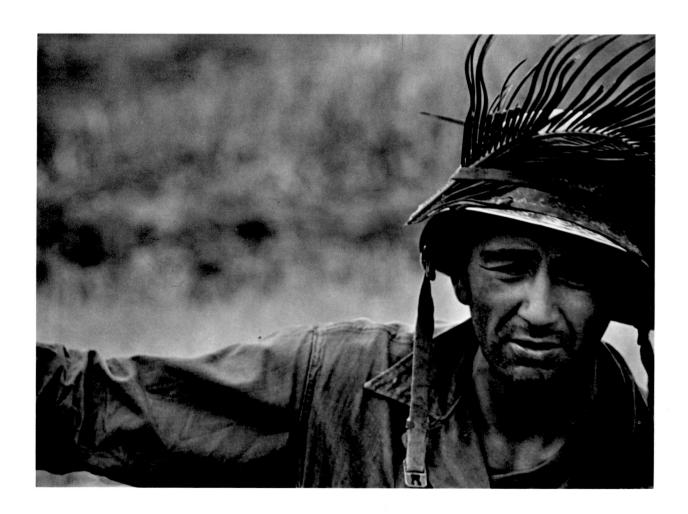

POSTWAR AMERICA

THE war was over and the peace was troubled. Smith now firmly held a set of conscious professional values: he wanted to help humanity see itself, understand itself, cure itself. It was a goal not unmixed with his fiery native ambition, partly concealed under a shy, kindly, but uneasy personality. His post-war reputation was enhanced by his affiliation with *Life* magazine, a powerful institution at that time. For *Life,* he constructed two photographic essays—"Country Doctor" and "Nurse Midwife"—that explored the subjects of birth and death in such powerful, direct, and compassionate ways that he became, during this five year period, one of the world's great photojournalists.

But that was only the best of his work. The burden of making a living for himself and his large family—worsened by the fact that he wasted money prodigiously—made him take assignments that were not in harmony with what he deeply believed. Yet even his most commercial projects of this period are better than his pre-war work. The very strain of his high ideals had broadened him professionally and aesthetically. And the need for *Life* to reflect the half-world of entertainment found a happy response in Smith's own theatrical character.

The portraits he made in America in that post-war decade are not phony; they are clear, direct, and sympathetic. Impatient with authority, he gave hours of patience to his subjects. There is a solid truth to this part of his work that one can't find in the more brilliant and sardonic of his contemporaries. Smith was maturing not always emotionally, but in his craft, which is after all where it matters most.

FOLK SINGERS

America's largest celebration of mountain music, the Asheville Folk Festival kept alive the time-honored traditions of old English folk singing and dance. It was here in North Carolina that Eugene Smith created his first important postwar photo-essay. Visiting the people of the Blue Ridge Mountains, Smith moved to the rhythm of their lives and music, and discovered—at both the festival and in the community—a subject of classic American stature. This essay originally appeared in the October 20, 1947 issue of *Life* magazine.

SARAH BAILEY AND FIDDLIN' BILL HENSLEY, BROTHER AND SISTER, AT THE ASHEVILLE FOLK FESTIVAL

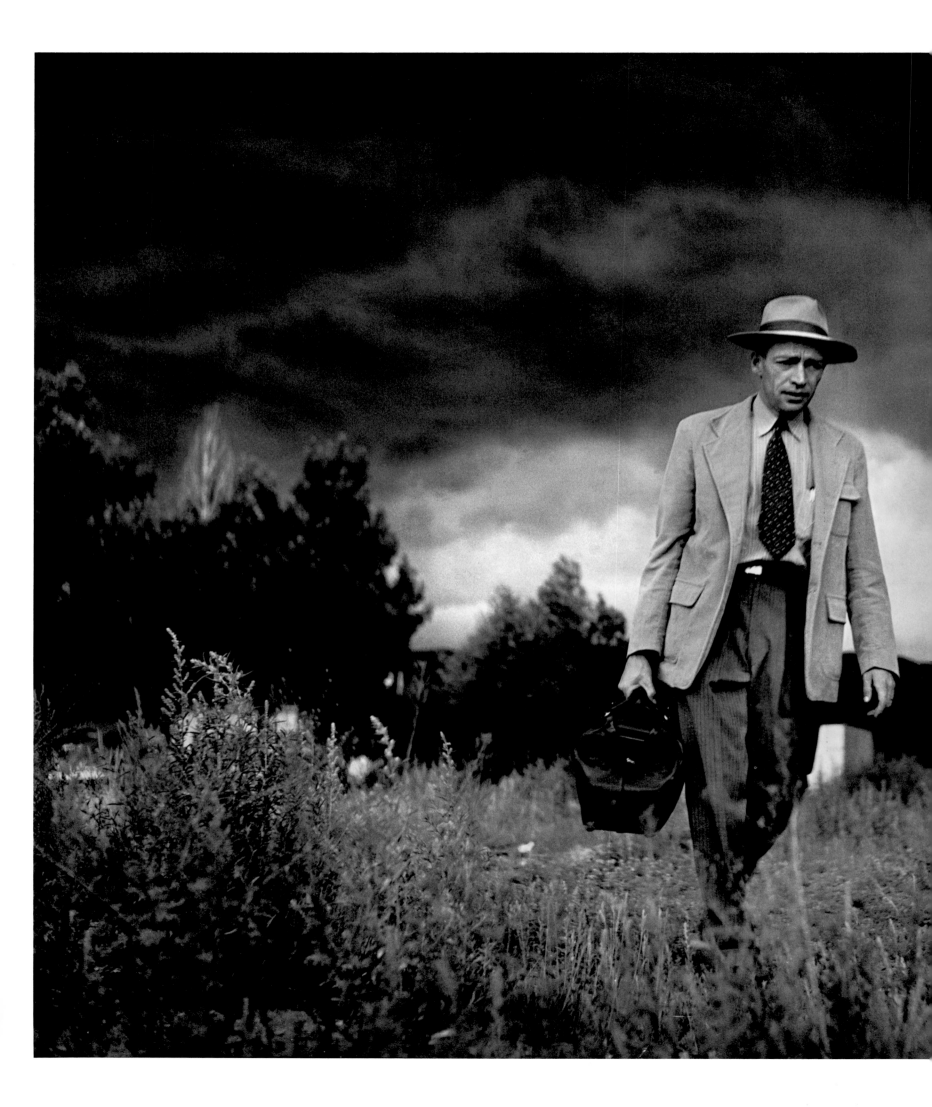

COUNTRY DOCTOR

"Country Doctor" was a breakthrough for Gene Smith and for photojournalism. Printed in *Life* magazine, almost a full year after "Folk Singers," the story of Dr. Robert Ceriani rated Smith an impressive eleven-page spread. Avoiding potential cliches, Smith created an earnest, empathetic portrait of an American folk hero. Dr. Ceriani was on call day and night—and so was Smith. He captured the doctor delivering babies, comforting patients, and binding wounds. He enlarged his portrait by finding the doctor in rare and private moments of relaxation—riding horseback, or catching a cup of coffee. In Smith's own words, "I spent four weeks living with him. I made very few pictures at first. I mainly tried to learn what made the doctor tick, what his personality was, how he worked and what the surroundings were. I had to wait for actuality instead of setting up poses. I simply faded into the wallpaper and waited. By fading, by being in the background, I was able to catch expressions and emotions. I moved quietly and didn't open my mouth. The doctor was terrific—a grand fellow, which leads me to say that on any long story you have to be compatible with your subject, as I was with him. I reserve my temperament for home and the darkroom."

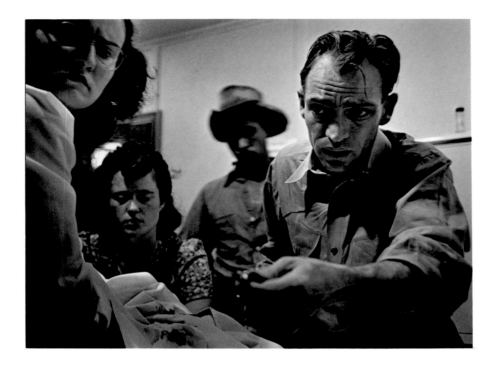

Within the "Country Doctor" essay, Smith told the story of 2½ year old Lee Marie Wheatly. Dr. Ceriani was called in to perform emergency surgery after the young girl was kicked in the head by a horse. Ceriani was sure she would lose an eye and attempted to find a way to soften the blow to her parents.

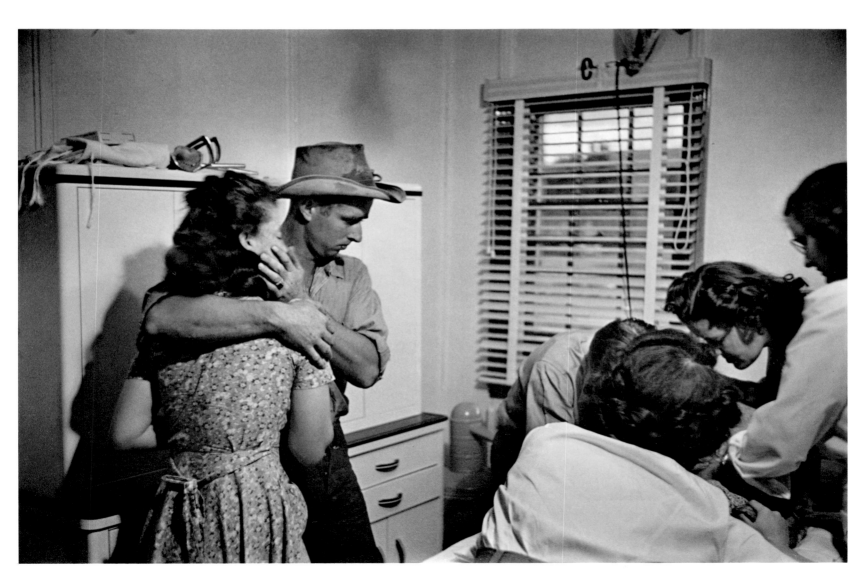

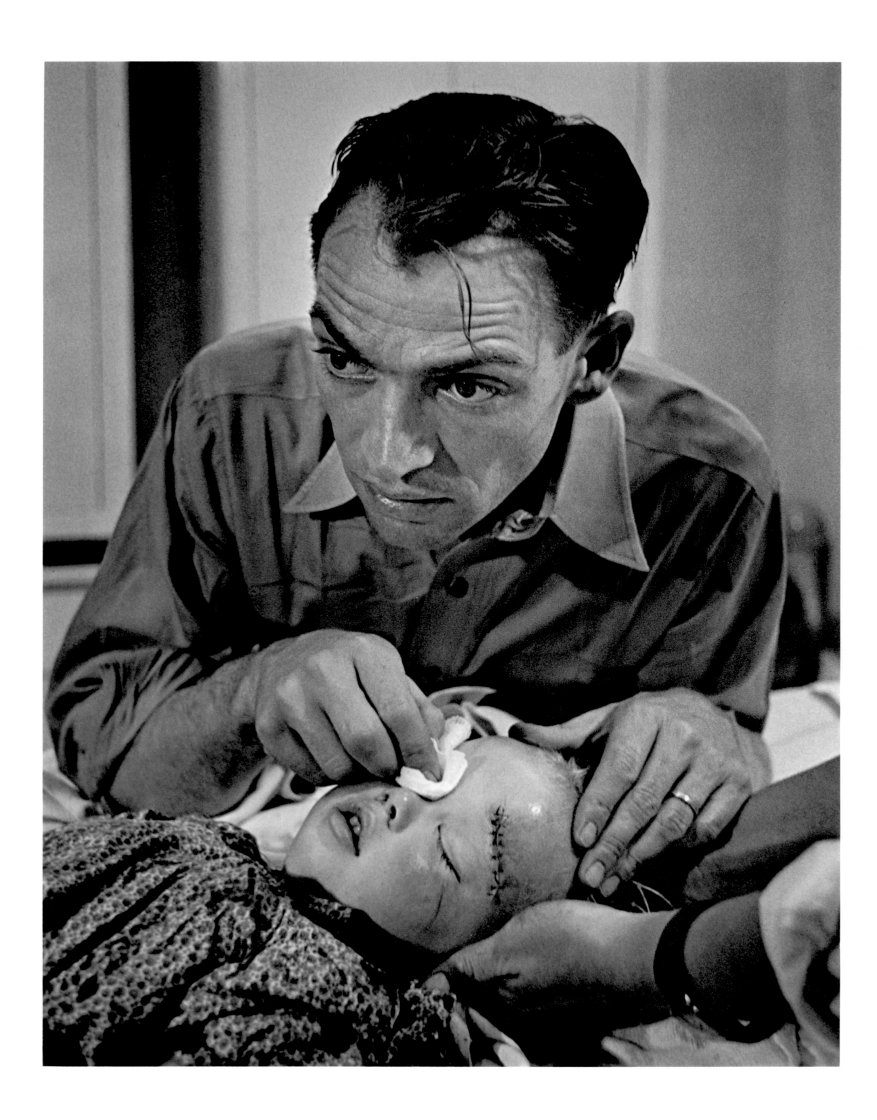

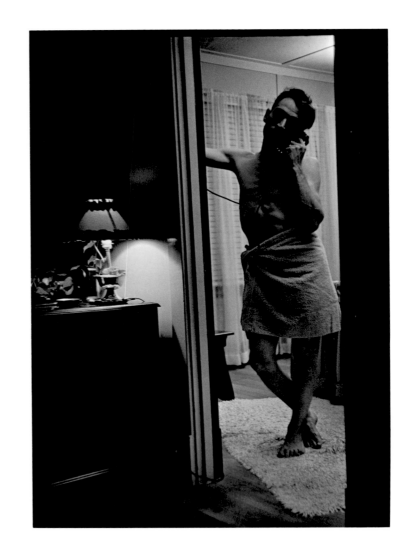

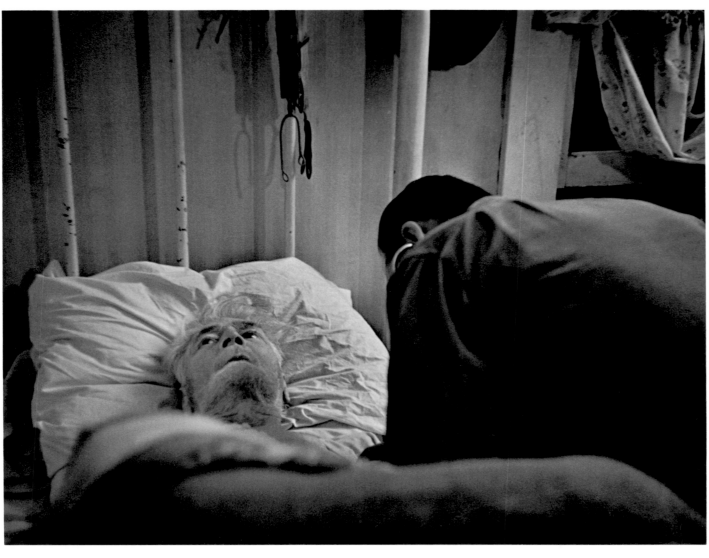

Smith accompanied Dr. Ceriani on an emergency night visit to the home of Joe Jesmer. 82 years old, Jesmer had experienced a heart attack, and the doctor was there to lend comfort to his final moments. In the photograph below, Mr. Jesmer's boarders look on as Dr. Ceriani calls a priest to meet him at the hospital.

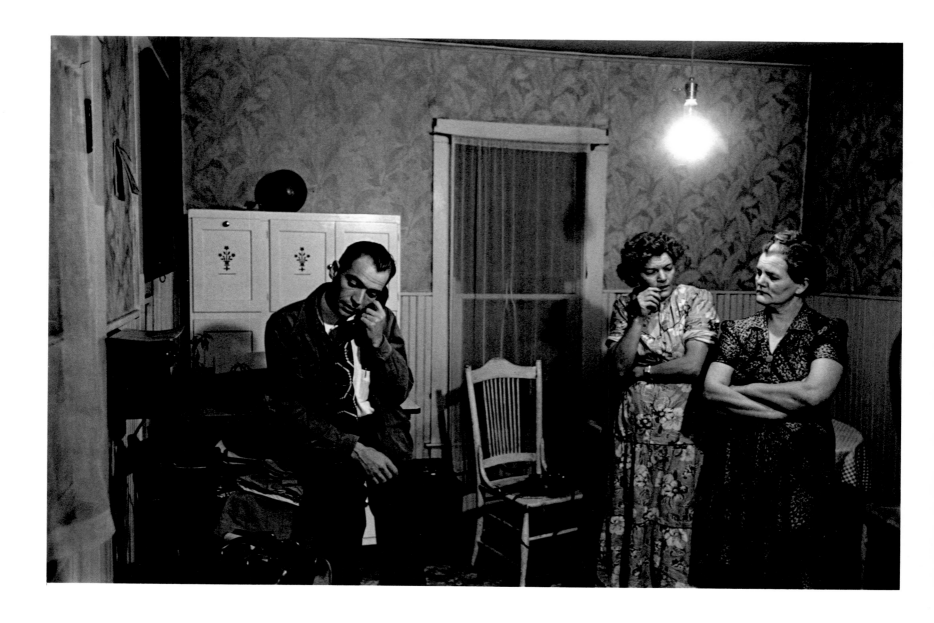

HARPSICHORDIST WANDA LANDOWSKA

RECORDING ARTISTS

Eugene Smith wrote: "I divide my life into two parts, before music and with music . . ." The photo-essay "Recording Artists" stands as a reflection of his love and devotion to the art. It is a sensitive portrait of a number of the greatest classical and popular musicians of the time, captured at their instrument or in the recording studio. These portraits are marked by the intensity and concentration displayed by both the subjects and the photographer. As Smith explained in an undated manuscript note: "A discovery of music. Involvement in music has given me a philosophy for examining the happenings of the world and attempting to translate this photographically. I don't expect anyone to see the relation to music. This is besides the point. Improve the grammar of what you are saying. Examine with care the subject of what you are saying." The essay was published in *Life* in 1951, an incredibly productive year for Smith in which he produced five theater stories as well as his great essays, "Nurse Midwife" and "Spanish Village."

CONDUCTOR BRUNO WALTER AND VIOLINIST JOSEPH SZIGETI
RECORD A BEETHOVEN CONCERTO

OPERA SINGERS HELEN TRAUBEL AND HERTZ GLAZ LISTEN TO A STUDIO PLAYBACK

CELLIST GREGOR PIATIGORSKY

PIANIST RUDOLF SERKIN

ALBERT SCHWEITZER, 1949

PORTRAITS

During his time at *Life*, Smith was often on commercial assignment, covering the theater, politics, and their luminaries. His portraits were distinguished by his intense interpretive power and mastery of craft. His hall of fame includes celebrities as diverse as Frank Sinatra, Lena Horne, Tennessee Williams, Harry Truman, Grandma Moses, and Albert Schweitzer—a subject to which he would later return.

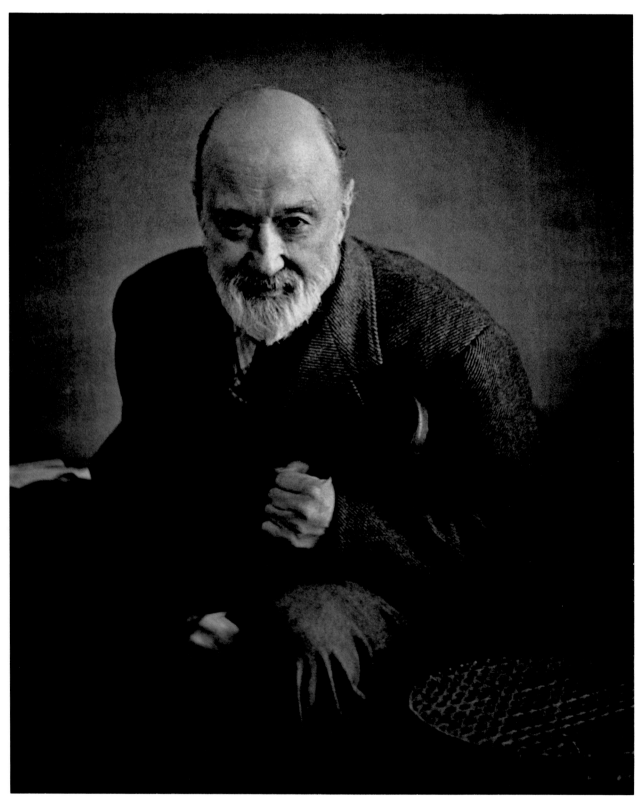

CHARLES IVES, 1949

"Rediscovered Genius" was the focus of Gene Smith's *Life* assignment during the week of May 24, 1948. His subjects—bronze sculptures by the reclusive and recently deceased Elie Nadelman—were uncovered by art historian Lincoln Kirstein in the Riverdale, New York, home of the artist. Nadelman left behind several decades of works which had never been publicly displayed and were not popularly known to exist.

GRANDMA MOSES, CA. 1947

TENNESSEE WILLIAMS, 1948

INSIDE THE HOME OF ELIE NADELMAN, 1948

KU KLUX KLAN

While passing through North Carolina, Smith had the opportunity to photograph a KKK rally. Shocked and fascinated, he rushed to document the clan and its rituals. This experience affected the treatment of his next great photo-essay, "Nurse Midwife." He wrote his mother on April 15, 1951: "This Southern story [referring to "Nurse Midwife"] will be another in which I call it as I see it only after many hours and days of impersonal interviewing, observing, and listening—I admit the KKK meeting was a strong dose of poison to receive at the beginning. The leaders spoke in warped vicious hatred that disregarded truth almost completely, while the majority of the 'common folks' who agreed spoke out of ignorance warped by the ravings of the leaders. And were the majority right when they stood by and watched them crucify the Lord? The majority are not necessarily right. They are told, and to some degree they then repeat, and it is because of this the obligation of my profession lays so heavily upon my conscience to weigh and balance all that I photograph and all that I ultimately state in public."

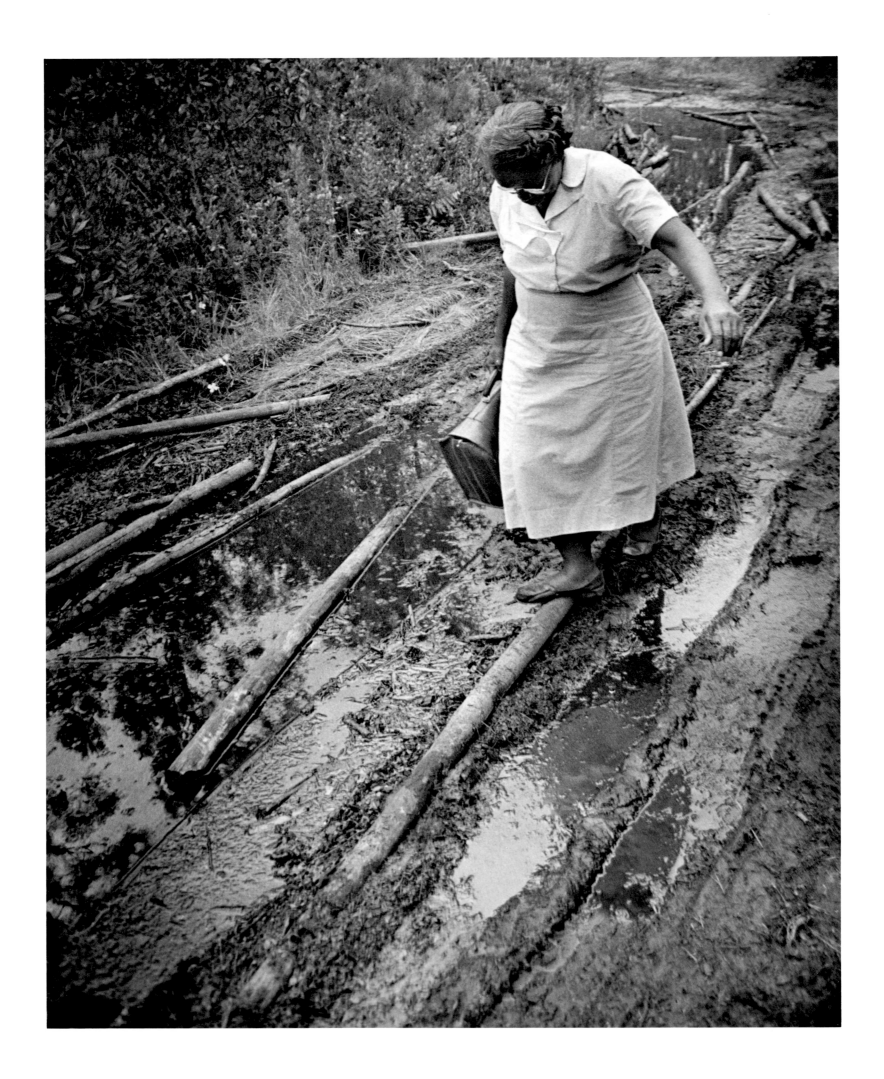

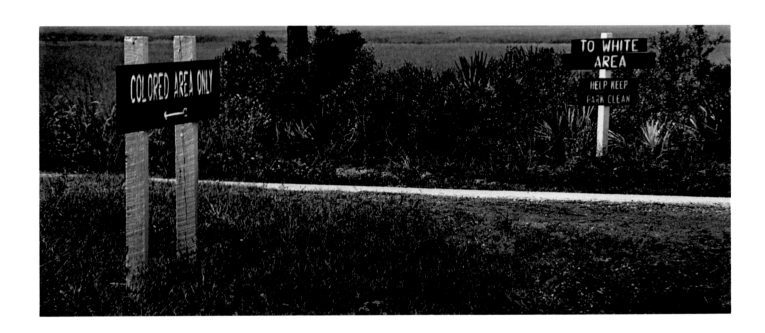

NURSE MIDWIFE

A licensed nurse midwife, Maude Callen provided medical care and social services
to over 10,000 people in a 400 square mile area of rural North Carolina. It had
been two years since the "Country Doctor" essay and Smith finally had a subject of
equal weight and power. The essay was published in *Life* magazine in the issue of
December 3, 1951, and ran for twelve pages. It drew a phenomenal public
response that inspired voluntary gifts amounting to $18,500 for Maude's new clinic.
Smith wrote his mother at the project's inception: "I think I have my new project. I
presume this story, which I wish to carefully and tenderly do, with taste and
understanding, that I will be called sacriligious in some quarters—
banned in Boston and hated in the South. It will be a story of a midwife and it will
probably be centered around a negro. There will be the usual complaints of
devoting so much space to negroes and . . . That is just too bad. I think it can be a
great story, and am quite excited about doing it. As usual, it will be extremely
tough to do."

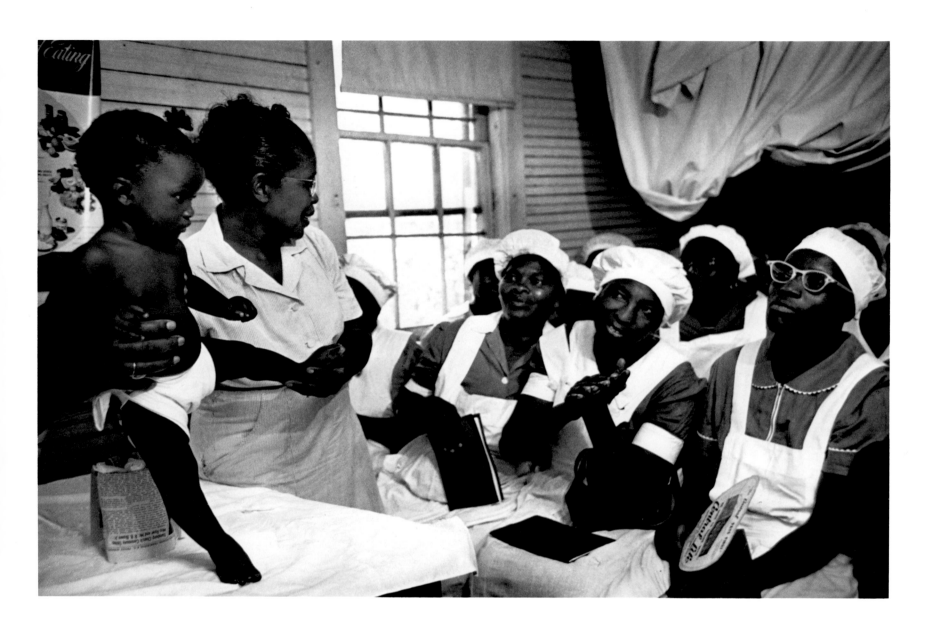

Maude Callen set up a temporary clinic in an old church. It was here that Smith captured her tending patients and training apprentice nurse midwives. He stayed close to his subject, creating a portrait of both a community and one woman's devotion to its well-being. Smith hoped this essay would do even more. In his 1958 lecture notes, he wrote: "I talked to people and I talked to doctors . . . I built a story like a play, with ingredients, a cast . . . that had meaning beyond the people involved. I wanted to do something with sincerity that would take away the guns of the bigoted."

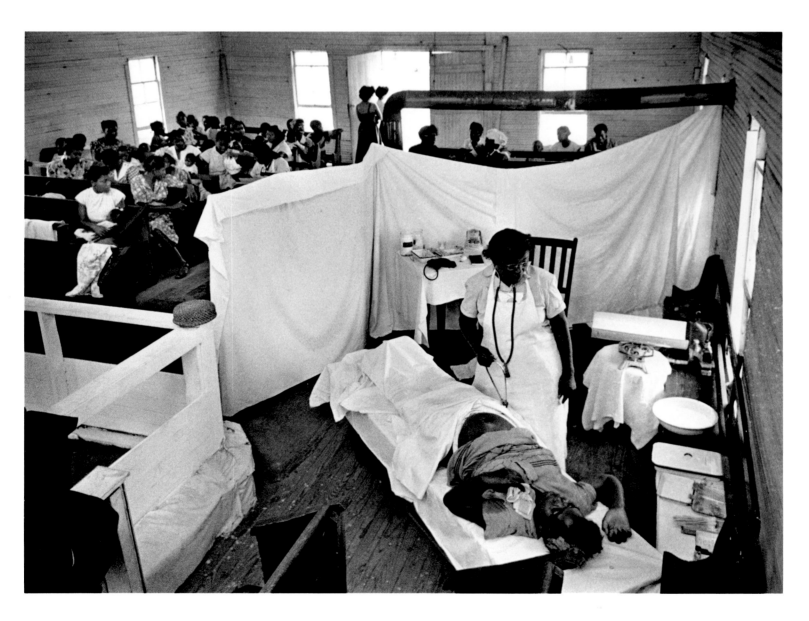

Despite the prejudices of the time, Smith was determined to enter the delivery room. He wrote his mother: ". . . there will be the usual complaints of those who are horrified at the thought of a story touching upon birth—no matter how tastefully and tenderly it is done." Smith accompanied Maude Callen to a half-dozen labors during weeks of effort and captured these images of midwife and apprentice preparing a child's bath, aiding the labor, and comforting a young mother.

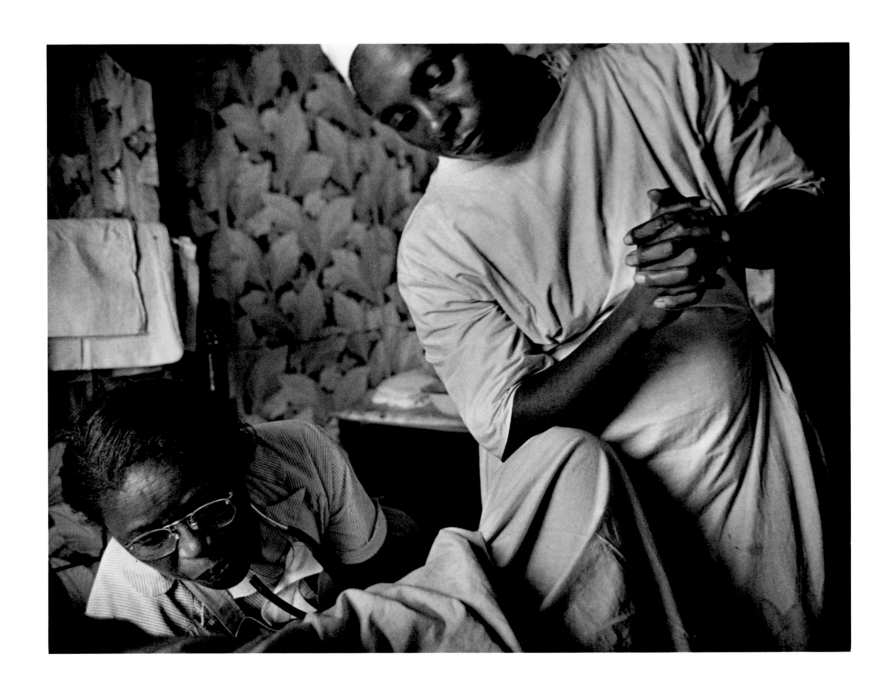

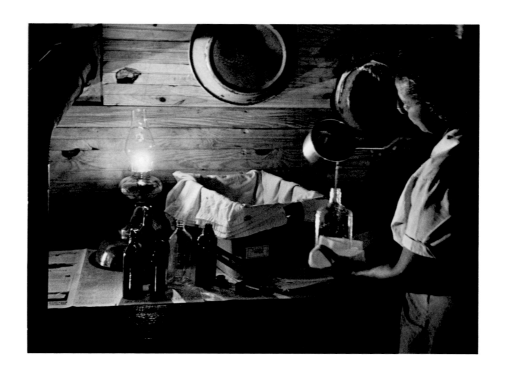

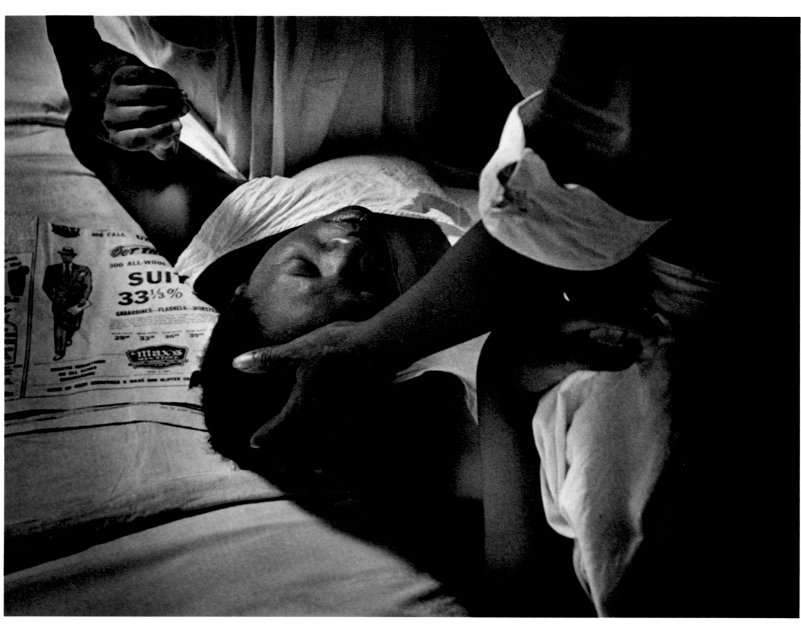

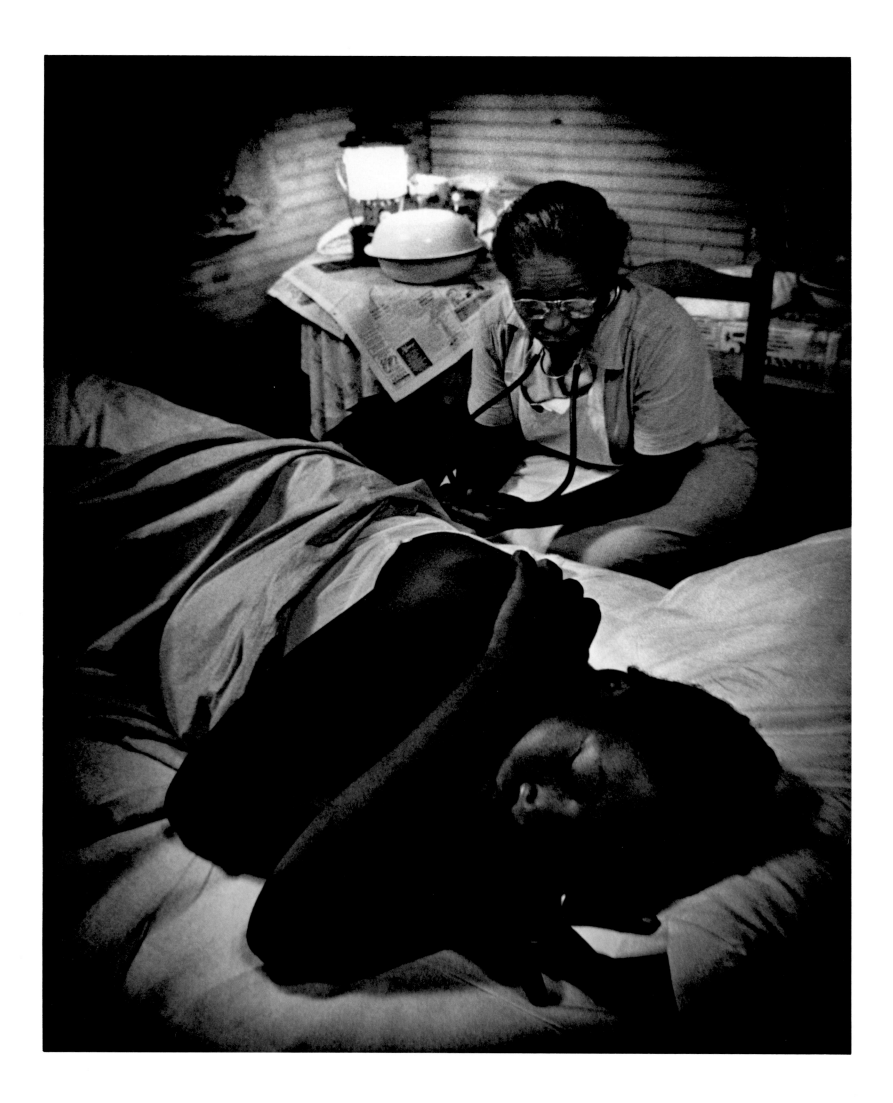

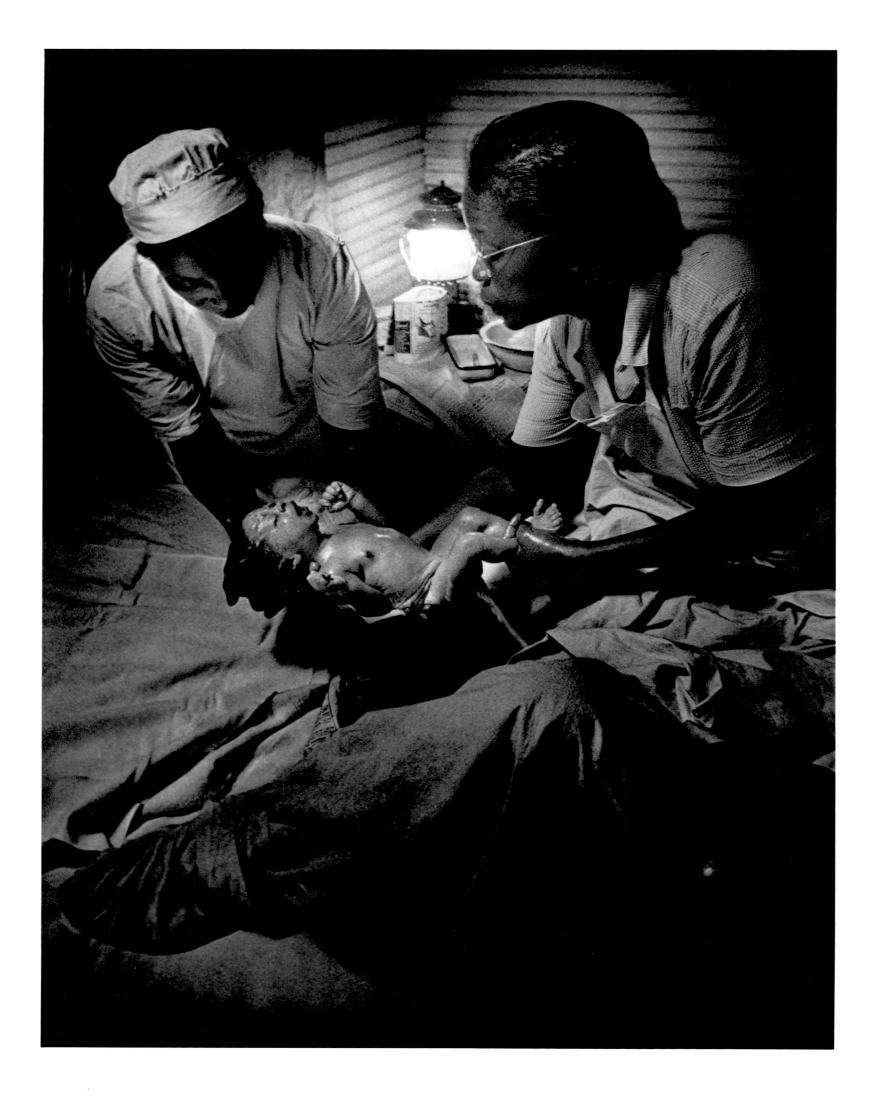

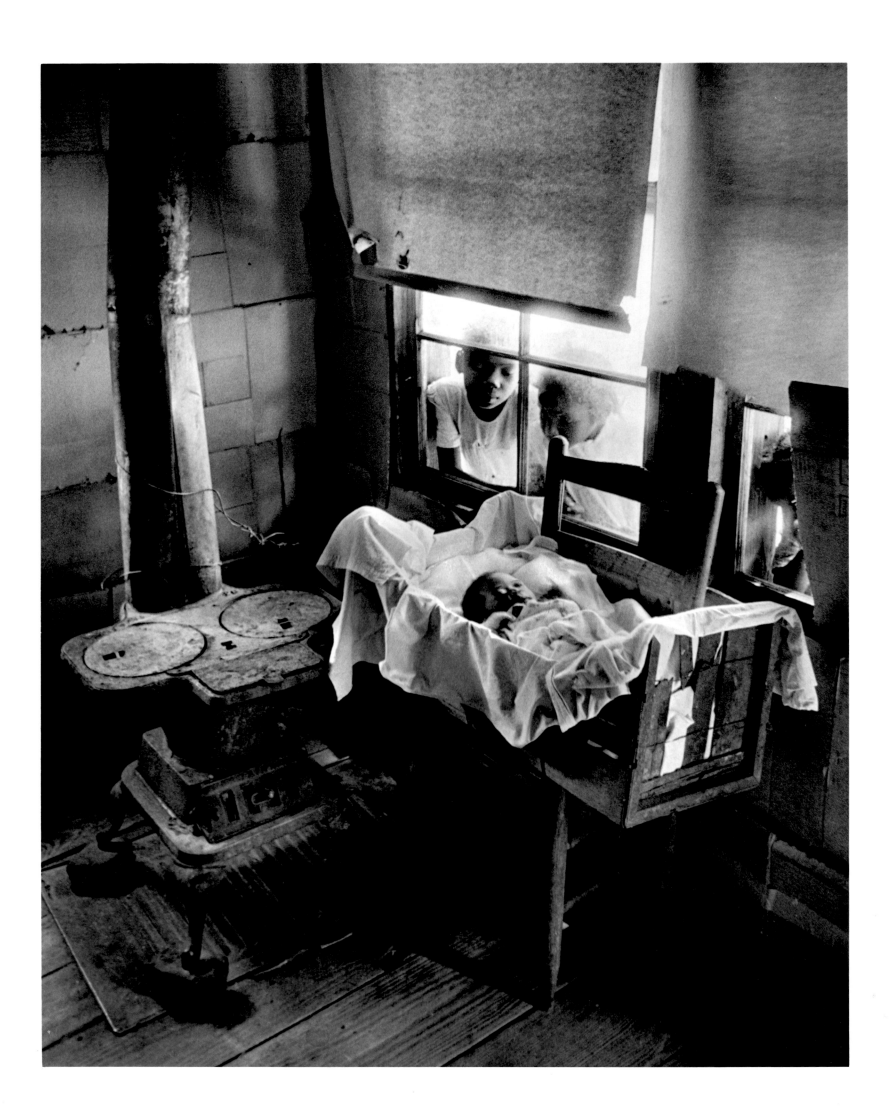

"Then again out of it all there comes a moment relaxed by a reward, a feeling of warm contentment rather than happiness. This reward . . . comes mostly from within and is the understanding within myself that something I have tried to create, or to interpret to others with my pictures has been at least fairly well accomplished."

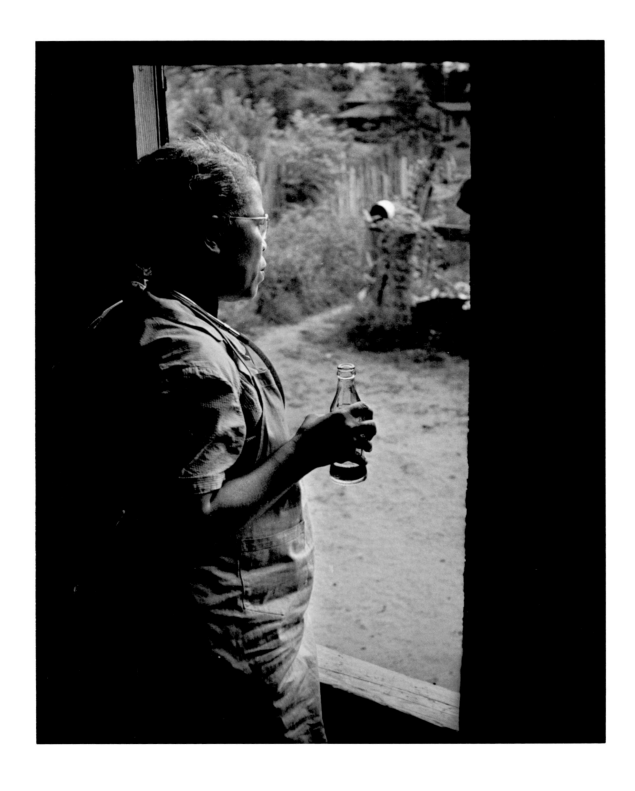

"This essay on the nurse midwife, Maude Callen, is, in many ways, the most rewarding experience photography has allowed me. The published story received an overwhelmingly good response, but more than that, there is the woman herself . . . In the most special way, she is probably the greatest person I have been privileged to know: combining a marvelous wisdom and compassion, a strength of true humility and true pride, all given direction through knowledge and purpose in a sheer beautiful balance."

ABROAD

FOR a small-town boy from Wichita, Kansas, Gene Smith was surprisingly at ease abroad. He saw things through the lens of his work; and his acute vision made this unfamiliar world as clear as the world at home. The three essays he did in Wales, in Spain, and in Africa—all for *Life* —were alike in their darkness, gentleness, and melancholy. One might argue that these were traits of his own personality. He photographed the working-class landscapes of Wales and the electoral disaster for Prime Minister Clement Attlee; the Spanish village of Deleitosa; and the leper colony in Lambarene— Schweitzer's own theatre! None of these is a cheerful subject. Smith insisted, of course, that the results in each case were finally optimistic; and although this was not true at the time, it has perhaps become true as their local tragedies recede into historic time.

Something more subtle has also changed in Smith's work over more recent years. It is a new sense of interconnection between one image and another, and between one spread of images and the preceding and the succeeding. They reflect and comment upon their neighbors, not with words, but with subliminal connections; what one feels is a kind of consensus of mood, of poetry spoken in the same visual language, in a similar drama of light and shadow.

BRITISH PRIME MINISTER CLEMENT ATTLEE, 1950

GREAT BRITAIN

In 1950, England was in the throes of one of its most dramatic elections, and *Life*'s editors sent Eugene Smith to cover it. Prime Minister Clement Attlee, a member of the Labour party, had campaigned vigorously against a resurgent Tory party and election night was at hand. After waiting a full hour "to catch the most significant expression," Smith found in Attlee the proper note of poignancy to produce a classic of political reportage. That photograph, reproduced on the previous page, ran in *Life* with the caption, "Attlee Surveys the Ruins of Victory." Of this period, Smith wrote: "In South Wales (which was my assigned area) there was little physical evidence of a grimly-fought election . . . I decided . . . to try photographic symbolism of Labour party claims and promises and through these show the basis of their strength . . ."

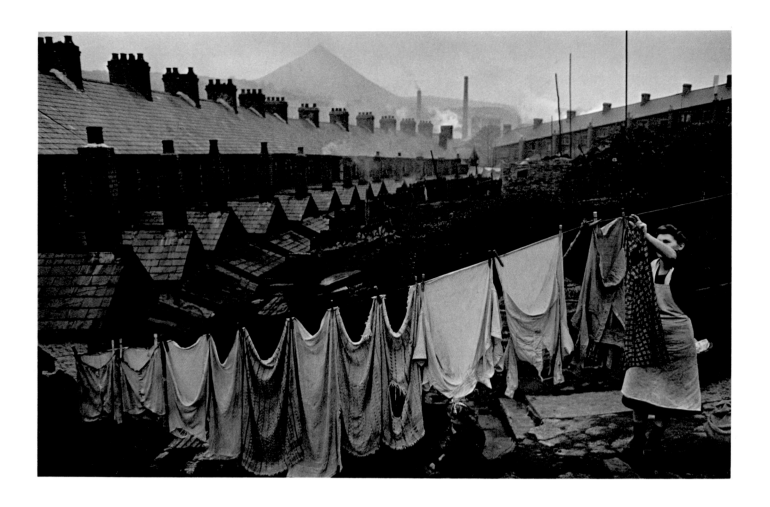

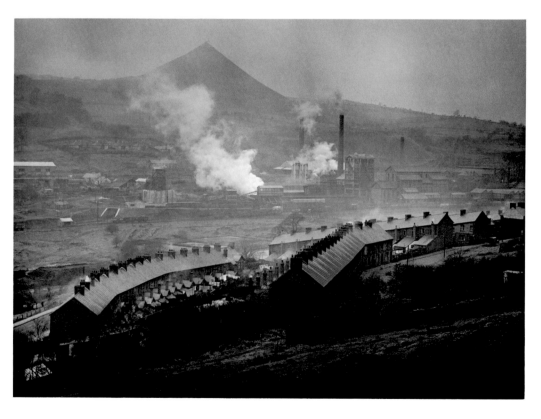

"I left the main caravan for part of a day, photographing where I would, and anything I felt could be tied to the election. It was a day in which my seeing seemed boundless, and, though mostly unprinted, it was perhaps the most creative day of my life."

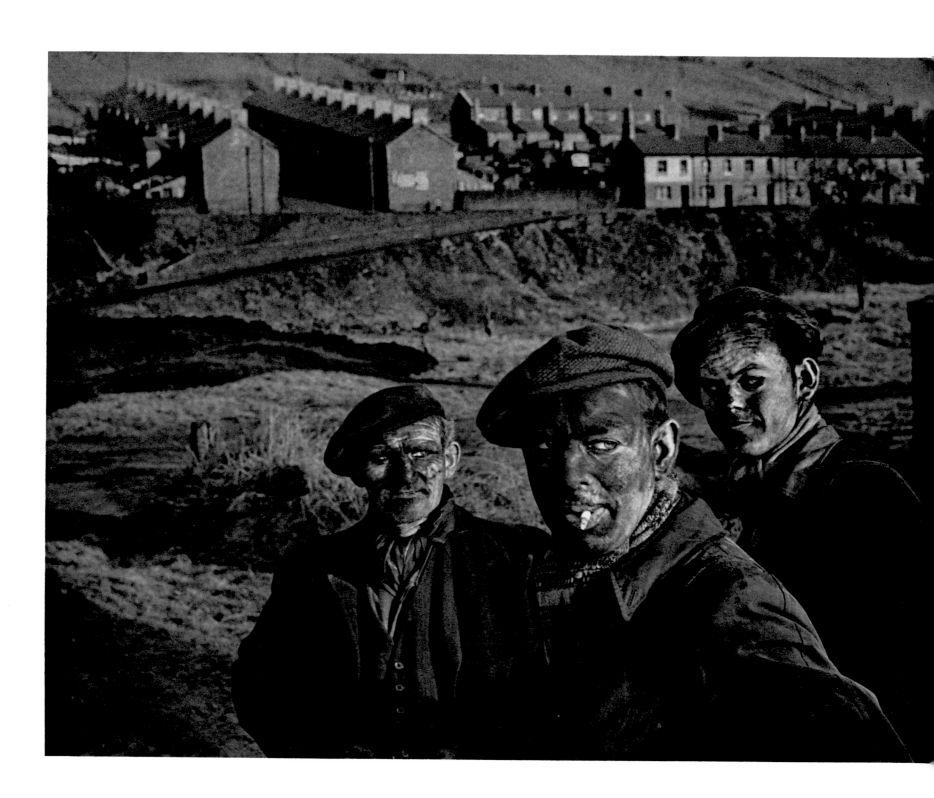

SPAIN

Since the late thirties when he experienced Robert Capa's coverage of the Spanish Civil War, Smith dreamed of photographing Spain. He sought a "balanced truth of Spain"—the source of worldwide political controversy at the time. Along with his assistant Ted Castle and an interpreter, Smith spent three exhaustive months searching for the story's center and found it in the town of Deleitosa. This town had been virtually untouched by the industrial revolution, containing no railroads, highways, telephones, or modern sanitation. Peasants still scratched a living from the harsh soil, watched by Franco's police and consoled by the church. The result of Smith's work was perhaps his most famous *Life* photo-essay, "Spanish Village," published in the issue dated April 9, 1951. This essay included two of Smith's classic images, both included here: "The Spinner" and "The Wake."

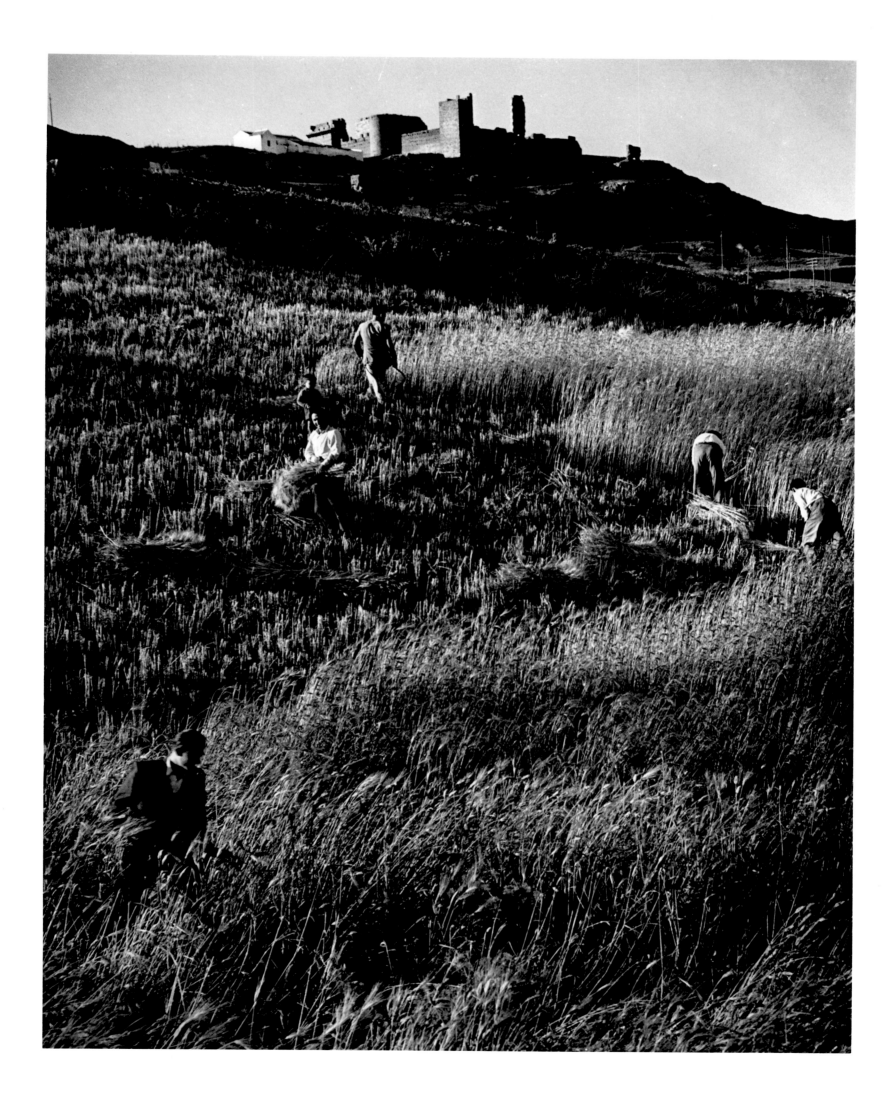

"I would rather make warm and friendly photographs but when I looked at these people in the Guardia Civil I was aware that at least two of the three had tortured their countrymen, and I could not feel very friendly."

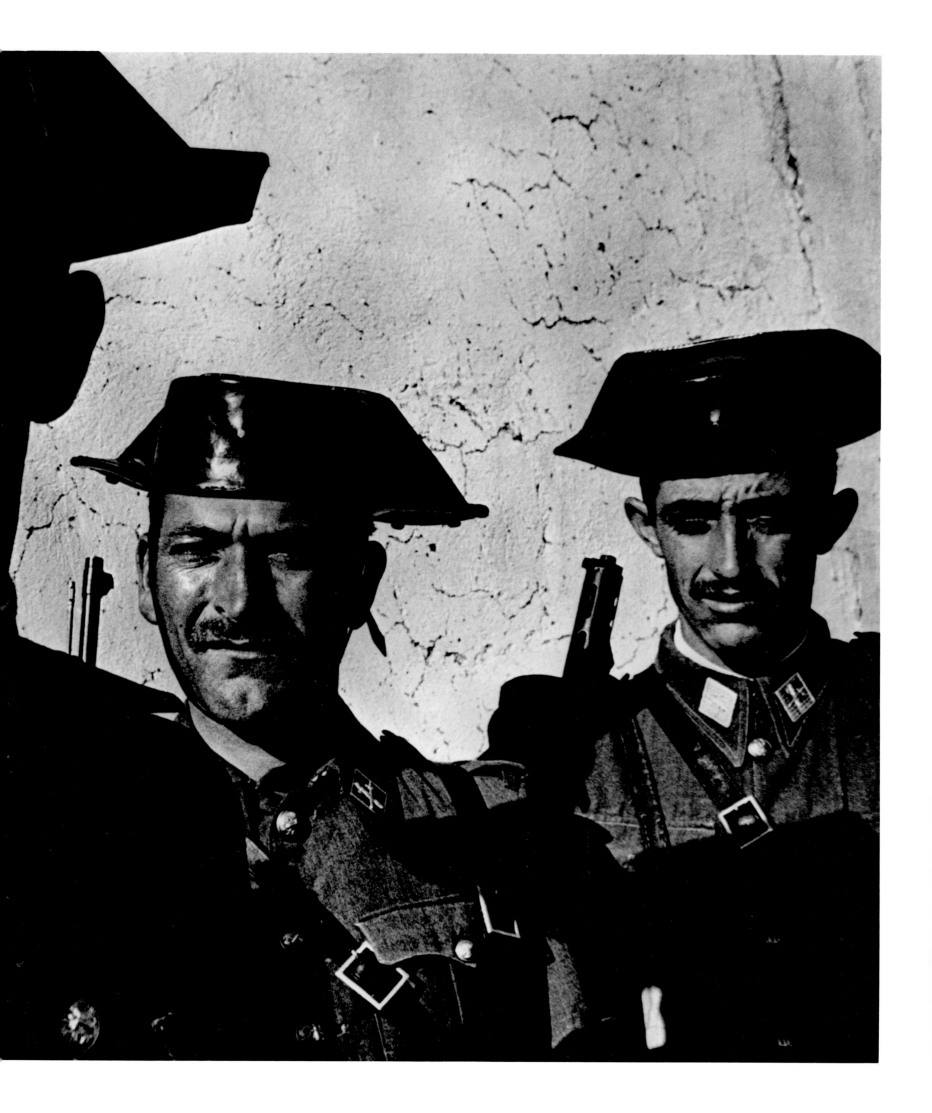

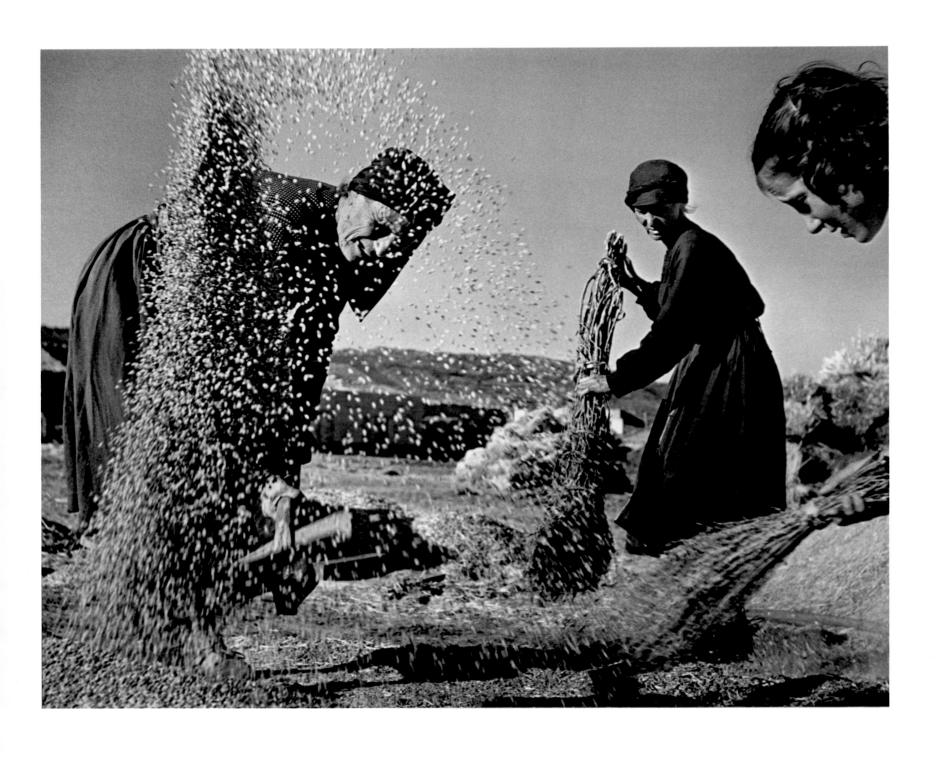

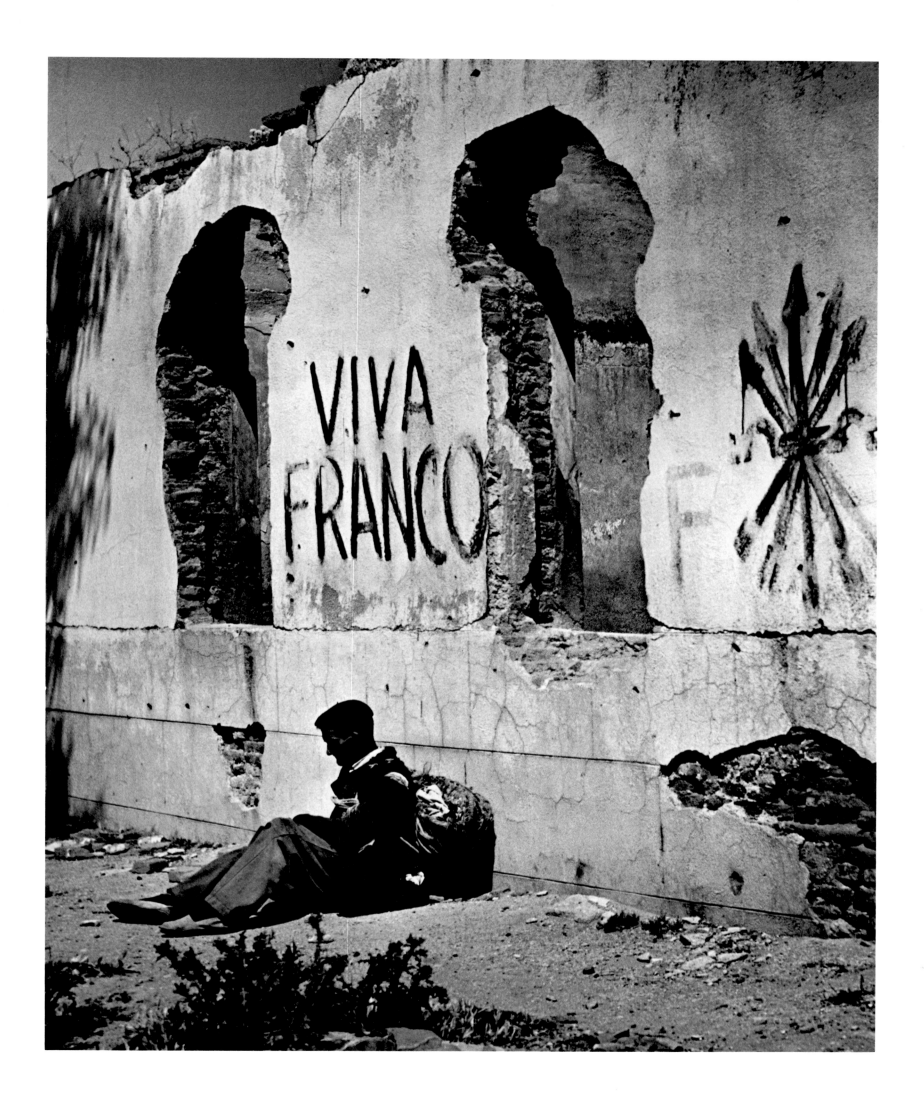

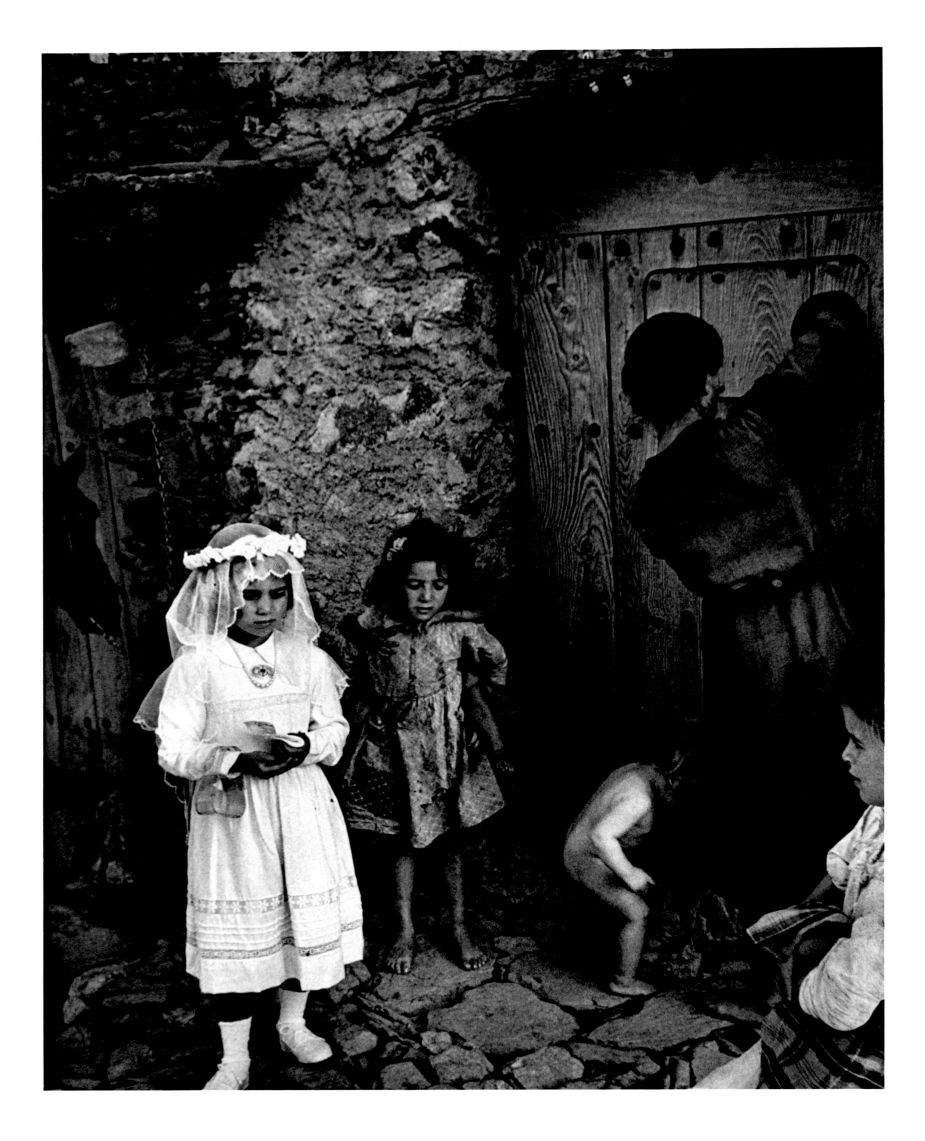

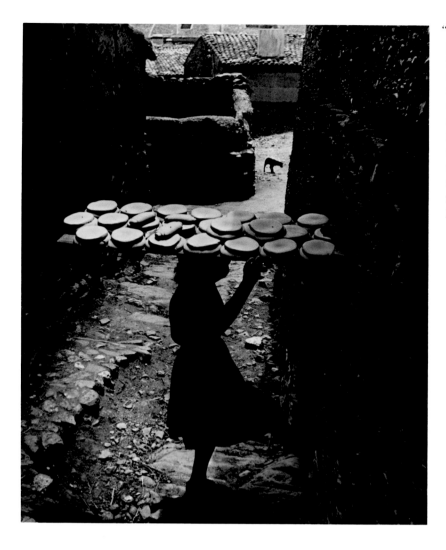

"These photographs are pictorial paragraphs from my portrait of a modest village. I went away from the publicized historical attractions, the unrepresentative disproportion of the main cities; far away from the tourist landmarks, Spain is to be found. Spain is of its villages, simple down to the poverty line, its people unlazy in slow paced striving to earn a frugal living from the ungenerous soil. Centuries of the blight of neglect, of exploitation, of the present intense domination, weigh heavily—yet they, as a whole, are not defeated. They work the day, and sleep the night; struggle for, and bake their bread; believing in life, they reluctantly relinquish their dead."

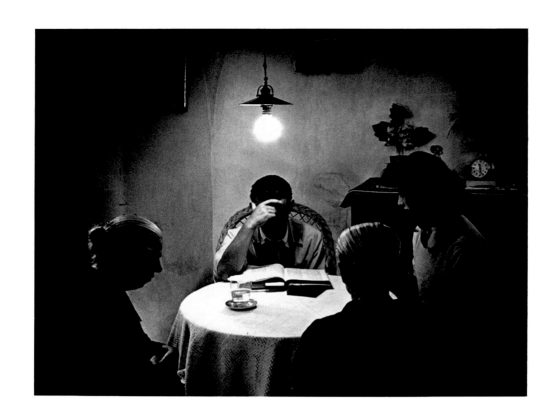

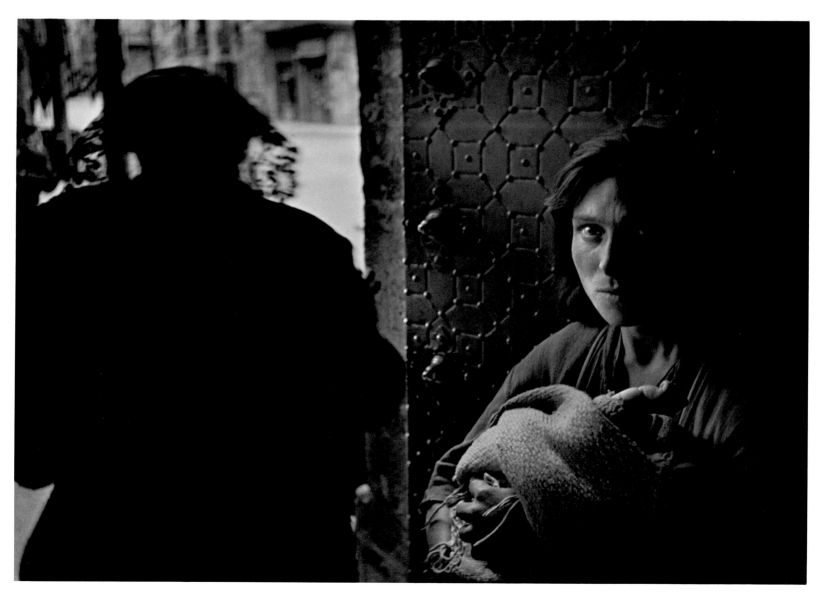

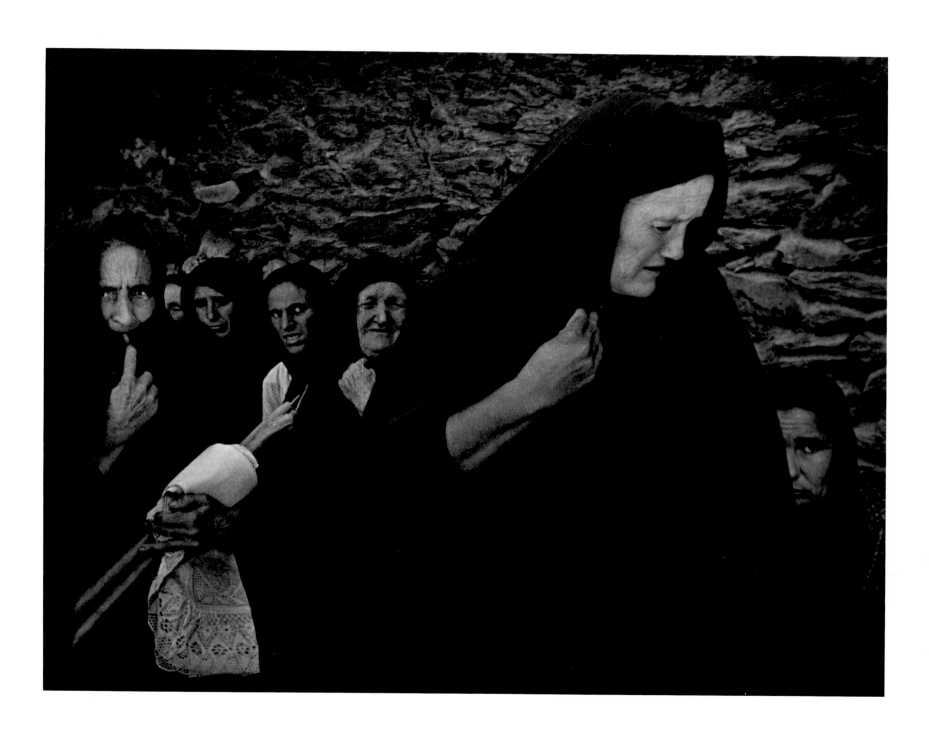

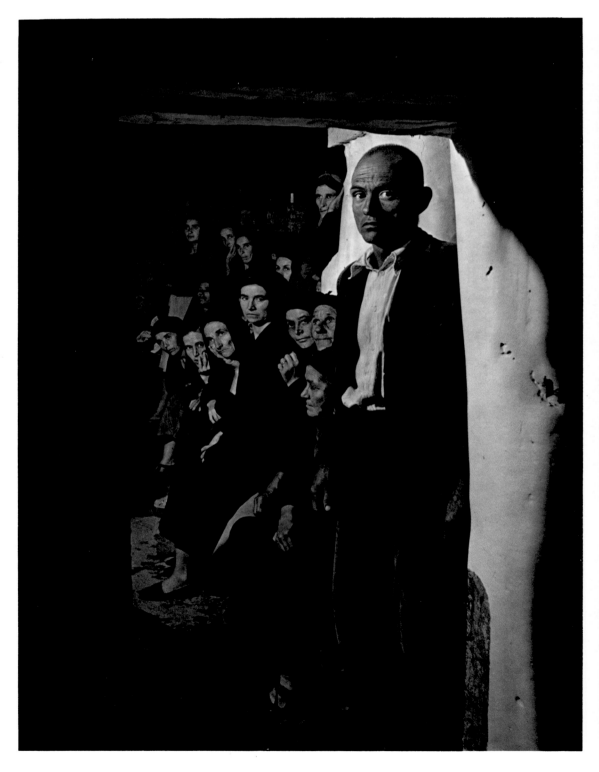

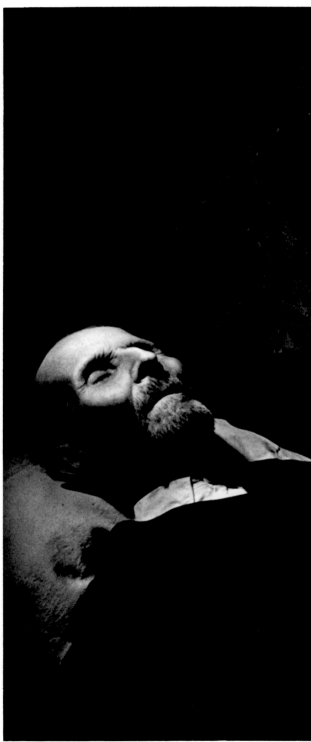

THE WAKE

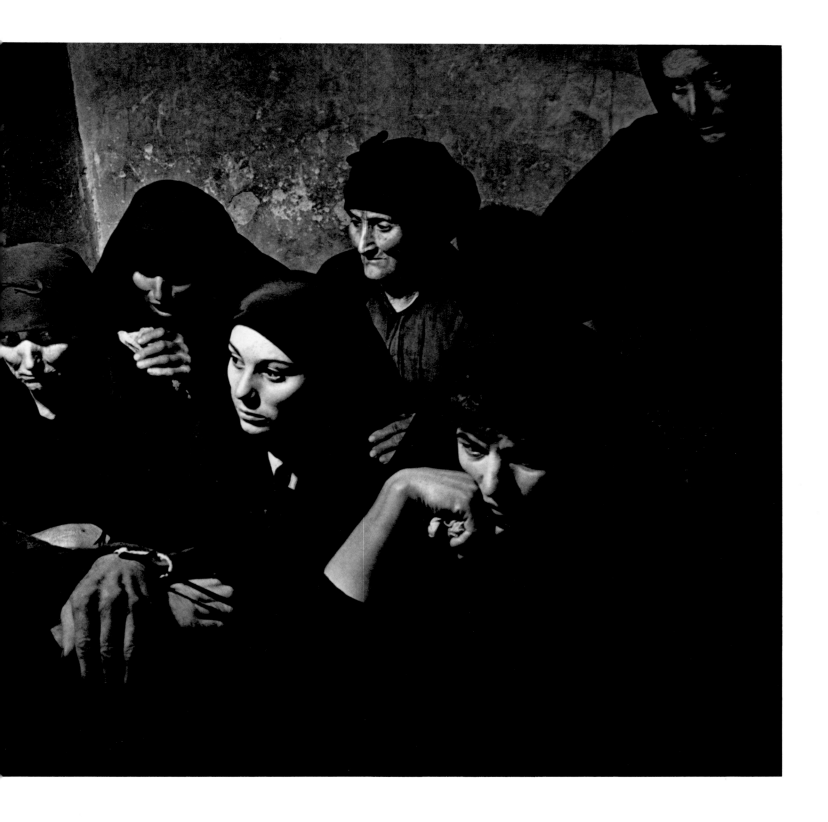

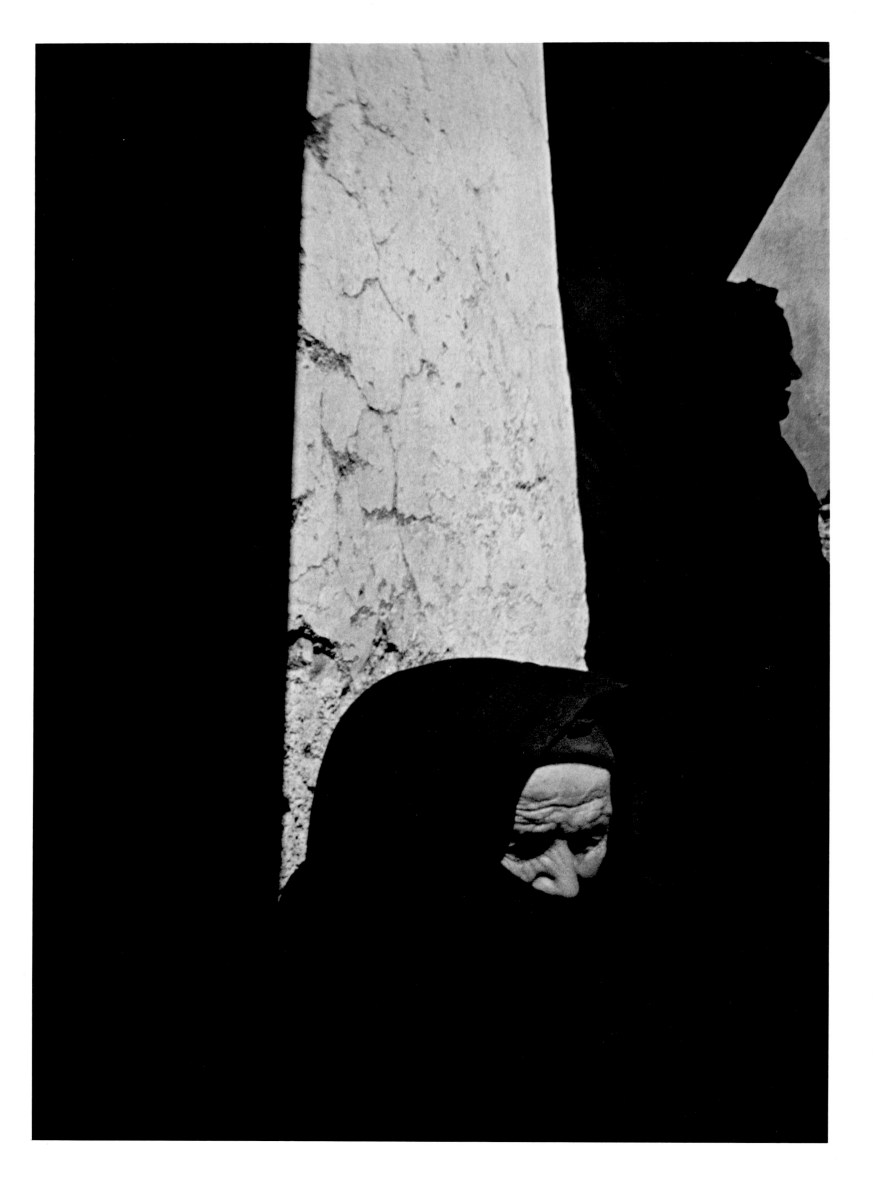

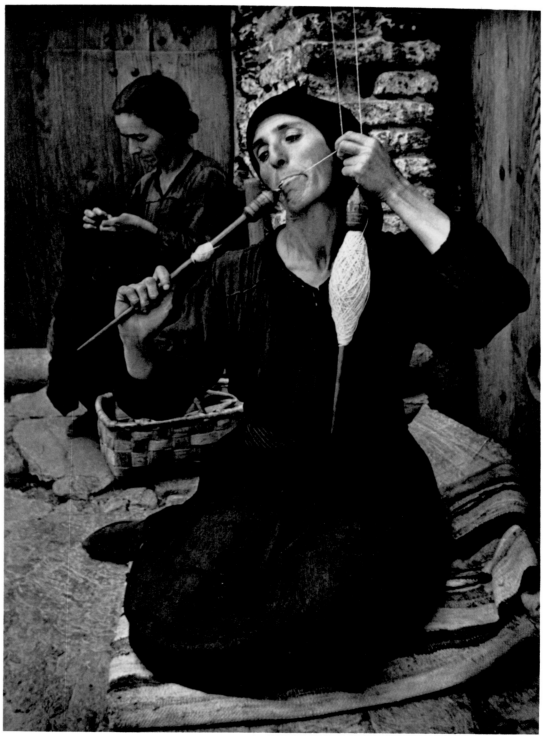

THE SPINNER

SCHWEITZER IN LAMBARENE

A leper settlement was the subject of Smith's sole photo-essay in 1954. Originally he traveled to French Equatorial Africa to cover Dr. Albert Schweitzer, but the story grew to encompass not only the man but life in the village of Lambarene. As the work took shape, there were times when Smith was uncertain. He wrote to his mother: "It is a strange and complex story of paradox, and three weeks here leaves me unknowing how to translate it. I have two very good spreads of the story completed, four pages of good work, but the heart is missing, the pulse as yet undefined, but there is still time . . ." It was this essay, published in the November 15, 1954 issue of *Life* under the title "Man of Mercy," that provoked Smith's separation from the periodical. In his own words: ". . . it was a battle over the right of responsibility for my reportage, I was bluntly saying they could not run a story of mine and distort it, and I resigned trying to force them to work out the problems about the story."

"The visitor, unprepared, will even have difficulty in trying to determine the nature of the place: whether it is an African village, a game preserve, or a medical hospital. Actually, it is the sum of all three. It is of a wisdom, a philosophy, a total meaning uniquely its own. It is of one man laboring to accomplish according to his beliefs, with disregard for conformity and with a tremendous regard for the realities at point-blank range."

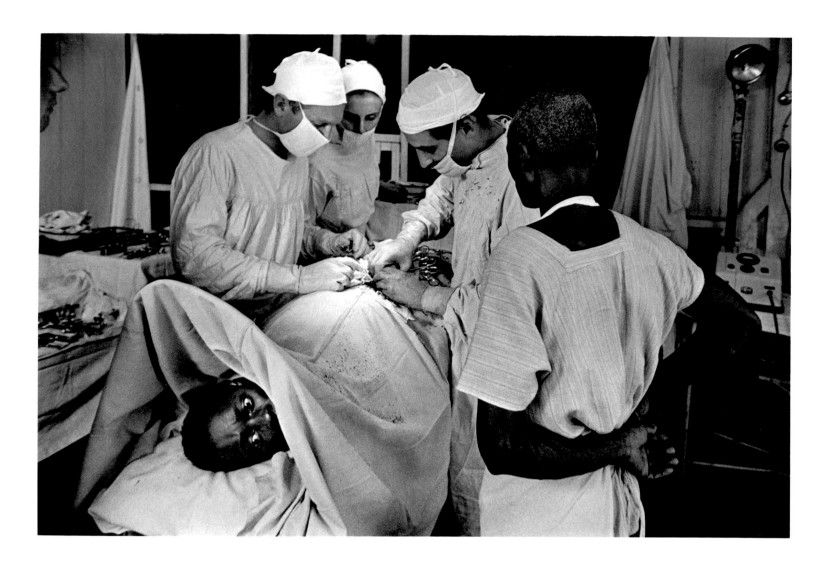

"It was established as a hospital—established is a misleading word, but established somehow might leave the impression that the hospital was suddenly there, rather than of all the sweat and heart that was poured into the building of it, and while Doctor Schweitzer was building it, he was also caring for the sick. He worked and is still working longer and harder hours than most men think they have any right ever to be asked to do. A belief in what you are doing, a direction of intent in life, give strength and a will to work, that nothing else can induce."

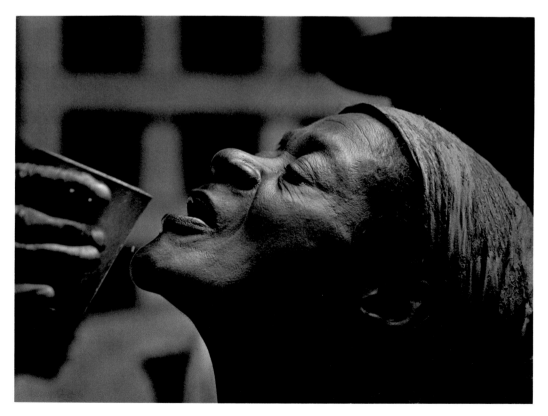

"Although this is at Schweitzer's place I believe
strongly it is an unfair photograph to present out of
context. I believe it should be presented as 'a
stockade for the insane, photographed in Africa '..."

"A giant of a man cursed with mortality and with a legend that bestrides him. I agree with his admonishment: 'And none of the greatest-man-in-the-world nonsense.' On this level I have a deep admiration and sympathy for him—even as he towers over most men."

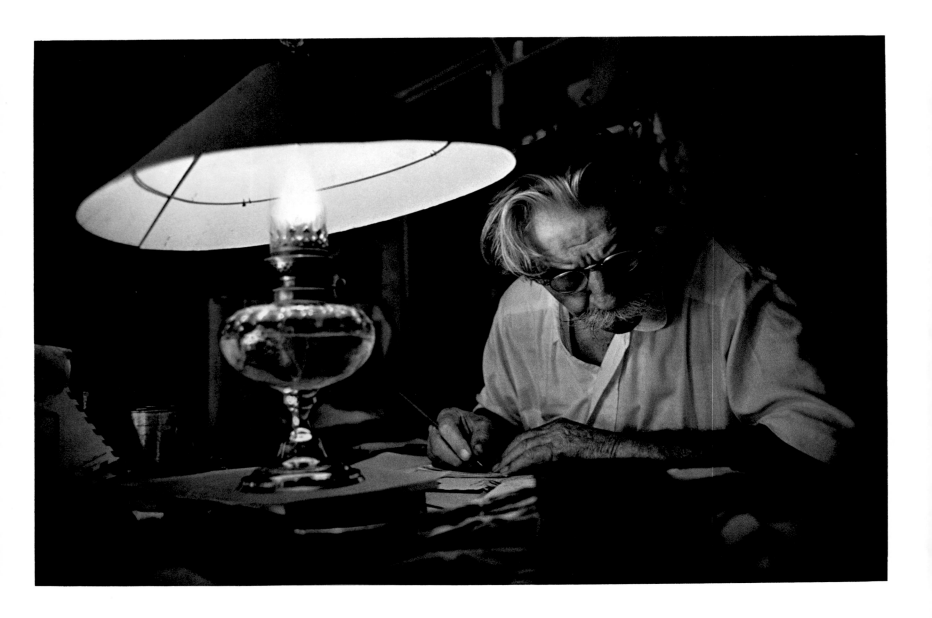

AFTER *LIFE*

SMITH had fought the powers of *Life* for years, becoming increasingly impatient with the compromises of commercial photojournalism. By the mid-50's, he challenged *Life* by resigning, and after a curious period of reluctance on both sides, his resignation became final. His next job, the profligate and epic essay on Pittsburgh, was his declared revenge. The psychic and domestic cost of a project—that was intended to last three months, and that went on, prodigiously, for three years— was the second turning point in Smith's life, as wrenching as his experience in war if far different in its consequence. He turned his huge energies inward, and these, churning and conflicted, gave birth to three sorts of visual poetry.

One was the dark lyricism of Pittsburgh, an epic poem of a city that he really disliked. Another was a result of self-imprisonment in his loft on New York's Sixth Avenue. The extended chain of images he made there, connected again by a vision that was sometimes ferocious and sometimes gentle, looked inward while looking outward at the walls and down through a broken window into the street.

A third sort of poetry was generated by several expeditions to a stockade and treatment center for the insane in Haiti, in 1958 and 1959. Smith photographed the terrible despair of the mentally ill as if he, too, could have been behind bars. There was never any pause in Smith's professional life; he was on an adventure in this period, into an inner country where he had never had time to go.

PITTSBURGH

Pittsburgh was the measure of Smith's ambitions as a photographer. In his copyright letter to the Library of Congress, he wrote: "During the year 1955, I made approximately 11,000 photographic exposures of, in, and around the city of Pittsburgh, Pa. It was all part of one project. It was something of a pioneering effort of interweaving many photographic themes, of which several could be individual photographic stories, into a gigantic and complex extension of the photographic-essay form." Due to its size and Smith's determination, the project was a source of great anguish to many, yet the scope of this urban landscape has never been matched.

". . . Pittsburgh, for me, was the most difficult
essay I have ever done . . . Schweitzer the next
most difficult . . . Pittsburgh was . . . too big, the
themes too diffuse. That is why I do not wish it to
be considered a journalistic report, though I feel it
firmly based in reportage's detailed research and
structured upon careful guts of facts without the
deformity of de-fleshed statistics . . . "

"To portray a city—as it is with man—is beyond any ending, and becomes a grave conceit to begin. And though the portrayal may have considerable validity, both for yesterday and tomorrow—even for today, it can never be more than an indication of the whole of a city."

". . . The one full freedom is man's right to dream. No government of whatever nature, no tyranny, no circumstance can remove possession of this right—the shortness of life and the caprices of destiny, the sarcasmic brutality with which reality can attack the dreamer does not alter the inextinguishable right. The presentation of the dream itself, the bringing of it into a degree of accomplishment, depends upon an individual's ingenuity in assimilating experiences and profiting from them—upon his ability of asserting inner or outer domination of his environment, upon his ability to transcend his defeats. These become a measure of the quality of a person's life . . ."

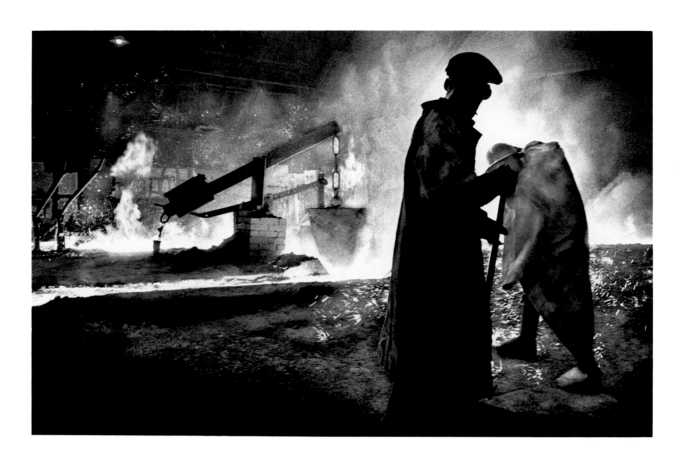

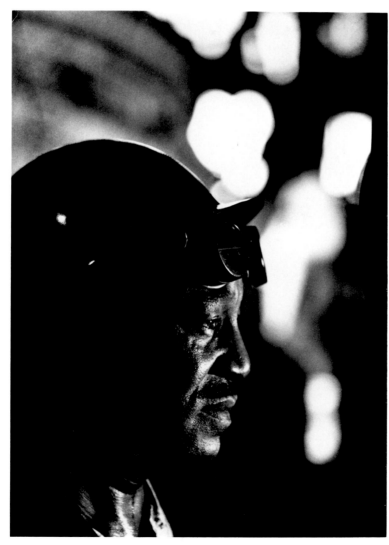

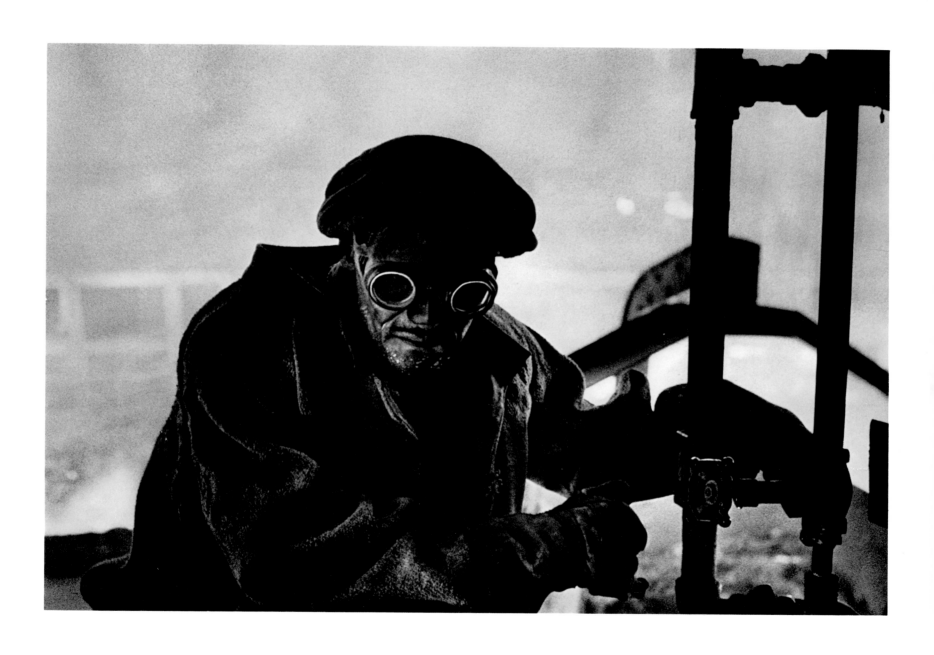

"... my project Pittsburgh, while it never turned into a love affair, was an extraordinary experience. And within the qualifications that no such project as the profile of a city could ever be complete, could ever be definitive through one man, and in only a few months stay—I believe the resultant set of photographs is (in its own way) the finest set of photographs I have ever produced—quality and quantity . . . The prints will establish the validity, and I think will erase— emphatically—any contrary words that may have been spoken regarding my project Pittsburgh."

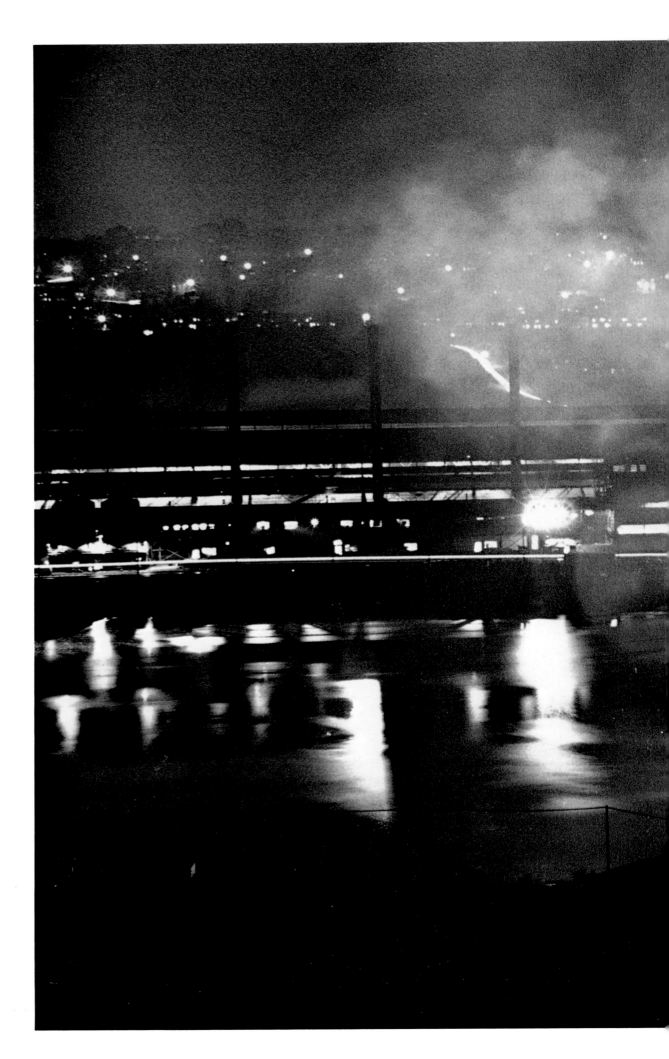

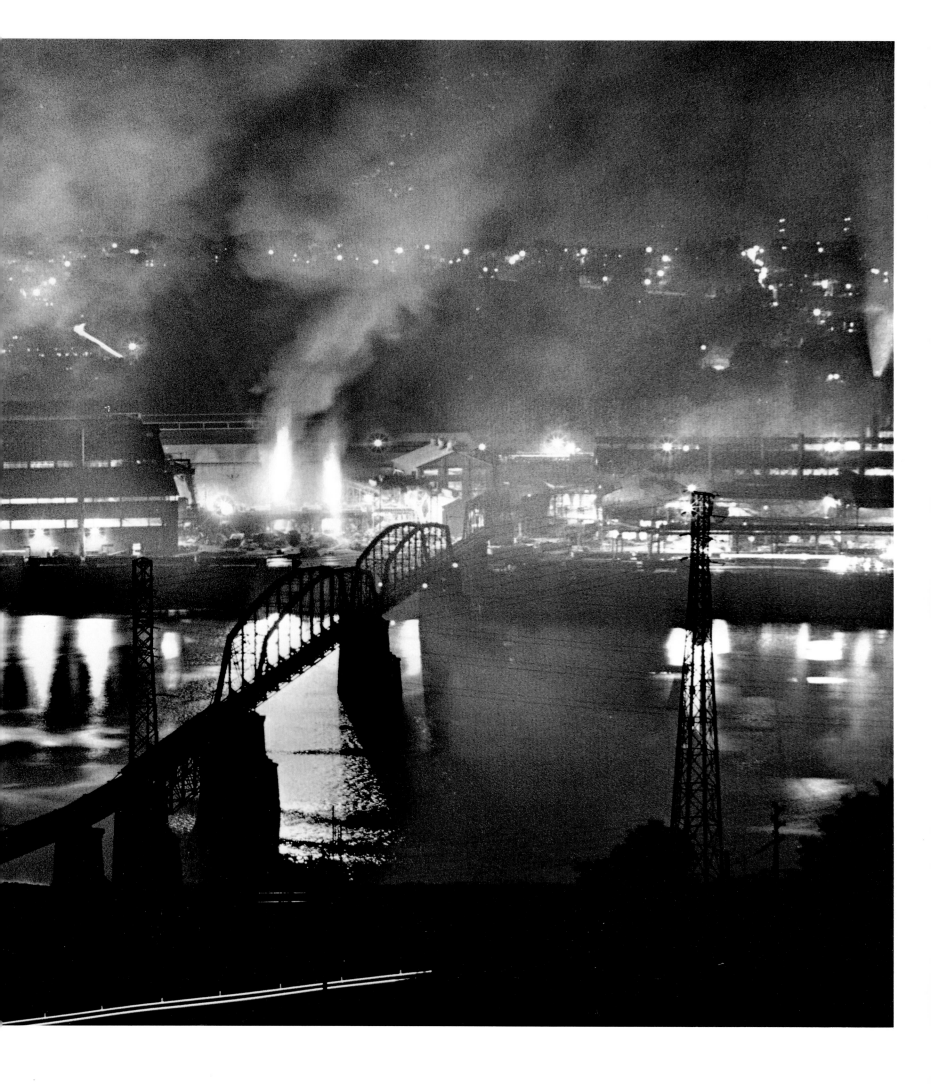

AS FROM MY WINDOW
I SOMETIMES GLANCE

In the mid-50's, Smith moved to Manhattan; he rented a loft on Sixth Avenue and from its second story window he photographed the street life below. Using the flattened planes of the telephoto lens, he abstracted the image more than he had ever done before. The result was a poetic essay of formal brilliance. In November of 1958, he wrote of his new home to Ansel Adams: "(My loft) . . . is a curious place, pinned with the notes and the proof prints . . . with reminders . . . with demands. . . . Always there is the window . . . it forever seduces me away from the work I at any moment will be doing in a cold water flat, an emergency place, with a sign on the door, 'No Anticipation Allowed,' the whole made personal and alive, and living, and from the desperate stabs to keep order in the retreat before detailed overwhelmment—always, there is the window; and I breathe and smile and quicken and languish in appreciation of it, the proscenium arch with me on the third stage looking through it down and up and bent along the sides and the whole audience in performance down before me, an everchanging pandemonium of delicate details and habitual rhythms."

196

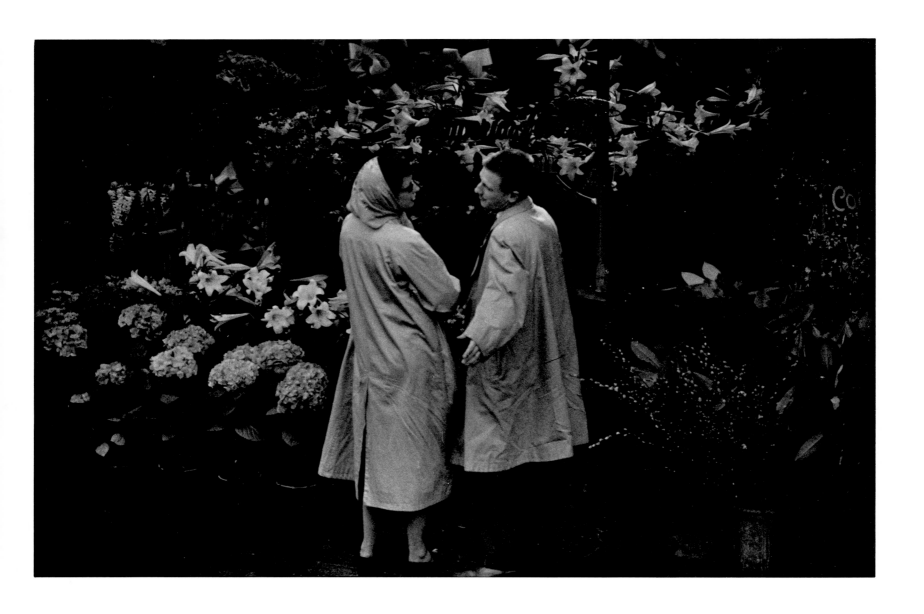

"I throw my love through the window and wonder at those who receive it—and I have taken all with a sleight of hand gentleness, secretly cradling all I have received from the unknowing givers. What is the key of enchantment? From the window it seems I will never stop photographing; every emotion with the world has its playground there."

THROUGH THE BROKEN PANE OF SMITH'S DARKROOM WINDOW

JAZZ

It was the period of abstract expressionism, beat poetry and cool jazz—and Smith was there to experience it. Turning his camera from outside to inside, Smith discovered that many of the era's jazz greats congregated in the loft of his upstairs neighbor, Dave Young. Smith became part of this scene, documenting its darkness and vibrancy. He wrote: "happenings such as three jam sessions going at once caused projection into the avant-garde through criss-cross blending . . . this dirty, begrimed, firetrap sort of place, with space . . . has claimed . . . more film than I have ever given to any other project . . ."

DAVE YOUNG'S UPSTAIRS LOFT

JIMMY STEVENSON

DAVE YOUNG

THEOLONIUS MONK

"... possibly the best jazz in America is found in the playing that goes on in the lofts of New York between jobs, or after work . . . This essay has a taste of the artist's urgent necessity and shows the jazz musician's search for his medium in one of the few places left for him to work at it. The pictures reflect tinges of the poverty that such personal searches can bring about—and in this it reflects a segment of America that in its search for quality is often on the edge of trouble. . . . I believe it to be a uniquely individualistic bit of Americana, and important . . ."

BACKSTAGE

RAHSAAN ROLAND KIRK

HAITI

"My best unpublished essay"—this is how Gene Smith referred to his work in Haiti. "I went to Haiti with Dr. Nathan Kline," he wrote, "to photograph the very poor facilities and treatment for certain mental patients. Dr. Kline felt that the photographs could aid him in building, staffing, and supplying a new treatment center . . ." During his three visits, Smith's view of Haitian life increasingly darkened. He began his work with photographs of the old mental hospital on the outskirts of Port-au-Prince, a relic of United States occupation in the 1920's. Smith witnessed conditions that were worse than those he had seen among Schweitzer's lepers. As a result, he opened up his essay to encompass a broader view of a society that could give birth to such pitiable conditions. Selections from his work were published in the journal *Roche Medical Image* (1960).

Smith was a firsthand witness to events both inside and at the gates of the palace of President François "Papa Doc" Duvalier. He came to feel that the president ruled over his countrymen as if they were his patients. Writing of Duvalier's headquarters, Smith noted that within arm's reach of a bible was "a holster and the pistol from it laying neat and close and turned for quickest use."

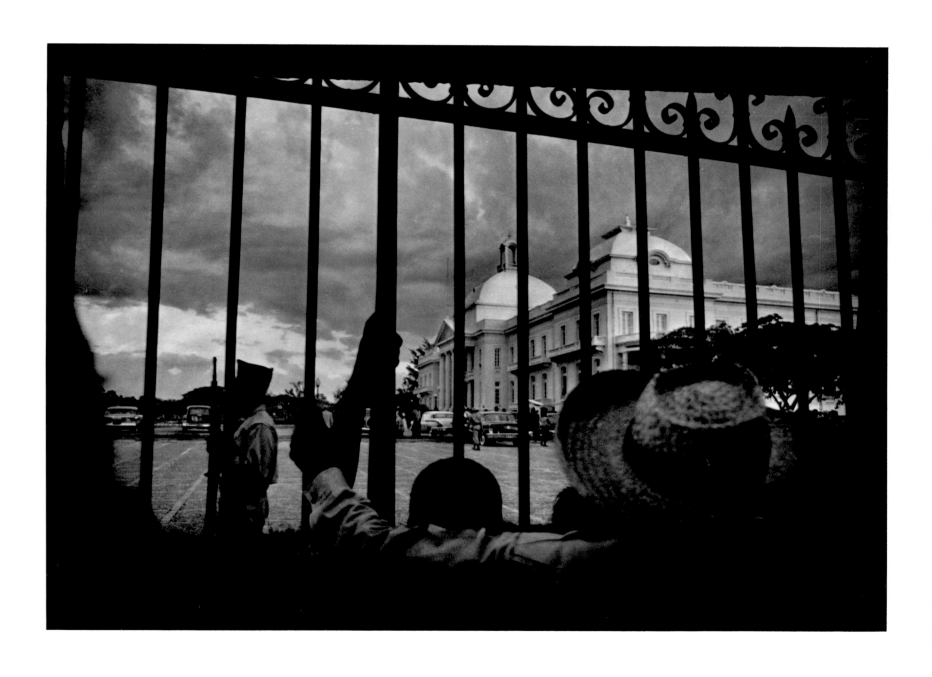

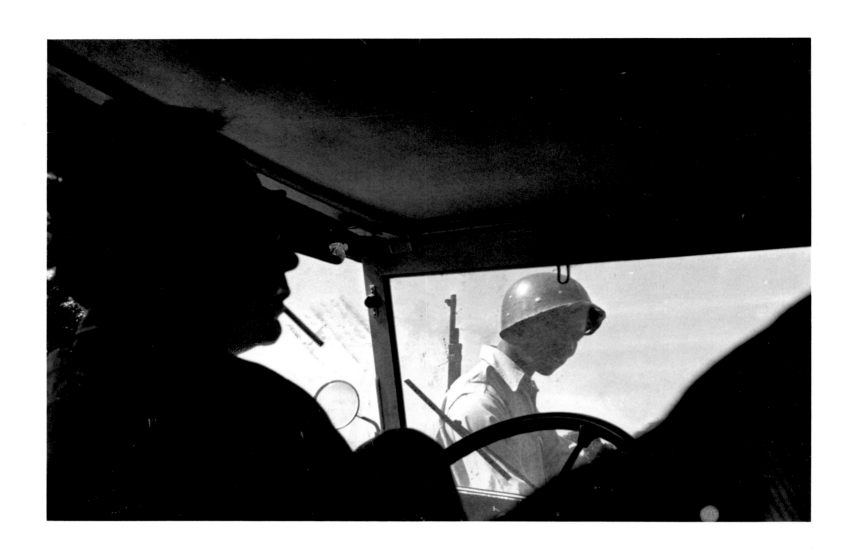

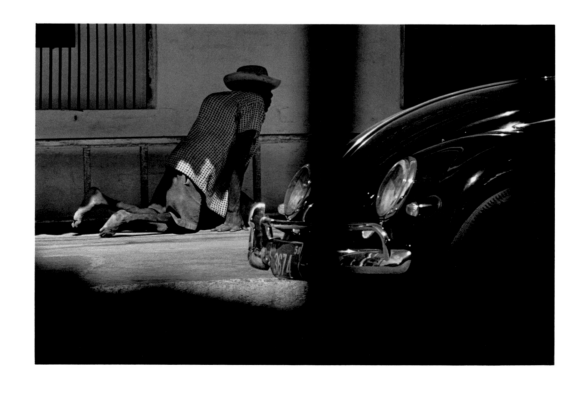

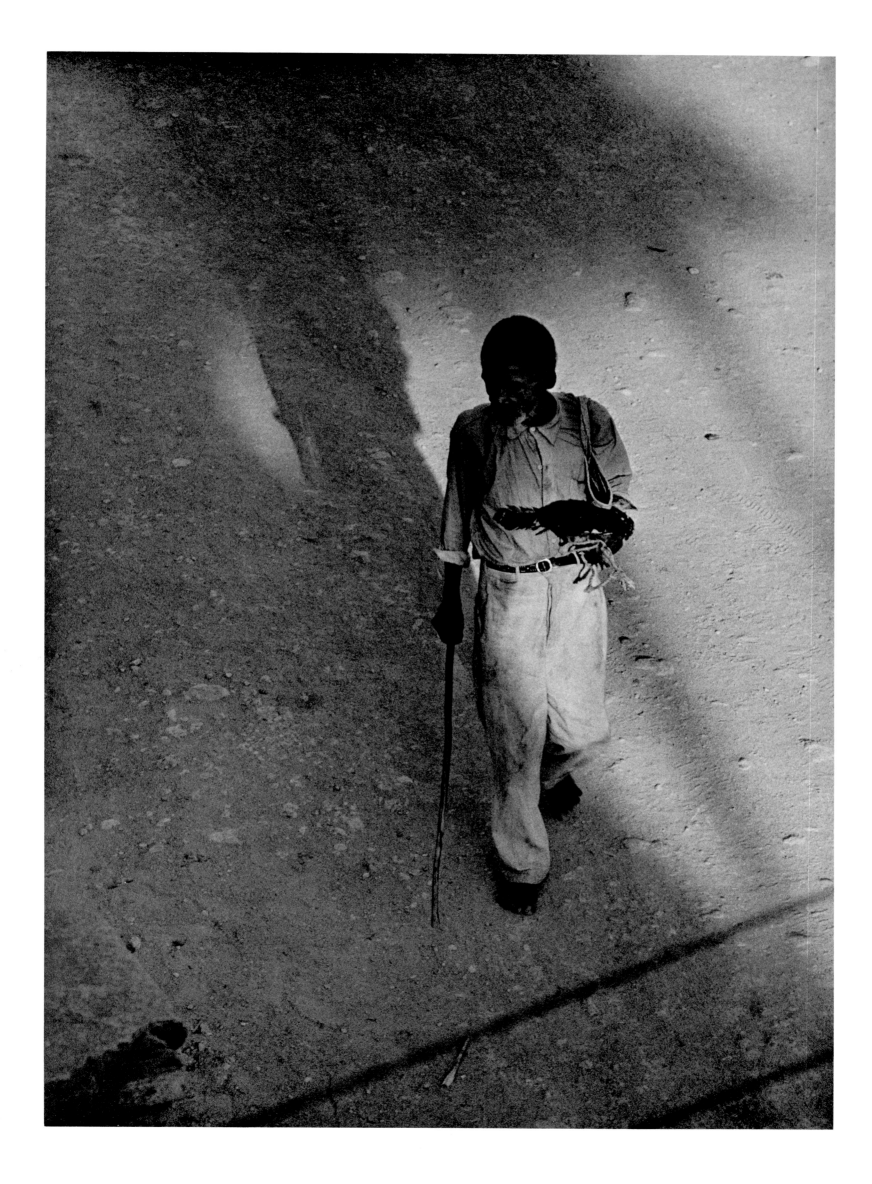

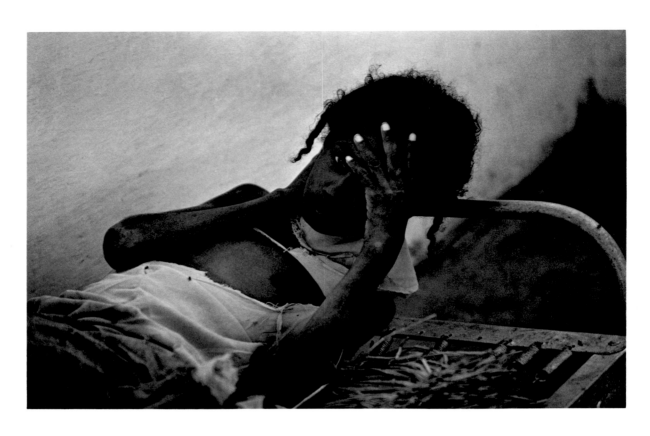

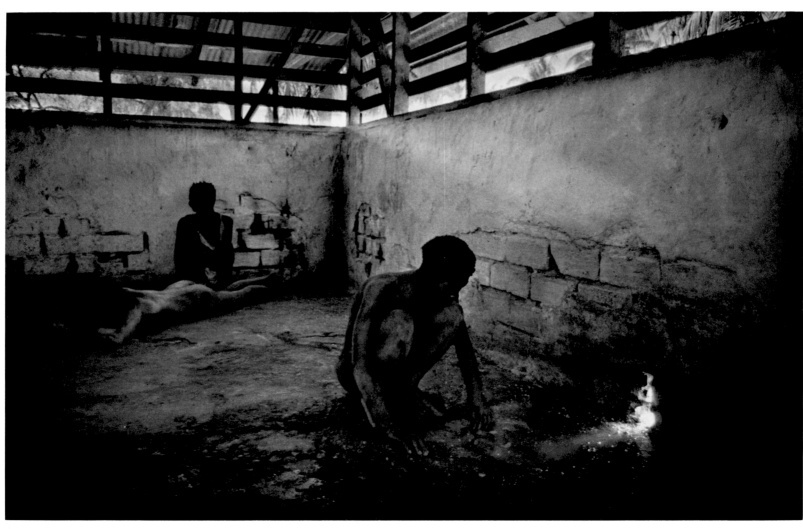

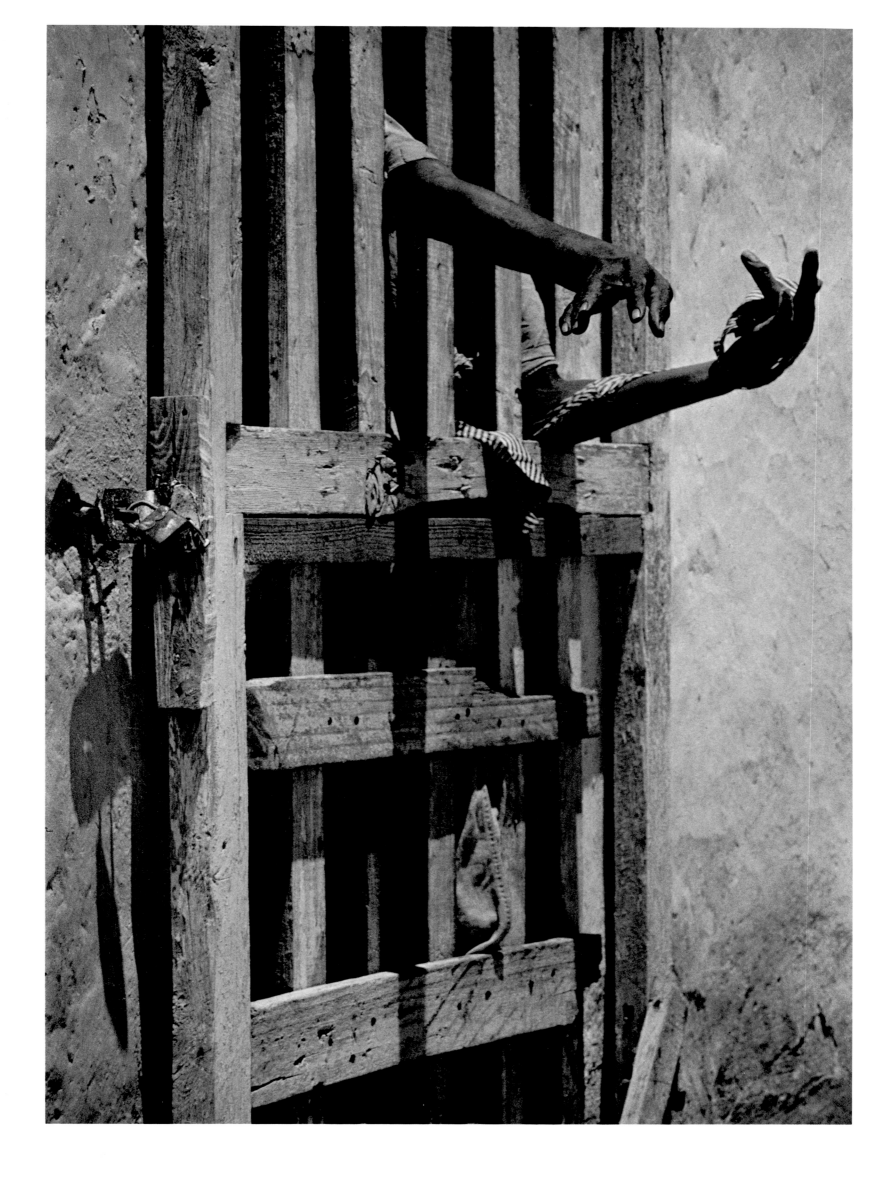

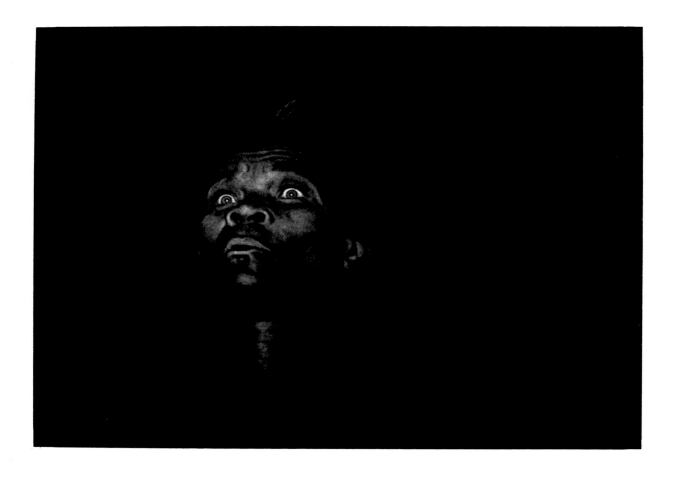

JAPAN

BY 1961 and 1962, Smith had, by virtue of his absence from a mass audience, become a mythic genius about whom scores of legends were told—some of which were true. His fame got him a very large and rather lucrative commercial job for the Japanese firm of Hitachi Limited. One does not, granting the technical brilliance of the work, feel that Smith had any great love for this metallic giant, although his more casual images of Japanese people and village landscapes have a sweet, sad truth that one remembers in his work on Wales.

Between 1971 and 1975, oppressed more and more by emotional and physical and financial problems, Smith, along with his second wife Aileen, produced the book *Minamata*. All of his craft, all of his ideals, all of his deepest and most hidden motives, were expressed in this last large work of his life. In a world determined to poison itself, this poem contains the essence of the way Smith uniquely saw. The single images, one by one, are hot to the touch; they scarify the conscience; they raise the suffering of an obscure town of fishermen into an epic condemnation of our own cruel and selfish century.

It is not usually given to an artist to make one more last, best work; Smith was lucky in that respect, at least; or not so much lucky as passionate. His was a civilized triumph of the will.

HITACHI

Smith spent a "cherished year" in Japan working for Hitachi Limited. The project afforded him the opportunity to work without money worries and with a battery of new cameras and lenses provided by Hitachi. The result was a highly personal book that represented Smith's good feelings about the country. Teacher and historian William Johnson writes that Smith's "sense of visual unity corresponded to the harmony between the Japanese people and their environment, establishing a mood of active, purposeful energy that Smith felt was an important characteristic of the Japanese people." Entitled *Japan, A Chapter of Image,* the book was never generally released in the United States, but Smith sold individual copies from his Manhattan loft. In his essay from the book, Smith wrote: *"Japan, A Chapter of Image* is an exploratory, somewhat experimental, highly intentioned photographic essay. For perspective, and to maintain the integrity of that high intent, I would here disclaim any guise as an expert on Japan. It must be clearly understood that the thoughts, questions, images, and conclusions which follow are from an intense but limited personal experiencing of some things that are Japanese—and from considerable historical cramming. A chapter, not more . . . And—extremely important to me—I was 'taken in' (albeit warily) by the near constant feeling of a humanity which somehow escaped being utterly 'big business,' and by workers who seemed not entirely the 'contractual enemies' of management."

"The Japanese National Railroad has the heaviest burden of passenger travel in the world. Beyond the railroad being simply the best way for most Japanese to arrive somewhere else—there is a Japanese delight about train travel, the likes of which disappeared long ago from U.S. railroading . . ."

"So the themes came, two and more—infinitely
shaded with tradition and transition and tomorrow—
reflective of all that I could manage within the short
distance I had traveled in this uniquely textured
place. Themes of recognition—of a company, of a
country—and each within abstractions which I believe
give realizations each to the other; recognition itself
being a slight intelligence if not serving as an escort
toward comprehensions quite beyond those narrow
schemes of 'total image' so often thrust upon us. If
this essay is affirmative of Japan—notated with
admiration and apprehension—it is as I now believe,
and suggest. With considerable soul searching, that
to the utmost of my ability, I have let truth be the
prejudice."

INDUSTRIAL WASTE FROM THE CHISSO CHEMICAL COMPANY

MINAMATA

A dreadful disease was crippling hundreds of people in the Japanese city of Minamata. The source of the illness had been traced to the pollution of the sea and the fish by mercury waste from the Chisso chemical factory. Protests against Chisso were reaching fever pitch when Gene Smith and his wife Aileen arrived in the city. Smith documented their suffering with an unflinching eye, and championed their demonstrations. During the three years he spent there, he accompanied the protesters on every important mission they undertook—to the streets, to court and right up to the Chisso factory gates. Parts of the essay appeared in scores of magazines and newspapers throughout the world. The book, *Minamata,* was published in 1975. Smith wrote to *Life* editor Philip B. Kunhardt: "We believe that these pollution battles . . . may truly become important in history as the ending of the first industrial revolution and the beginning of a new industrial revolution. We believe it is going to force industrial morality and legality into something more approaching a responsibility that is one and the same. It certainly is going to condition minds and set precedents that will have repercussions throughout the world . . ."

FISHERMEN IN MINAMATA BAY

CHISSO WASTEWATER POOL FOR FACTORY DISCHARGES

CREMATION PYRE OF YOUNG DISEASE VICTIM, TOYOKO MIZOGUCHI

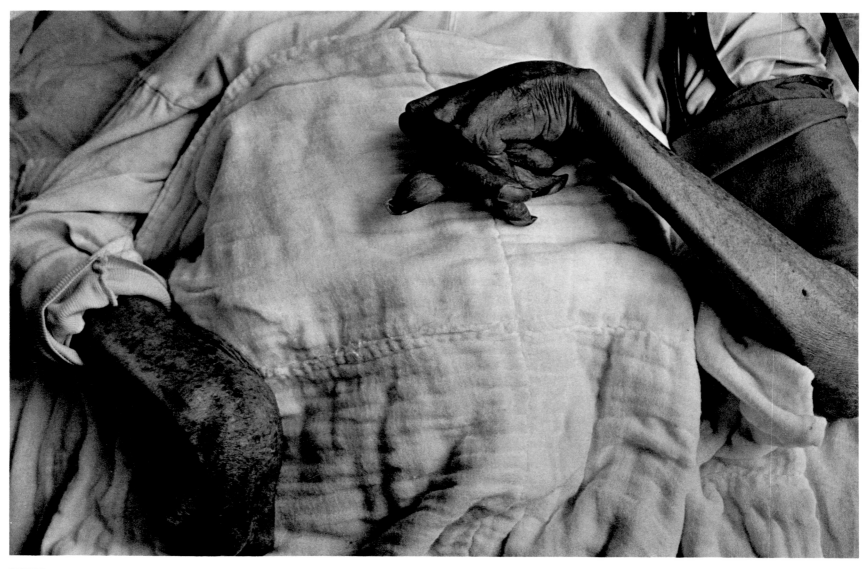

CRIPPLED HANDS OF MERCURY DISEASE PATIENT, IWAZO FUNABA

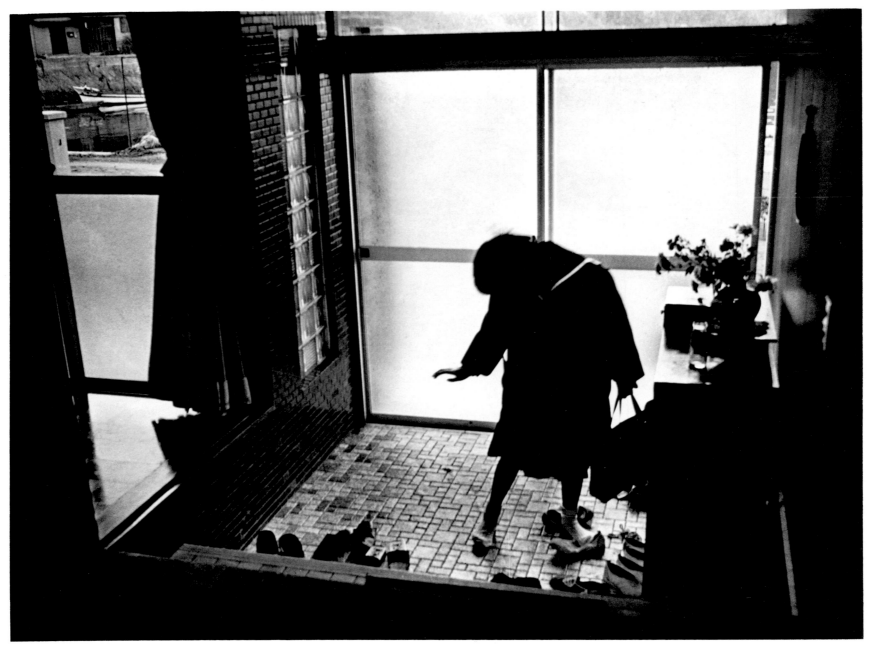

SEVENTEEN-YEAR-OLD SHINOBU SAKAMOTO, A VICTIM OF CHEMICAL POLLUTION SINCE BIRTH, RETURNS FROM SCHOOL

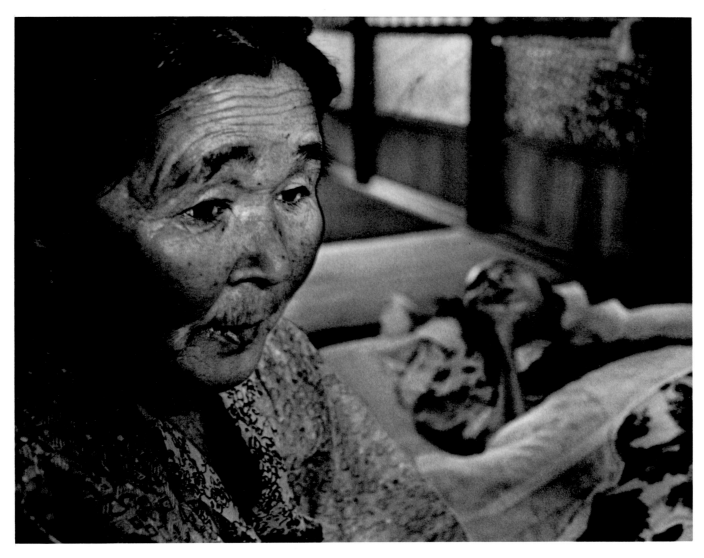

MRS. HAYASHIDA WITH HER CRIPPLED, DYING HUSBAND

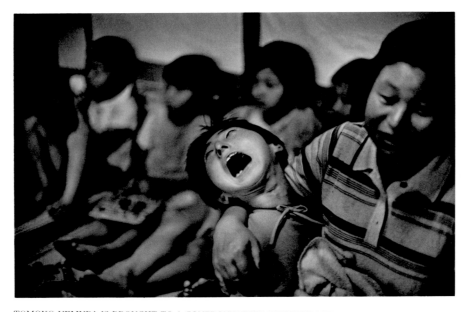

TOMOKO UEMURA IS BROUGHT TO A CONFRONTATION BETWEEN MERCURY DISEASE VICTIMS
AND CHISSO COMPANY OFFICIALS

FLAGS OF VENGEANCE: "WE SHALL PURSUE YOU TO JUSTICE,
AND WE SHALL NOT FORGET "

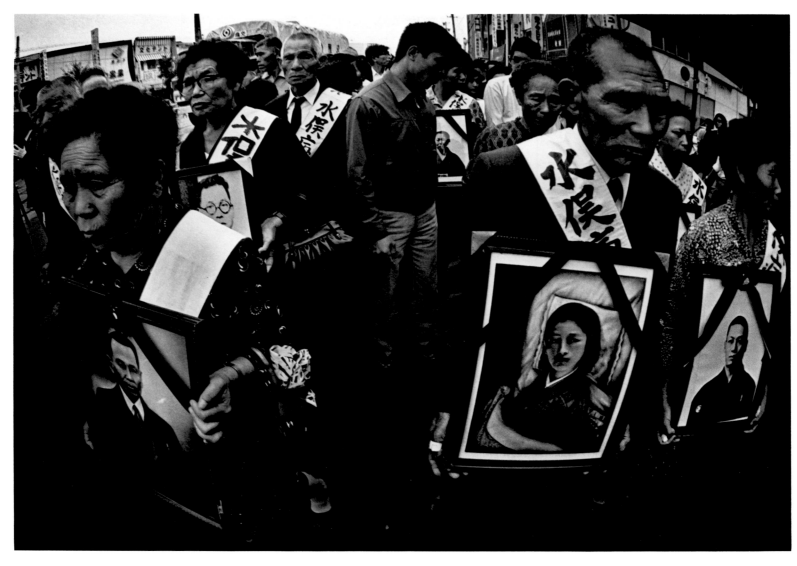

PATIENTS AND RELATIVES CARRY PHOTOGRAPHS OF THE "VERIFIED" DEAD ON THE LAST DAY OF THE MINAMATA TRIAL

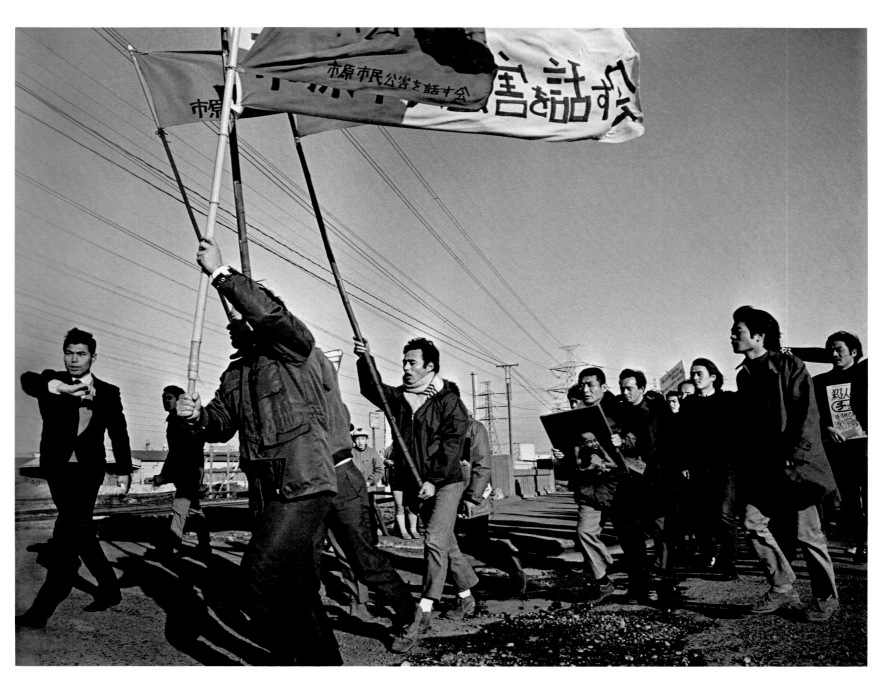

DEMONSTRATION ON CHISSO'S GOI PLANT NEAR TOKYO

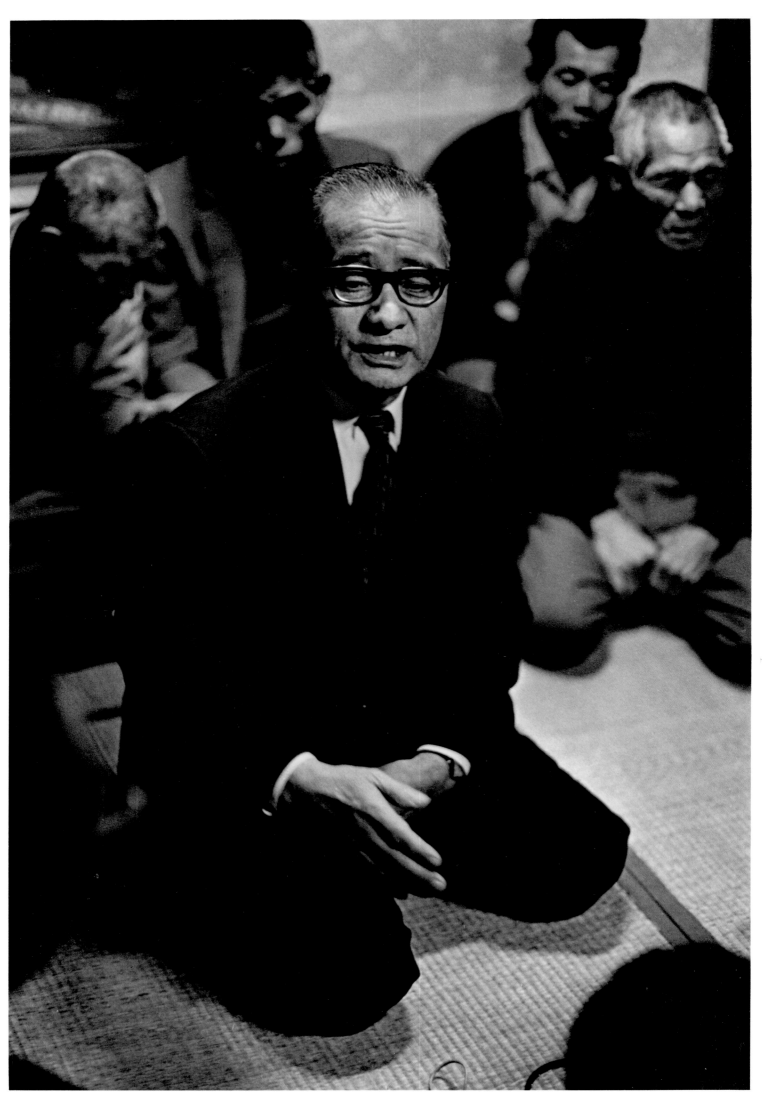

CHISSO PRESIDENT KENICHI SHINADA FORMALLY VISITING THE FAMILY OF A MERCURY DISEASE VICTIM

"Photography is a small voice, at best, but sometimes—just sometimes—one photograph or a group of them can lure our senses into awareness. Much depends upon the viewer; in some, photographs can summon enough emotion to be a catalyst to thought. Someone—or perhaps many—among us may be influenced to heed reason, to find a way to right that which is wrong, and may even be inspired to the dedication needed to search for the cure to an illness. The rest of us may perhaps feel a greater sense of understanding and compassion for those whose lives are alien to our own. Photography is a small voice. It is an important voice in my life, but not the only one. I believe in it. If it is well-conceived, it sometimes works. That is why I—and also Aileen—photograph in Minamata."

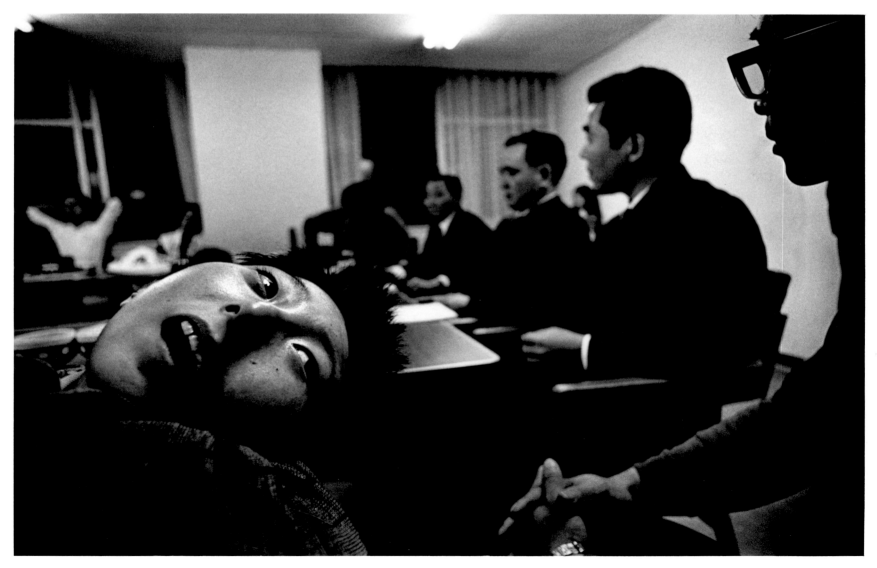

TOMOKO UEMURA AT A CENTRAL POLLUTION BOARD MEETING

TOMOKO UEMURA IS BATHED BY HER MOTHER

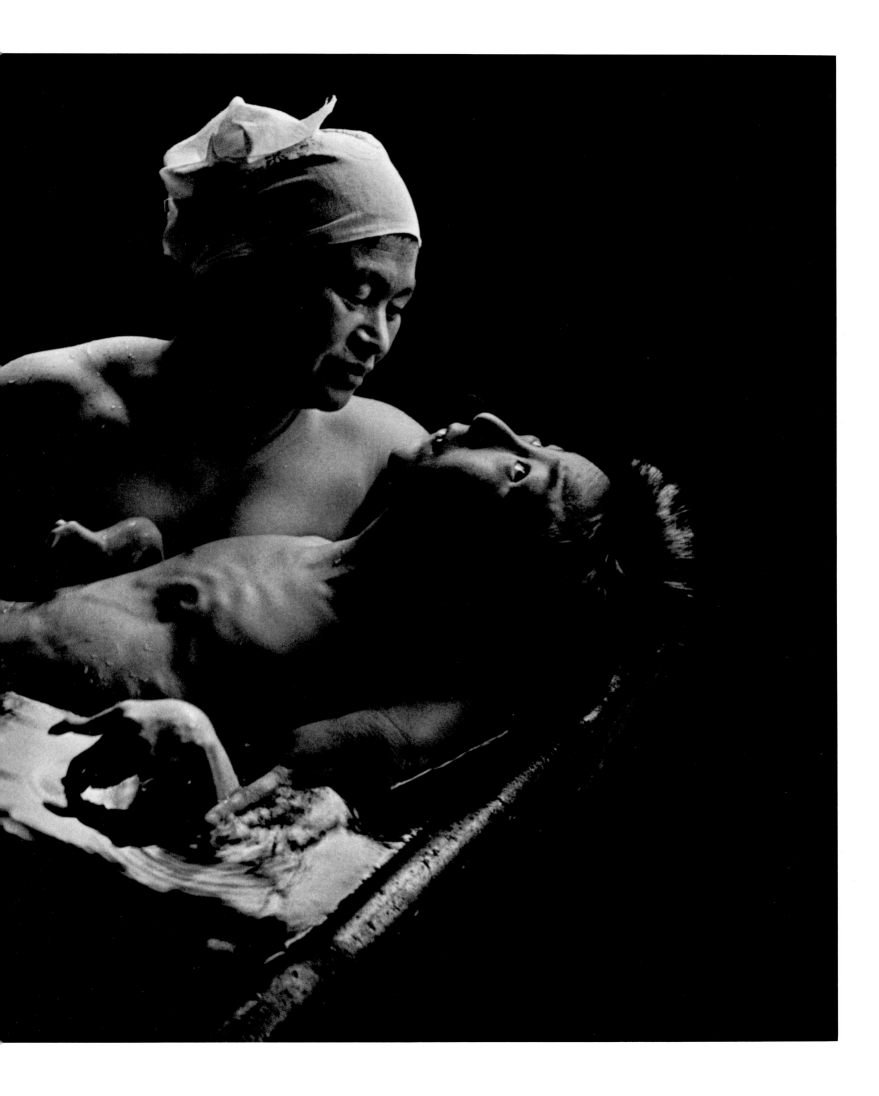

AFTERWORD

ONE COULD CALL W. EUGENE SMITH the martyr of modern photography, the man who sacrificed health, family, and fortune in the pursuit of high and lonely goals. This book is the measure of how well he achieved them. It projects his imagery, as photographer and writer, on the rumpled canvas of his life.

It was a life of epic dimension. It embraced the epochs of depression, war, postwar prosperity and disillusion. Smith worked on four continents and probed deeply into the lives of people both great and humble.

It was the intensity of Smith's life, rather than its breadth, that gave his work such haunting quality. He never lost his provincial excitement and wry amusement concerning everything he saw and heard; strangely enough music stimulated him more than the visual arts. Smith caught his subjects by their eyeballs, transmitting their emotion, through his incredible empathy, to his emulsion. Once on film, he labored like an alchemist over his images, demanding the improbable from chemicals and paper. His prints are superb examples of the darkroom arts.

Intuitively, Smith embraced all mankind, determined to use the camera "as a weapon of my good intentions." His targets were racism, poverty, and pollution; his goal was peace. Despite the somewhat simplistic nature of this philosophy, Smith's dedication to such causes, and his often desperate demand for greater creative freedom in the media, made him a folk hero to a new generation of photojournalists—young and old. The W. Eugene Smith Memorial Fund, with 63 trustees and advisors from 15 countries, gives a competitive annual grant to a photographer "who aspires to work in the Smith tradition." It is one of the most highly prized awards in photography and journalism.

In this volume Ben Maddow has drawn on the incredible written archive that Smith left to the University of Arizona's Center for Creative Photography with its thousands of papers and letters, recording Smith's dreams and his despair. It had been Smith's intention, upon joining the University of Arizona faculty in 1977, to complete a massive book which he had begun in 1954 with the encouragement of Romeo Martinez, then editor of *Camera* (Lucerne). Smith saw the book as a visual symphony, counterpointing the somewhat inchoate but nevertheless powerful themes of his personal and photographic philosophy. When he died, not only was his "symphony" unfinished; he and the Center had only barely begun to straighten out the chaos of his eleven-ton archive. Fortunately, this task was assigned to the skilled and loving hands of William S. Johnson, a trained photo-historian. In less than a year, Johnson put the basic archive in order and edited the remarkable *W. Eugene Smith: Master of the Photographic Essay* (1981), the first real "catalogue raisonnée" of a contemporary photographer.

It was published by *Aperture*, more as an act of faith than of commerce. It won for *Aperture*'s publisher Michael Hoffman the right to tackle the "big book," the one that would attempt to fulfill Smith's goal of distilling the essence of his lifelong work. Smith would have called it *Let Truth Be the Prejudice*, after his monumental 1971 retrospective sponsored by the International Fund for Concerned Photography at New York's Jewish Museum.

As Ben Maddow points out in his fascinating chronicle, Gene knew how to pick his friends. He used them, mercilessly, as he used his family. And oddly enough, they loved him for it. Speaking for Gene Smith's family and friends and particularly for those who have long labored toward this book's completion:

We take pride in, and hope you benefit from, his prejudice.

JOHN G. MORRIS

Bibliography

PHOTOGRAPHIC ESSAYS BY SMITH

Life

"Land Fighting on Saipan." *Life*, vol. 17, no. 3 (July 17, 1944), pp. 24–25. 3 b&w.

"Saipan. Eyewitness Tells of Island Fight," by Robert Sherrod. Photographs for *Life* by Peter Stackpole and W. Eugene Smith. *Life*, vol. 17, no. 9 (Aug. 28, 1944), pp. 75–83. 14 b&w, illus. 3 by Stackpole, 11 by Smith. [Portrait and brief biography on p. 19.]

"Japanese Civilians on Saipan." *Life*, vol. 17, no. 19 (Nov. 6, 1944), pp. 45–48, 50. 14 b&w.

"Hospital on Leyte." *Life*, vol. 17, no. 26 (Dec. 25, 1944), pp. 13–17. 9 b&w. [Portrait and brief biography on p. 11.]

"Marines Win Bloody, Barren Sands of Iwo." *Life*, vol. 18, no. 11 (Mar. 12, 1945), pp. 34–37. 4 b&w by Smith, 3 b&w by various photographers. [Portrait plus biography on p. 23.]

"The Battlefield of Iwo. An Ugly Island Becomes a Memorial to American Valor." Photographs by W. Eugene Smith. *Life*, vol. 18, no. 15 (Apr. 9, 1945), pp. 93–101. 12 b&w plus front cover.

"Okinawa. Except for Japs, It Is a Very Pleasant Place." *Life*, vol. 18, no. 22 (May 28, 1945), pp. 87–91. 6 b&w by J. R. Eyerman, 5 b&w by Smith.

"Americans Battle for Okinawa: 24 Hours with Infantryman Terry Moore. 'Wonderful' Smith tells about advancing through the mud and getting hit by a motor fragment," by W. Eugene Smith. *Life*, vol. 18, no. 25 (June 18, 1945), pp. 19–24. 18 b&w by Smith, portrait of wounded Smith on p. 25.

"Trial by Jury. *Life* Reports Case of the State vs. Bowers." Photographs for *Life* by W. Eugene Smith. *Life*, vol. 24, no. 20 (May 17, 1948), pp. 124–133. 40 b&w.

"Country Doctor. His Endless Work Has Its Own Rewards." Photographed for *Life* by W. Eugene Smith. *Life*, vol. 25, no. 12 (Sept. 20, 1948), pp. 115–126. 28 b&w.

"Recording Artists. Great Musicians Perform in a World the Public Never Sees." Photographed for *Life* by W. Eugene Smith. *Life*, vol. 30, no. 13 (Mar. 26, 1951), pp. 122–127. 22 b&w.

"Spanish Village. It Lives in Ancient Poverty and Faith." Photographed for *Life* by W. Eugene Smith. *Life*, vol. 30, no. 15 (Apr. 9, 1951), pp. 120–129. 17 b&w.

"Nurse Midwife. Maude Callen Eases Pain of Birth, Life and Death." Photographed for *Life* by W. Eugene Smith. *Life*, vol. 31, no. 23 (Dec. 3, 1951), pp. 134–145. 30 b&w.

"Chaplin at Work: He reveals his movie–making secrets." Photographed for *Life* by W. Eugene Smith. *Life*, vol. 32, no. 11 (Mar. 17, 1952), pp. 117–127. 31 b&w.

"The Reign of Chemistry: Monsanto Company's vast operations show how the country's fastest growing big industry has become a dominant factor in the U.S. economy and changed every American's daily life." Photographed for *Life* by W. Eugene Smith. *Life*, vol. 34, no. 1 (Jan. 5, 1953), pp. 29–39. 16 b&w, 2 color by Smith, 2 illus.

"My Daughter Juanita: A perceptive photographer displays the many moods of his 8-year-old." Photographed for *Life* by W. Eugene Smith. *Life*, vol. 35, no. 12 (Sept. 21, 1953), pp. 165–171. 16 b&w, 1 b&w on front cover.

"A Man of Mercy: Africa's misery turns saintly Albert Schweitzer into a driving taskmaster." Photographed for *Life* by W. Eugene Smith. *Life*, vol. 37, no. 20 (Nov. 15, 1954), pp. 161–172. 25 b&w. [Statement plus portrait of Schweitzer on p. 27.]

"Drama Beneath a City Window." Photographed for *Life* by W. Eugene Smith. *Life*, vol. 44, no. 10 (Mar. 10, 1958), pp. 107–114. 14 b&w, 1 portrait.

"Colossus of the Orient: Somber beauty of Hitachi, Japan's great manufacturer." Photographed for *Life* by W. Eugene Smith. *Life*, vol. 55, no. 9 (Aug. 30, 1963), pp. 56A–63. 13 b&w.

"Death-Flow from a Pipe: Mercury pollution ravages a Japanese village." Text and pictures by W. Eugene and Aileen Smith. *Life*, vol. 72, no. 21 (June 2, 1972), pp. 74–81. 11 b&w.

McCall's

"1,200 minus 5 Leaves Nothing: The sad mathematics of war shroud Beallsville, Ohio, a fertile farm community turned fallow with sorrow." Photographs by W. Eugene Smith. *McCall's*, vol. 97, no. 2 (Nov. 1969), pp. 76–81. 13 b&w. [Thirteen photographs of small midwestern town with commentary by an unidentified author; pp. 80–81 contains a poem "Ares" by Eugene McCarthy and four photographs of gravestones by Smith as a coda.]

[Popular] Photography Annual 1959

"Pittsburgh—W. Eugene Smith's Monumental Poem to a City." Photographs by W. Eugene Smith. Introduction by H. M. Kinzer. *Photography Annual 1959* (1958), pp. 96–133, 238. 88 b&w, 1 portrait , 1 illus. [The most complete presentation of Smith's largest single essay, "Pittsburgh."]

Roche Medical Image

"The Haiti Story: from voodoo to modern psychiatry." *Roche Medical Image*, vol. 2, no. 2 (Apr. 1960), pp. 17–22. 9 b&w. [This is the most complete realization of the Haiti essay in print. Discusses the history of the founding of a modern psychiatric center in Haiti through the efforts of Dr. Louis Mars and Dr. Nathan S. Kline and others.]

The Second Coming Magazine

"Portfolio: Ku Klux Klan photographs by W. Eugene Smith." *The Second Coming Magazine*, vol. 1, no. 3 (Mar. 1962), pp. 21–27. 7 b&w.